Sacred Nile

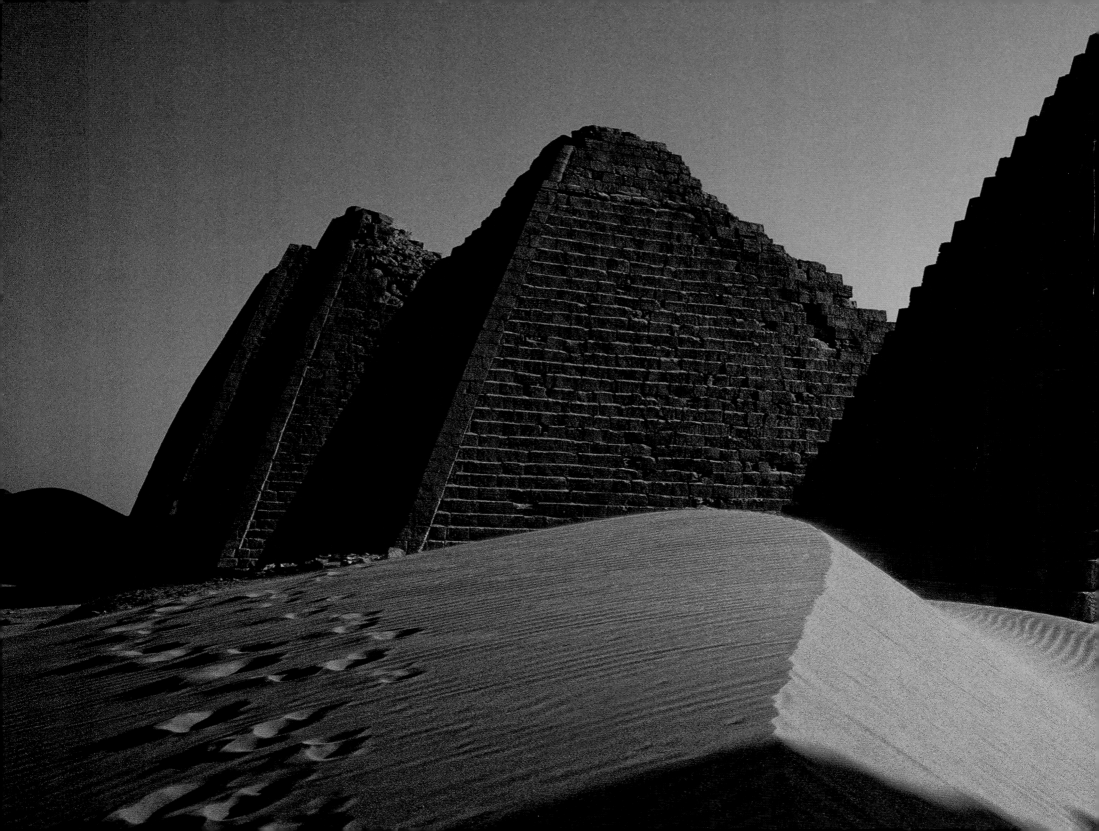

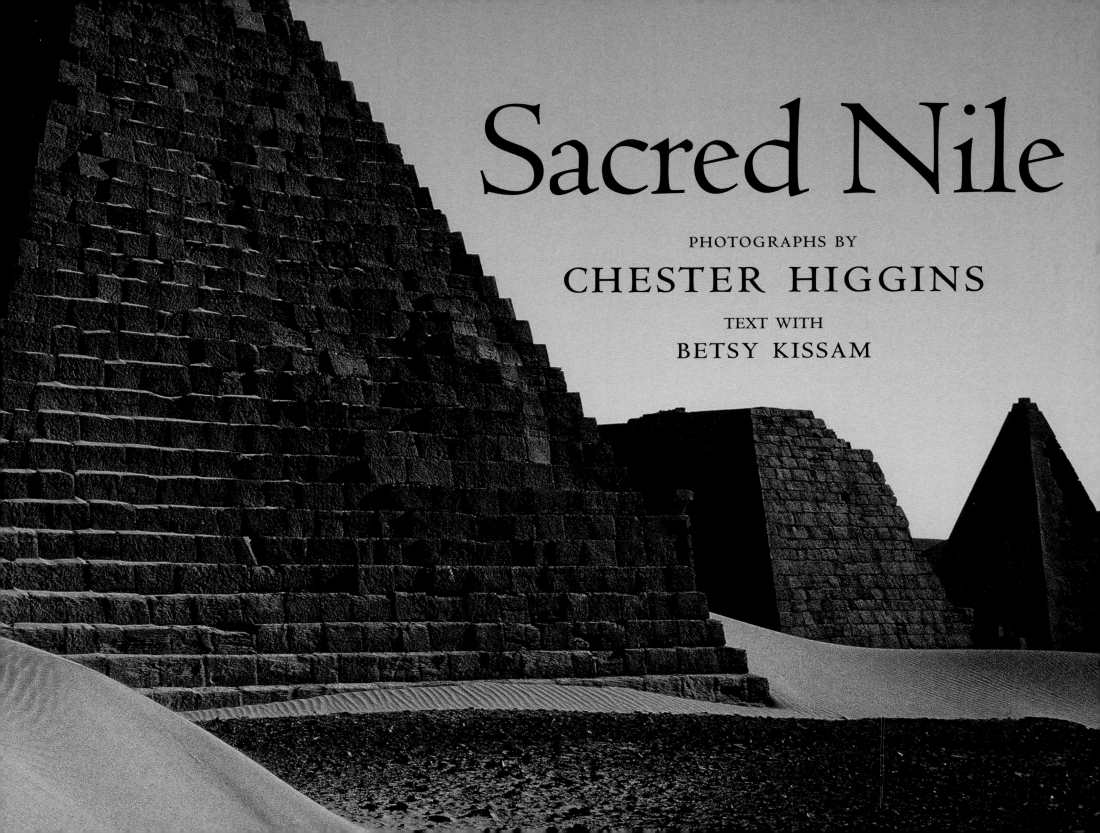

Sacred Nile

PHOTOGRAPHS BY

CHESTER HIGGINS

TEXT WITH

BETSY KISSAM

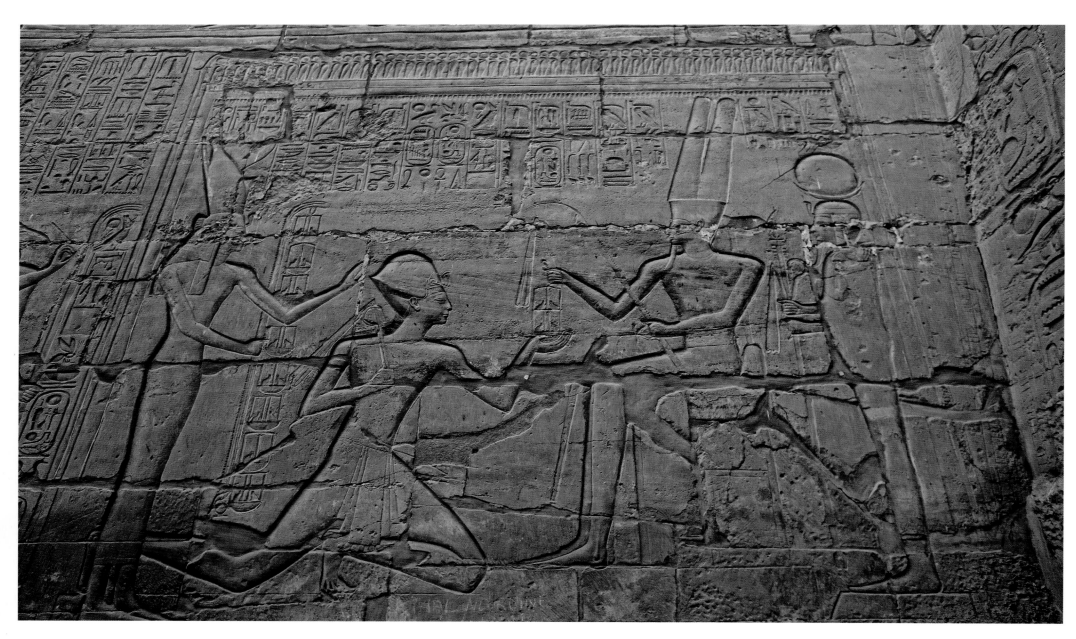

Kemet — The Holy Family of Karnak: King Ramses II kneels to be anointed by the
seated Holy Father, the supreme divinity *Amen*, and the Holy Mother *Mut*; their
Holy Son *Khonsu* stands behind his father. 14th century BCE Temple of *Amen*.
Karnak, East Bank, Luxor, Egypt, 2019

We dedicate *Sacred Nile* with love to our rising stars.

ISARO

ORION

SHAQUILA

 ለጋስ ዓባይ

Sacred Nile

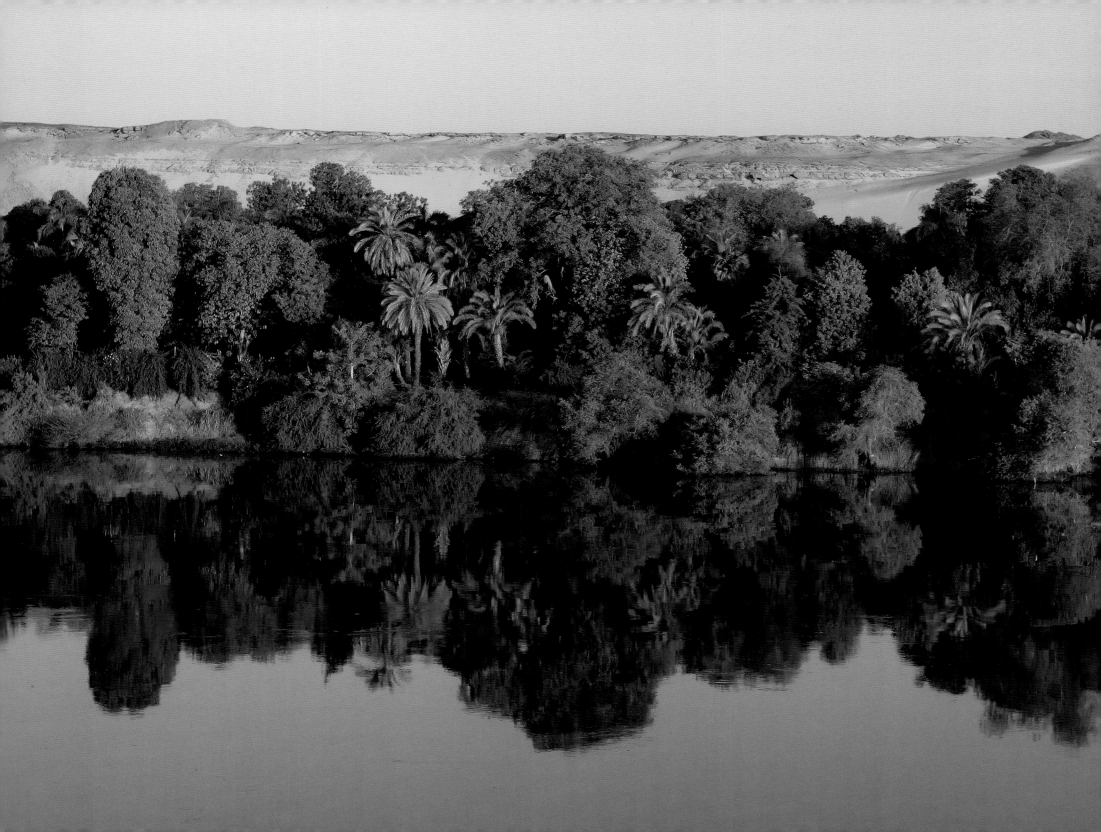

As the debate about the African origins of human civilization continues to be an important facet of our current intellectual discourse, *Sacred Nile* by Chester Higgins comes as a guiding compass. As a participant observer of the region for nearly half a century, Higgins's manuscript is an excellent first-hand witness to the religious and cultural contributions of one of the most — if not the most — significant centers of human history. From Aksum to Kemet, and Nubia, Meroe, and Kush, *en passant*, Higgins's book chronicles essential Nile Valley stories carved in sacred images of people and texts, natural sites, symbolic stone columns, walls and statues. As such, I consider this book a must-read for all those who wish a better understanding of African civilization, in particular, and world civilization, in general.

— **Thierno Thiam,** Chair, Department of History and Political Science, Co-Director of the Integrative Public Policy and Development Ph.D. Program, Tuskegee University

River Nile seen from Kitchener's Island. Aswan, Egypt, 1979

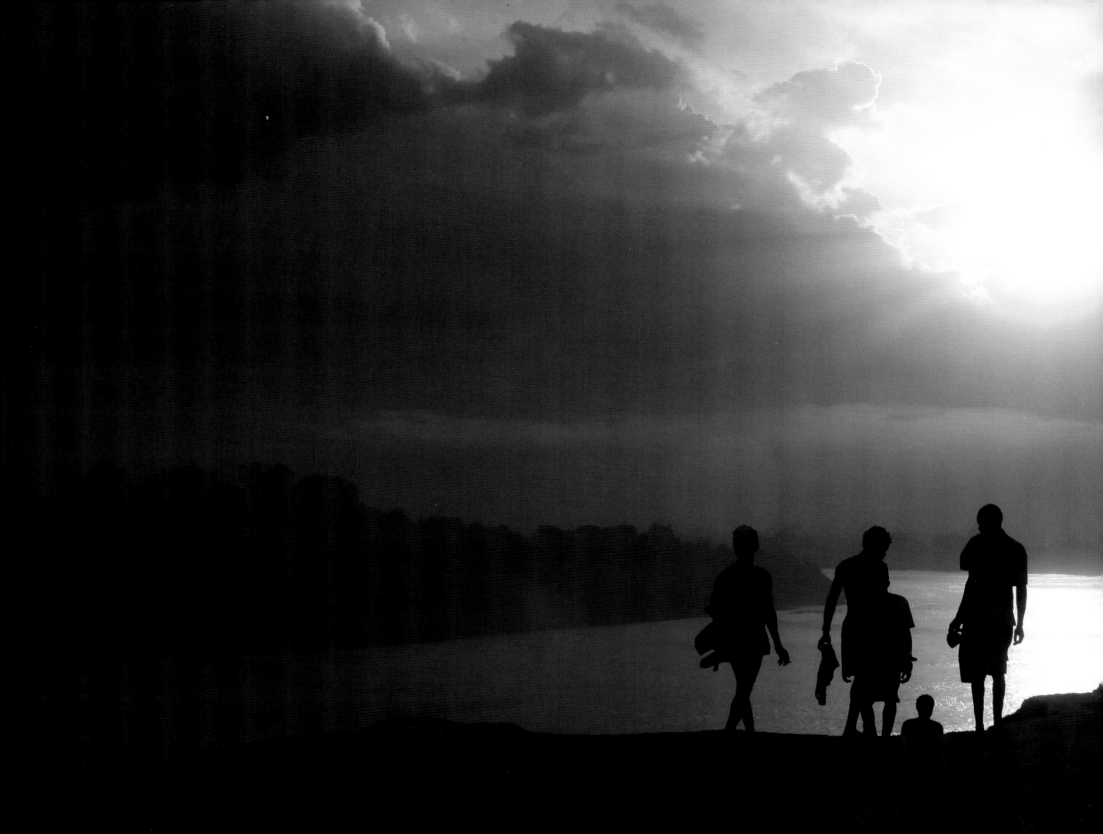

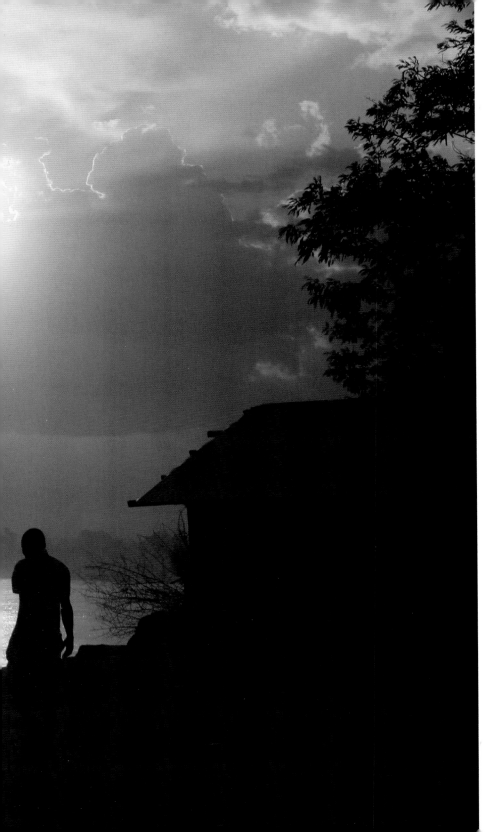

Contents

On the bank of the Atbara River which flows into the
River Nile in Sudan. Gondar Region, Ethiopia, 2010

Notes on Ancient Names

Known as **Kemet**, the Black Land — Ancient Egypt was a theocracy where the government ruled in the name of God and was administered by monarchs, mostly kings. The very first Dynasty was established c. 3100 BCE. There were a total of thirty Dynasties, ending in the fourth century BCE.

The people of *Kemet* called territory south of them, **Nubia**. Scholars generally agree that the word *Nubia* is derived from the ancient Egyptian word *nub* for gold, which was plentiful in the mines of *Nubia*. Today historians cite the Ancient *Nubian* Kingdom of Kerma, the Ancient *Nubian* Kingdom of Napata, and the Ancient *Nubian* Kingdoms of Meroe, as the discrete polities layered within the same territory now recognized as northern Sudan. Classical historians identify land south and east of Egypt as "Ethiopia," the Land of Burnt Faces. Early cultures within the boundaries of today's Ethiopia are still being discovered through excavations; the Aksumite Kingdom (c. first to seventh century CE) is the most deeply researched state so far with numerous ancient relics, including the monumental obelisks in the city of Aksum.

Sacred language of priests

During its decline, starting in the fourth century BCE, *Kemet* suffered three hundred years of Greek occupation. In those years, Hellenized iterations of many Egyptian deity and place names came into usage. Their unique identities were subsumed under the conquering culture. The ability to comprehend hieroglyphs — the sacred language used between priests — faded from memory by the late fourth century CE.

The West paid scant attention to this vibrant African spiritual culture until General Napoleon Bonaparte, accompanied by a legion of French scholars, led a military campaign into Egypt in 1798. This was followed in 1809 by the publication of the collective works of those scholars — *Le Description de l'Égypte*. During its brief occupation, the French Army found the trilingual Rosetta Stone with a 196 BCE royal decree written in demotic and hieroglyphic scripts and ancient Greek.

A little more than a decade later in 1822, French linguist Jean-François Champollion (1790–1832) deciphered the hieroglyphic and demotic scripts. The entire world was to become and remain enthralled by this sophisticated culture.

Consonant-based

As a linguist Champollion had an edge over his English competitors in the race to decipher the ancient language. He was fully versed in the Coptic language, which is a derivative of the ancient Egyptian hieroglyphic language written in the Greek alphabet. It was used by Egyptian Christians, the Copts, as the language of their religion and so survived the adoption of Arabic with the coming of Islam into Egypt. Its survival became the port of access for Champollion and the rest of the world.

Although Champollion succeeded in breaking the code of the written languages of *Kemet*, there is no aural memory of how the hieroglyphs actually sounded because the hieroglyphic script is consonant-based with no vowels and only a few semi-vowels. Thus, attempts at pronunciation vary. Pronunciations are at best humble but well-intentioned stabs. One is therefore unable to say that the name of a deity or a ruler is definitely pronounced this way or that way. A quick search of Egyptological writings shows a lack of agreement in pronunciation (as revealed through vowel choice) among some of the most respected academics in the field. The journey to nail down an empirical standard is less frustrating, definitive, than it is elusive, teasing and all the more fascinating.

The name of one deity in particular has numerous pronunciations — all of which, by the way, acceptable — based on the choice of vowel: *Amen*, the supreme Divinity of both *Kemet* and *Nubia*, written with three hieroglyphs, is transliterated IMN. The first hieroglyph is a semi-vowel generally understood to sound: "ah"; but the second and

third glyphs — the M and N — are consonants with no vowel attached. In this book, I use the vowel 'e' for *Amen*.

Because proper names from *Kemet* — more than 5,000 years ago — often come to us with distortions, I have prepared a chart on the next two pages showing names transliterated directly from the hieroglyphs to the closest sounding English letters. (I also added phonetic spellings for these names.) After the transliterated names are those more commonly in use in English-speaking countries today. Out of respect for the people who lived along the Nile and first worshiped these deities, I tried to use the names matched as closely as possible to the hieroglyphs. These are italicized in the text as are words from other indigenous African languages.

Kings and Queens Rule

Pharaoh is not an indigenous word in the Ancient Egyptian language. Most scholars support the theory that the Ancient Egyptian word for great house, *pr aa*, was the basis for the Hebrew word *Pharaoh* in the Holy Bible and the Greek: *Pharaó*, which gained currency in *Kemet* as the title for monarchs in the late New Kingdom and thereafter, especially for the Greek Ptolemaic rulers, including the legendary Cleopatra. Since so many centuries stand between us and these rulers and cloud our perceptions, I have identified the monarchs of *Kemet* with the titles King and Queen.

Archaeologists have found that women in *Nubia* seem to have ruled more often and held more power than their counterparts in *Kemet*. In the *Nubian* Meroitic Kingdom, the title *Qore* was held by rulers of either sex. *Kandake* was an important female appellation; as yet, it hasn't been ascertained definitively if the *Kandake* was the King's mother or future King's mother; but only very prominent queens held that title.

Wooden torso of King Tutankhamen, Dynasty 18. Grand Egyptian Museum, Cairo, Egypt, 2000

Transliteration with Vowels (pronunciation)	Hieroglyphs / Transliteration		Common Usage
Kemet (**Ke**-met)		KMT	The Black Land; Egypt
Kemetiyu (Ke-**met**-ti-u)		KMTYW	People of Kemet
Waset (**Wah**-set)		WST	Luxor (called Thebes by Ancient Greeks)

Amen (**Ah**-men) Supreme deity, The Hidden One, Father of the Holy Family of Karnak		IMN	Amen, Amun, Amon
Amen Re (**Ah**-men Rah) Deity of Waset, consolidated with the Sun deity Re (of On) to become the national deity of Kemet		IMN RE	Amen Re, Amun Re
Anpu (**En**-pu) Deity of mummification		INPW	Anubis
Asar (**Ah**-sar) Lord of the Afterlife, Father of the Holy Family of Abydos; when his flesh is green, he is associated with regeneration		WSIR	Osiris
Ast (Ahst) Deity, Mother of Resurrection, Mother of the Holy Family of Abydos		IST	Isis
Aten (**Ah**-ten) Supreme Sun deity, Lord of the Sky		ITN	Aten, Aton
Hapi (**Ha**-pee) Deity of the River Nile waters which sustain the country		HPY	Hapi, Hapy
Heru (**Heh**-ru) Deified protector of the throne of Kemet, Son of the Holy Family of Abydos		HR	Horus

Transliteration with Vowels (pronunciation)	Hieroglyphs / Transliteration		Common Usage
*Het Heru (Het **Heh**-ru)* Deity, beloved by women, Symbolic Mother of monarchs		HT HR	Hathor
*Khonsu (**Kahn**-su)* Deity of the Moon, Son of the Holy Family of Karnak		KHNSW	Khonsu
*Ma'at (Ma' -**aat**)* Deity of truth, justice and harmony; divine order		MAAT	Ma'at
Min Deity of fertility, for agriculture and animals		MN	Min
Mut (Moot) Deity, her name means "mother"; Mother of the Holy Family of Karnak		MT	Mut
Nut (Noot) Deity of the canopy of the Heavens; the force of continuity, she births the Sun each morning		NT	Nut
*Ptah (Pah-**tah**)* Deity of creation and maker of all things		PTH	Ptah
Re (Rah) Deity of the Sun, ruler of the Sky and the Earth		RE	Re, Ra
*Re Herakhty (Rah Her-**ax**-tee)* A merging of the Sun deity *Re* with *Heru;* known as *Heru of the Two Horizons*		RE HRKHTY	Re Horakhty, Ra Horakhty
*Sekhmet (**Sek**-met)* Deity known as the chief enforcer, capable of destroying (and protecting) humanity		SHMT	Sekhmet
*Seth (**Se**-teh)* Deity of evil, chaos and destruction		STH	Seth, Set
*Tehuti (Te-**hoo**-tee)* Deity of recording and communicating knowledge		DHWTY	Thoth

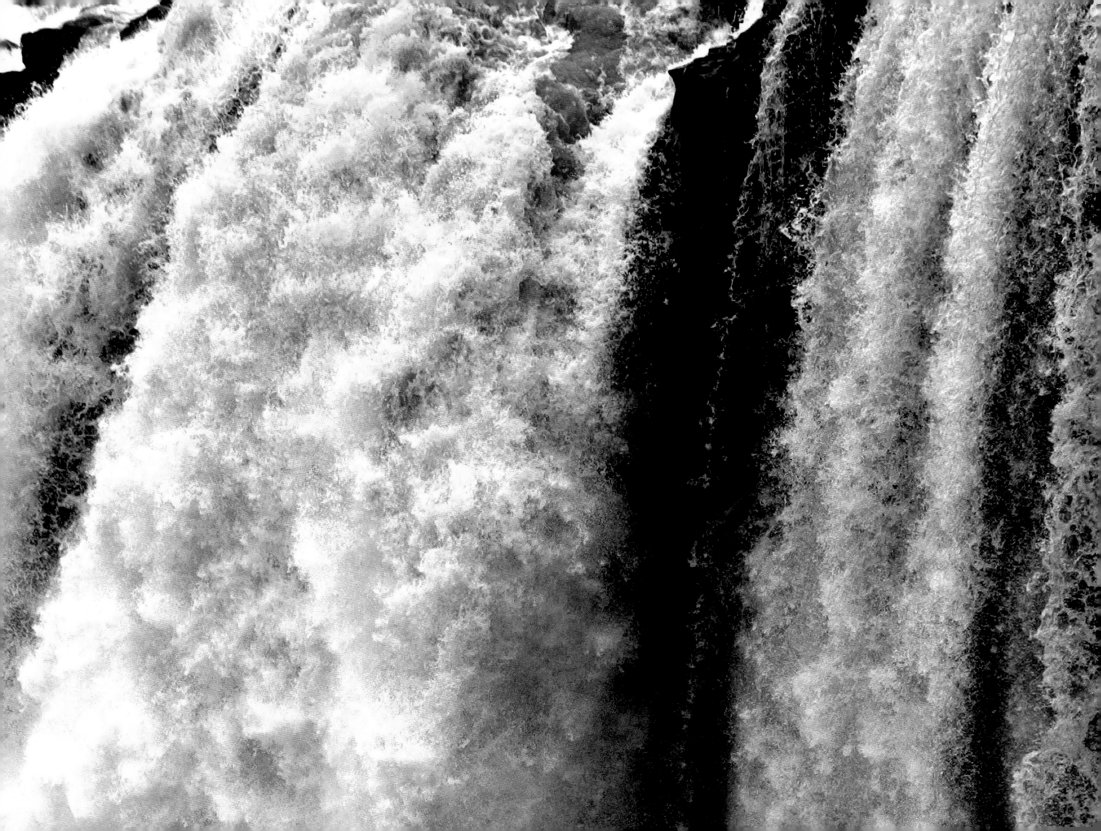

The Journey

We humans worship ancient memories in search of a divine future.

Sacred Nile is my portrait of the spiritual imagination and the genesis of faith in Africa. Ancient records left in stone detail Africans' philosophical quest to wrestle with the seminal issues of who we are, where we are, and what is our purpose. In my photographs, I celebrate the sacred agency of people of African descent and their foundational influence on all Western religions. The images illustrate a millennia-long migration of faith up and down the River Nile, the living waters that link Ethiopia, Sudan and Egypt. The ancient land of Egypt was called *Kemet*, translated as The Black Land. The ancient territory of Sudan south of *Kemet* was called *Nubia,* from the ancient word *nub,* or gold.

With this visual record of faith, I propose to redefine the beginnings of belief at its earthly place of origin, along the sacred Nile. Coming face to face with the monumental remains of Ancient Egypt, I realized that the African foundation of religion had been obscured by miseducation. The story of Ancient Egypt's enduring and innovative civilization has been uprooted from the memory of African people.

The north-flowing River Nile in northeastern Africa is fed by two main tributaries: the Blue Nile, originating at Lake Tana, Ethiopia, which contributes eighty percent of the water as well as the fertile silt and the White Nile, which arises in the Great Lakes region of Central Africa. For this study of the origins of spirituality and faith, I begin in Ethiopia. The Blue Nile River from the Ethiopian highlands flows downhill north to Khartoum, Sudan. Here, the Blue and White Niles merge to form the River Nile that courses through the deserts of Sudan and Egypt on its way to empty into the Mediterranean Sea.

Tis Esat (Water That Smokes) or Blue Nile Falls. Bahir Dar, Ethiopia, 2013

For fifty years I have returned regularly to this waterway to deepen my perceptions, my understanding and appreciation for the spirituality that was honed and is still celebrated here. I return to honor the spirits of our beginnings — the spirits of the Ancients whose wisdom still impresses and brings us peace.

Otherworldly beauty

There is some mystical, even supernatural quality, about the Blue Nile River. When the Greek historian Herodotus identified Egypt as "the gift of the Nile" in the fifth century BCE, he had no knowledge of the source of the river, which brought the fertile, volcanic soil and most of the water to Egypt. But anyone who has witnessed the watery turmoil created by the summer rains in the Ethiopian highlands, some 6,035 feet above sea level, can appreciate the otherworldly beauty of the frothing reddish soil in this water and its menace as it hurtles down mountainsides, tracking through ancient gullies and joining to form swift-flowing streams, tributaries, and then the impressive Blue Nile. The might of this river slices gorges through volcanic rock, creating canyon walls, some more than 4,000 feet deep. Twisting and turning, asserting its power to sculpt and sheer, alternately insinuating and imposing its imperatives in a juxtaposing of broad sweeps and tight curves, the water turns north and cascades down into the beseeching deserts of Sudan and Egypt. By the time the river reaches Khartoum in Sudan and joins the White Nile to form the River Nile, its elevation is 1,250 feet — having fallen nearly 5,000 feet in 900 miles. When at last the river reaches the Giza pyramids in Cairo, Egypt, its elevation is barely 64 feet. Before modern dams interrupted the flow, the Blue Nile carried about eighty percent of the water and fertile silt that transformed Egypt's parched desert plains:

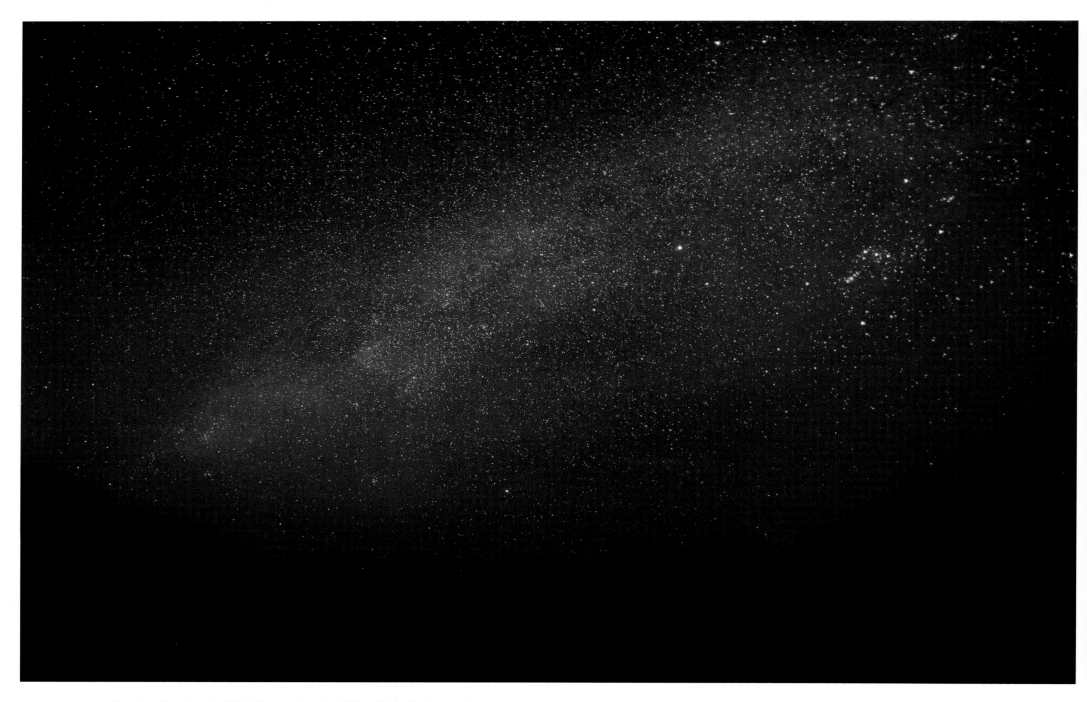

To Ancient Egyptians, the Milky Way was the celestial River Nile in the Heavens. Seen from Debre Damo Monastery at 7,400 feet above sea level. Tigray, Ethiopia, 2011

surely "the gift" that Herodotus recognized. All of life's dramas and all of life's repose — of birth, death and renewal, of action and rest, struggle and peace — have been conjured by these living sacred waters.

I have come to appreciate that Western faith borrowed heavily from the theological beliefs recorded in tombs and temples along the River Nile. My own personal journey into this African heritage began in 1973. I was in Egypt on assignment for an airline to make photographs for a tourist brochure. In Luxor, I was assigned to shoot the Temple of *Amen*.

It was in this Karnak Temple in Luxor where I first came upon the enigmatic and diverse array of sacred images made by the African people, their writings, and stunning flora, carved into stone columns, walls and statues. I had arrived here expecting to see representations of scenes from biblical narratives that I knew from childhood and Hollywood movie spectacles, featuring stern pharaohs ruling over an oppressed population that was powerless to resist. But now, here before me, these temple images showed reverent kings (pharaohs) bowing to their divinity and offering universal elements of water and fire (incense) for supplication and purification. These gestures were all harbingers of how human beings — no matter the religious belief to which they subscribe — express awareness, gratitude, humility and reverence before their Maker, today. What had ignited my imagination as a young boy — scenes of drama and conflict, conquering and vanquishing — failed to convey the full range of history and particularly the rich transcendent spirituality of deep belief represented in front of me. Nothing had prepared me for the impact or revelations. What I beheld there in 1973, and on subsequent trips to the River Nile, would change my life and my understanding of Africa's place in world history. What I began to see, with my eyes and lens, was a thrilling through-story of the unseen and unspoken.

Woven into the foundation of faith

Today religious zeal burns intensely at the source of the Blue Nile in the three Abrahamic religions and a Nature-centric faith. I juxtapose my photographs of contemporary rituals in Ethiopia with images of antiquity sites and artifacts found today in Egypt, Sudan and Ethiopia to promote a broader understanding and appreciation of the connections between ancient and modern River Nile faith.

It is essential to recognize how much the art of the ancient Nature-centric culture of *Kemet* is prized by some of our most venerated and prestigious museums, how much it excites our cultural imagination, and how much its theological influence is reflected by our contemporary

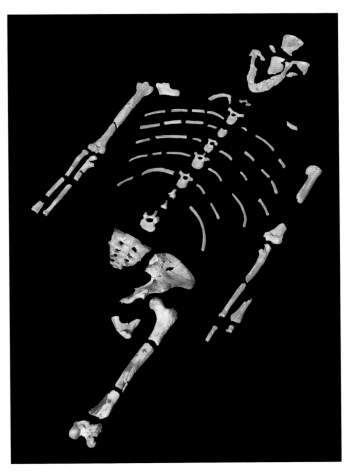

The 3.2-million-year-old fossilized skeleton of *Dinkinesh* (Lucy), found in 1974 at Hadar, Ethiopia. National Museum of Ethiopia. Addis Ababa, Ethiopia, 2004

faith. The earliest known written Holy Scripture — located on the walls of the 2500 BCE pyramid of King Unas in Saqqara (pronounced Sakkara), Egypt — introduces concepts of spirit, soul, resurrection, ascension and celestial afterlife, *nearly 5,000 years ago.* A code of morality carried forward in the Ten Commandments existed on papyrus millennia before the introduction of Judaism, Christianity and Islam. Ancient temple scenes foreshadow many of the symbolic transactions and elements and much of the iconography of modern worship: the hierarchy of clergy, the purifying power of water, prayer, incense, the symbol of a cross, the crescent, and even rituals. Many of the motifs and icons that arose out of the imagination of the sublime among the ancient River Nile people have over millennia been retooled, adapted and woven into the fabric of modern faith.

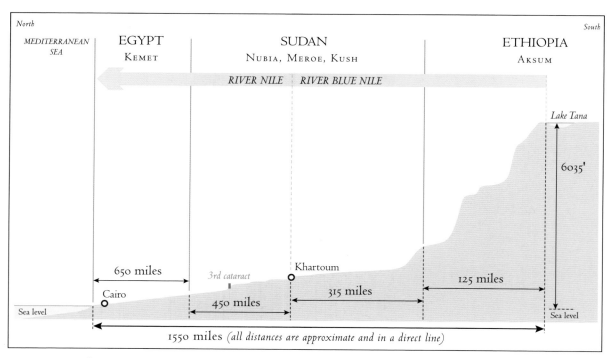

The topography of the Nile Trench from Lake Tana to the Mediterranean Sea. The Blue Nile River spills out of the Ethiopian Highlands at 6,035 feet above sea level downhill going north for nearly 440 miles to Khartoum, Sudan, where the water commingles with the White Nile to become the River Nile. The Nile riverbed continues to wander through the desert plains of Sudan and Egypt before it empties into the Mediterranean Sea, covering a meandering path of nearly 2,600 miles. Maps by Adrian Kitzinger.

Misty morning at the source waters for Lake Tana and the Blue Nile River. Bahir Dar, Ethiopia, 2007

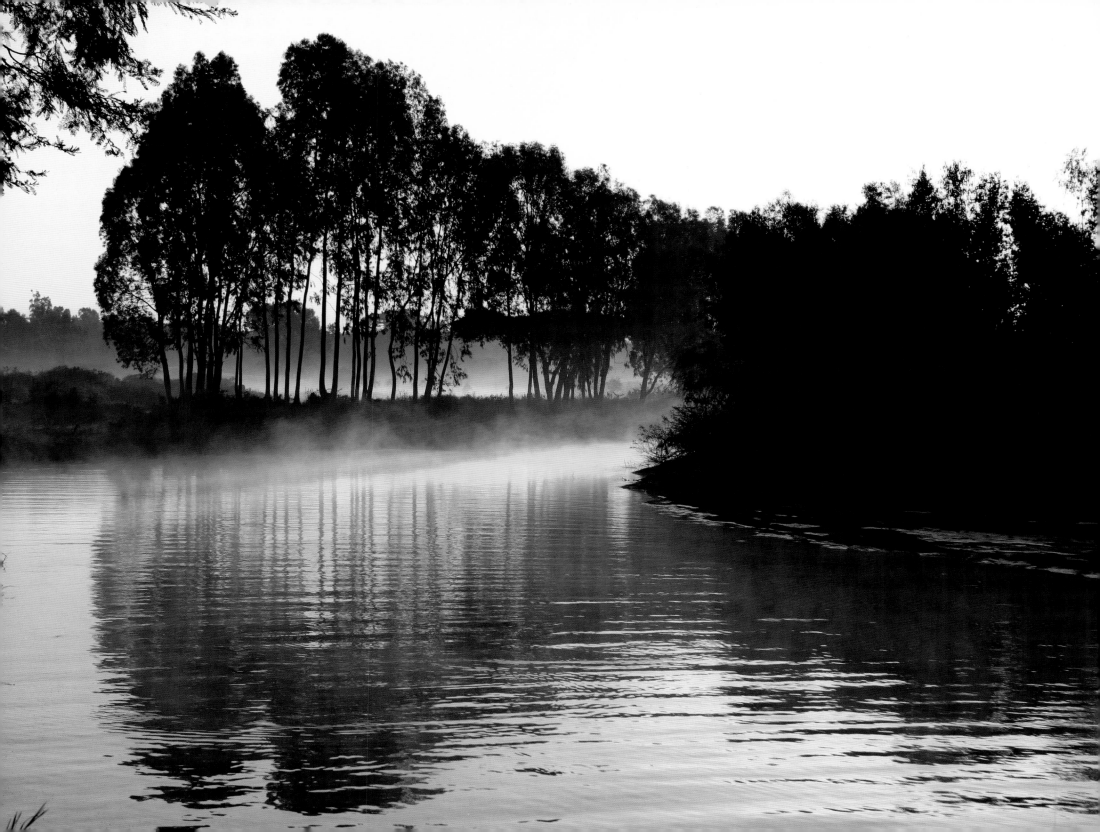

An African invention

Although the history of early faith has many layers yet to be discovered, I believe the Nature-centric spiritual system, originating and still practiced in today's Ethiopia, migrated downriver into *Nubia* and *Kemet*. Those who revere Nature depend upon its benevolence to sustain life. This worship reached its apex of expression in the desert lowlands of *Kemet*. It flourished here for more than 3,500 years before centuries of occupation by conquering forces of Assyrians, Persians, Greeks and Romans sapped its vitality and ultimately prohibited its practice. Key elements of this faith have been absorbed into later Abrahamic religions: Judaism, Christianity and Islam. In my photographs I look for similarities supporting our collective religious heritage.

A downriver migration of faith from Ethiopia to Egypt finds resonance in the words of first century BCE Greek historian Diodorus Sicilus, eyewitness to the glory of the *Nubian* Empire of Meroe. Chronicling oral history, Diodorus wrote ". . . the Egyptians are colonists sent out by the Ethiopians. . . . And the larger part of the customs of the Egyptians are, they hold, Ethiopian, the colonists still preserving their [Ethiopian] ancient manners." (Although boundaries of contemporary Ethiopia are not the designation accepted by ancient Greeks, who referred to the home of Black people south of the Mediterranean Sea, these words challenge views that deny ancient Egypt's African roots.)

Twenty-one centuries after Diodorus, Senegalese historian (and physicist) Cheikh Anta Diop, who studied the origins of the human race and pre-colonial African culture, declared that "the basic elements of Egyptian civilization are neither in Lower Egypt, nor in Asia, nor in Europe, but in *Nubia* and the heart of Africa; moreover, that is where we find the animals and plants represented in hieroglyphic writing. . . ."

Today, Egyptologists are starting to overcome their dissonance and accept ancient Egyptian culture as African. In his landmark work, *The Rise and Fall of Ancient Egypt* (2010), Toby Wilkinson acknowledges this when he writes, "The origins and early development of civilization in Egypt can be traced back to at least two thousand years before the pyramids, to the country's remote prehistoric past."

Climatologists contend that the desert in northern Africa wasn't always the dry, formidable landscape it is today; around 5000 BCE, the seasonal rains that had been sustaining grasslands for the grazing of cattle tended by nomadic herders started to lessen and pivot northeast. These rains have now mostly disappeared, and Egypt's terrain is predominantly desert except for a band of arable land on either side of the Nile; Sudan as well is more than fifty percent desert. Only in the highlands of Ethiopia can one still experience the more or less predictable rains that pool and accrue to create the impressive rush of water down the Blue Nile.

Being here

Faith is a matter of the spirit and the soul, two ineffable qualities that all living things possess. I believe Nature — the most complete and perfect iteration of how we experience life on planes both seen and unseen, perceived and intuited — plays the starring role in how we assume our existence. Nature, in unlimited manifestations, informs our understanding of an omnipotent power, the spirit and the soul, all concepts that have transitioned from culture to culture throughout time. Spirituality and religion — separate but related concepts — address what it is for all living beings to exist in this enormous Oneness — the singularity of all that is, was before and will be.

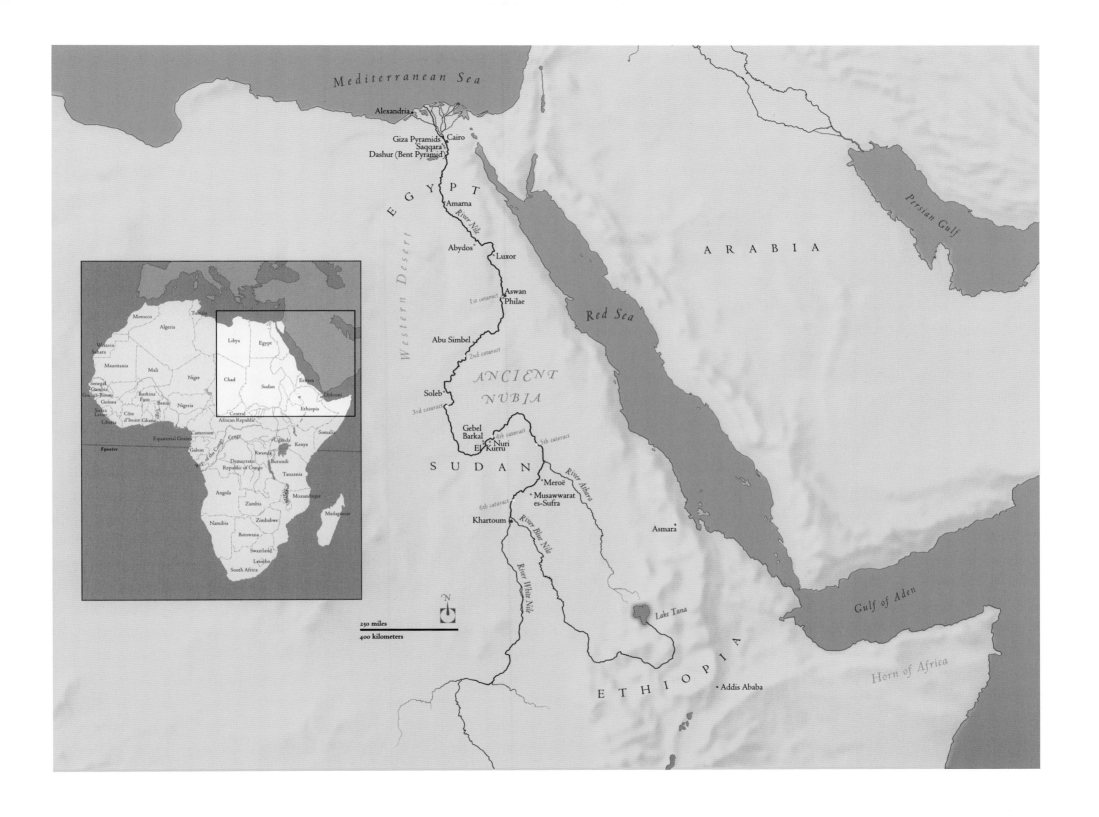

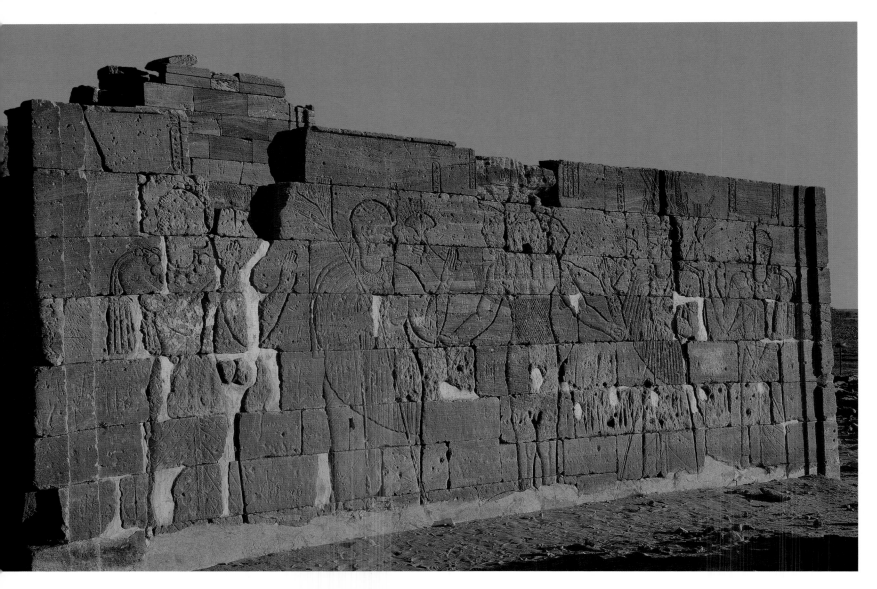

Nubia — Lion-headed warrior deity *Apedemak* (multi-tasking with three heads and four arms) receiving offerings from the King Natakamani and *Kandake* and *Qore* (Queen and Ruler) Amanitore (c. mid-1st century BCE to early 1st century CE; 2,200 years ago). Rear wall, *Apedemak* Temple. Naga, Sudan, 2007

Kemet — Luxor Temple, completed 3,234 years ago in 1213 BCE, New Kingdom. East Bank, Luxor, Egypt, 1988 ⟶

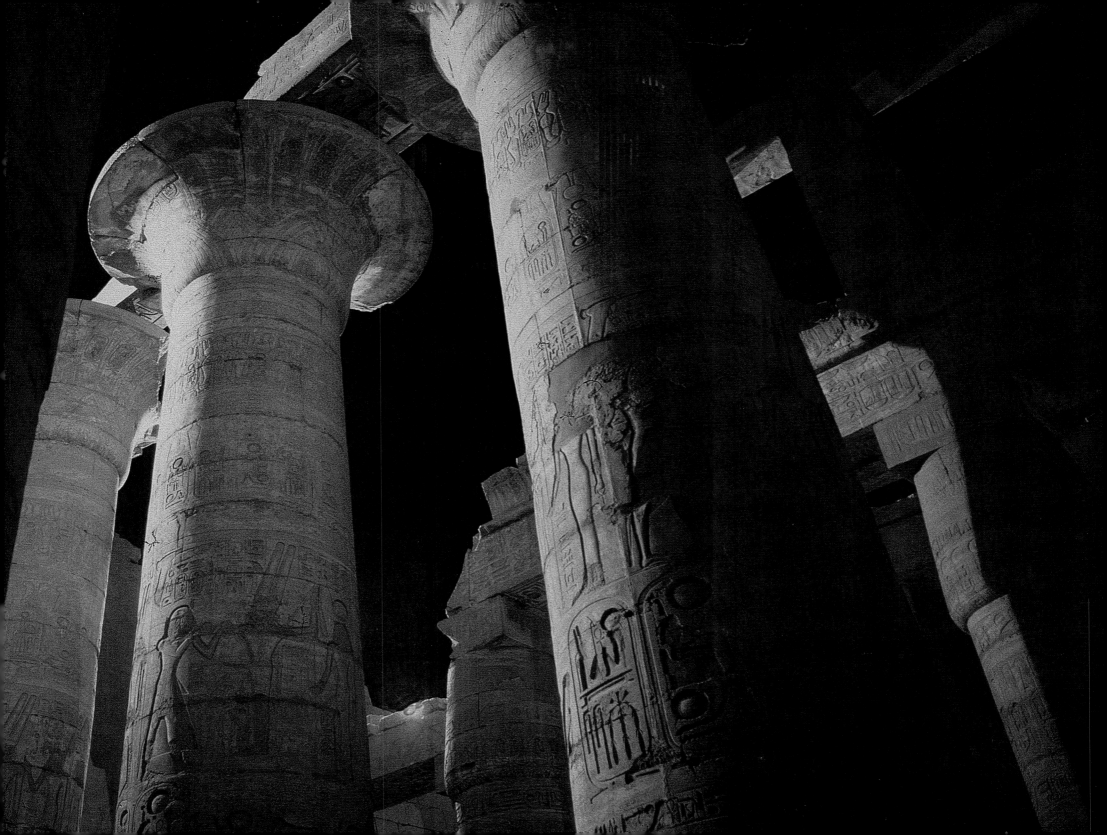

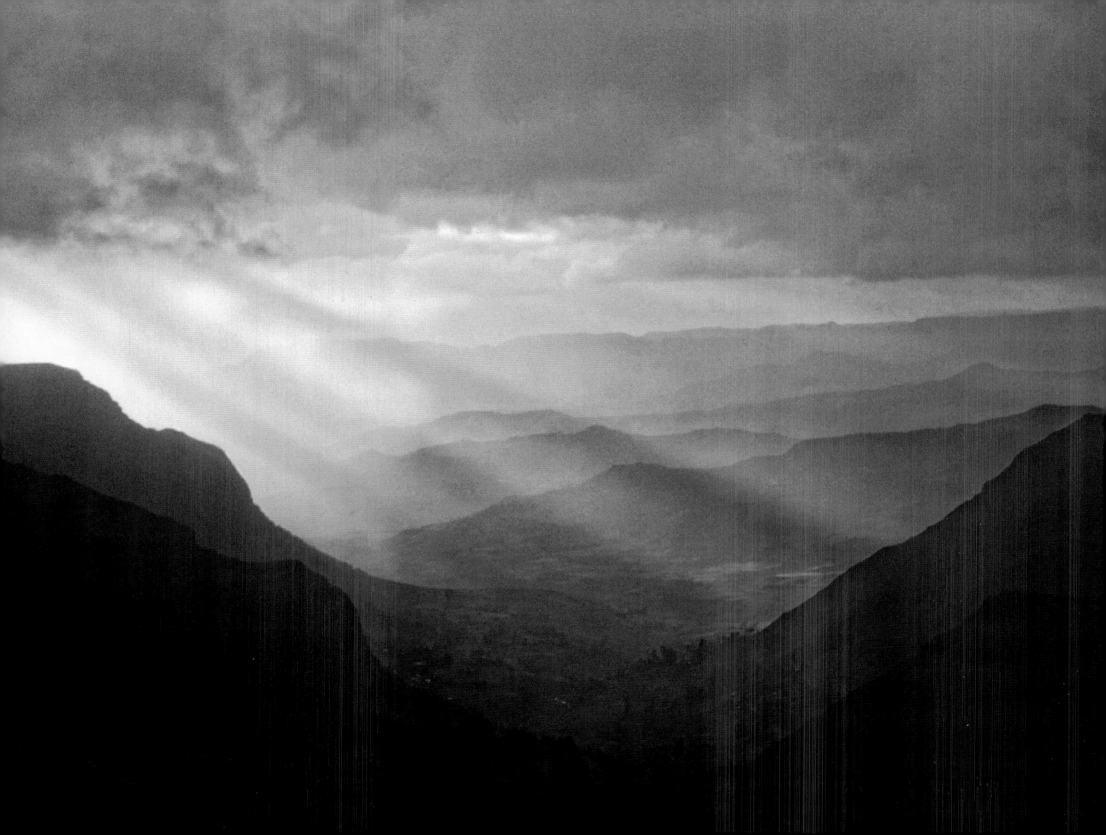

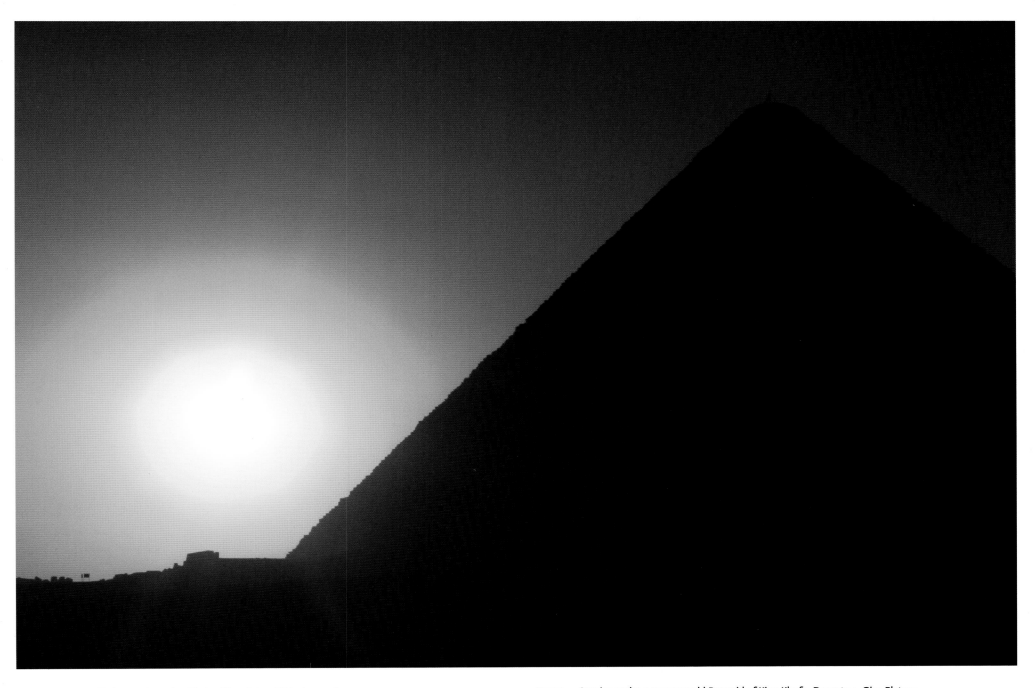

← Early morning mist. Simien Mountains, Ethiopia, 2008

Kemet — Sunrise at the 4,500-year-old Pyramid of King Khufu, Dynasty 4. Giza Plateau, Cairo, Egypt, 1980

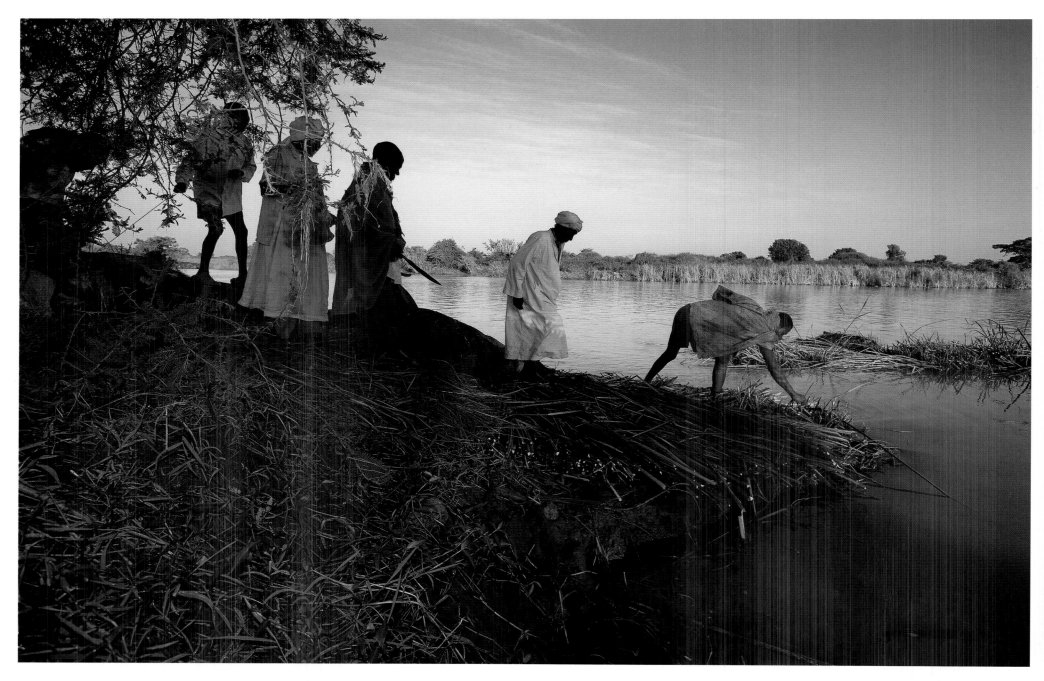

Sacrificial ceremony to the spirit of the Blue Nile waters by the Weyto people — known in the 19th century as hippopotamus hunters — on the shore of Lake Tana. Bahir Dar, Ethiopia, 2007

Simien Mountains, Ethiopia, 2016 ⟶

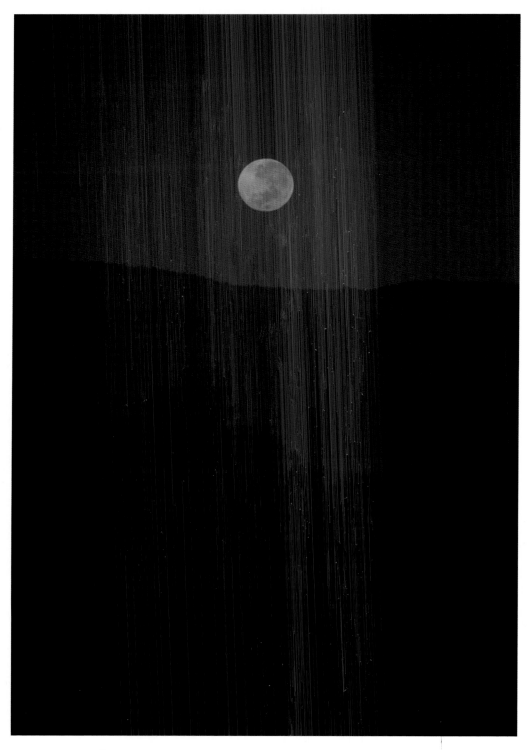

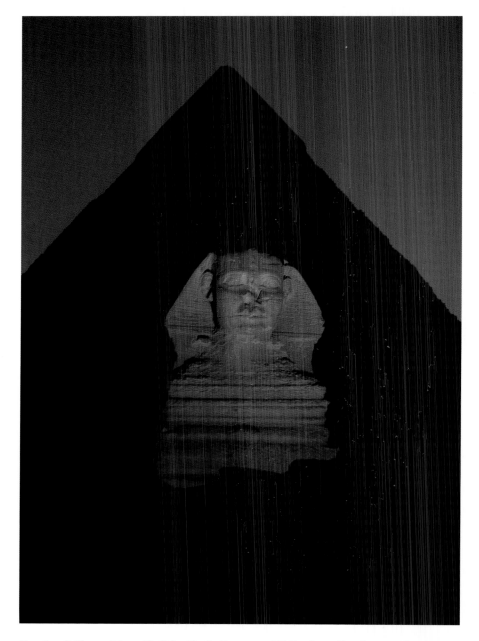

Kemet — Sphinx and Pyramid of King Khufu, Dynasty 4, Old Kingdom. Giza Plateau, Cairo, Egypt, 2003

<—— Moonrise over Lower Omo Valley. Ethiopia, 1988

Nubia — *Deffufa* (an ancient *Nubian* word for a mud brick construction) was the main temple of the city of Kerma in the Kingdom of Kerma (2500 to 1450 BCE). Even today this c. 4,000-year-old structure, in ruins, is nearly 60 feet high. Western *Deffufa*, Kerma, Sudan, 2007 ——>

28

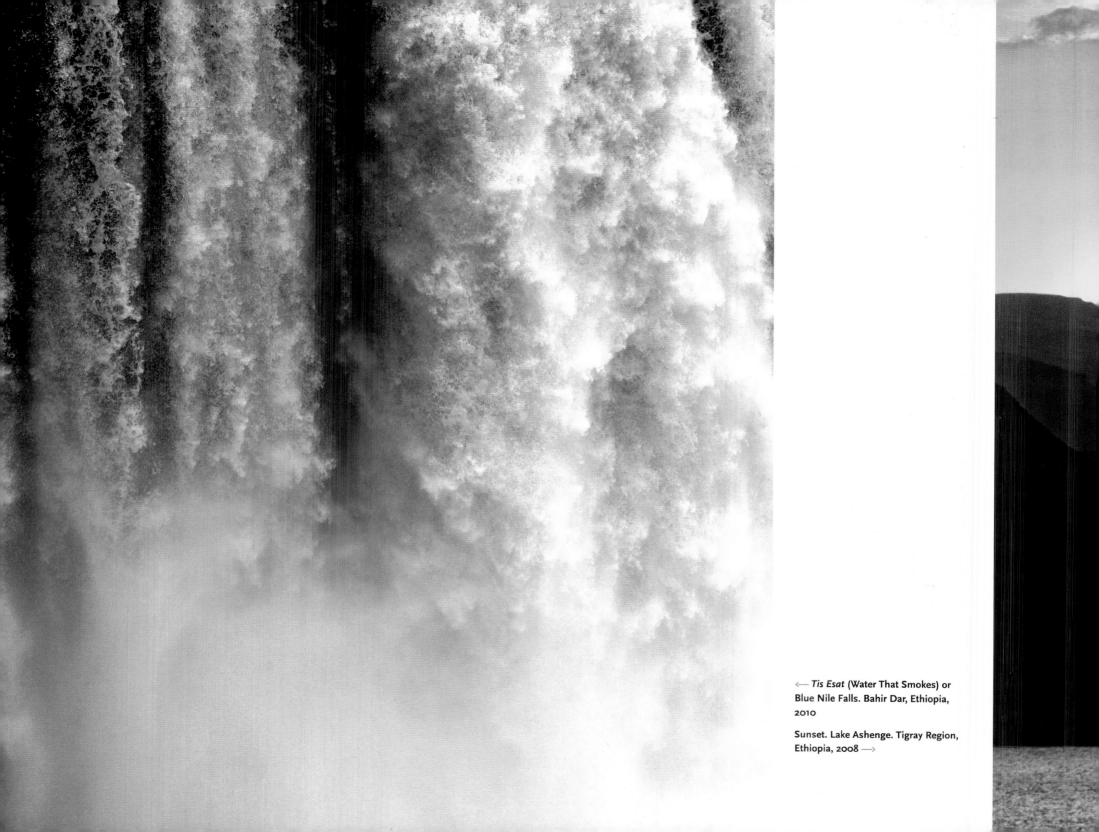

←— *Tis Esat* (Water That Smokes) or
Blue Nile Falls. Bahir Dar, Ethiopia,
2010

Sunset. Lake Ashenge. Tigray Region,
Ethiopia, 2008 —→

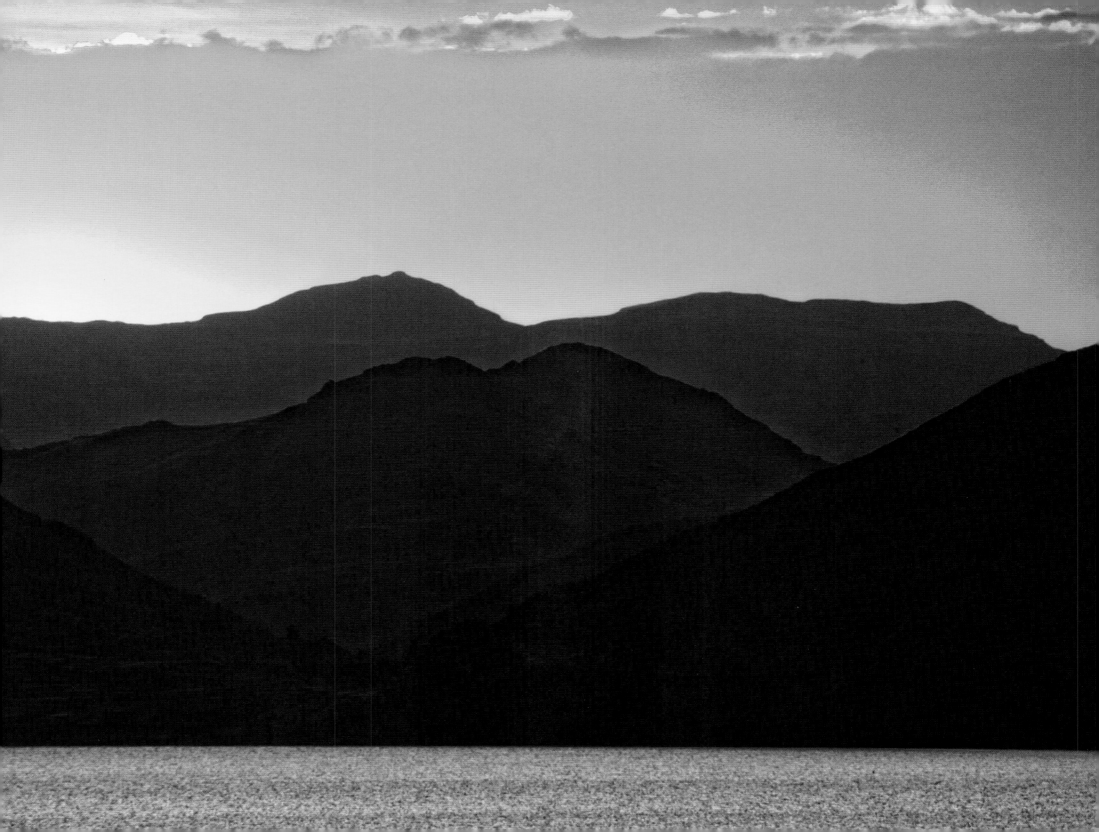

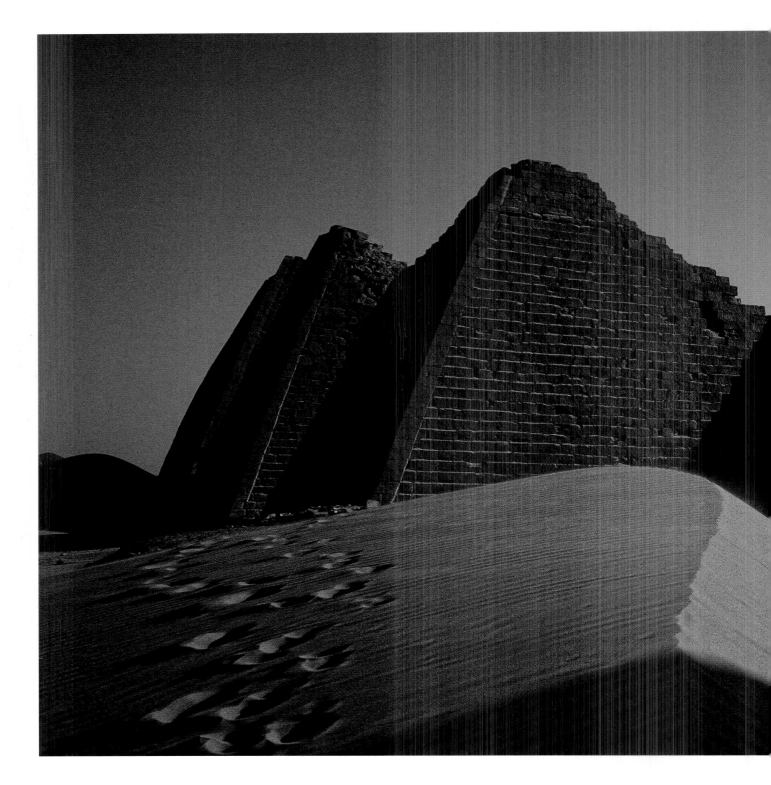

Nubia — Sunrise. Northern Royal Necropolis
(mid-3rd century BCE to mid-3rd century CE),
Meroitic Period. Meroe, Sudan, 1999

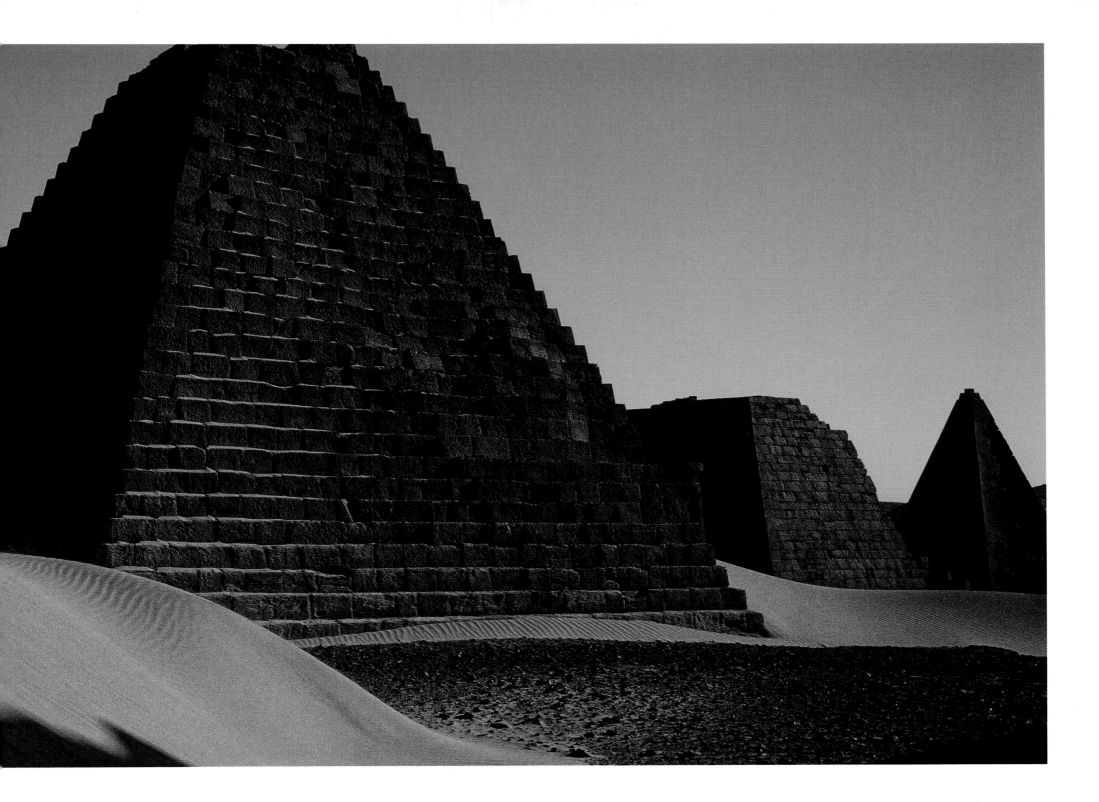

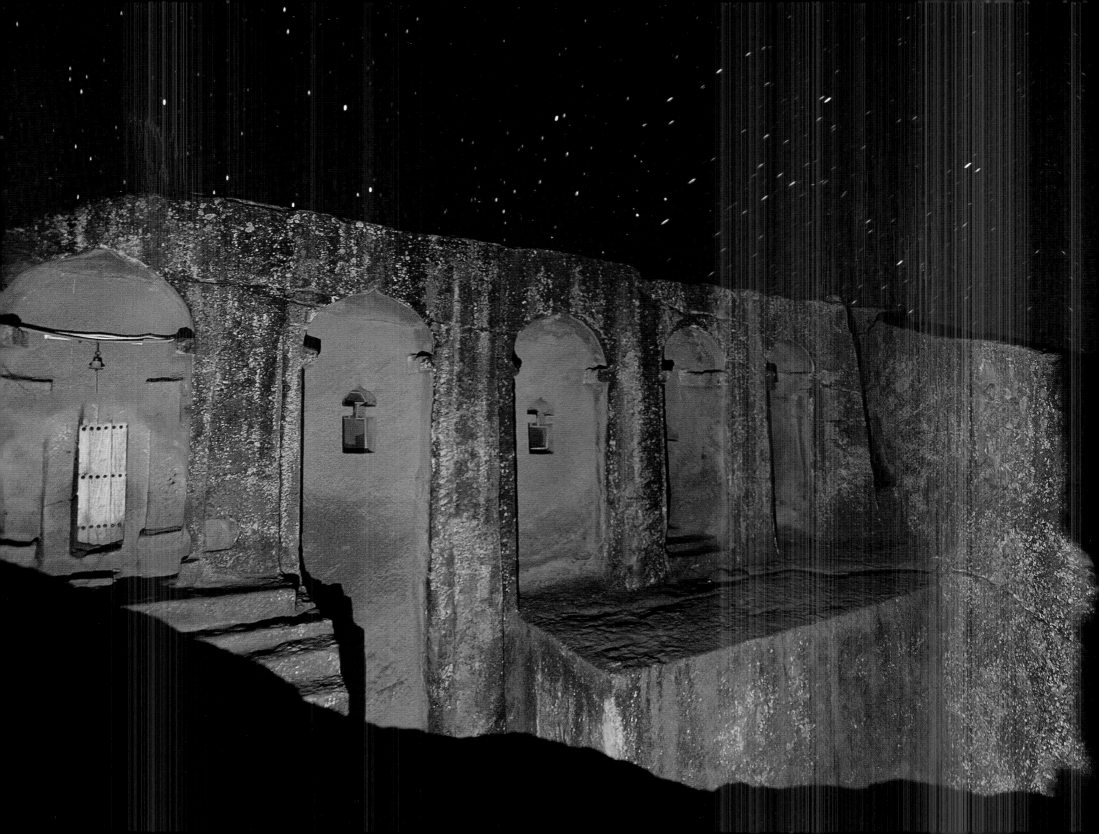

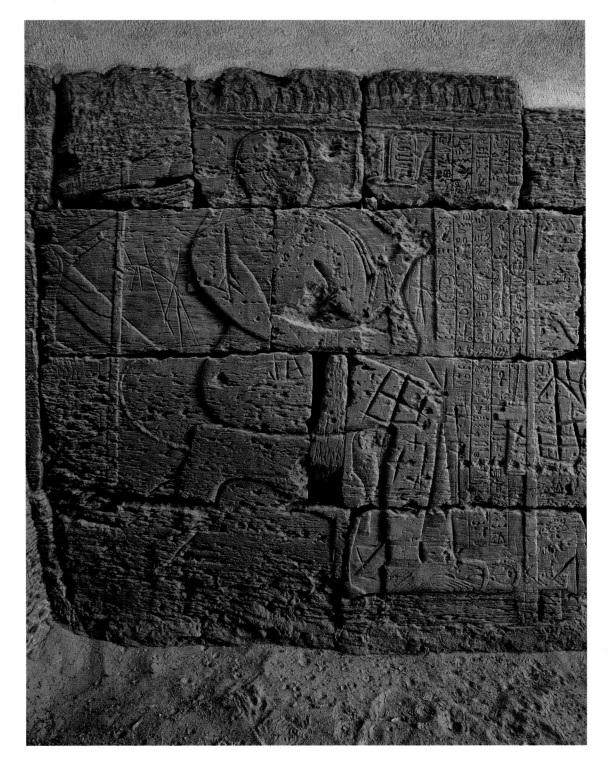

←— Starry night. *Bete* Gabriel and Raphael (Church of Gabriel and Raphael), one of the 13th century churches hewn from mountains 900 years ago. Lalibela, Ethiopia, 2008

Nubia — Queen Kanarta sits under a canopy lined with a row of *uraeuses* each wearing sun disks. In her left hand she holds three lotus flowers, and in her right, she holds a flail. North wall, Chapel of Pyramid 4, Southern Royal Necropolis, Meroitic Period. Meroe, Sudan, 2006 —→

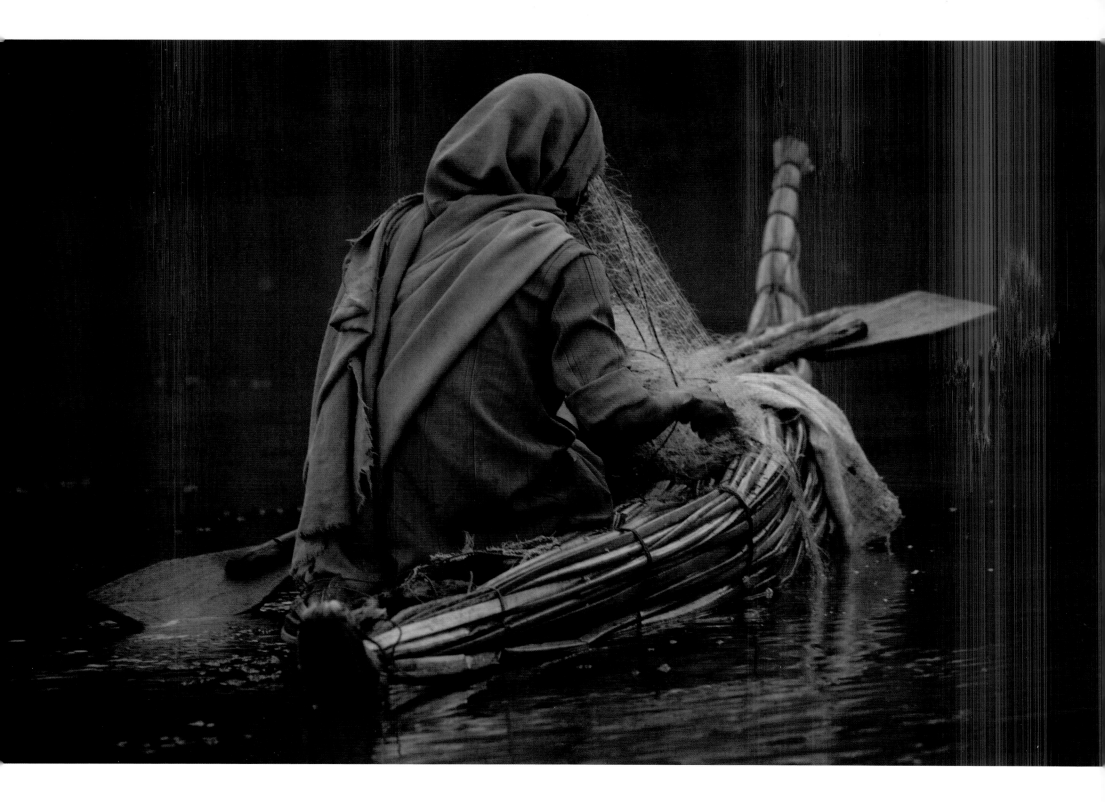

Children of the River

Because we are born to die, we fear time. We marvel at birth and await the ambush of death.

Since 1973 I have been exploring the rich spiritual landscape along the ancient Blue Nile River arising at Lake Tana in the highlands of Ethiopia — whose Middle Awash Valley is the site of the oldest human remains ever discovered — and flowing downhill north to the confluence of the Blue and White Niles at Khartoum, Sudan, and then as the River Nile through Sudan and Egypt to the Mediterranean Sea. Ancient people living beside this roughly 2,600-mile waterway — connecting Lake Tana to the Mediterranean — struggled to make sense of their environment where the unpredictable nature of rainfall and annual flooding determined their fate.

Westerners recognize the section of the river that commences in Ethiopia as the Blue Nile. But the people living there refer to it by its name in the Amharic language, *Abai*. And in Ethiopia's rich oral tradition, the river is identified as the biblical *Gihon* (of Genesis), the second of four rivers watering the Garden of Eden. In the West, the stretch of waterway marked from its confluence with the White Nile at Khartoum on through Sudan and Egypt to the Mediterranean Sea is called the overarching name, River Nile; ancient people of *Kemet* called it *Hapi,* deity of the Nile waters, so critical to their daily survival.

The duality of nature

On a recent trip to Ethiopia, I encountered people talking about "children of the river," a concept expressed as *yewenz lejoch* in Amharic, the second most widely spoken language in the country. Ethiopians use this phrase to characterize themselves as people living near and relying

Fisherman at Lake Tana using a *tankwa,* the traditional boat constructed from papyrus reeds. Bahir Dar, Ethiopia, 2011

upon the water of a river for travel and nourishment, for their own critical needs and for the crops and livestock upon which they depend. The complexity as well as the strength and originality of the cultural legacy, threading through ancient and contemporary societies along the Nile, challenges the imagination. This notion of children of the river resonates with me. It expresses what I have recognized and have been photographing for decades along the Blue Nile in Ethiopia as well as along its continuance as the River Nile through Sudan and Egypt.

What happened thousands of years ago beside this waterway in these three lands defied borders. There is much synchronicity in all worship. Africans have continuously nurtured and enriched the narrative of what they call their "walk with the Spirit." The profoundly spiritual people of the Nile believed that all things, animate and inanimate, possess a spirit or soul. They have celebrated the natural order of things and the duality of Nature: the world of the senses and the world of the spirits. In *Kemet* this sacred concept of duality was embraced as a way of life, called *Ma'at* — represented as the deity of truth, justice and divine balance. People here were the first to document their exploration of the mystery of the supernatural world, and today their ancient theological writings offer cosmic instructions for navigating the world of the divine.

The lost voice

In 1799 in Egypt, the discovery of the Rosetta Stone with its three scripts — hieroglyphic, demotic and ancient Greek — jumpstarted the discipline of Egyptology. Inscribed in 196 BCE with a decree by King Ptolemy V, this stone became the key to discovering the lost voice of the hieroglyphs after Jean-François Champollion at last cracked the code in 1822. Understanding this ancient hieroglyphic language of *Kemet* gave

us the means to unlock voices hidden inside theological documents. Scholars studying these documents saw similarities between ancient concepts and today's religions. Ongoing research into the still-undeciphered Meroitic language of the *Nubian* Kingdom of Meroe (300 BCE to 350 CE) has yet to yield translation. Farther upriver along the Blue Nile, an untranslated script thought to represent a pre-Aksumite presence is believed by Ethiopian linguists to be related to *Ge'ez*, the ancient Ethiopian liturgical language that is the root for today's East African languages of Amharic and Tigrinya.

Sharing roots

Indigenous archaeologists are beginning to recognize and advance an East African cultural and spiritual perspective. Through my photographs — far more immediate, powerful and accurate than the words I use to communicate my observations and ideas — I record patterns and connecting threads of an intertwined and often fused spiritual heritage spanning more than 5,000 years. Although the varied contemporary spiritual practices in East Africa draw authority from different sources and enact dissimilar rituals, they all share roots that arose on these riverine lands and iconography that is often visually similar. After initiating this project nearly fifty years ago, I have come to realize that the full story of our spiritual unfolding has been suspended into many outwardly unaligned parts, fractured by disparate interpretations.

The depth and originality of the legacy in this part of the world calls for recognition and intensive study. Now it is time to embrace our collective heritage of faith. I believe the deities of the religions we serve today are African-born, inspired by the sacred theology of Nile belief — making us all people of this sacred heritage.

Kemet — Nubians **bringing tribute to the Egyptian King. Tomb of Huy (c. 3,450 years ago), Dynasty 19. West Bank, Luxor, Egypt, 2000** ⟶

Hebraic students. Ha Tikvah Synagogue. Gondar, Ethiopia, 2002 ⟶

Muslim faithful praying. Grand Mosque. Yabello, Ethiopia, 2011 ⟶

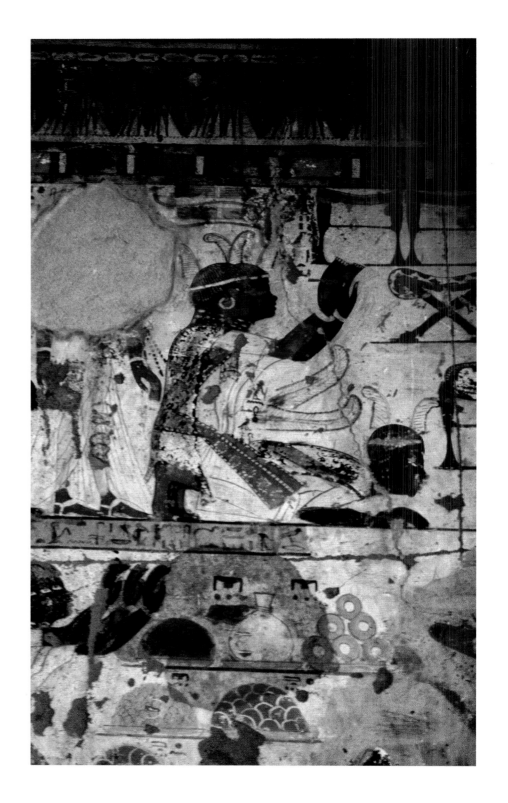

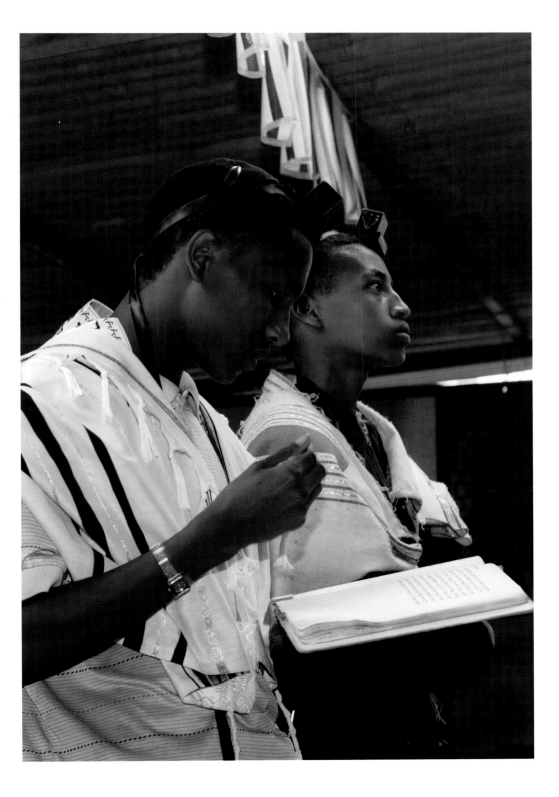
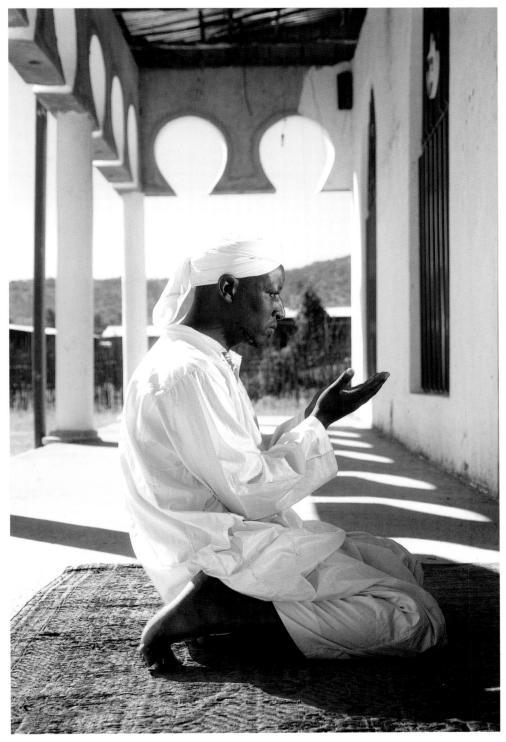

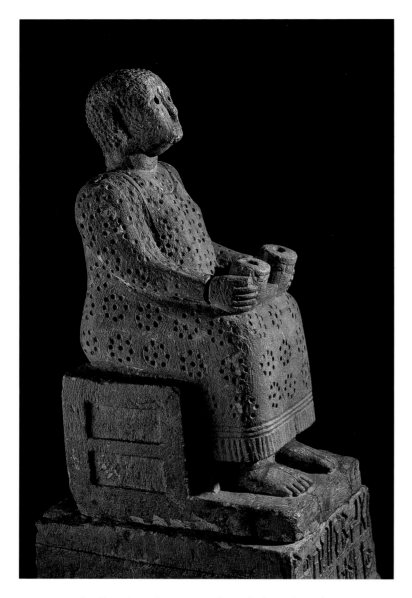

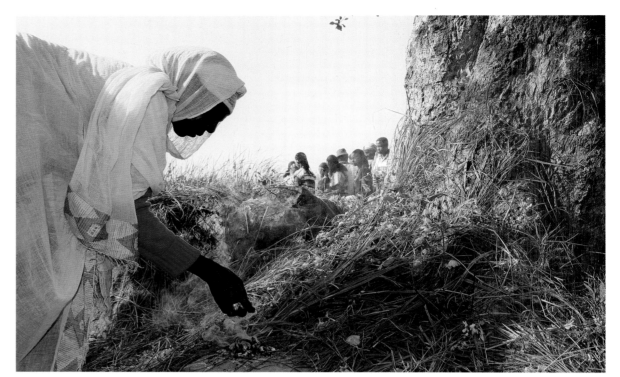

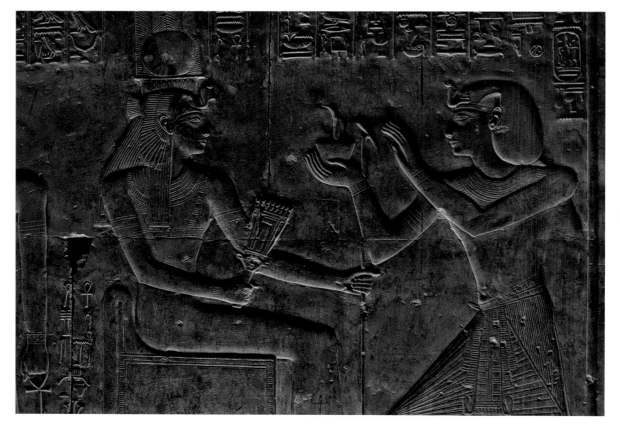

Pre-Aksumite — Stone statue of seated priest (5th to 6th century BCE; 2,700 years ago) holding offering vessels found at Addi Galamo in the Tigray Region. National Museum of Ethiopia, Addis Ababa, 2002

Incense offering to the supreme deity *Waaqa* at the *Oda* (sacred sycamore tree). Worship of *Waaqa,* the sky deity of *Waaqeffanna,* traditional religion of the Oromo people (the largest ethnic group in Ethiopia today). *Erecha* ceremony. Bishoftu, Ethiopia, 2006

Kemet — Incense offering to *Het Heru* (Hathor) by King Ramses II, c. 1300 BCE Temple of *Asar,* built by King Sety I, Dynasty 19. Abydos, Egypt, 2019 ⟶

Offerings to the Divine

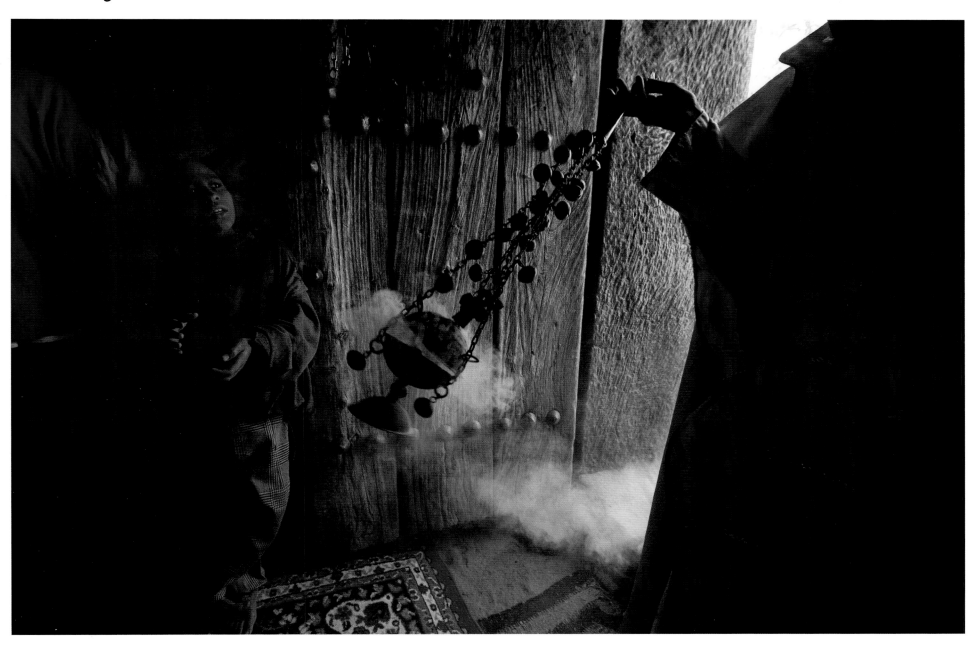

Priest swinging incense in a censer. Inside *Bete* Gabriel and Raphael (Church of Gabriel and Raphael), one of the 13th century churches hewn from mountains 900 years ago. Lalibela, Ethiopia, 2008.

More Divine Offerings

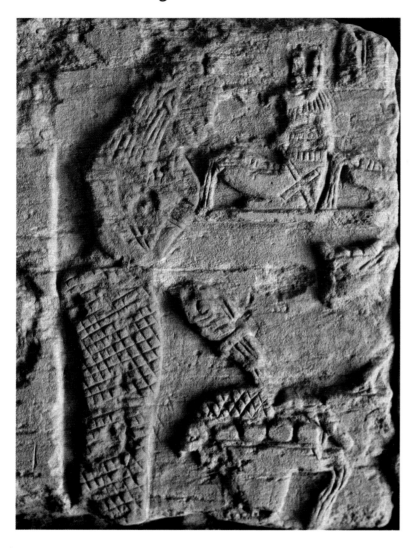

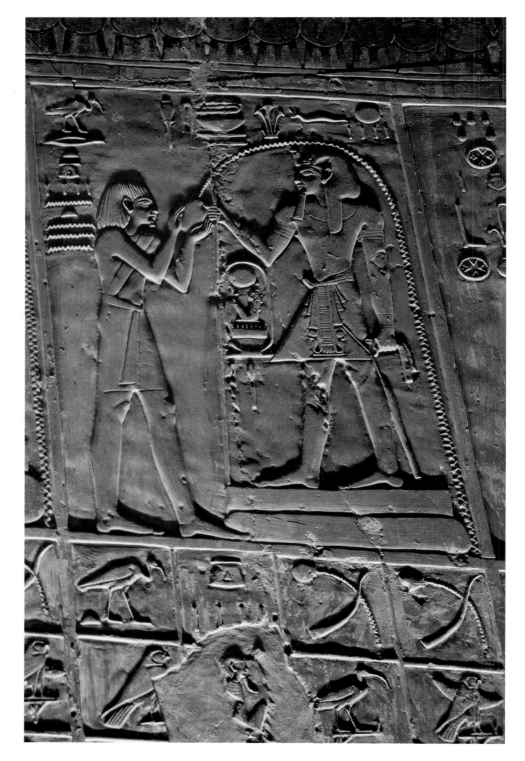

Nubia — Priest pours libation. South chapel wall of Pyramid 11, *Kandake* (Queen) and *Qore* (Ruler) Shanakhdakheto. Meroitic Period (170 to 150 BCE), Northern Royal Necropolis. Meroe, Sudan, 2006

Kemet — Purification ritual: priest pours life-giving water over King Sety I. 3,379-year-old Tomb of King Sety I, Dynasty 19. Valley of the Kings, West Bank, Luxor, Egypt, 2019 ⟶

Kemet — Queen Nefertari makes an offering to the deity *Het Heru* (Hathor) on the wall of her 3,200-year-old tomb, 19th Dynasty. Valley of the Queens, West Bank, Luxor, Egypt, 2019 ⟶

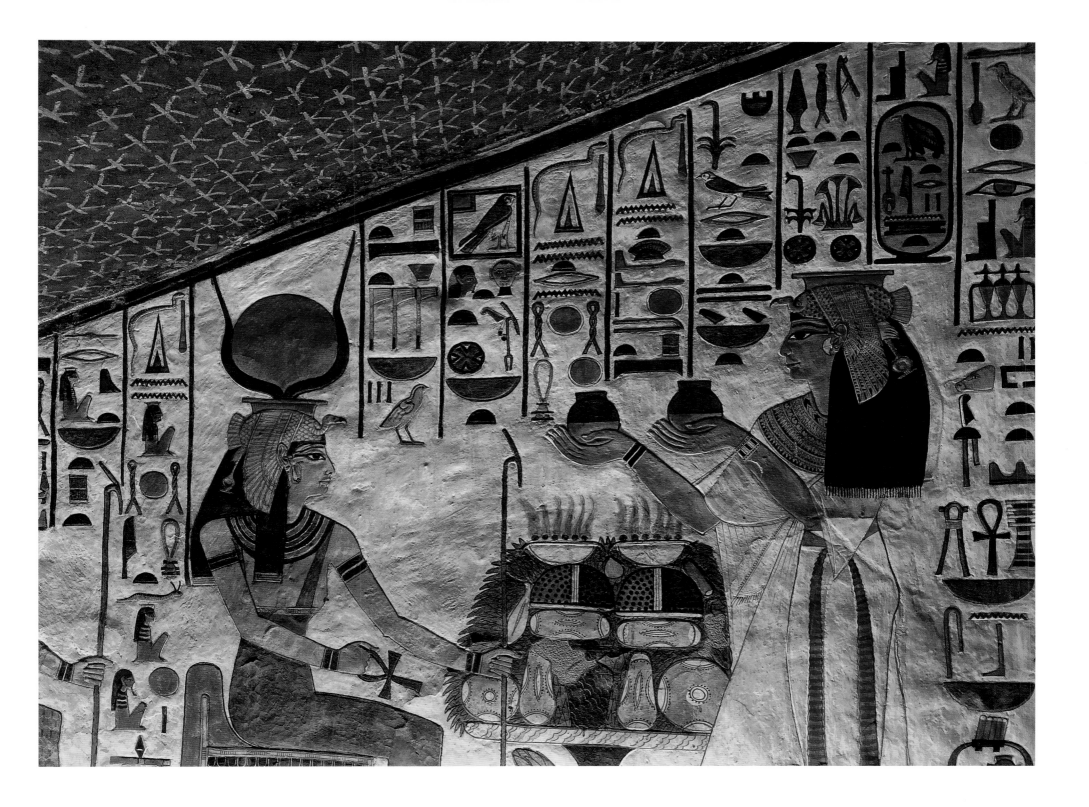

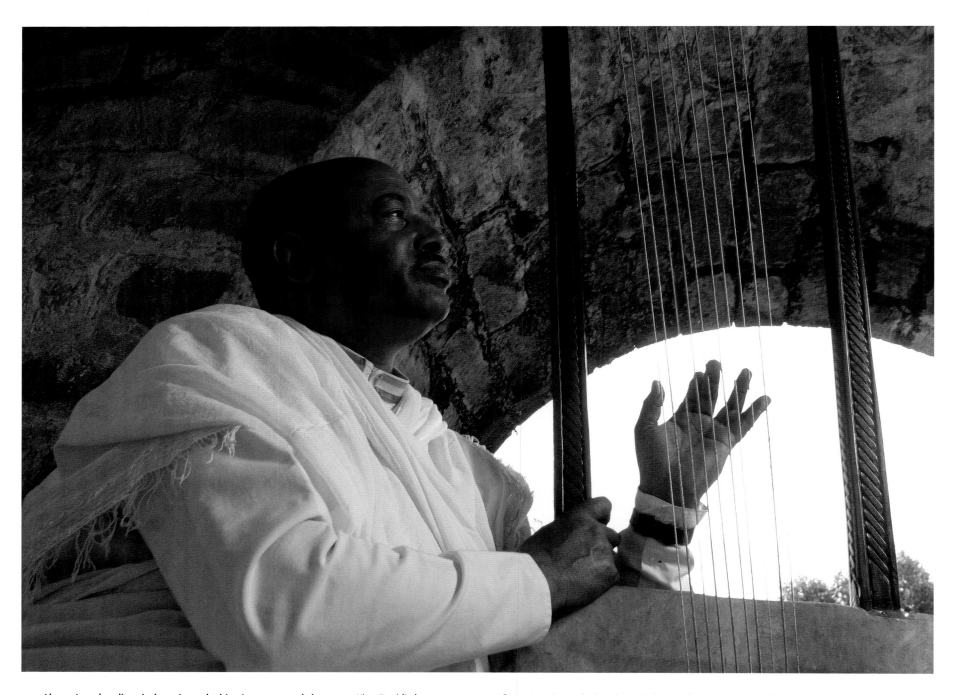

Alemu Aga plays liturgical music on the bèguèna, commonly known as King David's harp — an oversized lyre with ten strings. Mt. Entoto, Addis Ababa, Ethiopia, 2000

African American pilgrims dance in honor of ancient spirits. Lake Nasser, Egypt, 2006 ⟶

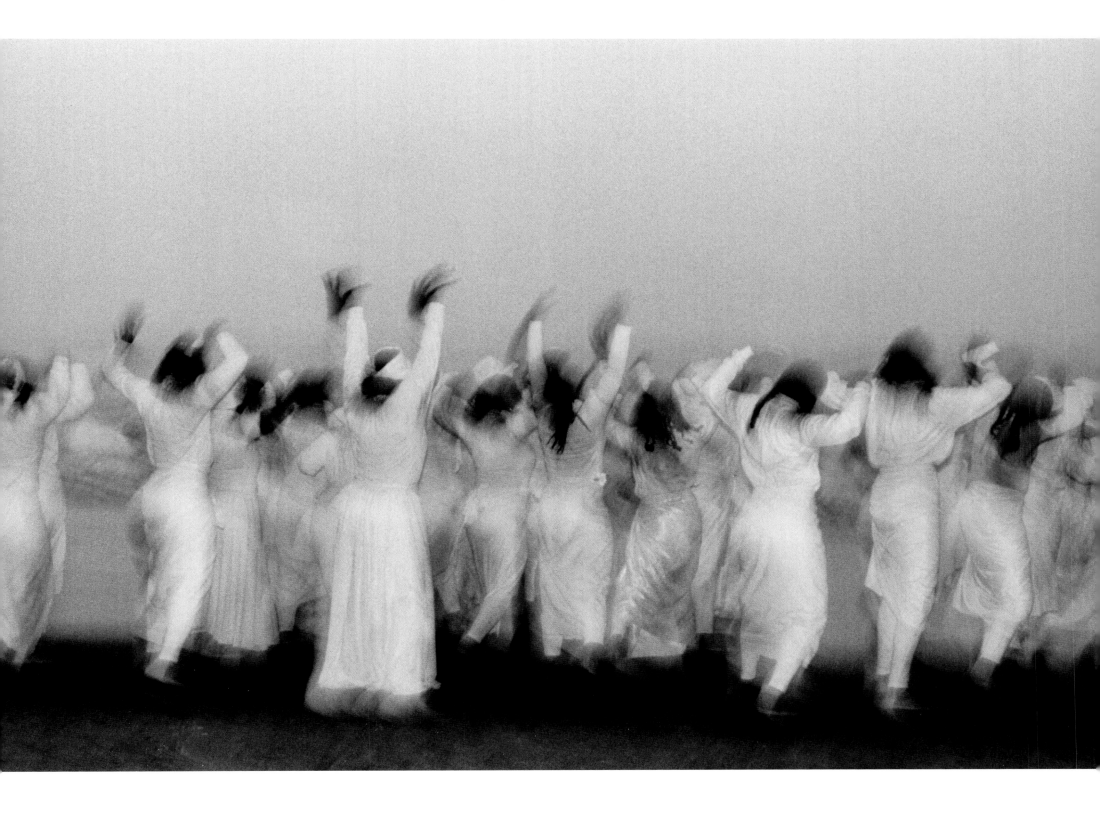

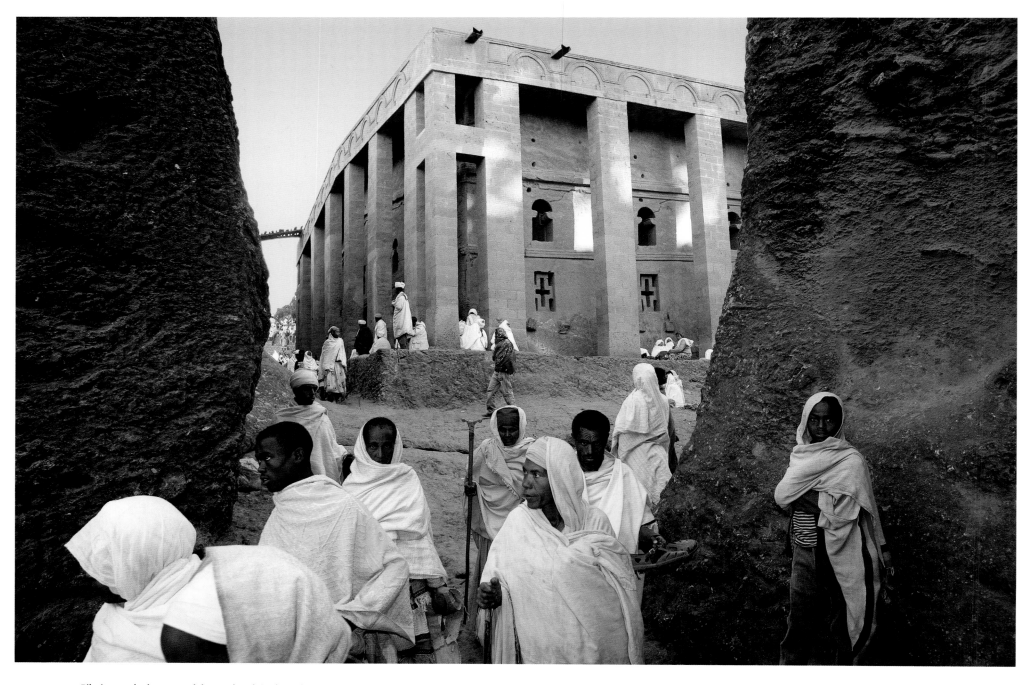

Pilgrims at the largest rock-hewn church in the 13th century complex of Lalibela.
Bete Medhane Alem (Church of the Savior of the World). Lalibela, Ethiopia, 2009

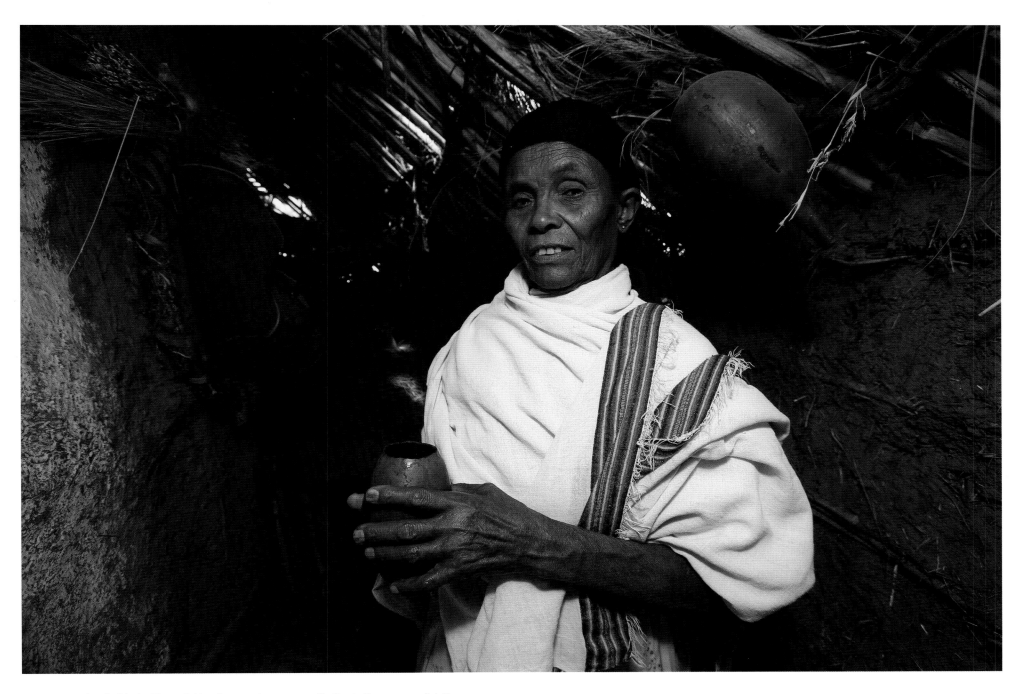

Priest inside the Woman's Temple preparing to pour a libation to the supreme divinity
Waaqa of the still-practiced traditional religion *Waaqeffanna*. Bishoftu, Ethiopia, 2007

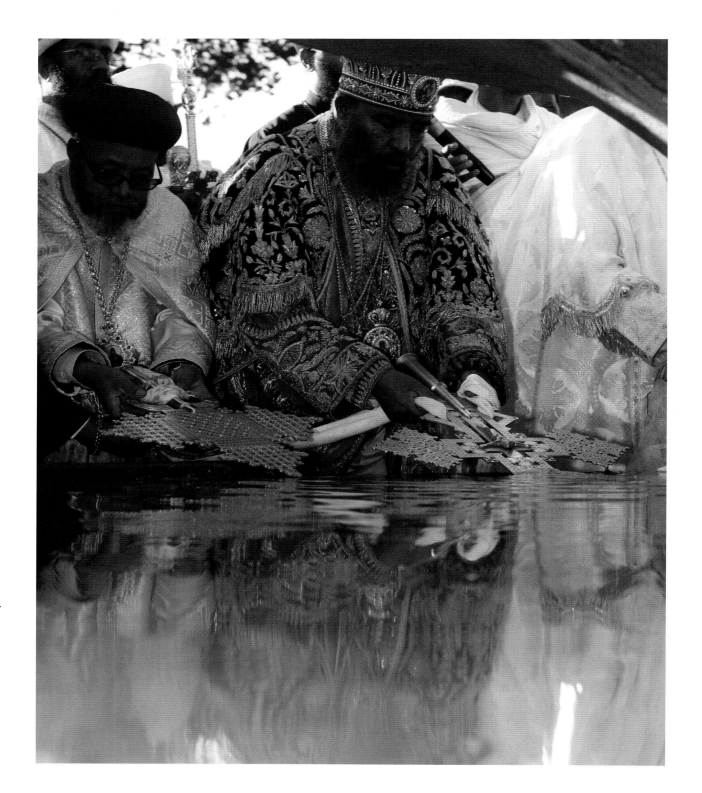

Ethiopian Tewahedo Church priests baptize crosses during *Timkat,* which celebrates the baptism of Jesus Christ by John the Baptist. Once the cross touches water, that water becomes sacred; it is then used to anoint the congregation. Addis Ababa, Ethiopia, 2007 ⟶

Muddy tributary heading to the Blue Nile River during the Ethiopian major rains (August–September). Simien Mountains, Ethiopia, 2010 ⟶

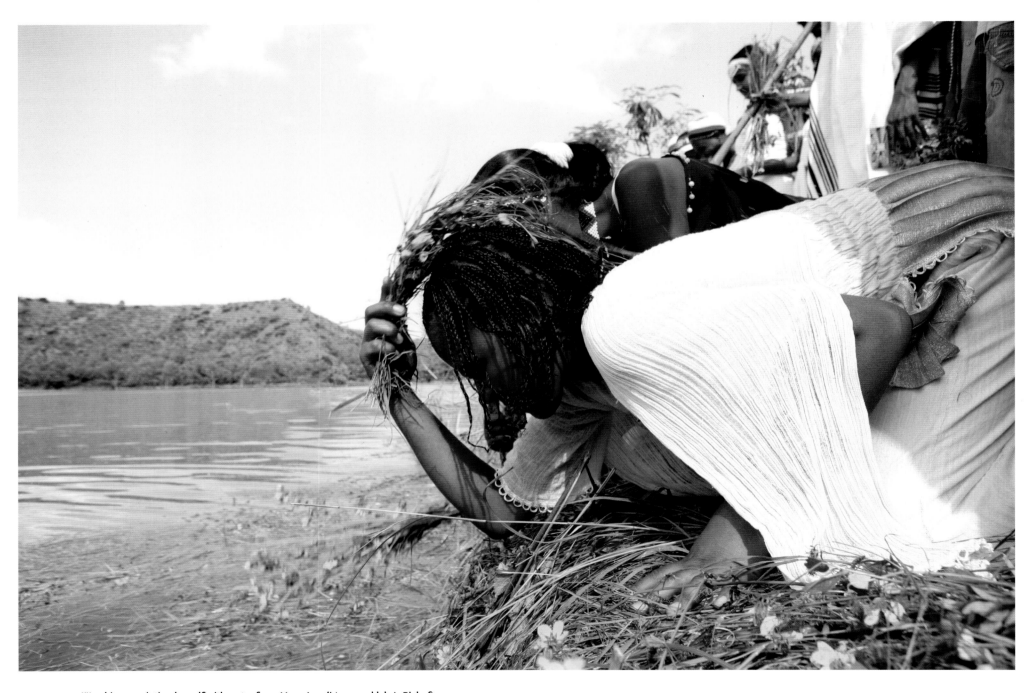

Worshiper anointing herself with water from *Hora Arsedi* (a sacred lake). Bishoftu,
Ethiopia, 2010

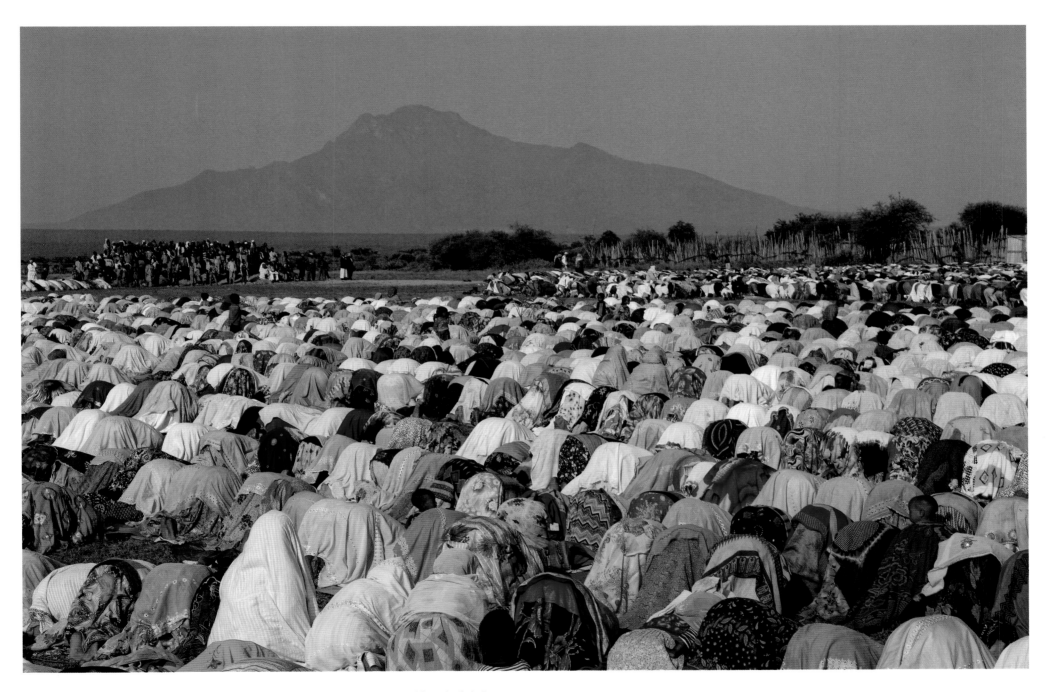

Women praying during the Muslim Feast of the Sacrifice at the 800-year-old Tomb of Sheik
Hussein. Bale Mountains, Ethiopia, 2013

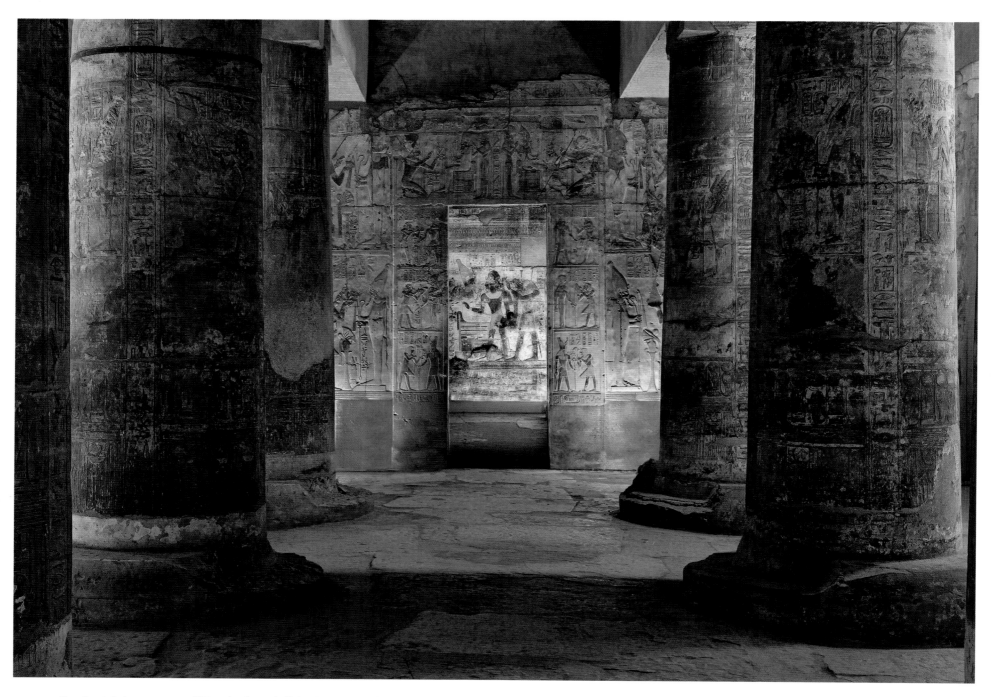

Kemet — Interior. 3,300-year-old Temple of *Asar*, built by King Sety I, and showing the
King making offerings to *Asar* (Osiris) in the chapel. Dynasty 19. Abydos, Egypt, 2006

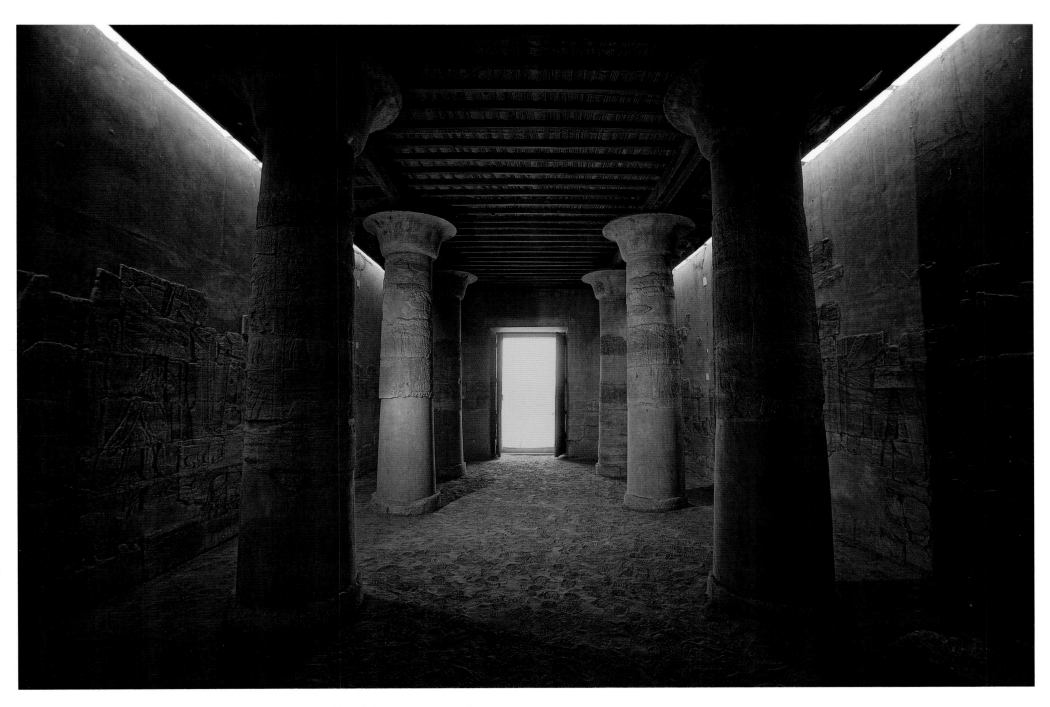

Nubia — Interior. *Apedemak* Temple, c. 240 BCE, Meroitic Period. Musawwarat es-Sufra.
Sudan, 2007

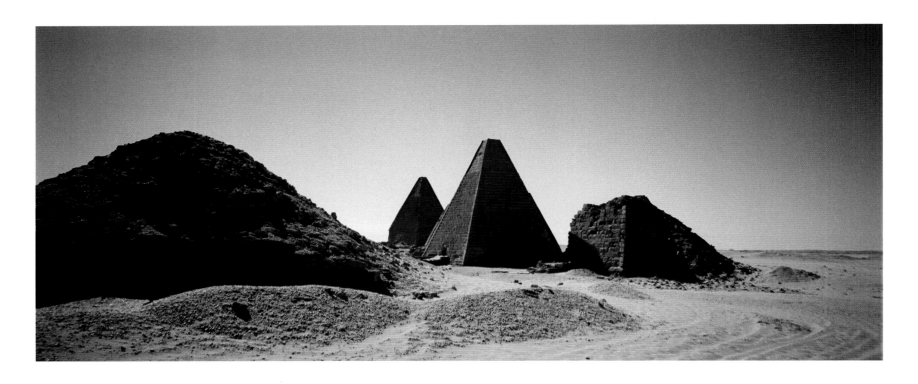

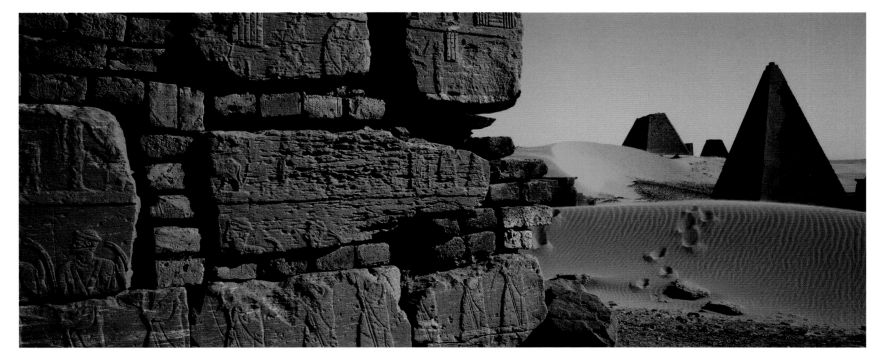

Nubia —Pyramids. Royal Necropolis (late 3rd century BCE), Meroitic Period. Gebel Barkal, Sudan, 2001

Nubia — Scene on the north chapel wall of Pyramid 8 (c. 2,000 years old), Meroitic Period. Northern Royal Necropolis. Meroe, Sudan, 2006 ⟶

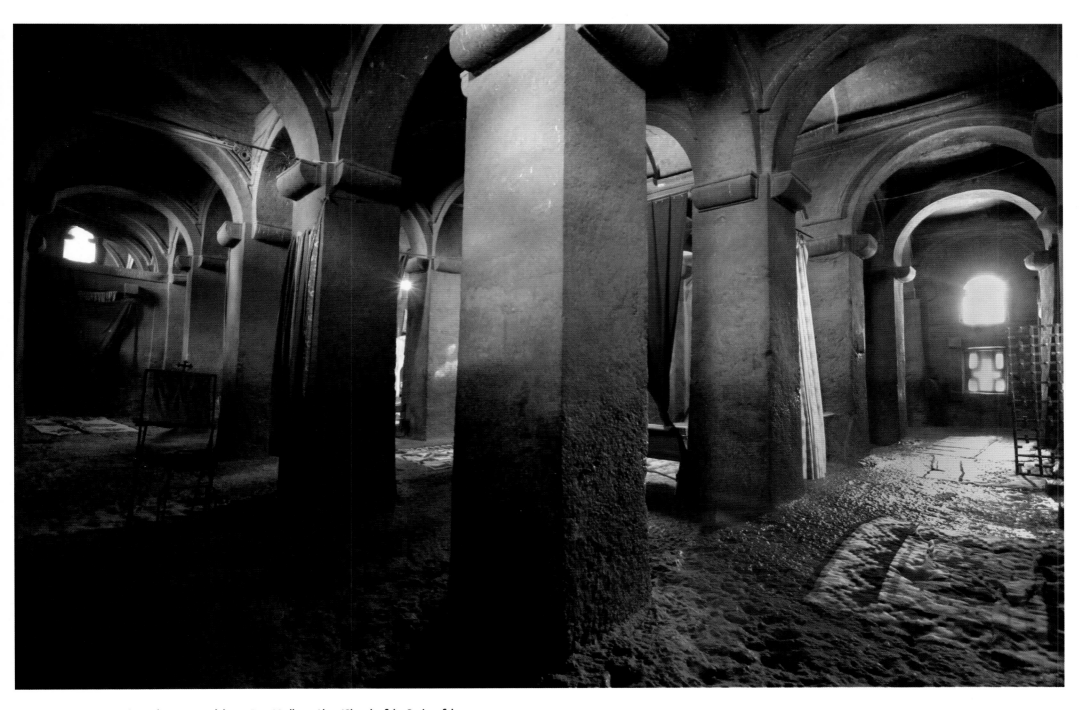

Interior. 13th century rock-hewn *Bete Medhane Alem* (Church of the Savior of the World). Lalibela, Ethiopia, 2007

Nile Boats

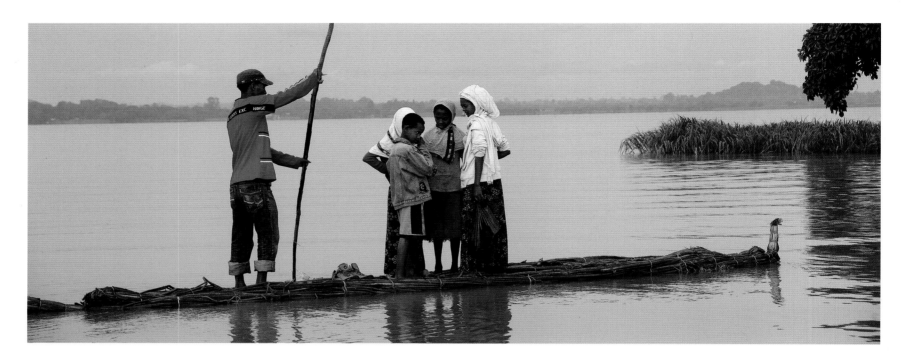

Papyrus ferry. Lake Tana, Bahir Dar, Ethiopia, 2014
The upturned bow of this papyrus boat is reminiscent of boats seen on tomb walls and model boats found inside ancient Egyptian tombs. It is believed the first Nile boats were made of papyrus. By around 3000 BCE, some Nile dwellers began constructing boats out of wood, many in the form of papyrus boats.

Kemet — Crossing over to the Afterlife in a bark (or boat). King Ay's Burial Chamber, Dynasty 18. Valley of the Kings, West Bank, Luxor, Egypt, 2000 —→

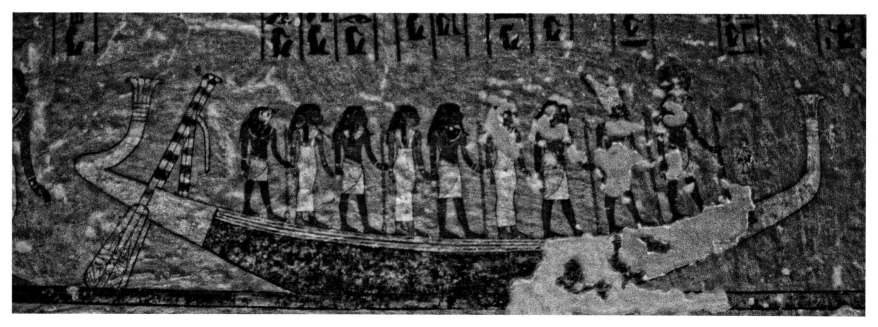

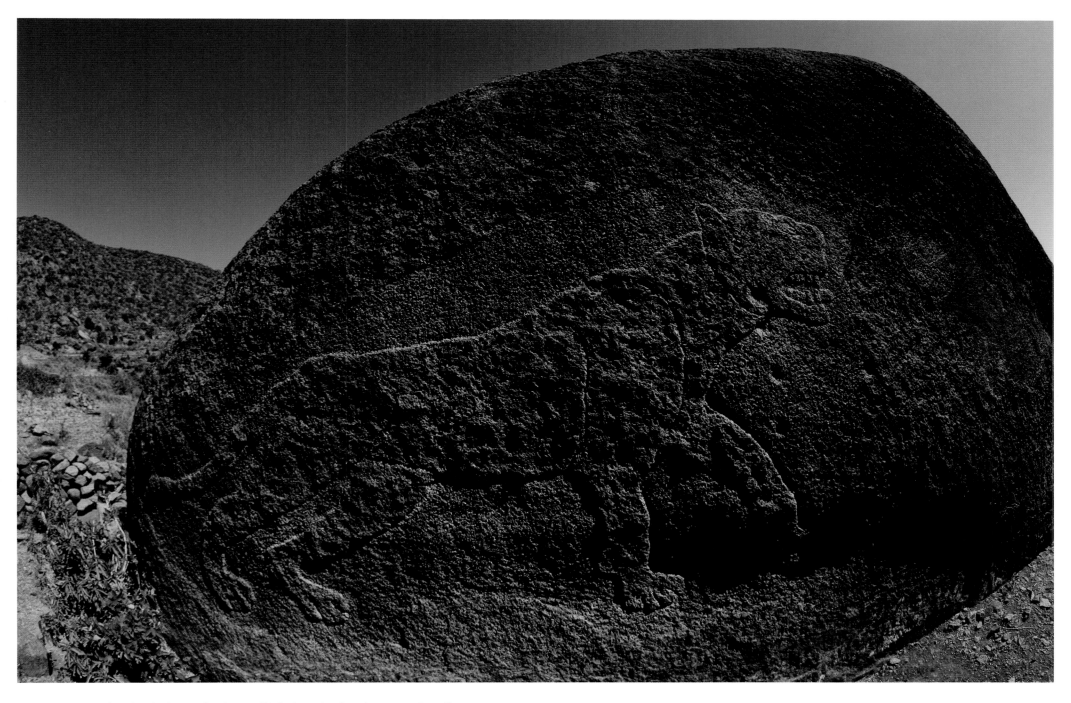

Aksumite Kingdom — The Lioness of Gobedra at the Aksumite quarry, a few miles
from the Aksumite Obelisk Park. Aksum, Ethiopia, 2009

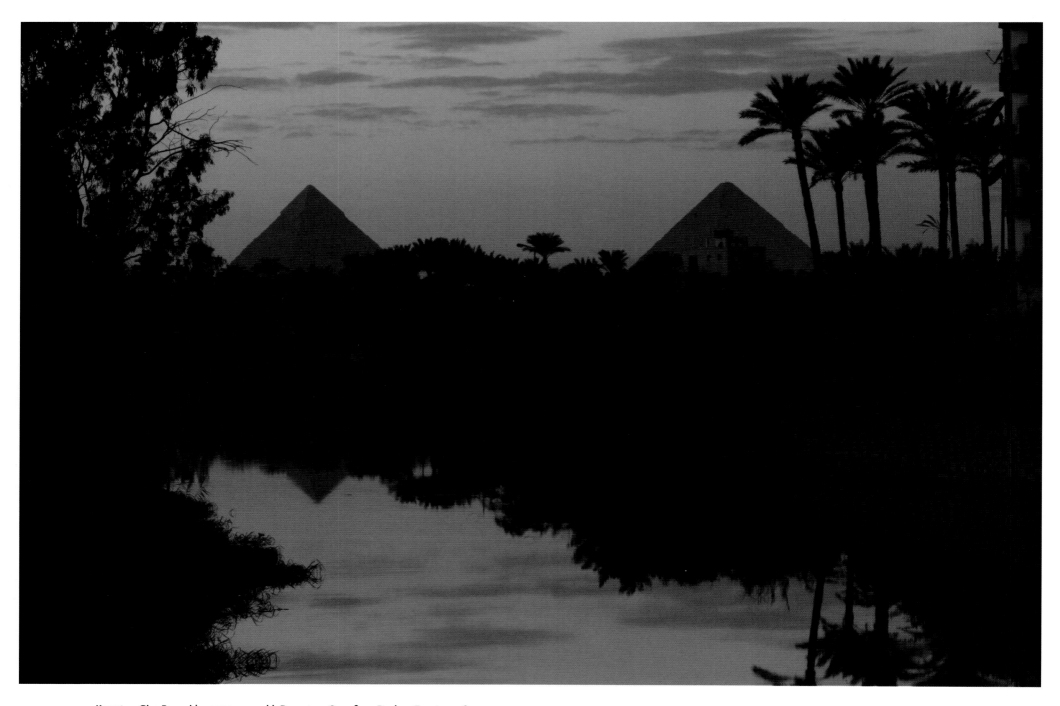

Kemet — Giza Pyramids, 4,500 years old, Dynasty 4. Seen from Dashur, Egypt, 2006

Simien Mountains. Ethiopia, 2003

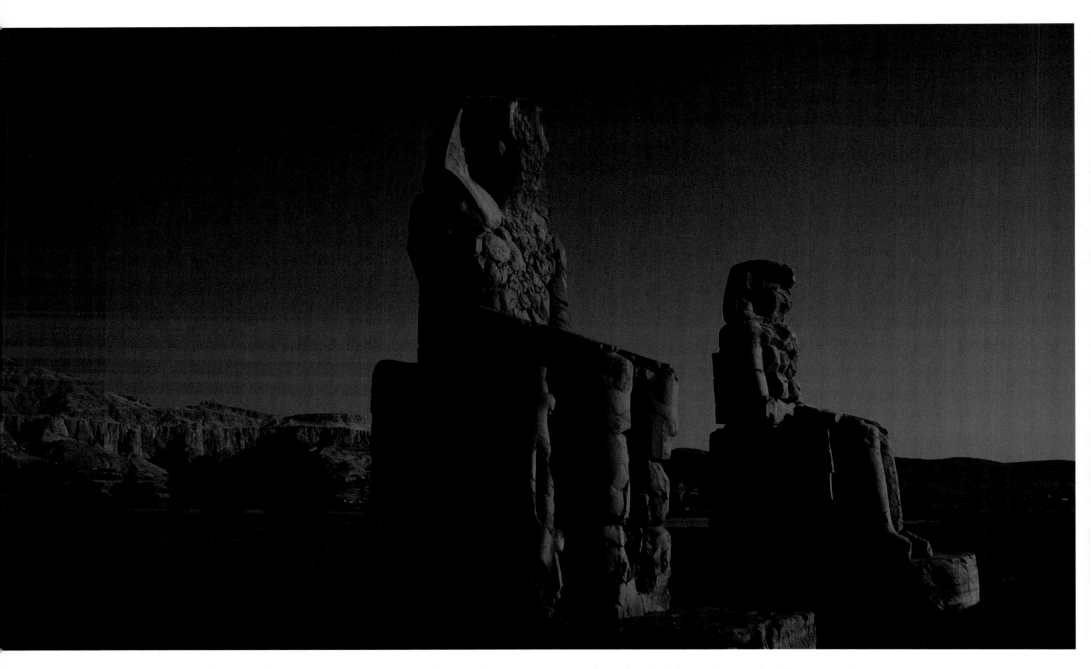

Kemet — Colossi of King Amenhotep III (1386 to 1353 BCE), Dynasty 18. West Bank, Luxor, Egypt, 1987

Early morning wind prints on desert sand. *Nubian* Desert, Sudan, 1999 ⟶

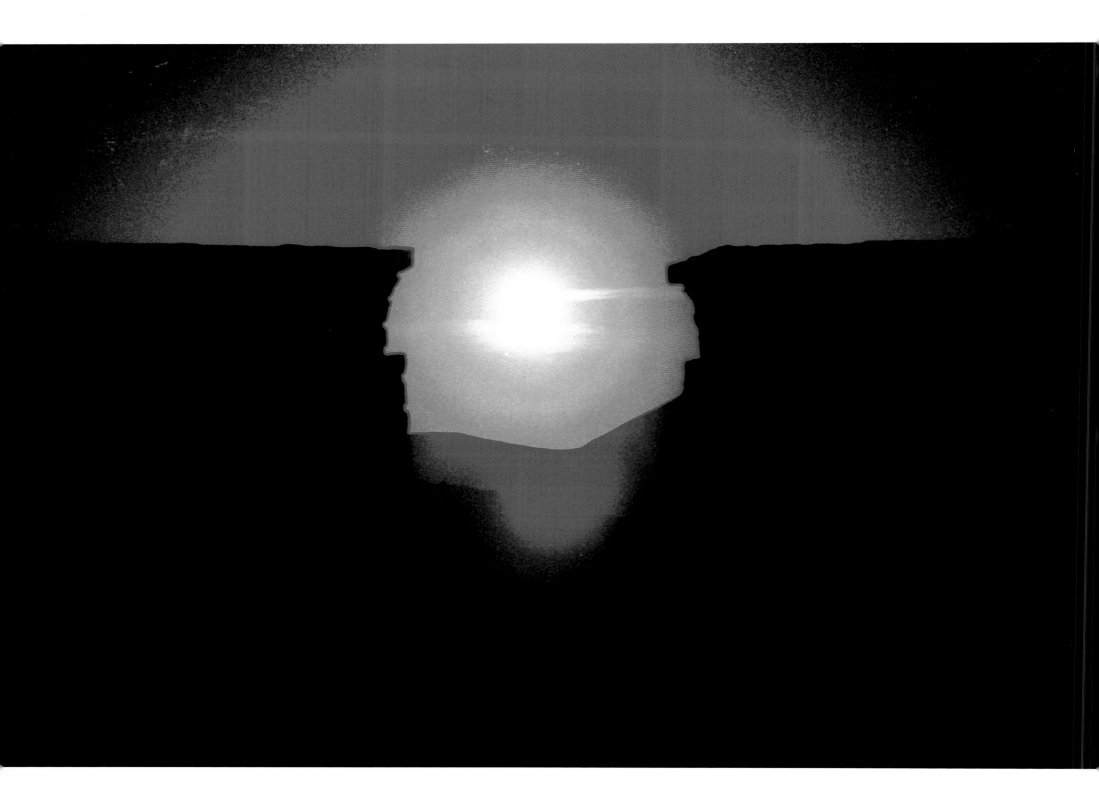

Divine Nature

The natural world manifests the sacredness of The Spirit.

Those who hold Nature to be sacred endeavor to maintain a harmonious relationship with all beings, animate and inanimate. Our ancient African ancestors observed and studied the structures, elements, cycles, rhythm and order of Nature. It followed that Nature would be their model for framing society's principles and values. They held that all decisions be made with the wellbeing of future generations foremost in mind.

In 2002 I accepted an invitation extended to me by Ethiopian cultural anthropologist Meskerem Assegued to join her for *Erecha,* the joyous annual festivities that honor the regeneration of people, plants and time.

The Oromo people of Ethiopia celebrate *Erecha* during the last week of September or the first week in October (depending on the lunar calendar), marking the end of Ethiopia's three-month rains with a popular collective commemoration in prayers, chanting and offerings. The Oromo in contemporary Ethiopia and parts of Kenya and Somalia revere the Divinity of Nature in their traditional religion, called *Waaqeffanna* (pronounced Wakafana). This monotheistic religion "is based on the worship of a Black Creator *(Waaqa Gurraacha)* and on a cult of Nature, which honours and celebrates the Divine Spirit *(Ayyaana)* in all existent beings and things," write anthropologists Gemetchu Megerssa and Aneesa Kassam in their 2019 book *Sacred Knowledge of the Oromo of the Horn of Africa.*

Kassam told me that, "the Oromo conceptualize their Deity as a Black Creator. He is in the Sky, but not the Sky. For the Oromo, blue equals black, so the blue sky, the dark rain-filled sky, the night sky, are all 'black', as is water." Nature worship is the guiding philosophy of *Waaqeffanna*; it is the source, the structure and the wisdom of this ancient and complex belief system. "Whilst all things emanate out of *Waaqa*, like the rays of the sun, as streams flowing out from an originating source, or as emergent roots developing out of the primary root, they also act in the world independently of Him. *Ayyaana* is thus an expression of this diversity of Nature." (Gemetchu Megerssa and Aneesa Kassam)

Toward the end of September 2002, I traveled to Bishoftu, some forty miles south of the capital city of Addis Ababa, with Meskerem Assegued to meet the spiritual Oromo group she was researching. Although Oromo people celebrate *Erecha* festivities at lakes and rivers, the one in Bishoftu is perhaps the largest and best known. Almost as soon as we left the capital, I began to notice dazzling bright yellow daisy-like flowers (*Bidens macroptera*) everywhere blanketing fields and hillsides. The Oromo call these native flowers of Ethiopia *kello*; the tender blooms mark for them the end of the dark period of rain and the return of the sun. These same flowers, known as *maskal* flower throughout the parts of Ethiopia that speak Amhara and Tigrinya, herald the start of the Ethiopian New Year on September 11.

Communing with *Waaqa*

In Bishoftu, *Erecha* festivities take place at the end of weeks of celebration — rites of purification, atonement and renewal. The major events take place on the banks of the sacred crater lake *Hora Arsedi* — one of seven lakes that taken together are believed by the Oromo to reflect the configuration of the constellation *Ursa Major.* The shore of one side of the lake is dominated by a holy sycamore tree or *Oda* (*Ficus sycomorus*). We arrived in Bishoftu to find morning mist still clinging to the surface

Nubia — **Sunrise from inside a pyramid chapel. Northern Royal Necropolis** **(mid-3rd century BCE to mid-4th century CE), Meroitic Period. Meroe, Sudan, 2007**

of the lake and dew carpeting the grass on its banks. A line of men, women and children, most dressed in white, emerged out of the mist. They were chanting, *marreyyoo, marreyyoo* (which the Megerssa/Kassam book translates as "another round of time has come around"). Celebrants carried symbols of rebirth — bunches of *kello* flowers and green grass.

As I began making photographs, it became clear that the congregants were rapt in spiritual communion. Their attention was riveted on the lake and tree in front of them and on their priest, Lomi Deme. Shaded by colorful umbrellas held aloft by members of the group, she wore a traditional Ethiopian white dress and had tied a white scarf around her hair. In one hand, along with grass and flowers, she held a sacred flail, or whip, and in the other, a long staff with a forked head; both represent her status as leader. At the lakeshore, Lomi Deme's flock stood by while she knelt to pray. Leaning over to kiss the earth beside the softly lapping water, she dipped her flail and the grass and flowers in the lake and shook the wet bundle over her shoulder to anoint herself. Turning she shook the last drops over her congregation. Then her group came to the water's edge, knelt down, dipped their own bundles in the lake water and anointed themselves. Standing, the whole group approached the sacred tree to make offerings. From one of her assistants, Lomi Deme accepted a gourd filled with brownish liquid made with fermented barley and corn and poured this libation into the lake for the water *ayyaana* (spirit). She laid her bundle of grass and flowers at the foot of the tree; her congregation made a line of their own bunches beside hers. Another assistant produced butter wrapped in false banana leaves, which she opened to spread an offering on the tree trunk. A heady scent arose from sticks of incense pushed into the ground around the tree, some from Lomi Deme's congregants and some from previous groups. More groups — elders, youth, families — chanting *marreyyoo, marreyyoo*, arrived with their priests. The Ethiopian anthropologist explained that the cow is an animal sacred to *Waaqa*, and butter is a gift from that animal. The bark on the trunk of this sacred tree, darkened over time by this practice, is poignant evidence of the generations of ceremonial worship here.

Links between Nile cultures

Until the past decade there has been no comprehensive history, written by indigenous practitioners, of this traditional religion; its knowledge had been solely preserved through oral tradition. Some researchers see links to *Nubia* and *Kemet*, epitomized by the sacred status of cows represented in drawings and paintings on ancient tomb walls located in *Nubia* and *Kemet*. Two powerful female deities, *Het Heru* (Hathor) and *Ast* (Isis), are tied to fertility and are represented at times with cow horns and ears. *Het Heru* is sometimes drawn in bovine form, nursing the monarchs from her udders. Also, in all three Nile cultures, ritual staffs bear striking visual similarities and denote the user's authority and standing to broker disputes.

An appreciation of the balance of cosmic order as the model for human society, so important in the worship of *Waaqa,* was reflected in ancient times at the other end of the Nile. An embodiment of the duality of Nature, the seen and unseen, good and evil, this central organizing philosophy of balanced living was conceptualized in *Kemet* as *Ma'at* — deity of truth — usually shown with a feather, the hieroglyph for truth.

The Ancient Egyptian cosmogony makes me wonder how the Sun deity *Atum* can be the creator force and the father that began everything — creating the Ennead, the beginning nine deities: four male and four female deities plus himself. *Atum* gave birth to the deities of air and of moisture who together birthed the deities of earth and the dark sky (*Nut*) who in turn birthed the Lord of the Afterlife *Asar* and his brother and the deity of immortality *Ast* and her sister. The deity *Nut* represents the vault of the night sky; personified as a woman in the downward dog position along the Equator, *Nut's* feet rest on the eastern horizon and her head is at the western. All things are in the embrace of the invisible black matter of *Nut*. Each sundown, *Nut* swallows the sun. At night the sun passes through her body, sparkling through star-shaped openings in her dress. In the morning, the Sun is reborn, recycled. Because she gives birth to the Sun each morning, I see *Nut* as the mother of the Sun, itself the fire

of creation and thus the activator of Nature. *Nut* in her darkness is the essence of light and continuity. She is for me the mother of the Sun — the beginning of everything.

Belief in natural forces that inspire these early faiths sets them apart from more recent Abrahamic religions which seem to find their inspiration and adherence in the testaments of prophets and saints. But some beliefs still find resonance. *Waaqa* priests invite ancestral *ayyaanas* (spirits) to join with the living in their celebrations. This tradition is still observed by contemporary Hebrew, Christian and Muslim congregations when they invoke the names of their prophets and saints. When reading the Torah, the Bible and the Koran, worshipers are acknowledging the sanctifying role of their own sacred ancestors — inviting them to behold, partake, bless, and witness their reverence.

The temple of the woman

After several trips to the annual *Erecha* celebration, I returned in October of 2007 with the same Ethiopian anthropologist Meskerem Assegued to a tiny village in Borja, about fifty miles south of Bishoftu. We were here to visit the Temple of the Woman, a circular structure of wood and straw, fused with mud and cow dung, under a conical-shaped thatched roof. Meskerem wanted photographs to document her research, and so she made it possible for me, a man, to enter — if ever so briefly. The low doorway of this temple forces all who enter to bend. It occurred to me then that being made by circumstance to bend from time to time is itself a posture of mindfulness and modesty. As my eyes adjusted to the interior semi-darkness, I noticed that a wooden pillar dominated the center of the circular space. Four cow udders were carved close to the top of the pillar. As I was making photographs of the interior space, women worshipers began to arrive. On a raised earthen mound the priest lit a fire, generating smoke, scented with incense, intended to purify. In trance with her eyes closed, she moved in a deliberate, dignified slow-motion spin pattern toward the center pillar. Falling against this wood pillar, she reached up to grasp the cow udders, and appeared to kiss the pillar. Other women — in traditional white cotton dresses with white shawls — began circling the fire in their own trance-like states. The only sound was the shuffle of feet on the dirt floor and a low hum coming from some of the women.

I was allowed to remain only a few more minutes, as the ceremony is forbidden for men's eyes. But the ambience of incense and the intense focus of the women on a sacred space they knew so well suggested why this worship remains strong.

A burst of light and warmth

The five-petaled yellow flowers that the Oromo call *kello* are named *maskal* (meaning cross) by the Christians of Ethiopia. Many Ethiopian Oromo people believe the Christian *Maskal* or Feast of the Exaltation of the True Cross — celebrated in city and town squares — to be a syncretized variation of *Erecha*. The Oromo maintain that elements of their faith were subsumed by the Ethiopian Tewahedo Church for *Maskal*. Both *Maskal* and *Erecha* celebrations happen at the close of Ethiopia's cold wet and dark three-month-long rainy season, within a week of each other. An important feature of *Maskal* celebrations are the bonfires, lit in town and village squares across the country, towering and visible from a distance. Believers say that in a dream, Byzantine Empress Helena (248 to 328 CE), mother of Emperor Constantine, was instructed to build a fire, the smoke of which would reveal the location of the True Cross upon which Jesus Christ was crucified. Both festivals honor a burst of light and warmth, a harbinger of the coming spring.

Resurgence

The worship of *Waaqa* — forbidden by an Ethiopian government edict in the late 1800s — began to evidence resurgence among its believers after the ban on its practices was lifted in 1996. Since my first visit to the *Erecha* celebration in Bishoftu in 2002, when only a few thousand faithful came together at the sacred lake, the festival has exploded in popularity. By 2010, a local newspaper, *Addis Fortune,* reported four million visitors at that year's *Erecha* festivities.

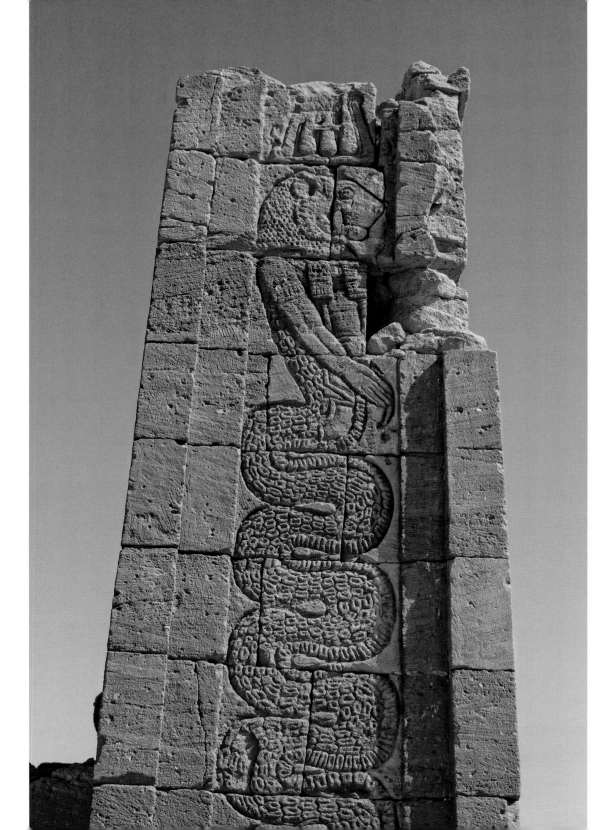

Nubia — Apedemak, lion-headed warrior deity in snake form. Side of pylon, Temple of *Apedemak*, Meroitic Period (300 BCE to 350 CE). Naga, Sudan, 2007 ⟶

Christian pilgrim passing through one of the subterranean passages that connect the 13th century churches hewn out of living rock. Lalibela, Ethiopia, 2007 ⟶

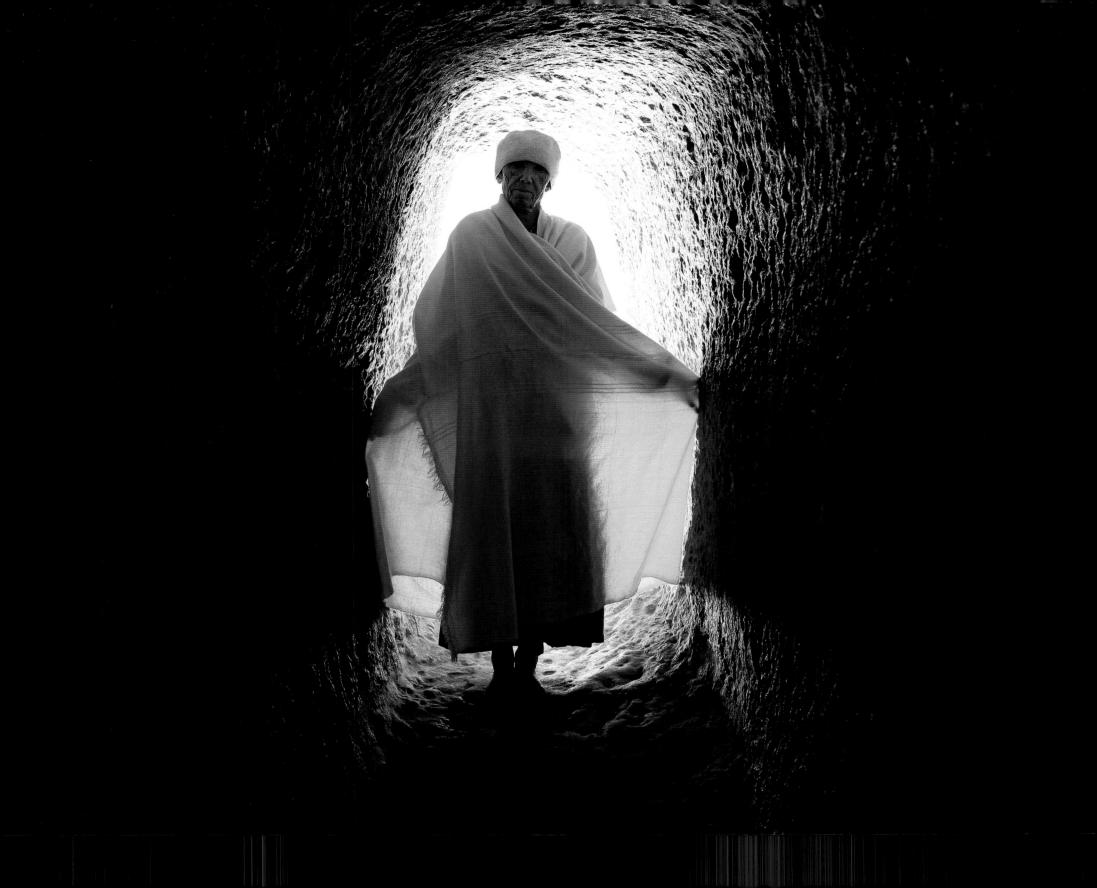

Cow as Sacred Animal

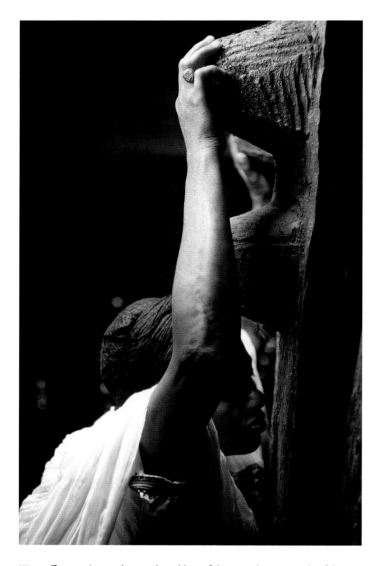

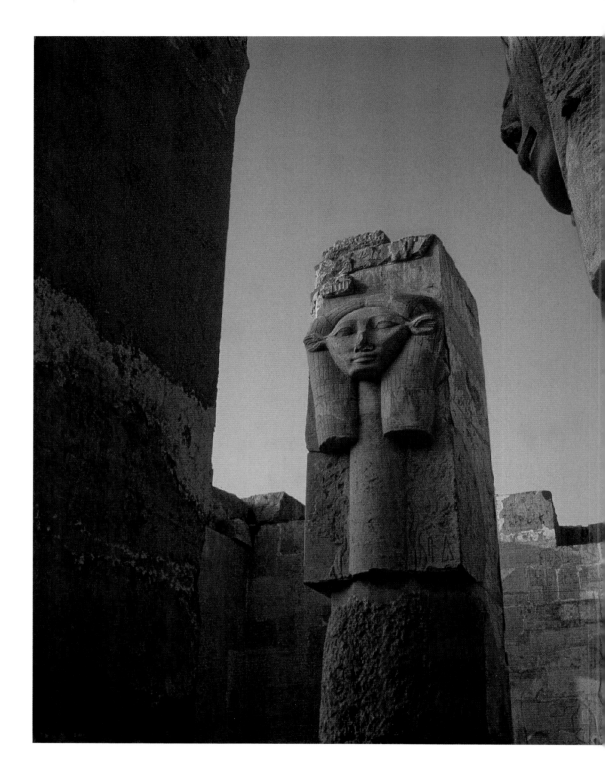

Waaqeffanna priest embraces the udders of the sacred cow. Temple of the Woman. Borja, Ethiopia, 2007

Kemet — Cows are sacred in nature religions of both *Kemet* and Ethiopia. The pillars in the Chapel of *Het Heru* (Hathor) show the deity with bovine ears. *Het Heru* protected the monarch and provided her with the divine sustenance of her milk. Mortuary Temple of Queen Hatshepsut (1507 to 1458 BCE), Dynasty 18. Deir el-Bahari, West Bank, Luxor, Egypt, 2001 —→

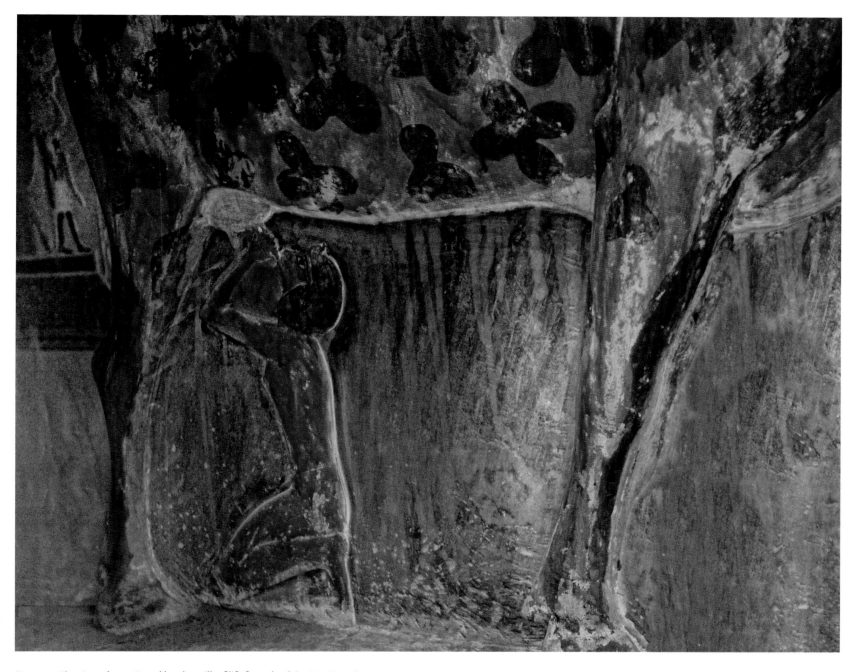

Kemet — King Amenhotep II suckles the milk of life from the deity *Het Heru* (in cow form); being nursed by *Het Heru* endowed the King with power and divinity. From the ruins of the Temple of Thutmosis III (1479 to 1425 BCE), Dynasty 18. Deir el-Bahari, West Bank, Luxor; now in The Egyptian Museum, Tahrir Square. Cairo, Egypt, 2019

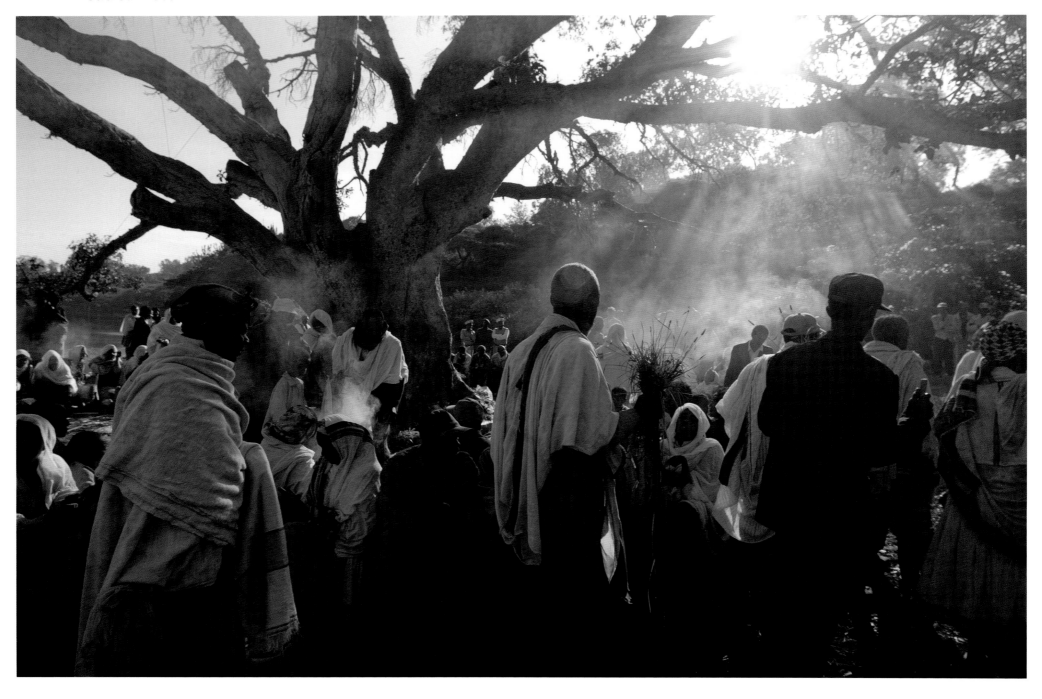

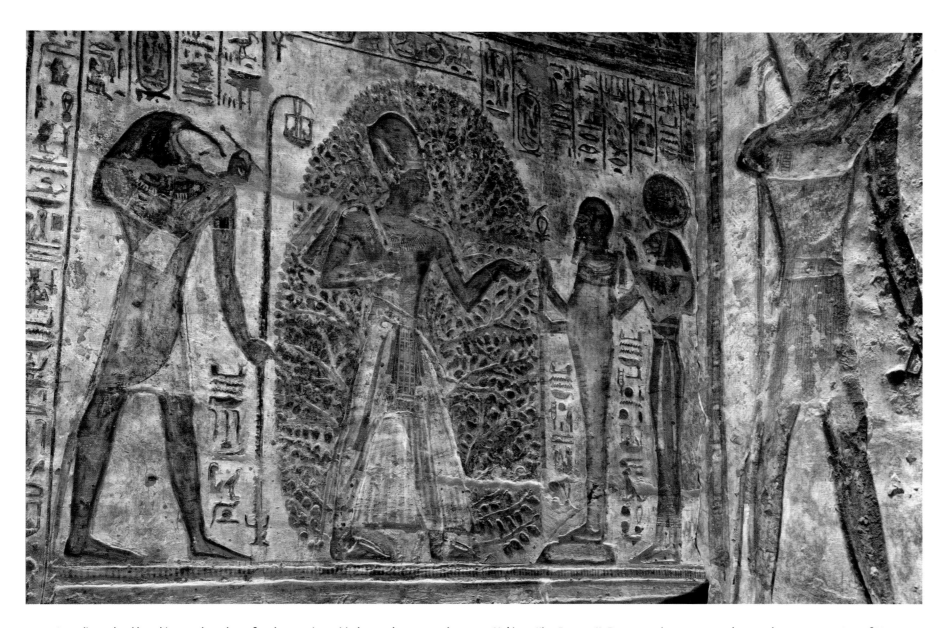

←— According to local lore this sacred tree has a female nurturing spirit that can be compared to the ancient Egyptian tree of life — *Het Heru* (Hathor) sometimes manifested as a sycamore tree. Worshipers of *Waaqa* place offerings of grass and yellow *kello* flowers. They light incense and candles, spread butter and honey on the sacred sycamore bark and pour libations to honor the supreme deity *Waaqa*. Annual *Erecha* festival. Bishoftu, Ethiopia, 2010

Nubia — King Ramses II, Dynasty 19, in ceremony at the sacred sycamore tree (one of *Het Heru's* manifestations). Here, the creator deity *Ptah* and his consort *Sekhmet* declare the King will have a long life. The ceremony is being documented by *Tehuti* (at left), deity of recording and communicating knowledge. Ramses built this Egyptian Temple of Derr in occupied *Nubia*. Lake Nasser, Egypt, 2007

Nubia — Pyramid in Royal Necropolis,
Meroitic Period (300 BCE to 350 CE).
Meroe, Sudan, 2007 ⟶

Tamaber. Northern Highlands,
Ethiopia, 2007 ⟶

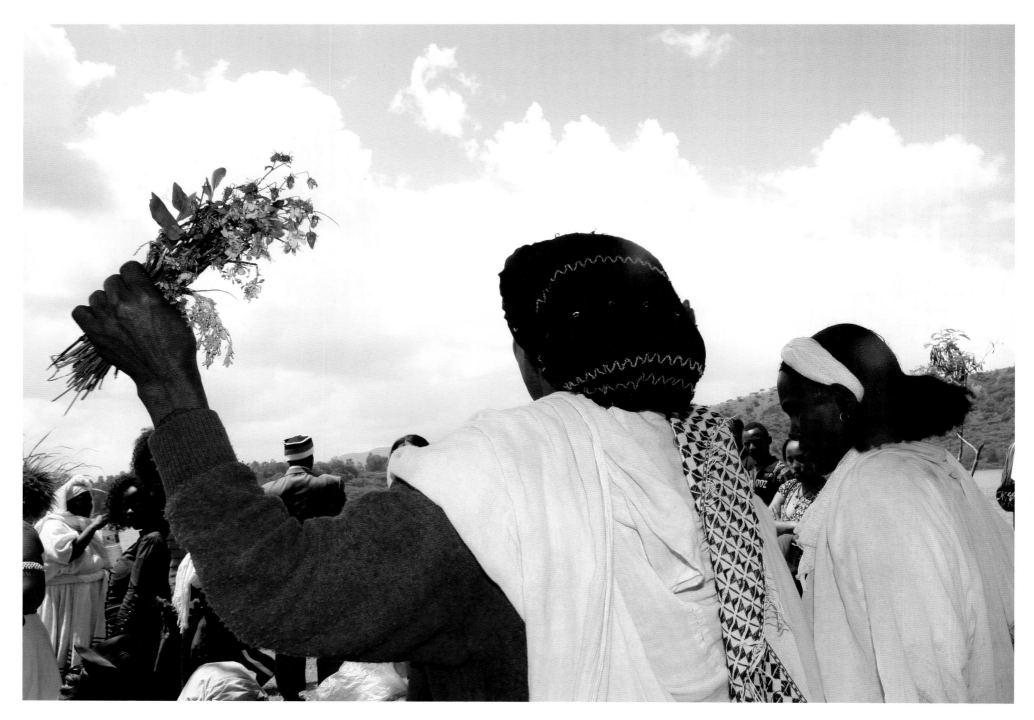

Celebrants bring yellow *kello* flowers, representing happiness and rebirth, and green
grass offerings to the spirit of *Waaqa. Erech*a festival. Bishoftu, Ethiopia, 2011

74

Tankwa or papyrus boat in moonlight. Lake Tana. Bahir Dar, Ethiopia, 2011

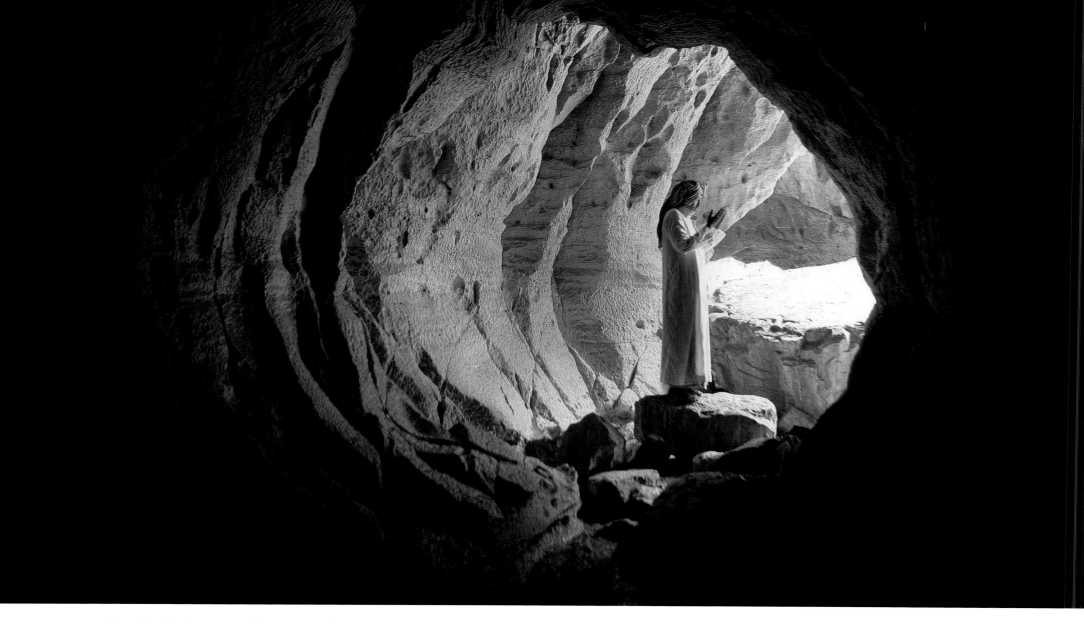

Imam. Sacred Sof Omar Cave. Bale Mountains, Ethiopia, 2010

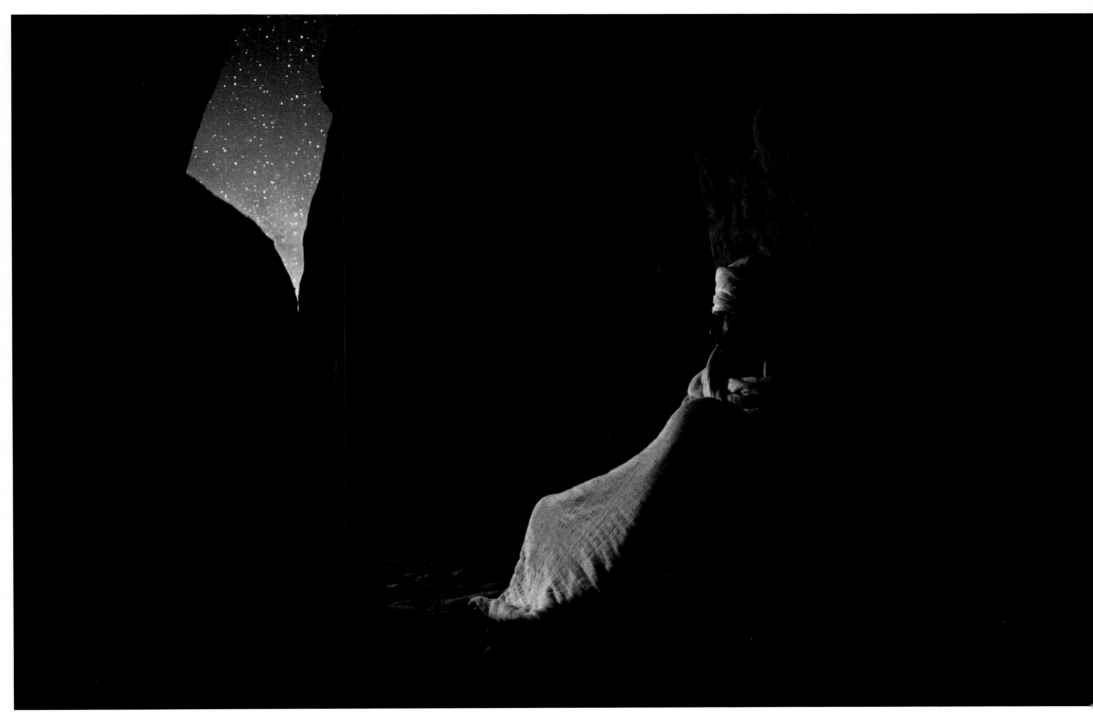

Priest in the sacred cave of *Abune Yemata Guh* (c. 6th century rock-hewn church).
Hawzen, Ethiopia, 2011

Ram's horn tribute. *Bete Israel* blow the *meleket* (shofar or sacred ram's horn) for
High Holy Days. Gondar, Ethiopia, 2003

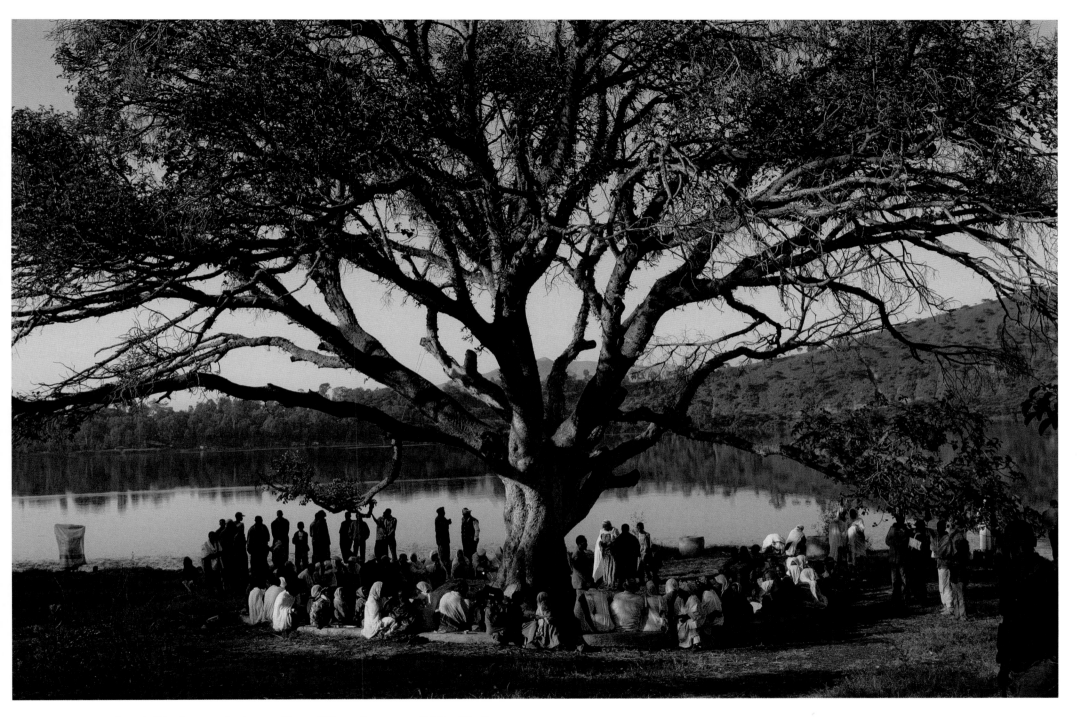

At the end of the three-month rains, worshipers of *Waaqa*, the supreme divinity of the Oromo people, gather around the *Oda* (sacred sycamore tree) beside the holy crater lake *Hora Arsedi*. *Erecha,* the annual celebration of renewal. Bishoftu, Ethiopia, 2002

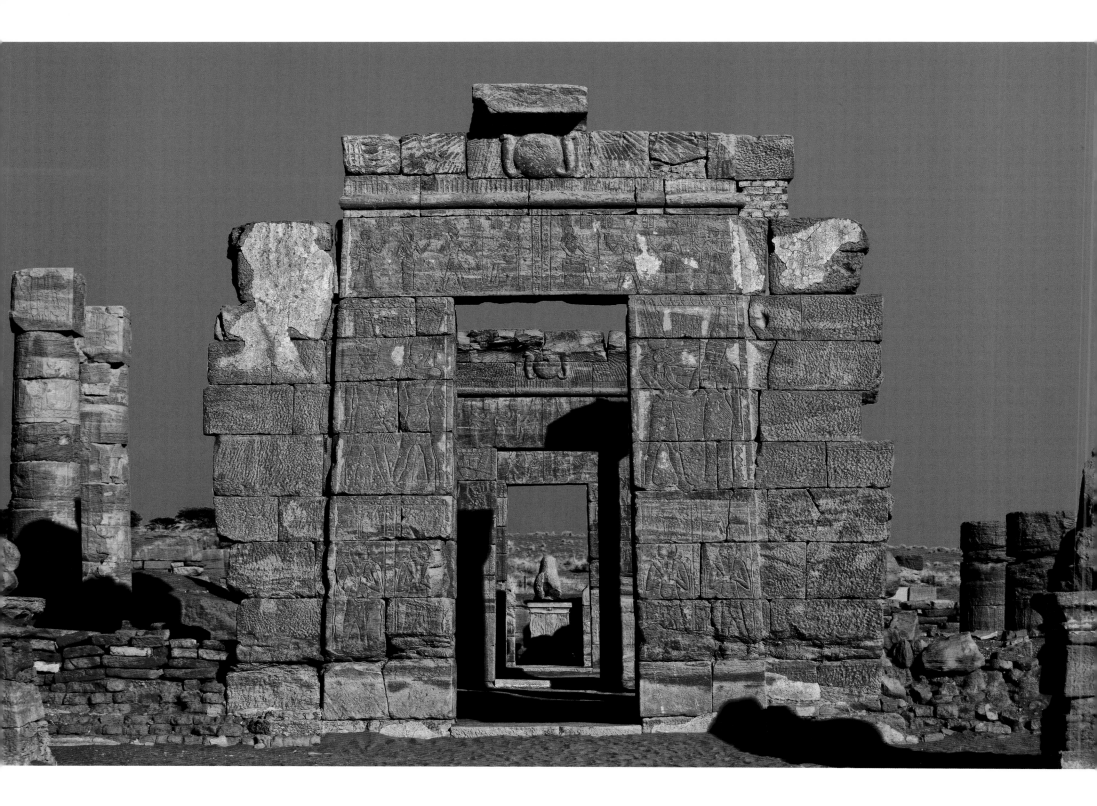

←— *Nubia* — *Kandakes* (queens) and *Qores* (rulers) were an important part of the royal structure of *Nubian* Meroitic Kingdoms. King Natakamani and *Kandake* and *Qore* Amanitore — as seen on the upper left and right sides of the temple doorway — commune with their supreme divinity *Amen* (the Hidden One). Temple of *Amen,* Meroitic Period (300 BCE to 350 CE). Naga, Sudan, 2007

Sunset. Aswan, Egypt, 2008

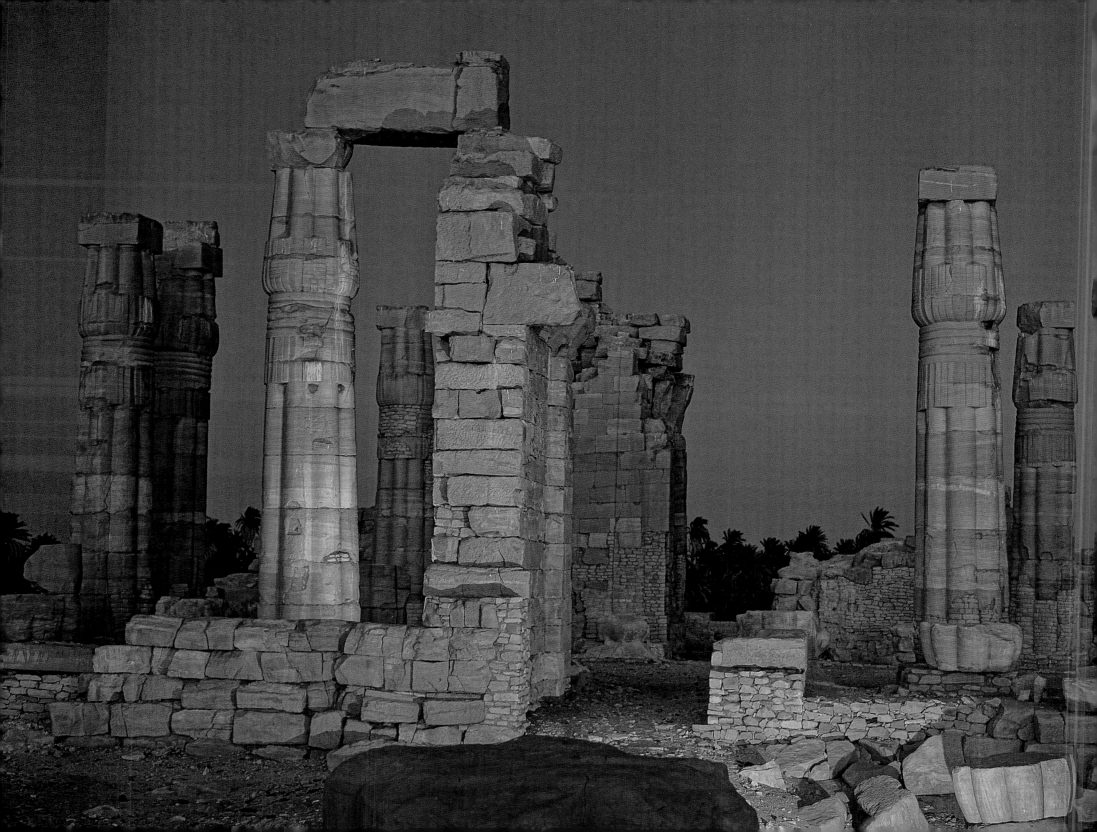

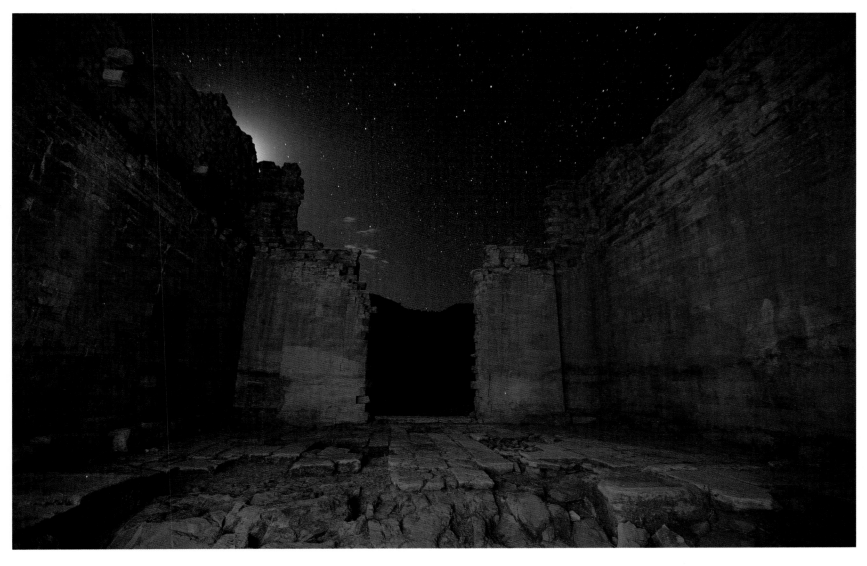

←— *Nubia* — Sunset. Temple of Soleb, built 3,500 years ago by King Amenhotep III in the 14th century BCE, Dynasty 18. Soleb, Sudan, 2007

Pre-Aksumite — Moonrise. Temple of the Moon (c. 500 BCE). Yeha, Ethiopia, 2009

Sacred Staffs

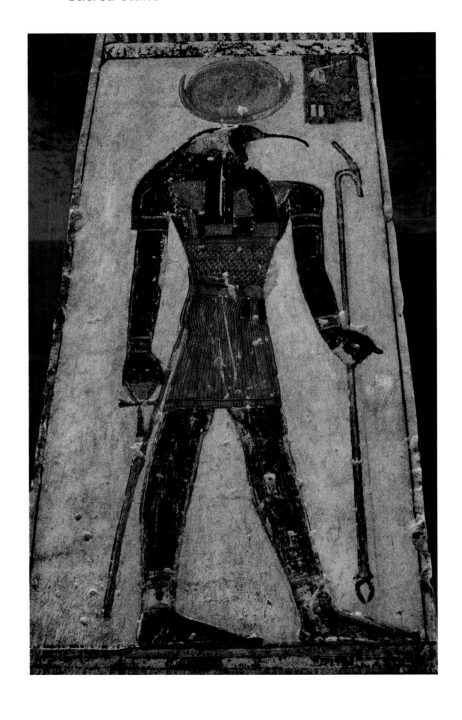

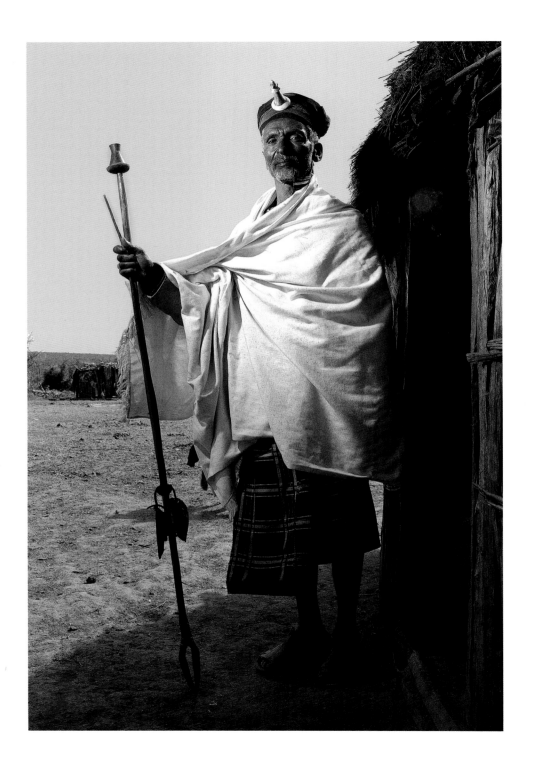

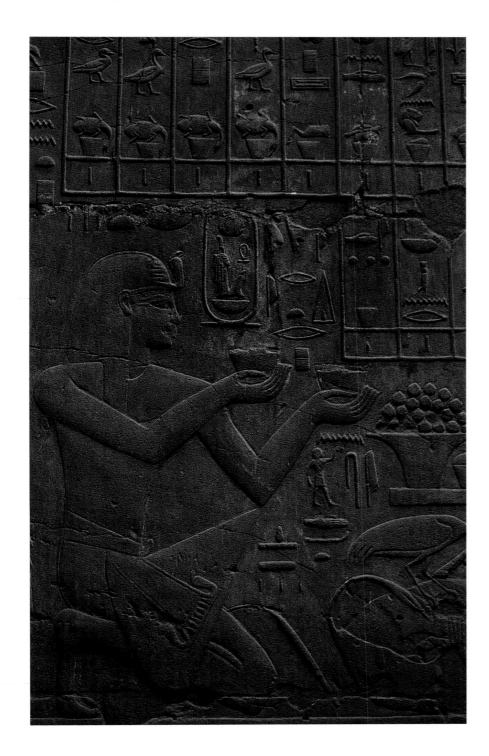

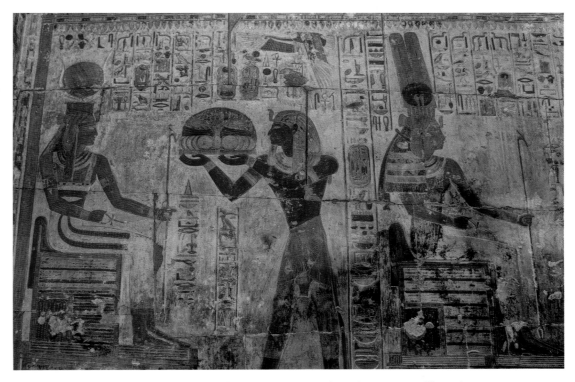

Kemet — King Sety I offering food to the deity *Het-Heru* (Hathor). The 3,300-year-old Temple of *Asar* (Osiris), built by King Sety I, Dynasty 19. Abydos, Egypt, 2019

⟵ *Kemet* — King Amenhotep III, Dynasty 18, makes an offering to the deity *Amen*. Temple of *Amen* (14th century BCE), Karnak. East Bank, Luxor, Egypt, 1998

The design of the staff of authority in *Kemet*, as well as the design of the one still carried by Oromo elders in contemporary Ethiopia, signifies the power to judge disputes. They both end in a distinctive curved fork.

⟵ *Kemet* — Deity *Tehuti* (Thoth) holds the *was*-scepter (the staff of authority). c. 3100-year-old Tomb of King Ramses VI, Dynasty 20. Valley of the Kings, West Bank, Luxor, Egypt, 2016

⟵ An Oromo elder displays the staff of authority. On his head, he wears a *kallacha,* a symbol sometimes associated with the ancient deity of fertility *Min*, worshiped in *Kemet*. The *kallacha* signifies the elder's elevated rank among the Oromo people of the Horn of Africa. Yabello, Ethiopia, 2011

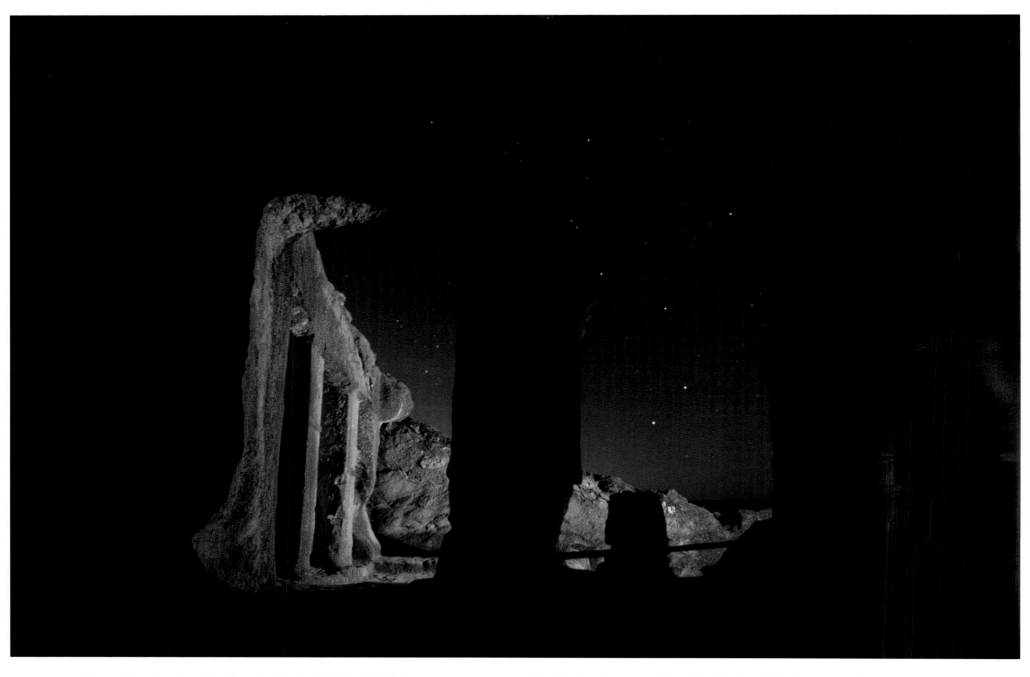

A starry night. 13th century *Bete Mercurius* (Church of Saint Mark). Lalibela, Ethiopia, 2009

Blue Nile River Gorge near Gojjam fills with red mud after the summer rains. Northern Highlands, Ethiopia, 2006 —→

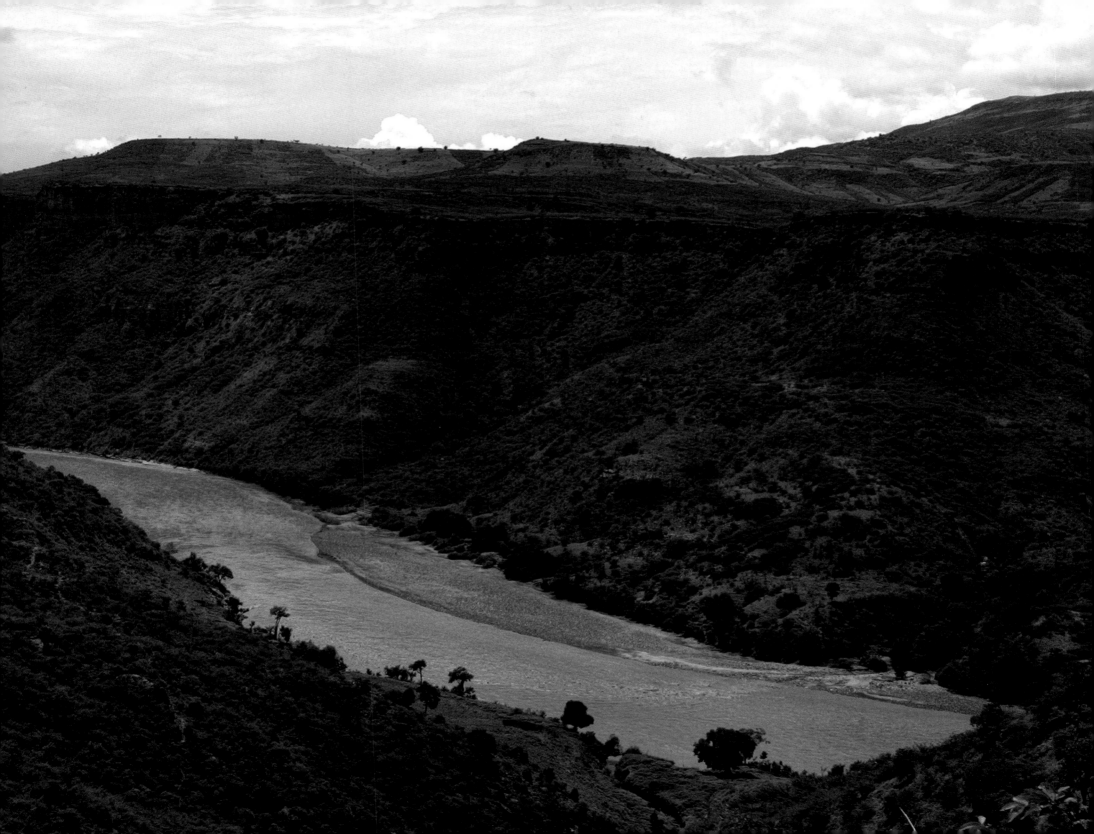

Sacred Space

We seek a place of intimacy to bare our souls. To reach the Divine, we whisper.

Ancient people left messages in stone. The sacredness of stone is quite literally palpable along the sacred Nile, evidence of the earliest Africans' faith in the everlasting qualities of stone and of the civilizations they created, which made such conspicuous use of it.

Using an engineering expertise that we no longer possess, excavators created precise structures from living rock. They carved into rock mountains to create sacred sanctuaries. Employing processes for removal of rock rather than adding extraneous building materials, they were able to create sanctuaries naturally anchored deeply in and of the earth. At three sacred spaces carved into cliffs and mountains — my favorites along the River Nile — I feel myself to be walking through pages of scripture and witnessing people engaged in dialogue with their Divinity. Here is spiritual legacy from the perspective of Nile River mystics who recorded their own sacred narrative and defined themselves and their culture.

Ramses, the great builder of temples

At the first location at Abu Simbel, Egypt, four 65-foot colossal stone figures of a seated King Ramses II acted as sentries observing all activity at the Nile border between ancient *Kemet* and *Nubia*. (This temple complex was relocated in 1964 after construction of the High Dam at Aswan flooded its original site.) The statues and, behind them, the Grand Temple honoring King Ramses II as a deity were carved in the 13th century BCE from a single sandstone mountain. Chosen by the supreme deity *Amen*, the King was the Divinity's representative on earth. Between the heads of the middle two of the seated statues, a more than ten-foot-high statue of the sun deity *Re Herakhty (Heru of the Two Horizons)* is situated in a niche, strategically above the temple entrance. Two smaller bas-relief figures of the King, in scale with the deity, depict the King paying tribute to *Re Herakhty*.

The Grand Temple extends one hundred eighty-five feet, deep into the belly of the mountain, and contains massive floor-to-ceiling (roughly three-stories) living rock pillars, each carved in the likeness of the King. Interior temple wall scenes depict Ramses at war as well as show him to be communing with his deities. In battle scenes the King always wins handily, his efforts divinely sanctioned by the protective deity *Heru* (Horus), who here is depicted as a hawk hovering above the carnage.

In a recessed chamber at the rear of the temple is an intimate arrangement of four statues: Ramses with three deities. Two days a year, rays of the rising sun reach all the way to the back of the temple to illuminate a row of four seated statues. The natural light creates a potent mystical tableau of the deified King and deities *Amen Re and Re Herakhty*, both representations of the sun deity *Re*. The third, *Ptah*, the creator deity, remains perpetually in shadow.

At dawn, the sun bathes the temple façade and colossal statues of Ramses in a warm red glow. During this brief transformation, Ramses comes alive, and I wonder if some of the King's subjects, like me, sought this temple early morning for meditation or worship. How many, I wonder, came dressed in resplendent white — likely linen for the ancients, cotton for me. I visualize the ancient visitors in long-flowing garments, such as are represented in tomb paintings and similar to those still worn by pilgrims flocking to holy sites in Ethiopia.

Sunset at the First Cataract. River Nile, Egypt, 2007

Amen's southern residence

About seven hundred miles upriver at Gebel Barkal in Sudan, 276 miles north of Khartoum, Sudan, is the massive *Nubian* sacred mountain known since the 15th century BCE in ancient Egyptian mythology as *djew wab* (the pure mountain). According to this mythology, Gebel Barkal was the southern residence of the deity *Amen,* the supreme figure in the cosmology of both *Kemet* and *Nubia*. Rising up three hundred forty-one feet out of the desert, this isolated flat-topped sandstone formation is fronted by a towering two hundred sixty-two-foot rock pinnacle seen as a representation of the *uraeus,* or rearing cobra. The *uraeus* is synonymous with the royal power of ancient Nile monarchs. It appears on the crowns of sovereigns of *Kemet, Nubia*, and also, it seems, on some pre-Christian gold coins of Aksumite kings (rulers of a part of Ethiopia and *Nubia* c. 100 to 940 CE).

An extensive religious center, recognized as *Amen's* birthplace, prospered here. Around the 7th century BCE, the 25th Dynasty King Taharka commissioned a temple to stand in front of the steep cliff of Gebel Barkal and excavated some fifty feet into the living rock of the mountain. Taharka dedicated this temple to *Mut,* deity of the heavens and consort of *Amen*. Only the footprint of the freestanding portion of this temple remains in evidence today along with two standing pillars showing the face of *Het Heru* (Hathor) with cow ears carved into the two capitals. However, the antechamber and the Holy of Holies — the name for the exclusive areas reserved for priests and the King — remain inside the mountain in the living rock.

Scenes of King Taharka in audience with the deity *Amen* inside the "Pure Mountain," his consort *Mut* and their son *Khonsu* — the Holy Family of Gebel Barkal — adorn the walls of the antechamber and the Holy of Holies. In a compelling relief, Taharka is shown making an offering to the seated *Amen*. In this depiction, the deity is sitting inside his mythological home, the flat-topped mountain with its natural rock pinnacle. Here, the rock pinnacle has been drawn as an actual *uraeus*. I felt blessed to have made my own pilgrimage to this ancient holy place and to be inside these restricted holy chambers — to be in this chamber, accessible to but a fraction of the many who came before me.

The New Jerusalem

About two hundred miles east of the source of the Blue Nile River, in the town of Lalibela, Ethiopia, there are eleven monolithic churches excavated and entirely chiseled from rock mountains in the 13th century. Known as the Rock-Hewn Churches, they are today a UNESCO World Heritage Site. A sea of pilgrims and tourists visit daily, arriving for the numerous Christian High Holy Days observed throughout the year. Christianity became Ethiopia's state religion in the 4th century CE during the reign of its first Christian ruler, Aksumite King Ezana — a few centuries after the religion's introduction to Egypt and Sudan. This was a turning point in Ethiopian history — the time when the country turned away from a belief in Nature to embrace Christianity. Ethiopian Tewahedo Christian Churches contain a mix of iconography from earlier pre-Christian eras, including Aksumite obelisk symbolism.

On my first trip to this site in 1974, the town of Lalibela could be reached by foot (the preferred mode of pilgrims), by four-wheel drive vehicles over unpaved roads, or by plane a few direct flights a week. It was still the rainy season when I arrived in Addis Ababa, the capital of Ethiopia, more than five hundred miles away from Lalibela. Muddy roads and flash floods made hiring a vehicle and driver problematic. Still, I longed to see the country, not just fly over it. So, after a few days, I was at last able to find a touring company willing to send a driver with a four-wheel drive sturdy car to transport me to Lalibela. After a week of wet and mountainous terrain travel, my driver and I finally arrived at the Lalibela church complex. Suddenly, in the deep chill of an overcast morning, the driver directed me to disembark and to then climb a steep hill. At the top, peering down over the rim, I looked into a huge excavated rectangular pit, thirty-two feet deep. There underground, rising from the pit, loomed *Bete Medhane Alem* (Church of the Savior of the World). The Church was flanked by a massive colonnade of thirty square rock pillars, all solidly rooted in the living rock. The church roof — which would represent the crest of the mountain — was a couple of feet higher. I stopped in the midst of a cluster of pilgrims, all of us in the thrall of this seemingly improbable structure that had once been a solid mountain. No one

knows how these eleven churches were constructed from eleven rock mountains, all within a rough circle with about a quarter-mile diameter. The enduring myth is that they were fashioned at night by angels for King Gebre Meskel Lalibela, who reigned from 1185 to 1225. During his reign, toward the end of the 12th century pilgrimages to Jerusalem were no longer safe. Oral history says that the King, after making a pilgrimage to Jerusalem, decided he would build his own Jerusalem. Today Lalibela is said to be Ethiopia's New Jerusalem; the river passing through the nearby town was renamed the Jordan River by the King.

After a few minutes of rapt focus, I walked farther around the rim of *Bete Medhane Alem* and came to steps, hewn into the wall of the pit. Stepping down these to the stone courtyard below, I came to the church entrance. Before me, wrapped from head to toe in traditional thick white cotton *shammas*, more pilgrims each leaned into the doorway to humbly kiss the stone. They then removed their shoes before crossing into the hallowed sanctuary. I left my own shoes at the doorway. Inside I encountered more pillars and geometric designs. Fragrant faded tapestries and curtains — permeated with the lingering scent of incense — hung against the rock walls. A roughly hewn stone floor was mostly covered with well-worn hand-woven carpets. There were no chairs or pews; instead, collections of wooden prayer sticks with T-shaped tops were available for worshipers to put under their arms as support during the hours-long services. I noted that doors and windowlike apertures were cut in the arch shape of the tops of the Aksumite obelisks. Traversing a rock tunnel, I came to a smaller monolithic structure, *Bete Maryam* (Church of Saint Mary), with more obelisk-shaped apertures and some in the shape of the Greek Cross — all looking toward the rock that forms the side of the pit.

My driver was concerned about us becoming stranded by the punishing afternoon rains, so he had only given me a few hours to explore; our time at Lalibela was somewhat abbreviated. I saw only one more church that day: *Bete Giyorgis* (Church of Saint George). The roof of this church is formed in the shape of the Greek cross with four equal arms.

Celestial drama greets pilgrims

For the next three decades, I dreamed of photographing an image of the cosmic drama that daily greets the faithful before sunrise on their way to service. For my shoot, I chose *Bete Giyorgis*, small enough to capture with five strobe lights. After two years of planning, steadfast solicitations and prickly negotiations with both the Ethiopian government and church hierarchy, I finally obtained approval to shoot in early morning.

In 2008 — on what was my twelfth trip to Lalibela — my wife and I at last had permission to go to the church. We arrived at 4 AM with a crew of my facilitator/driver and his assistant plus ten locals to help with my equipment. We began setting up four battery-operated studio strobe lights at the base of the church — in that forty-two-foot-deep pit — and another strobe to light the church roof from above. Worshipers, barely visible in white garments, moved sinuously up and down hillside paths on their way to the church. At 4:30 AM, a loudspeaker began broadcasting the prayers and chanting of worshipers already within the church.

Everything was going well until I made the first test shot; my remote activator wasn't triggering the lights in the pit. Only the strobe from the hill above the church and which was illuminating the roof was activating. The stone of the mountain around the church blocked the signal to the other strobes. I would have to improvise. My time was lessening as the black of the night sky began to lighten. After a few minutes of consultation, my longtime friend and facilitator Tedros Berhanu and I worked out a very low-tech solution. Positioning himself at a corner of the pit outside the church where he could watch the strobe above, Teddy was able to see this strobe flash, set off his own, and call out to the others in the pit to activate theirs. I knew I had to make the shoot work in as few frames as possible before our echoed shouting, though restrained, would disturb those within the Church.

Not far away, roosters were crowing and cows were lowing. I took it all in, standing with my camera on a small hill above the church under a breathtakingly starry sky. Just as the stars began to fade in the blue-black of the predawn, I was finally able to capture the celestial drama that daily welcomed worshipers.

← *Kemet* — Sunrise. The 3,245-year-old Grand Temple of King Ramses II, Dynasty 19.
Abu Simbel, Egypt, 2007

Nubia — Early morning sun. Southern Royal Necropolis, Meroitic Period (300 BCE to 350 CE).
Meroe, Sudan, 2007

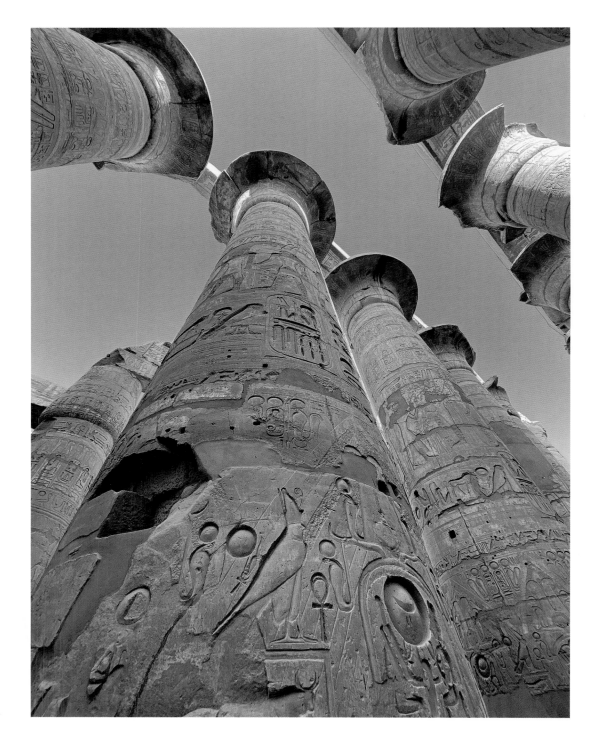

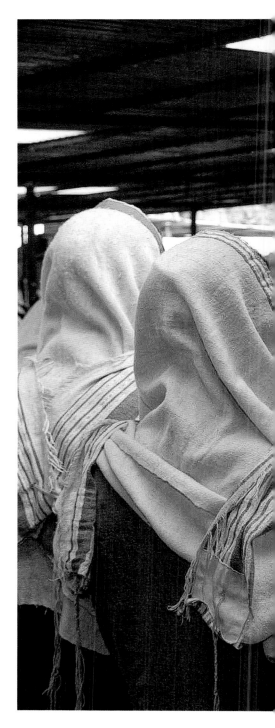

Kemet — Hypostyle Hall, 3,500-year-old Temple of *Amen*, Karnak, New Kingdom. East Bank, Luxor, Egypt, 2019 ⟶

The men's section, Ha Tikvah Synagogue. Gondar, Ethiopia, 2015 ⟶

Imam, seated at the courtyard of the Tomb of Sheik Hussein, holds a replica of the staff carried by the 13th century Muslim Sheik. Bale Mountains, Ethiopia, 2013 ⟶

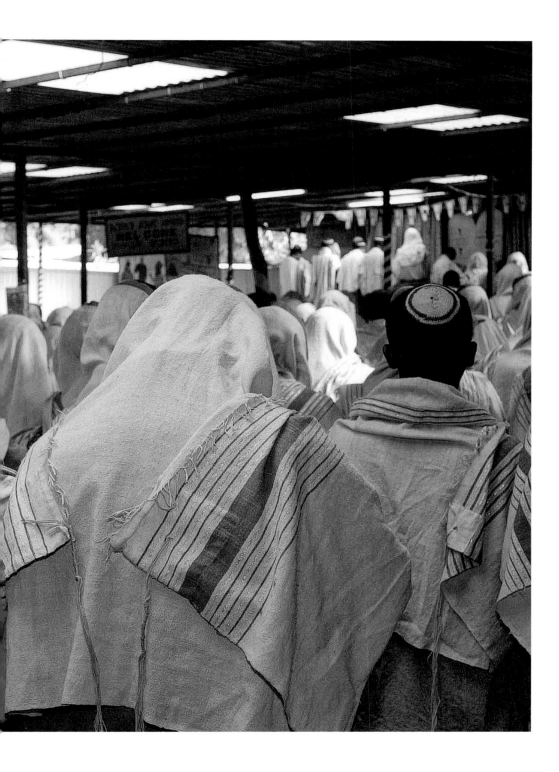
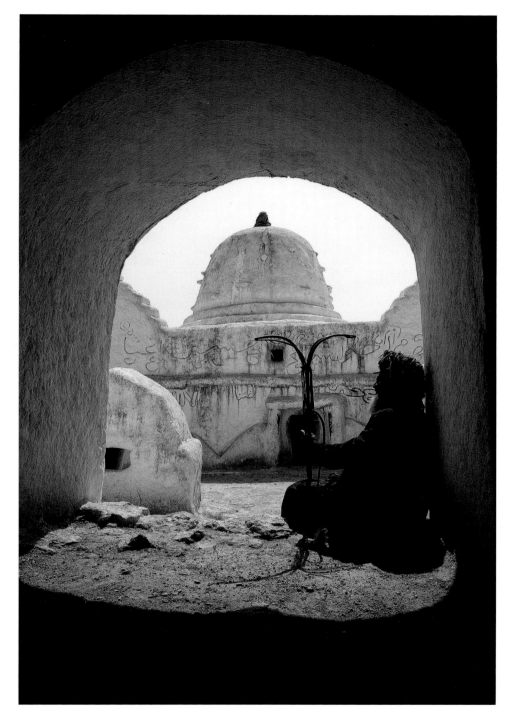

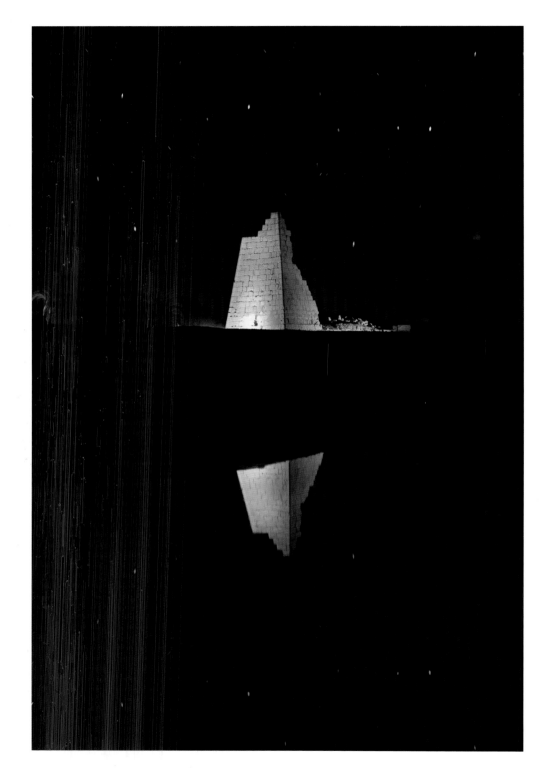

Kemet — Chapel ruin at 14th century BCE Temple of *Amen*, reflected in a sacred pool at night. New Kingdom. Karnak, East Bank, Luxor, Egypt, 2007 ⟶

Nubia — It is believed ancient people thought the rocky outcropping on this mountain represented a *uraeus*—the sacred serpent that was the emblem of supreme power — worn on the headdresses of divinities and sovereigns in ancient *Kemet*, Nubia and early Aksumite Kingdom rulers. Gebel Barkal (Holy Mountain), Sudan, 2007 ⟶

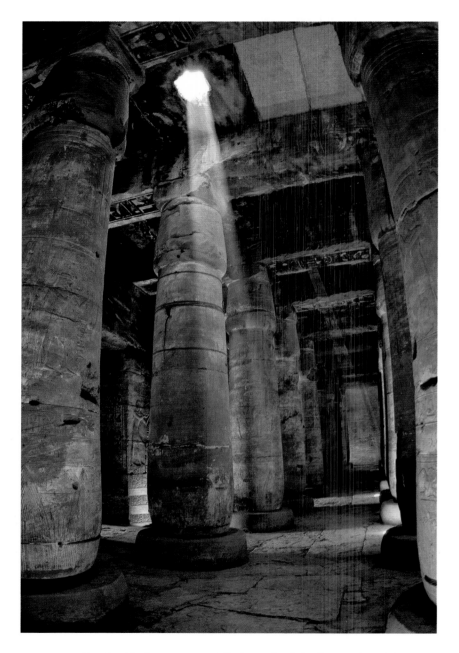

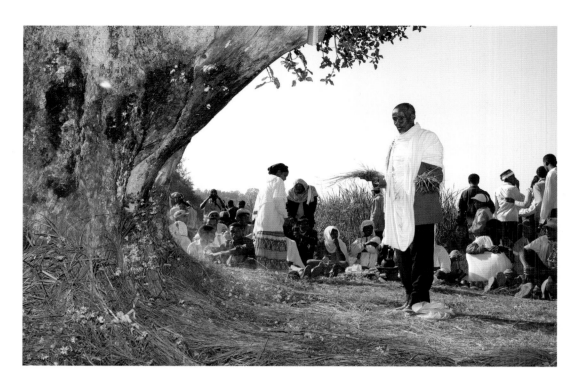

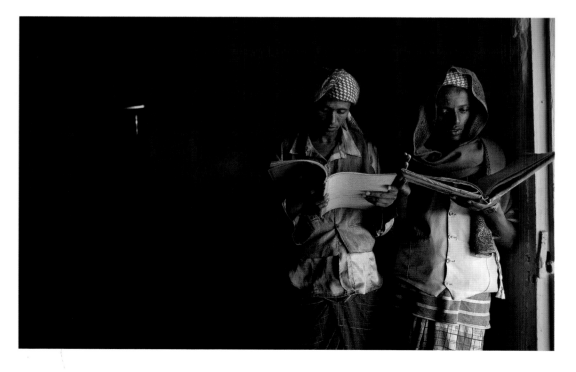

Kemet — Abydos was a sacred pilgrimage site dating from predynastic Egypt. Colonnade Hall, 3,300-year-old Temple of *Asar* (Osiris) built by King Sety I, Dynasty 19. Abydos, Egypt, 1988

Making offerings to the sacred sycamore tree, revered by *Waaqa* faithful of the Oromo traditional religion: *Waaqeffanna*. Bishoftu, Ethiopia, 2010

Islamic students. Aliey Mosque. Kemise, Ethiopia, 2011 ⟶

Pilgrims in early morning mist outside the 13th century *Bete Medhane Alem* (Church of the
Savior of the World). Lalibela, Ethiopia, 1974

A Configuration across Centuries

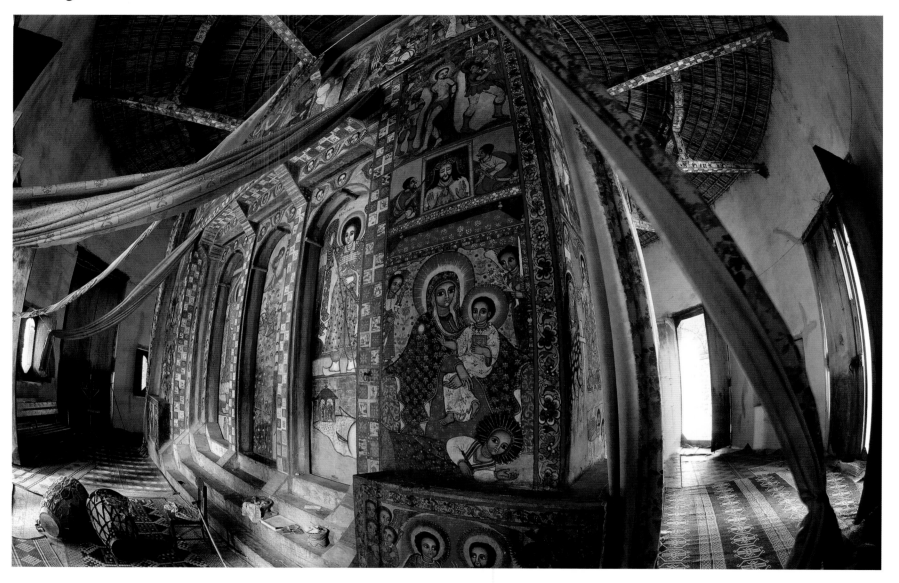

Late 18th century Narga Selassie Monastery. Dek Island, Lake Tana. Bahir Dar, Ethiopia, 2016

Every Ethiopian Tewahedo Church houses a *tabot*, a replica of the Ark of the Covenant — kept today in The Treasury at Aksum — and which is revered as sacred and kept in the Holy of Holies. Church sacred structures and Egyptian temples follow a similar pattern with three distinct and separate chambers: one for congregants, one for the priesthood, and the third, the Holy of Holies. The Holy of Holies houses sacred icons and access is restricted to the priesthood; it is only entered on high holy days.

Kemet — Grand Temple, completed in 1224 BCE for King Ramses II, Dynasty 19. Abu Simbel, Egypt, 1988 —→

In many Egyptian temples, the Holy of Holies held replicas of sacred barks (or boats), inside which were hidden statues of the principal deities of that temple. Like those in the Ethiopian Tewahedo Churches today, these icons were brought out, safely protected from the eyes of believers, to be venerated with much rejoicing and adoration.

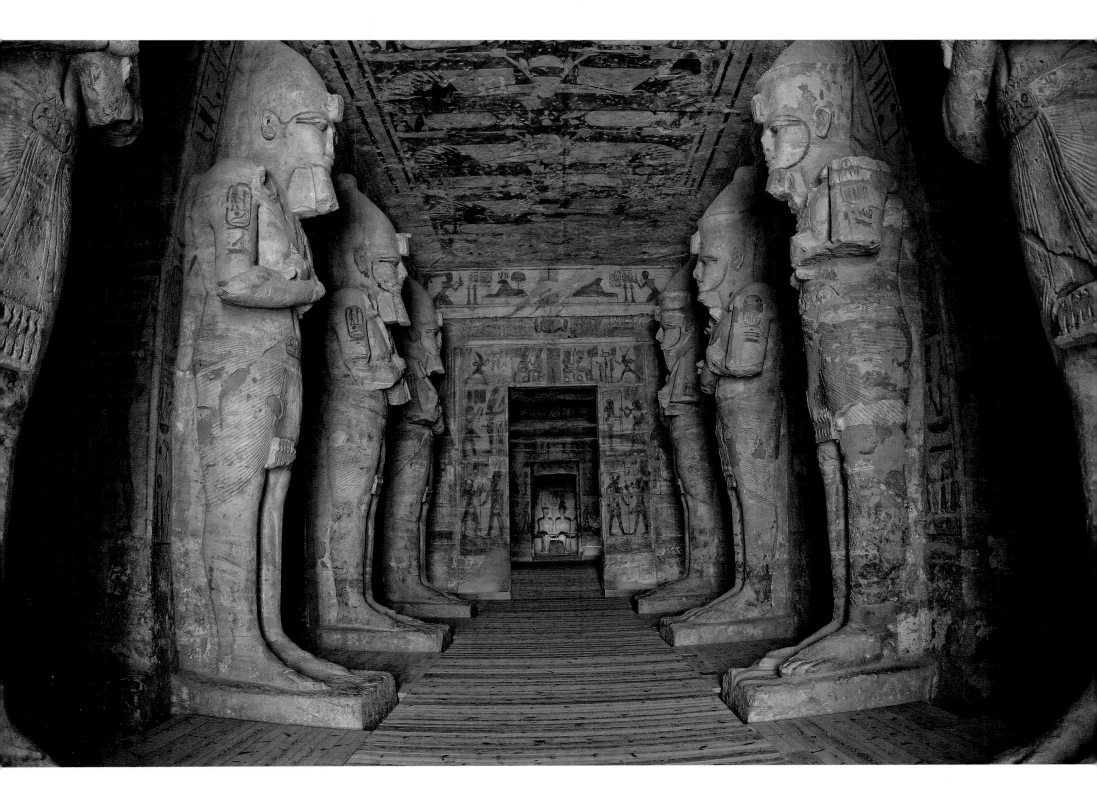

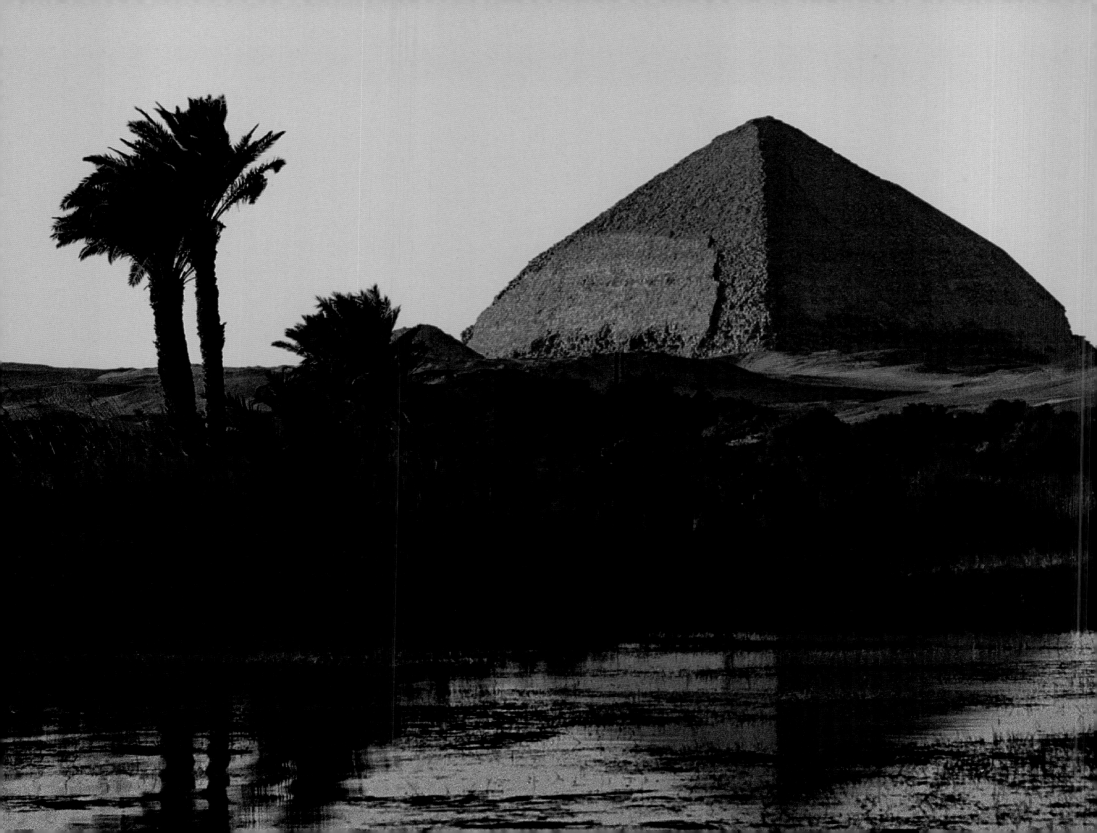

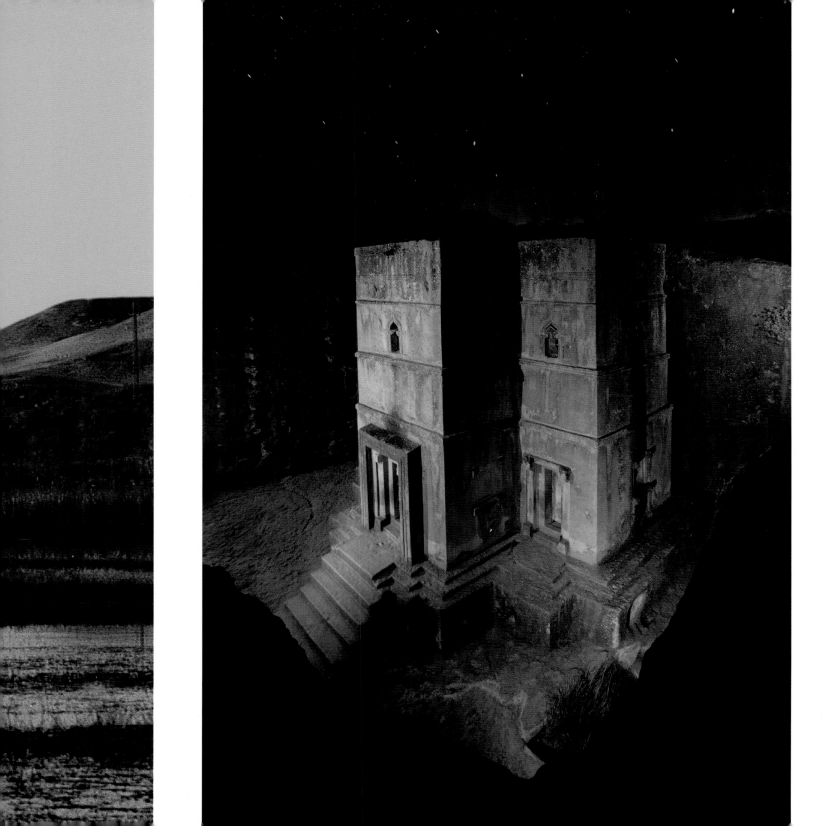

<——— *Kemet* — The 4,700-year-old Bent Pyramid
of King Snefru, Dynasty 4. Dashur, Egypt, 2010

<—— Rock-hewn 13th century *Bete Giyorgis*
(Church of Saint George). Lalibela, Ethiopia, 2007

103

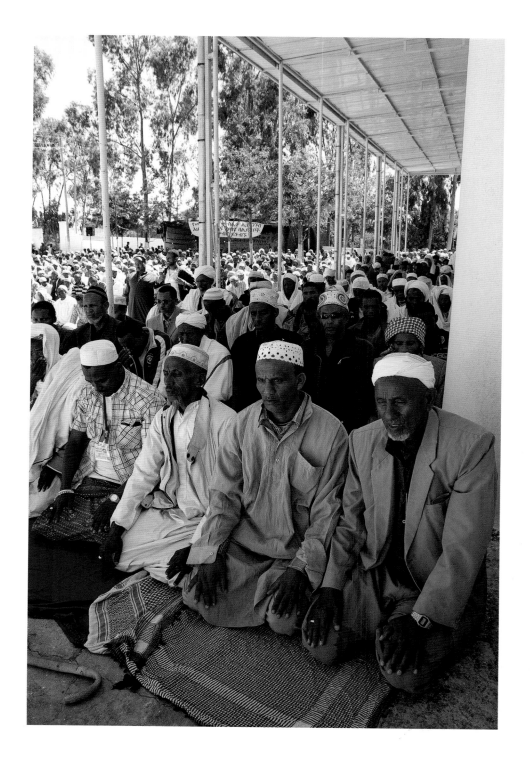
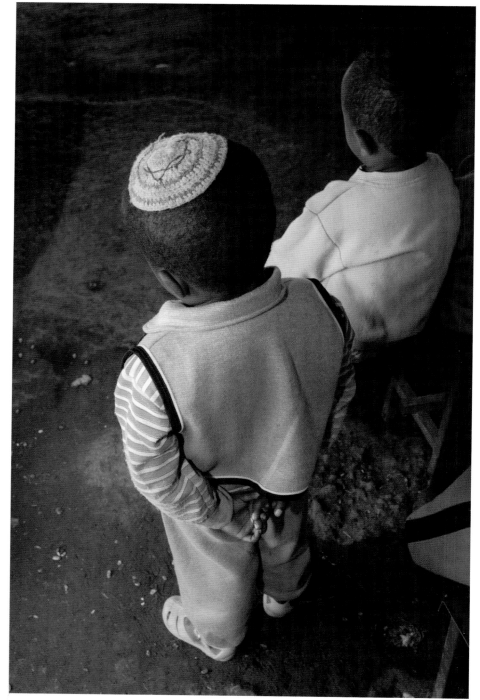

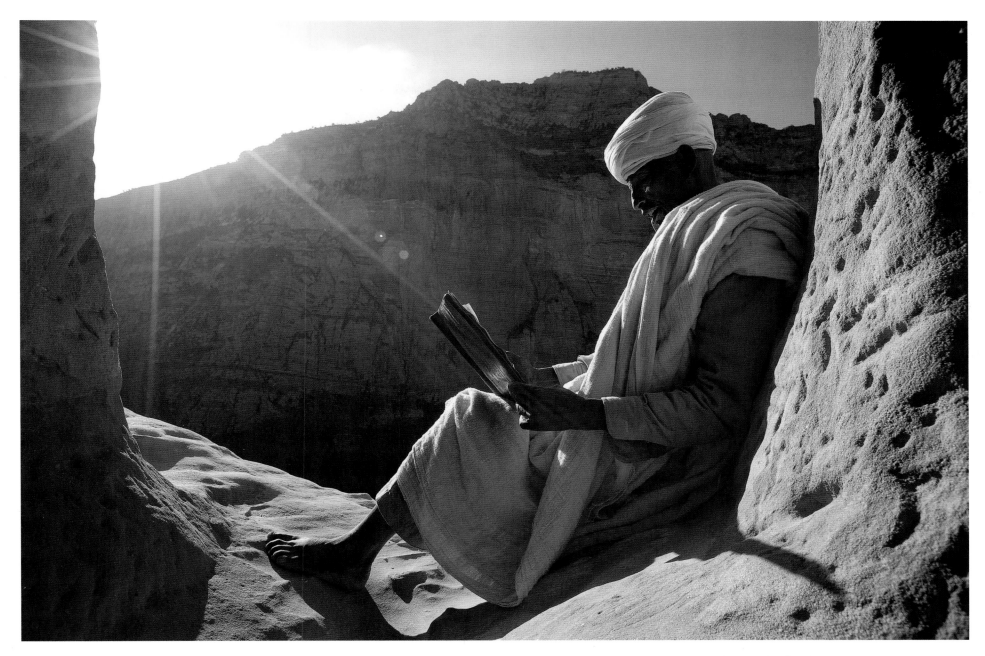

←——— Negash Amedin Mosque — built in the 7th century — is one of the oldest mosques in Africa. It houses the shrine of Negash (King of Aksum) and tombs of twelve of Mohammed's companions who fled to the Aksumite Kingdom to escape persecution. Negash, Ethiopia, 2011

←—— Praying at Ha Tikvah Synagogue. Gondar, Ethiopia, 2002

Priest at *Abune Yemata Guh*, a rock-hewn church said to date from the 6th century. Hawzen, Ethiopia, 2011

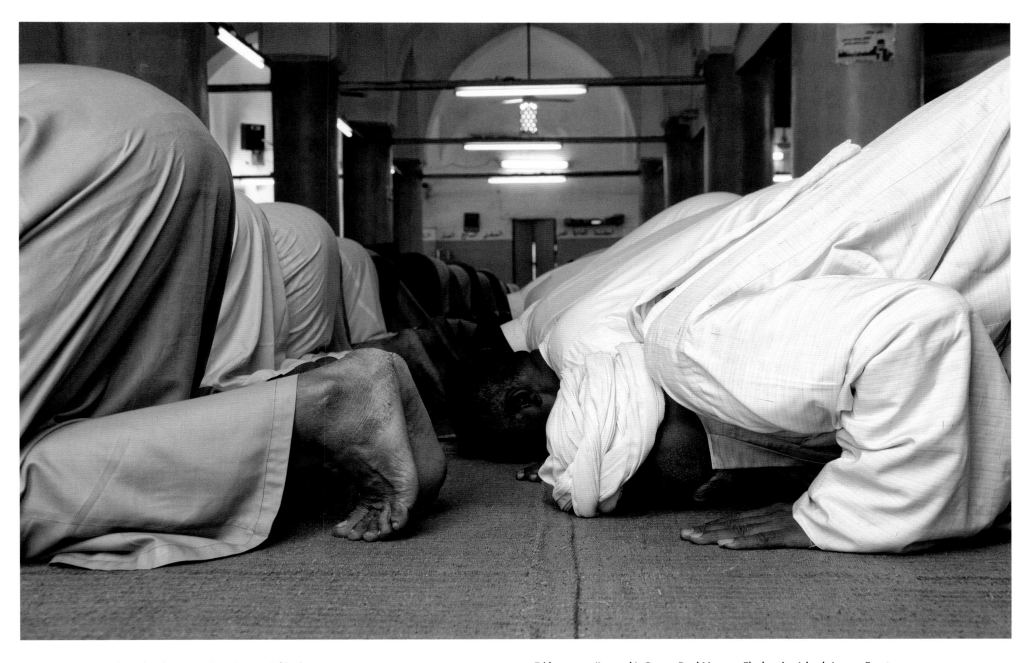

← Sunrise. Gheralta Mountains. Hawzen, Ethiopia, 2011

Friday prayer (Jummah). Gamaa Dool Mosque, Elephantine Island. Aswan, Egypt, 2019

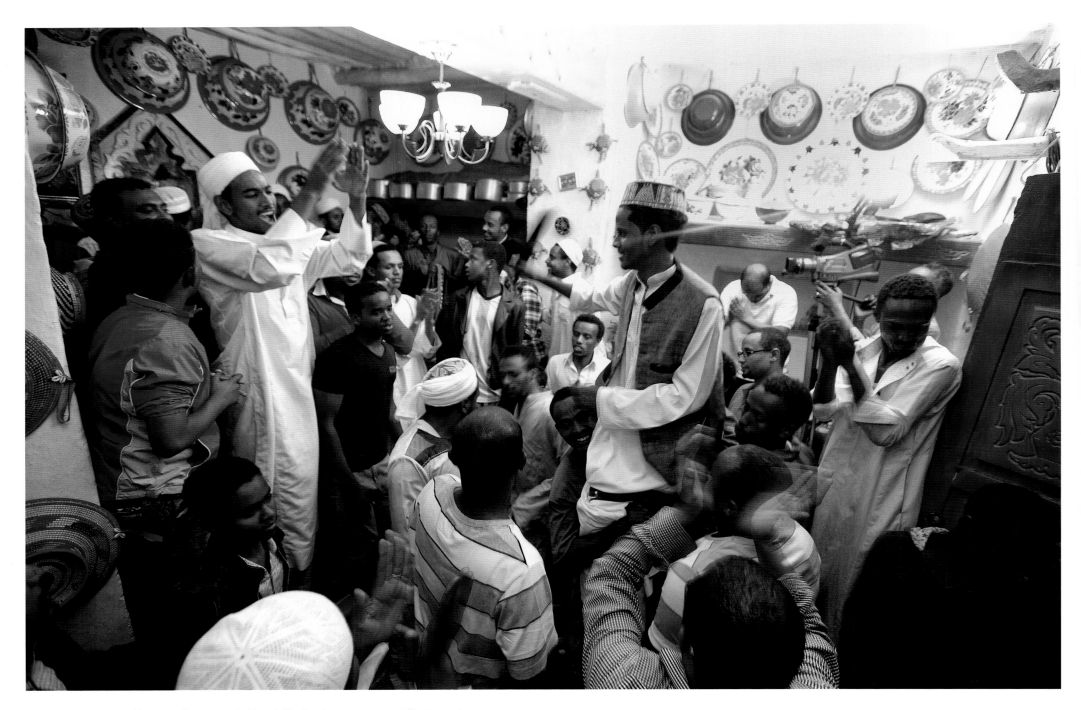

A wedding party for a groom in his neighborhood mosque. Harar, Ethiopia, 2016

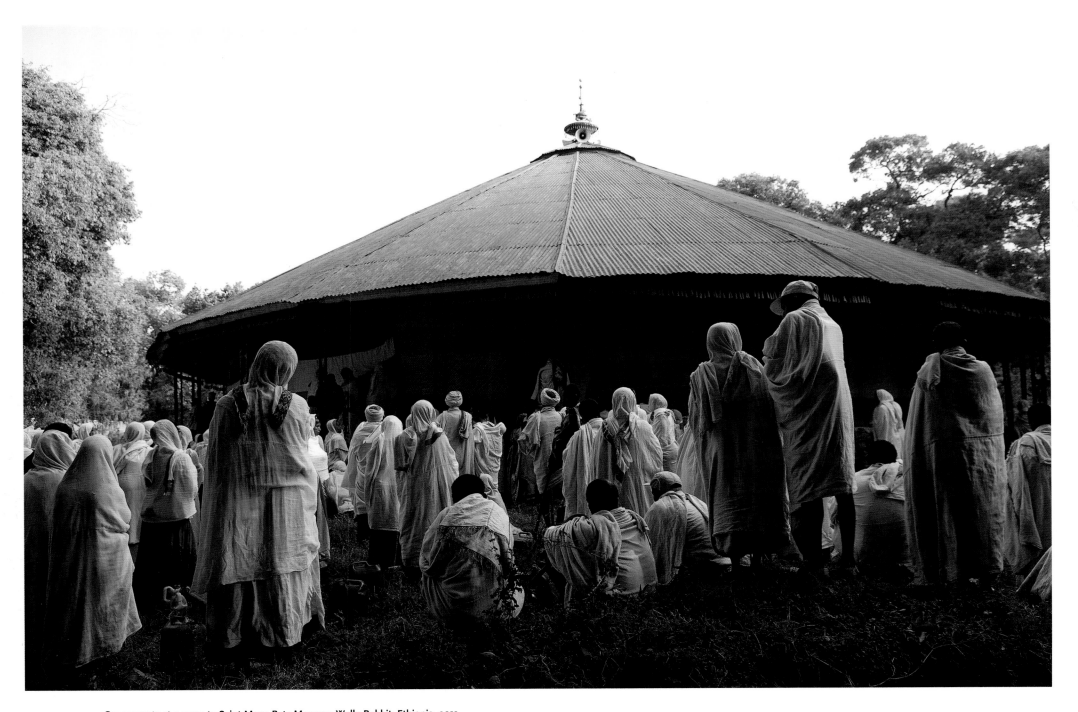

Congregants at a mass to Saint Mary. *Bete Maryam*, Wollo Robbit, Ethiopia, 2011

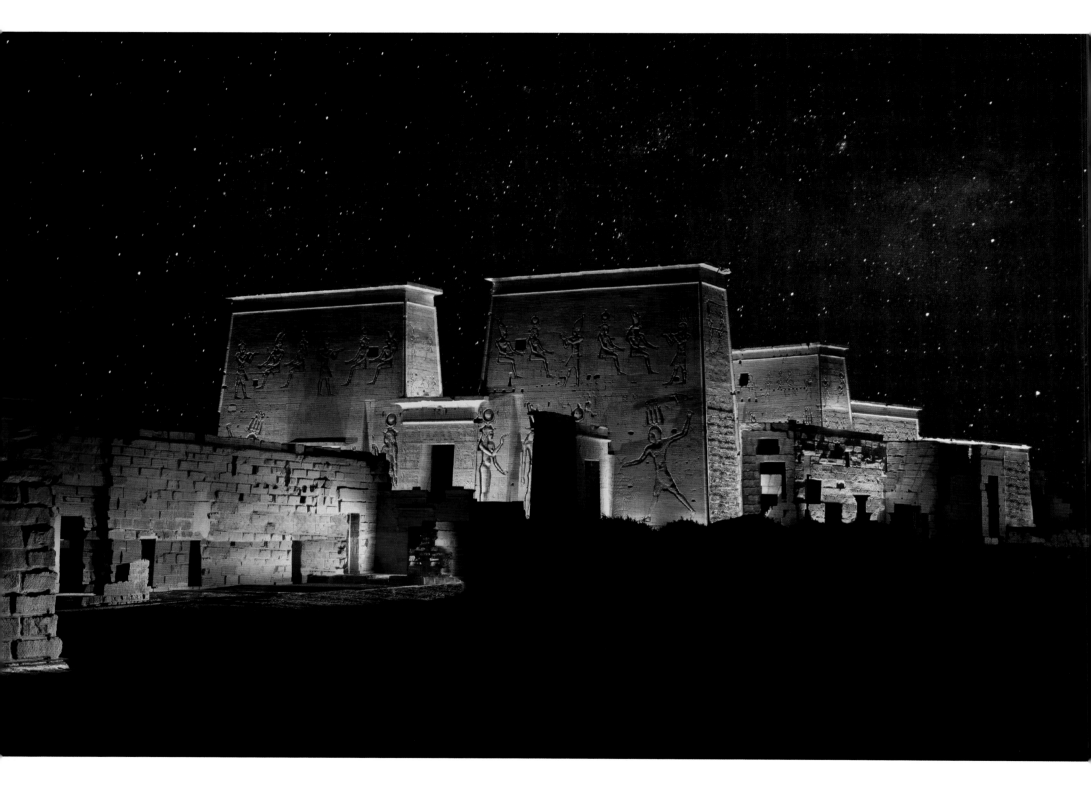

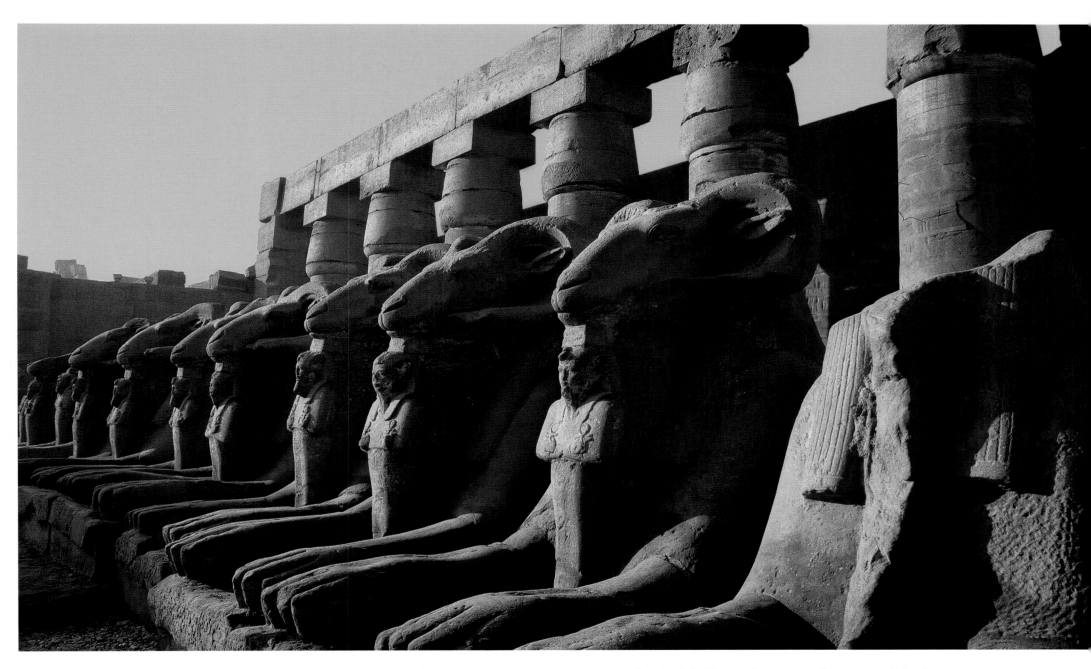

←—*Nubia* — Nighttime light show. Egyptian Temple of *Ast* (Isis) at Philae, built c. 350 BCE by the last Egyptian king, Dynasty 30. Aswan, Egypt, 2007

Kemet — Avenue of ram-headed sphinxes at the entrance to the 3,500-year-old Temple of *Amen*. The supreme divinity and protector of kings, *Amen* is often represented as a ram or ram-headed figure. Karnak, New Kingdom. East Bank, Luxor, Egypt, 2007

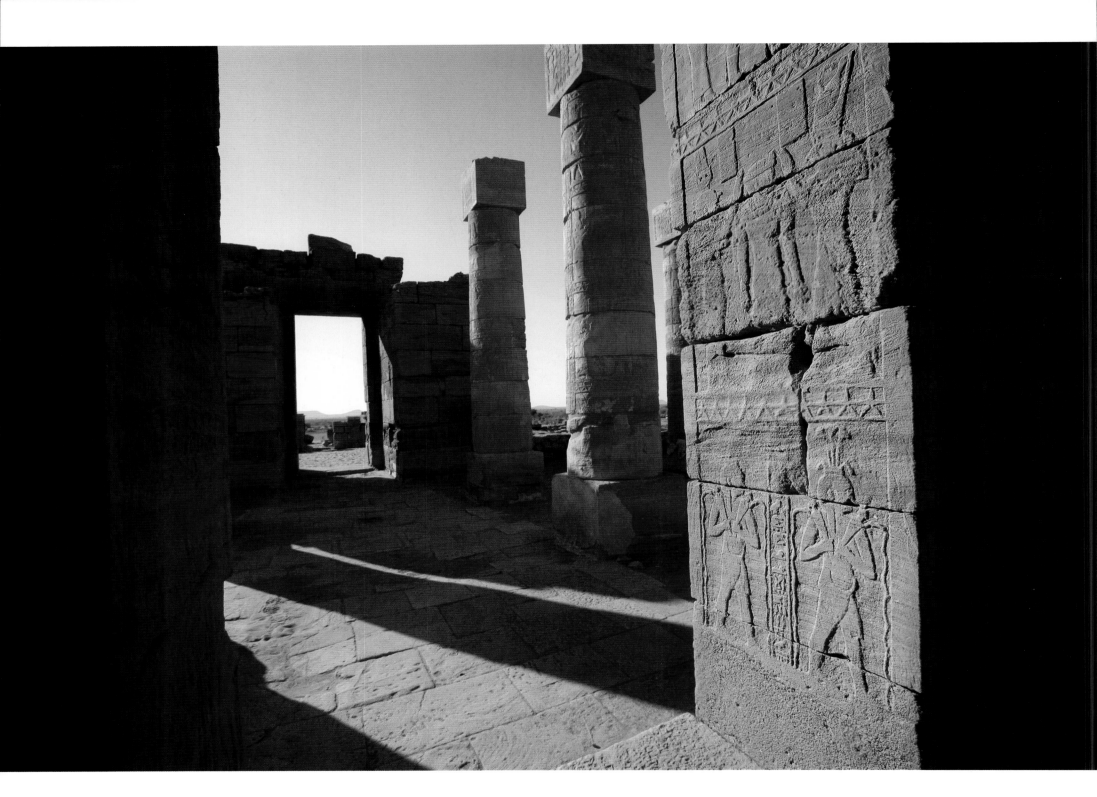

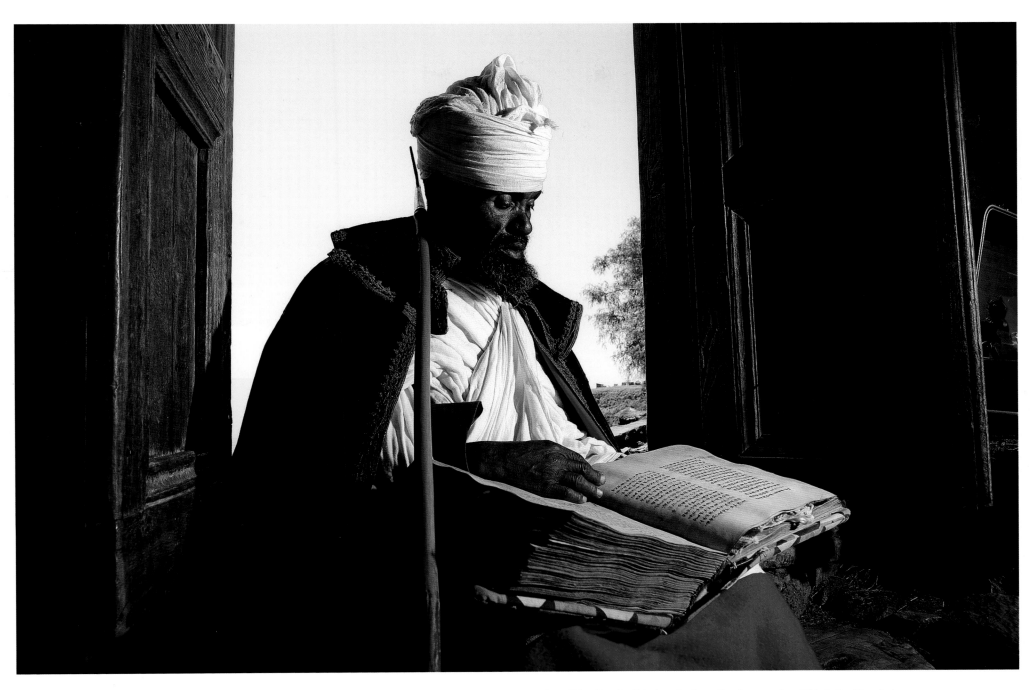

←— *Nubia* — Sun Court. Temple of *Amen*, Meroitic Period (300 BCE to 350 CE). Naga, Sudan, 2007

Priest of the Church of Naakute Laab reading from a vellum Bible in the Church doorway. Near Lalibela, Ethiopia, 2010

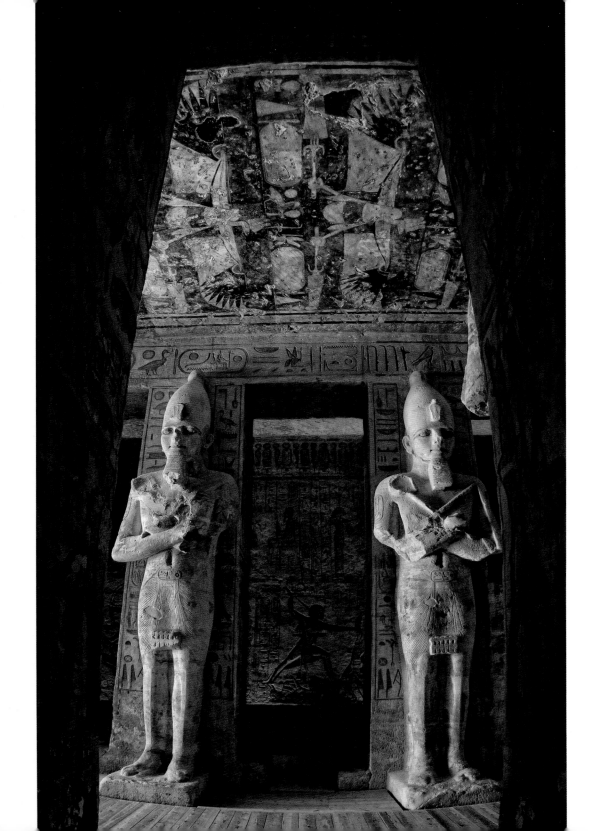

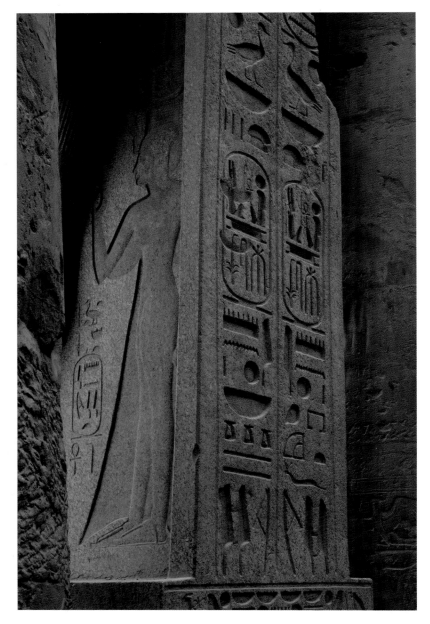

Kemet — The back of a statue of King Ramses II inside Luxor Temple Complex. East Bank, Luxor, Egypt, 2019

←*Kemet* — Interior of the Great Hall showing three-story statues of King Ramses II, Dynasty 19. Grand Temple of Ramses II (13th century BCE). Abu Simbel, Egypt, 2012

Kemet — Pylons of the front of the 1400 BCE Luxor Temple Complex, dedicated to the rejuvenation of the King and a focus of the annual *Opet* festival. East Bank, Luxor, Egypt, 2007 →

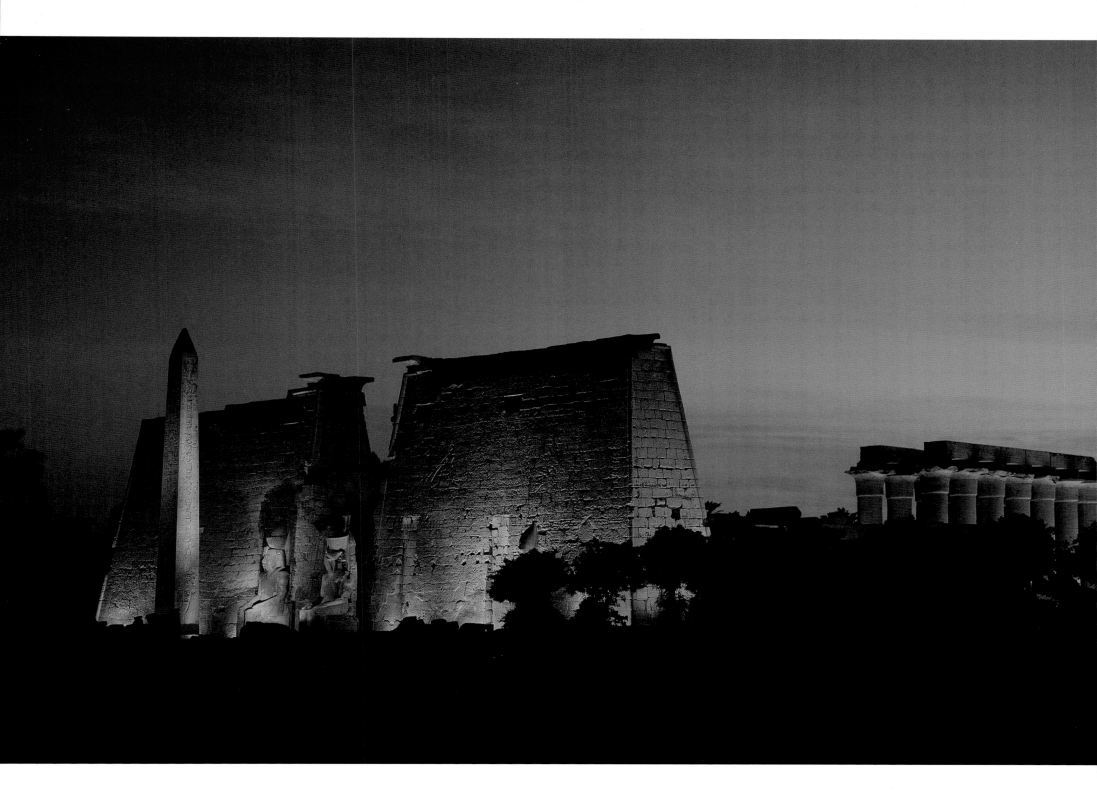

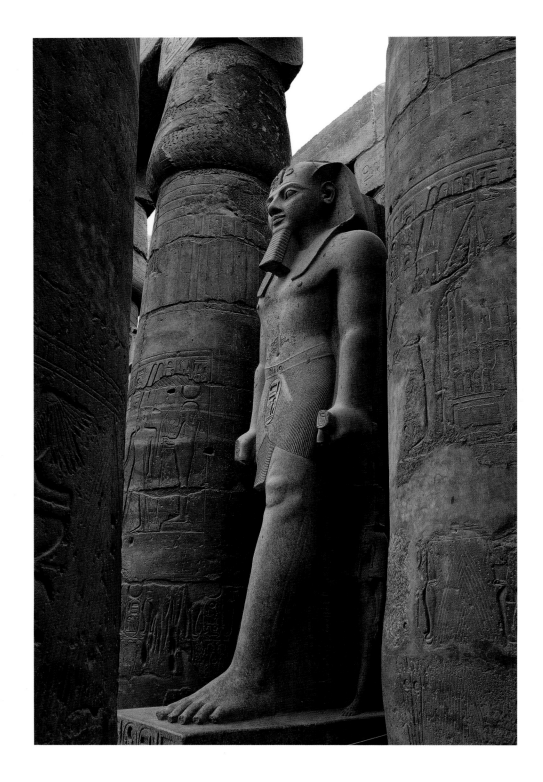

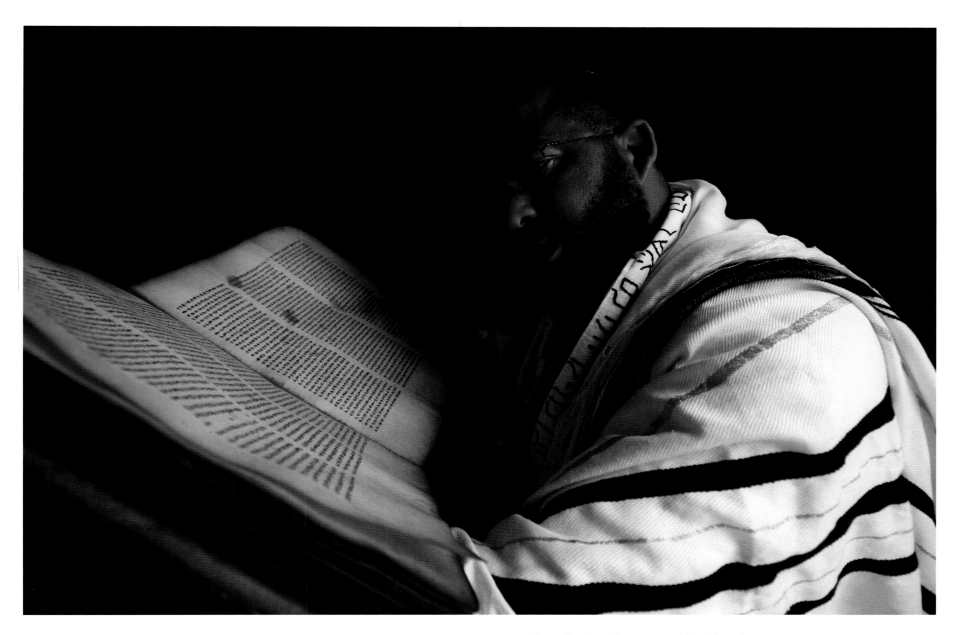

←·········*Kemet* — Entrance to the 3,300-year-old Mortuary Temple of Sety I. West Bank, Luxor, Egypt, 2007

←···· *Kemet* — Statue of a striding King Ramses II, Dynasty 19. Courtyard of the Temple of Luxor. East Bank, Luxor, Egypt, 2019

Kes (Rabbi) reading the Old Testament. Addis Ababa, Ethiopia, 2010

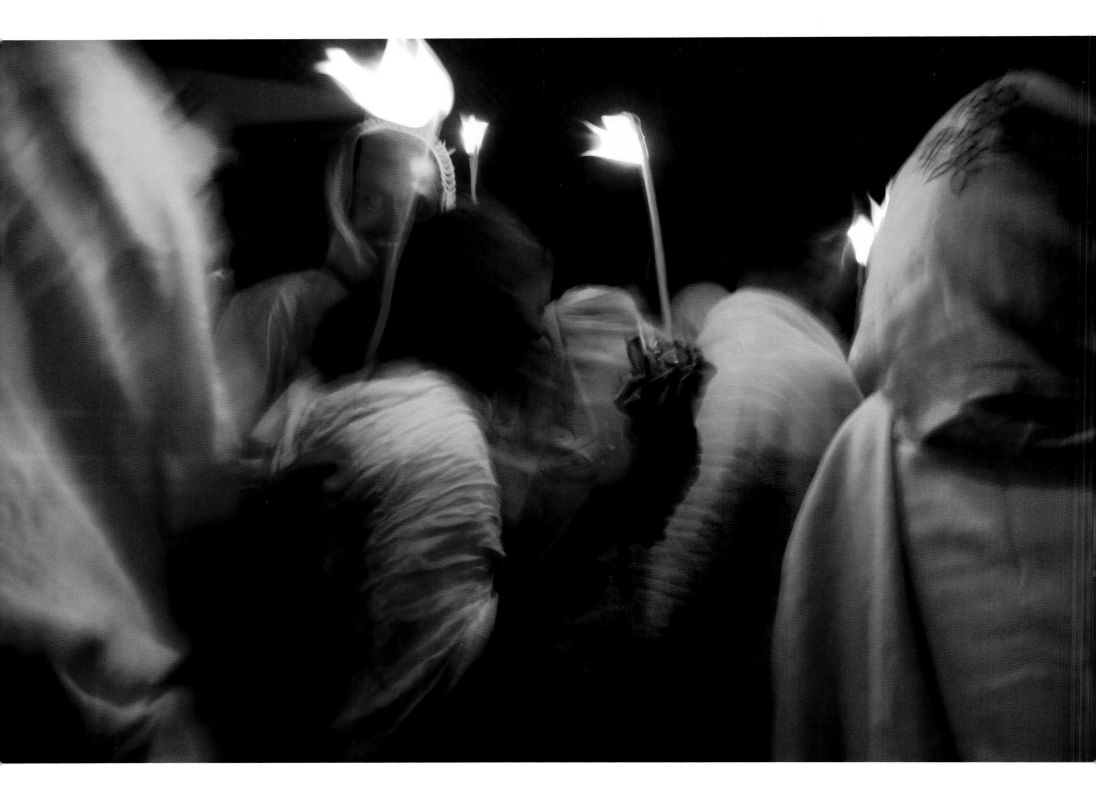

Drama of Ritual

Uncertainty and a desire for absolution drive the mystery of ritual.

The ancient land of Ethiopia is today shared by worshipers of *Waaqeffanna* (pronounced Wakafana), *Bete Israel* (House of Israel), Christianity and Islam. What all these Ethiopians have in common is a deep spiritual ardor that defines the daily life of faith inhabited by each group. Pilgrimages to sacred sites are an integral expression of spiritual life here. Worshipers from all across the country as well as neighboring nations, travel on foot, by bus, car and plane in order to assemble and commune in honor and expression of their faith. While sojourning, they stay with family, in improvised campsites and at guesthouses and hotels. It is humbling and at the same time deeply stirring to witness such passionate devotion in the chanting, praying, singing and processions of all of these believers.

Celebrating renewal

The most popular pilgrimage for worshipers of *Waaqeffanna* — the traditional Nature-centric spiritual religion of the Oromo people of Ethiopia takes place in Bishoftu at the *Oda* (sacred sycamore tree) beside the sacred lake *Hora Arsedi*. Pilgrims come to recognize their supreme deity *Waaqa* and honor the *Ayyaana,* the Divine Spirit in all existent beings and things. This *Erecha* festival marks the end of the major rainy season, a time of renewal and of offering thanks to *Waaqa* for the returning sun that activates a new season of growth. I describe my own experience at just such an *Erecha* festival in Chapter Three — Divine Nature.

Night procession for the annual November Festival of Saint Mary. Here celebrated at the Cathedral of Our Lady Mary of Tsion. Aksum, Ethiopia, 2011

Mecca in the Horn of Africa

In October, 2013, I joined East African pilgrims from all corners of Ethiopia and neighboring countries to witness a festival at the Tomb of Sheik Hussein, the 13th century Muslim holy man renowned for performing miracles and bringing Islam to southeastern Ethiopia. All told, several thousands of us were traveling to the Muslim Feast of the Sacrifice, a celebration of Abraham's willingness to sacrifice his son at God's command.

A winding dirt road delivers pilgrims — mostly in overflowing buses, in vans filled with families and some on foot — through the Bale Mountains to a remote section of eastern Ethiopia. Groups of pilgrims often sing litanies, said to be celebrating the Sheik's accomplishments. On account of his humility, generosity to the poor and miracles, he is known as a saint in Sufi Islam. Lush green rolling foothills — some dotted with coffee trees — were occasionally punctuated by protruding rock formations, remnants of long ago volcanic activity. We descended from the foothills to open plains that presented a vista with panoramic views of the Sheik's mausoleum sitting low on the plateau. Topped by a brilliant whitewashed dome, the burial structure is situated within a white-walled square enclosure with what look like stepped gables at each corner. The entire stucco complex, surrounded by another gabled whitewashed wall, sparkled against the wide expanse of clear blue sky. Many pilgrims carried the iconic forked staff, a replica of the one carried eight hundred years earlier by Sheik Hussein.

During this three-day festival in 2013 — culminating in the Feast of the Sacrifice — celebrants camped on every available patch of ground; we were easily 20,000 people. Sheep — the animal that Abraham sacrificed to God in lieu of his son — bleated from the tops of vehicles.

More sheep were herded in flocks along the dusty roads. In the sacred literature, Abraham is told by God to make a sacrifice of his only son to show his faithfulness. At the moment that Abraham is preparing to sacrifice his son, God presents him with a ram. The sheep that are sacrificed here become the feast for the pilgrims on Friday, after *Jummah* prayers. Although the Koran does not specify the sheep or ram as an animal chosen by God in lieu of his son, Muslims accept the word of the prophets — in this case Abraham in the Bible — that came before the Koran was revealed.

All around the village, large and small groups of the faithful established temporary outdoor set ups, cooking on open fires and eating together off communal plates. Early morning on the opening day of the festival, I left my tent to wander into the Sheik Hussein compound to find it already teeming with pilgrims. In a lingering mist, women fetched pails of holy water from a sacred pool within the compound. In front of the mausoleum, I joined a crowd inching toward the entrance, a clearance so low that it required all to bend at the waist to pass through the thick adobe entrance. Just before entering, many stopped to kiss the walls of the doorway. Directly inside there is a dramatic dome. Under the dome, six feet off the ground on a wooden platform, are the bones of the Sheik wrapped in coarsely woven pale burlap. The space is tight, with barely room for three people deep to shuffle inch by inch as they circle the sacred remains. Rays of light from slits in the ceiling caught the dust motes kicked up by the feet of men and women, some with children in tow, making reverential circuits. The aura inside the mausoleum is hushed and reflective. After completing my circuit, I returned outside and passed through the packed courtyard to another sanctified space where more pilgrims sat in silence, held candles and collected the dry earth, believing it to possess medicinal qualities. Along the side walls, raised benches provide respite for those who want to linger a few more precious moments in prayer or meditation. Sheik Hussein is revered as an intercessor, as evidenced by the numbers of pilgrims that collect the earth to rub on their bodies, swallow and bring home to remedy health issues.

At noon on the third day, the faithful assembled on a vast plain, forming east-facing lines for a final collective festival ritual — men on one side and women on the other. The women's side was a patchwork of color; the pilgrims — especially women — dressed in bright hues. Loudspeakers broadcast a ritual prayer, the *salat,* recited by an Imam. With that, all began reciting this prayer in unison. It is typically performed five times daily by believers. Prayer is perhaps the most important of the five pillars of Islam — of which the other four are faith, alms, fasting and pilgrimage. As I watched, the actions of individuals dissolved into a collective flow: worshipers stood, bowed, knelt and prostrated themselves and then finished in a kneeling position. After a few minutes of personal meditation, they dispersed.

Echoes in time

For Ethiopian Tewahedo Church Christians, the two-day festival of *Timkat* is the ritual reenactment of the baptism of Jesus Christ by John the Baptist. It is one of the most important and widely celebrated Christian festivals. The faithful congregate for *Timkat* right after mid-January in locales near water sources. *Timkat* in Lalibela, Aksum, and Gondar attracts thousands of pilgrims.

Every Church sanctuary in Ethiopia houses a *tabot,* or replica of the Ark of the Covenant. Ethiopians maintain that the original Ark of the Covenant, housing the stone Tablets of Law that Moses received from God, resides permanently under guard in Aksum in The Treasury nearby the Cathedral of St. Mary of Tsion. *Timkat* rituals take place at a water source that is sanctified by the presence of all the Church *tabots*. I imagine these rituals have changed little since the 4th century CE when Aksumite King Ezana converted to Christianity, abandoning the Nature faith of his ancestors, and proclaiming Christianity the state religion.

I chose to witness *Timkat* in 2016 in Gondar, one of the most popular locations. *Timkat* processions come together in Gondar at the large pool of water (filled annually for the celebration) surrounding the Bath of Emperor Fasiladas, who ruled Ethiopia in the 1600s.

Congregations from about ten local churches were there that year. Jubilant figures danced down streets strewn with the green grass that signifies renewal. Ritual processions of priests, in heavily embroidered vestments and shaded by huge colorful traditional umbrellas, were accompanied by their church congregations and more pilgrims. Atop the head of the High Priest from each church was perched the precious *tabot,* shrouded in brocade. Buoyed by drumming, ululating, singing, horns, sistrums (percussion instruments) and incense from smoldering censers, the celebrants fused into a swirl of boisterous, unfettered joy. Before the clergy of the various Gondar churches, young men laid down red rugs, one and then another, repeatedly, for the priests to step on as they marched through the city.

At the close of the first day, the High Priests paraded single file with the *tabots,* held aloft, back and forth a few times across the narrow bridge that leads to the Bath House. In the glow of the setting sun, this pageantry became mystical. The adoring crowd around the pool pulsed with pushing and shoving for sight lines until the priests crossed for the final time as the light began to fade. The priests entered and secluded themselves in the Bath House. The *tabots* were kept overnight in the presence of the clergy. Pilgrims maintained vigil all night — sleeping on the ground under the stars — around the water outside the Bath House, while the clergy within celebrated the Divine Liturgy. At dawn, priests came out of seclusion to begin the ceremony to bless the water in the pool; after about an hour of ritual, a designated High Priest descended the steps of the pool to touch the water with his processional cross, triggering the reenactment of Christ's baptism. Enthused by a background of more ululating, clapping and singing, the faithful leapt into the water, a few feet deep, their splashing limbs shattering the placid surface. Some pilgrims reached in to fill bottles with this holy water.

By mid-afternoon most of the *tabots* began their solemn journey back to their church's inner sanctums once again. The day following *Timkat* is another grand annual festival, dedicated to St. Michael, which also happens to commemorate the first miracle of Christ at the wedding in Galilee. At the end of the third day, the St. Michael *tabots* which had stayed behind also made their journey back to their respective churches. Every time a *tabot* is removed or returns to its church, the High Priest circles the church three times with the *tabot* on his head, to the accompaniment of the ululating congregation.

The Ethiopian Tewahedo Church has a full calendar of holy days; in fact, every single day of the year is dedicated to two, three or even more saints. Four days of every month — the 1st, 3rd, 16th, and 21st — are dedicated to the Virgin Mary. The Archangels Michael and Gabriel have the monthly 12th and 19th dates dedicated for them respectively. Saint George's Day is on the 23rd, while that of the Savior of the World (*Medhane Alem*) is on the 27th. Each church celebrates its particular patron saint every month. Apart from *Timkat, Maskal* (The Finding of the True Cross), *Liedeit* (Christmas) and *Fasika* (Easter) are also resplendent religious festivals.

Yesterday, today and tomorrow

The pageantry of *Timkat* echoes the joyous celebration that was the *Opet* Festival as depicted on ancient temple walls in Luxor, Egypt. Although the two festivals happened at opposite ends of the Nile separated by millennia, there are remarkable similarities. Rejuvenation is a theme found in both. In *Kemet*, the monarch represented the divine authority of *Amen* on earth to the people. During *Opet*, priests are visible — on the walls of the Red Chapel of Hatshepsut in the Karnak Temple and of the Luxor Temple — in ritual procession bearing chests with sacred statues of the Holy Family of *Waset*: the supreme deity *Amen* with his consort *Mut*, and their son *Khonsu*. The sacred statues concealed inside the chests are brought out from their shrines in the inner sanctum and travel on a sacred wooden boat, called a bark, carried by priests aloft on their shoulders. Images in both Temples show processions ferrying the chests through the mile-and-a-half avenue of human-headed sphinxes lined with revelers. For the rejuvenation ceremony of *Opet,* the Holy Family sacred statues take up temporary residence in the Temple of Luxor. *Opet* was held at the New Year when the Nile flooding was at its

height. Just as the water brought renewed life to the land, this festival is believed to have re-energized the monarch's powers.

In contemporary Ethiopia, the *Timkat* ceremony rejuvenates the spirit of people through the sacred ritual of Baptism. The High Priest transports his church's sacred *tabot* — wrapped in brocade cloth — on his head through streets, teeming with boisterous revelers, to join with other priests and *tabots* at a water source. Huge, colorful ceremonial umbrellas held aloft over the heads of Priests during *Timkat* mirror the graceful ostrich feather fans that seem to float above *Opet* Priests in temple art. For *Opet* processions, we see representations of musicians, singers, dancers and ecstatic pilgrims. For *Timkat* ritual processions, we see and hear musicians including drummers, horn blowers and sistrum shakers, dancers and, of course, wildly enthusiastic pilgrims. Images of the sistrum, a percussion instrument fundamental to both ancient *Opet* and modern *Timkat* celebrations, are depicted on temple and tomb walls in *Kemet*. Both the ancient and modern rituals commemorate their religions' most sacred icons — brought out on these exceptional highly anticipated occasions to be venerated in public by the faithful.

The People of Moses

Ethiopia was mostly unknown to the Western world until 1790 when Scottish adventurer James Bruce published *Travels to Discover the Source of the Nile,* including a map of the country. This book introduced the West to Ethiopia and its many religious faiths, including that of Hebrews, called *Bete Israel or* House of Israel.

In 2002 on a visit to Gondar, Ethiopia, I sought to photograph a community of *Bete Israel*, in their temporary synagogue on the outskirts of the city. This was my first visit with Ethiopian Hebrews, people I had read about in the Bible but assumed no longer existed in Ethiopia. This group of *Bete Israel* was awaiting transport to Israel as part of Operation Solomon (the Israeli government airlift transporting Ethiopian Hebrews who wanted to migrate to Israel). Lisa Schachner of South Wing to Zion was helping to facilitate this mass airlift and expedited permission for me to meet the families.

In this makeshift enclosed space under a corrugated zinc roof, roughly five hundred people were gathered. The women wore traditional Ethiopian white cotton dresses. Against the chill of the afternoon, they wrapped themselves in the thick classic white cotton shawls called *shammas*. The men, mostly in drab western garb with a mix of white, blue and red skullcaps, also wrapped themselves in thick white *shammas*. Men and women sat apart, as they do in all Orthodox faiths practiced in Ethiopia. Congregants faced a dais where *Kessim*, or Rabbis, offered prayers, sang songs and bowed to the Torah. At the close of these rituals, six *Kessim* circled the entire congregation from the dais around and back to the front. A *Kes* (Rabbi) carried a Torah, concealed in an elaborate velvet sleeve. An image of a crown was embroidered on the sleeve above a representation of the Tablets with numerals to denote the Ten Commandments. Another *Kes* held a second Torah encased in a simple gold and green sheath.

In 2011 and again in 2016, I visited Ethiopia's capital and largest city Addis Ababa and headed into the Kechene neighborhood to meet with a group of Ethiopian Hebrews. The International Israelite Board of Rabbis, New York City, facilitated my introduction to this community. These individuals had chosen to remain in their country of birth instead of relocating to Israel.

I have heard at least two accounts of the history of *Bete Israel*. For one, the Bible mentions King Solomon of Israel and the Ethiopian *Kandake* (Queen) Makeda, known as Sheba. The Ethiopian *Kebra Nagast,* or *The Glory of the Kings,* an epic account thought to have been written in the 14th century CE, expands this narrative. In it, the *Bete Israel* are said to be descendants of the sons of high priests from Solomon's Israel, who in 10th century BCE accompanied Menelik — himself said to be the son of Solomon and Sheba — when he returned to Ethiopia after visiting his father King Solomon in Jerusalem. Menelik is credited with founding the Solomonic Dynasty of Ethiopia. The *Bete Israel* individuals with whom I spoke in Addis Ababa reject this account. They shared with us their oral history,

according to which, they believe their people migrated through Elephantine Island in southern Egypt along the River Nile to northern Ethiopia. Historical documentation from papyri discovered at Elephantine Island attest to a Hebrew community, existing from around the 6th to the 4th century BCE, thought to have been attached to a mercenary army protecting Egypt's southern border. Historians presume this garrison may have supported invading Persians, resulting in the local population rioting against the community; perhaps this hostility precipitated a migration south. As yet, there is no documentation showing how, or even if, the *Bete Israel* came through Egypt. Perhaps one day new discoveries will confirm their belief.

A Most significant moment

In 2011, I was thrilled to accompany a small *Bete Israel* congregation to the 10,500-foot high Mount Entoto on the outskirts of Addis Ababa for a partial celebration of *Sigd*. *Sigd* is the *Ge'ez* word for prostration. (*Ge'ez* is the ancient classical language of Ethiopia and today the main liturgical language of the Ethiopian and Eritrean Tewahedo Orthodox Churches and the *Bete Israel* community.) This rite gives honor to Moses receiving the Ten Commandments from his God at the top of Mount Sinai. A country of rugged landscapes with towering peaks, Ethiopia offers ideal locations for reenacting this narrative.

That afternoon on Mount Entoto, I photographed *Bete Israel* men, women and children, bundled in *shammas* against the chill wind, absorbed in listening to their *Kes* read passages from the Torah at the top of the mountain. This singularly unique Ethiopian commemoration ritualizes a seminal moment in Hebrew history and its observance keeps that memory alive.

Sacred Water

Sacred pool. The 800-year-old Tomb of Sheik
Hussein. Bale Mountains, Ethiopia, 2013

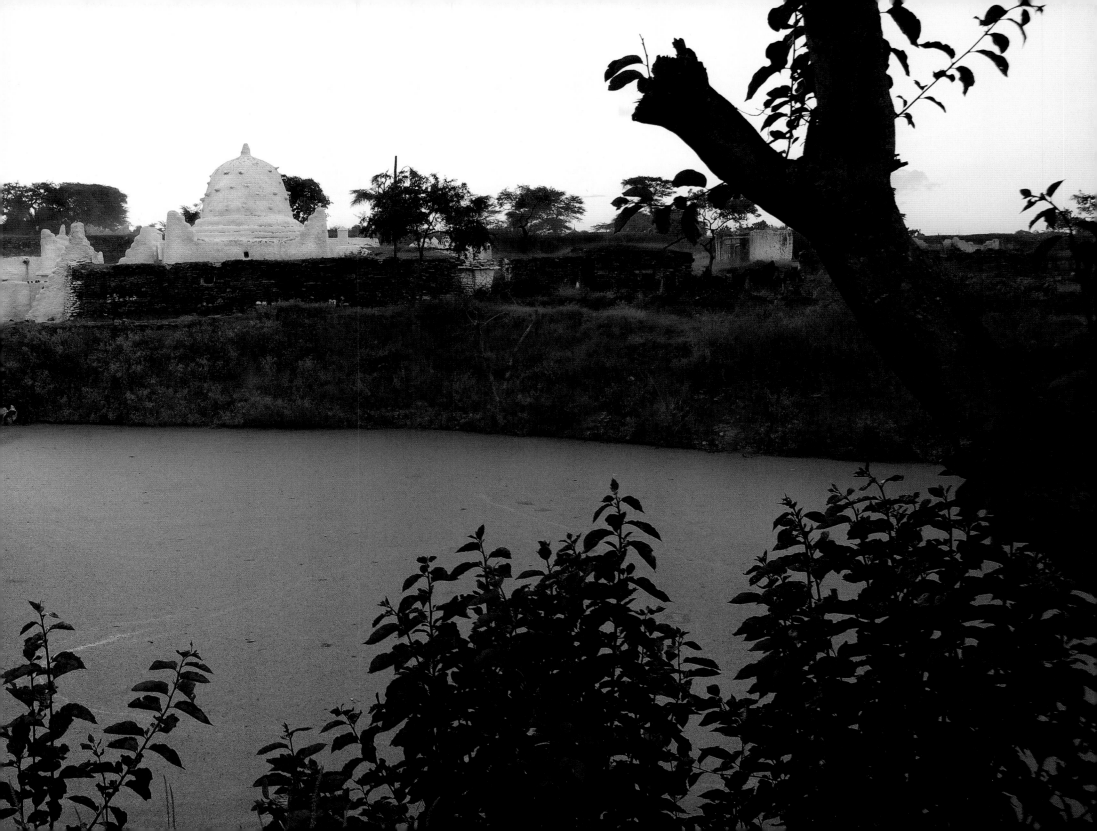

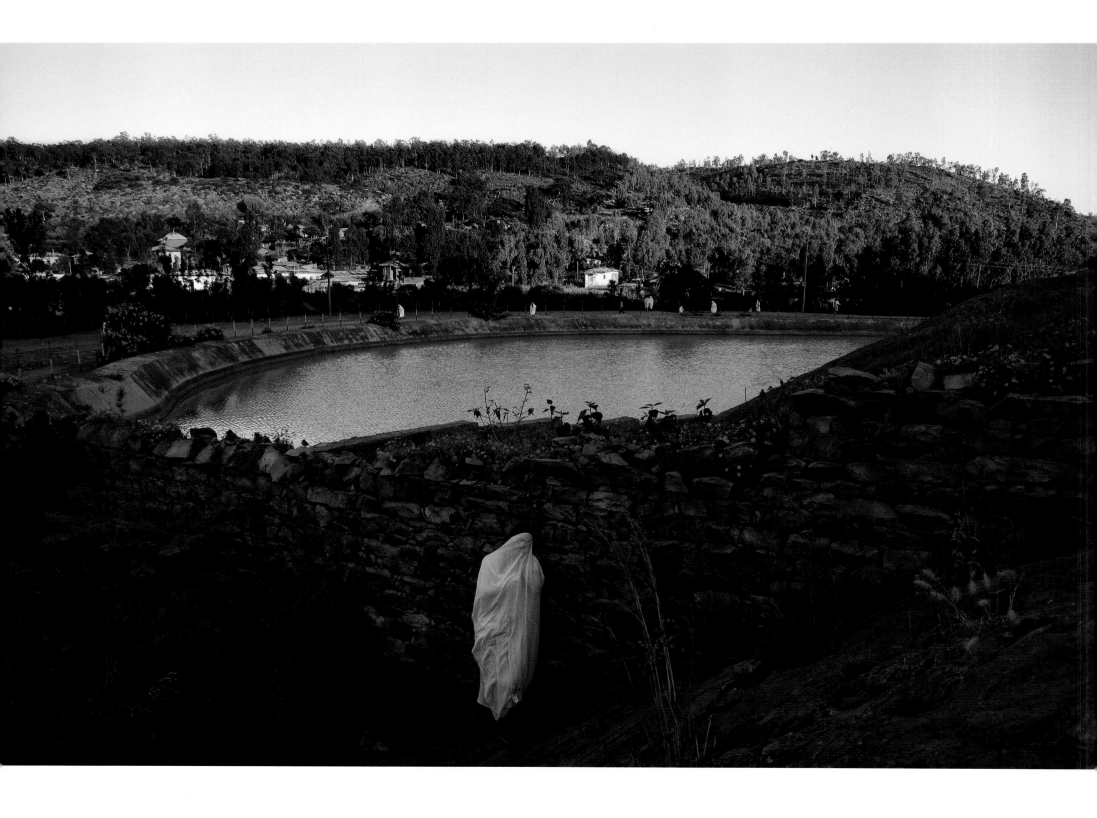

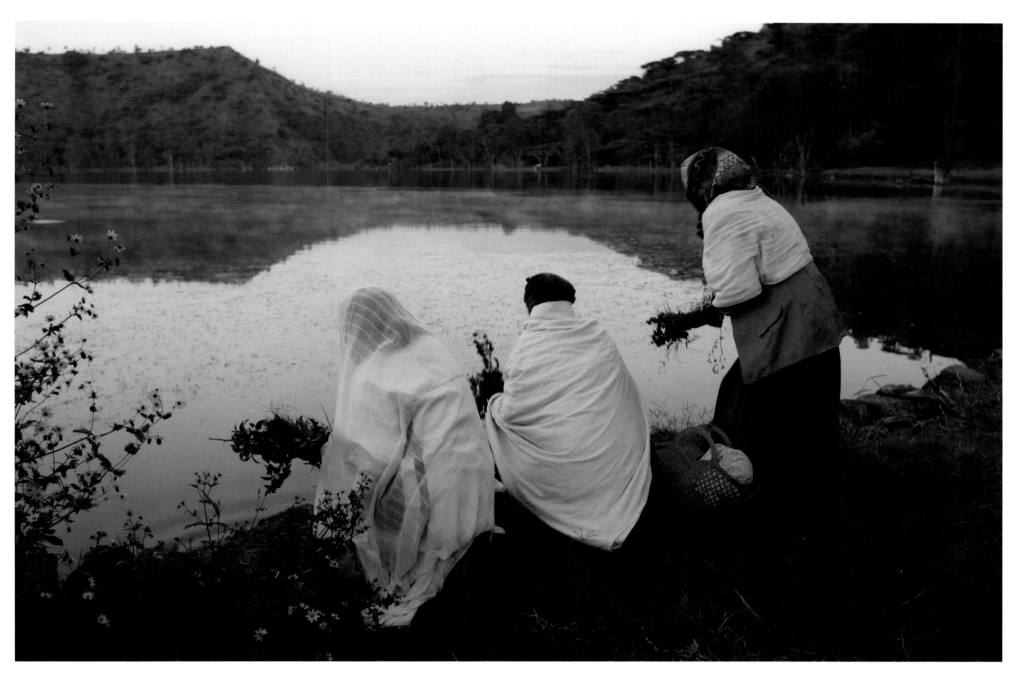

←—Christian pilgrim outside an ancient reservoir — the focus of the Baptism ceremony for *Timkat* in Aksum — and which is sometimes referred to as the Bath of Sheba. Aksum, Ethiopia, 2010

Making offerings beside sacred *Hora Arsedi*. *Erecha* celebration. Bishoftu, Ethiopia, 2001

Celebrating Renewal: *Opet* and *Timkat*

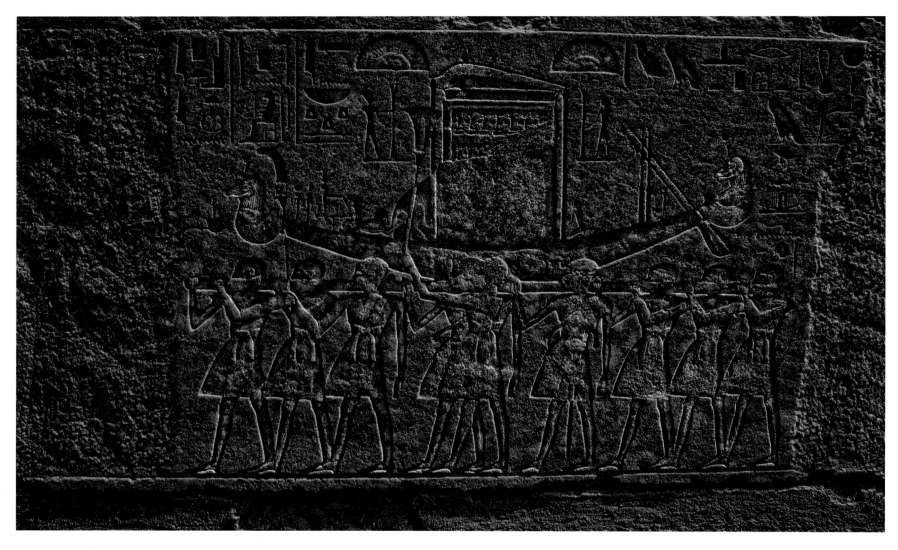

Kemet — Bas-relief of Priests carrying a bark on their shoulders. Inside the bark's cabin were hidden statues of the Holy Family of *Waset* (Luxor). Red Chapel, Sanctuary of Queen Hatshepsut, Dynasty 18. 14th century BCE *Amen* Temple, Karnak. East Bank, Luxor, Egypt, 2001

Renewal is the central theme for the Festivals of *Opet* observed 3,600 years ago in *Kemet* and *Timkat* celebrated in contemporary Ethiopia. *Opet* Priests brought the three members of the Holy Family of *Waset* (*Amen*, his consort *Mut*, and their son *Khonsu*) in their barks from the *Amen* Temple of Karnak to the Temple of Luxor for an annual ceremony to regenerate the King's power. Images show ostrich feather fans and the procession of priests.

Priests carry *tabots* (replicas of the Ark of the Covenant), enshrouded in brocade, on their heads to a water source. *Timkat* festival. Gondar, Ethiopia, 2016 —>

For *Timkat* (celebrating the baptism of Jesus Christ by John the Baptist), Ethiopian Tewahedo Church High Priests transport their Church's *tabot* (a replica of the Ark of the Covenant given to Moses by God) to a nearby water source in order to reenact Christ's baptism. This ritual represents a symbolic spiritual renewal of the people. Traditional umbrellas held aloft over the heads of priests during *Timkat* mirror the graceful ostrich feather fans that seemed to float above *Opet* priests. For *Opet* processions there were musicians, singers, dancers and ecstatic pilgrims; *Timkat* processions feature musicians, including horn blowers and sistrum shakers, and dancers plus wildly enthusiastic pilgrims.

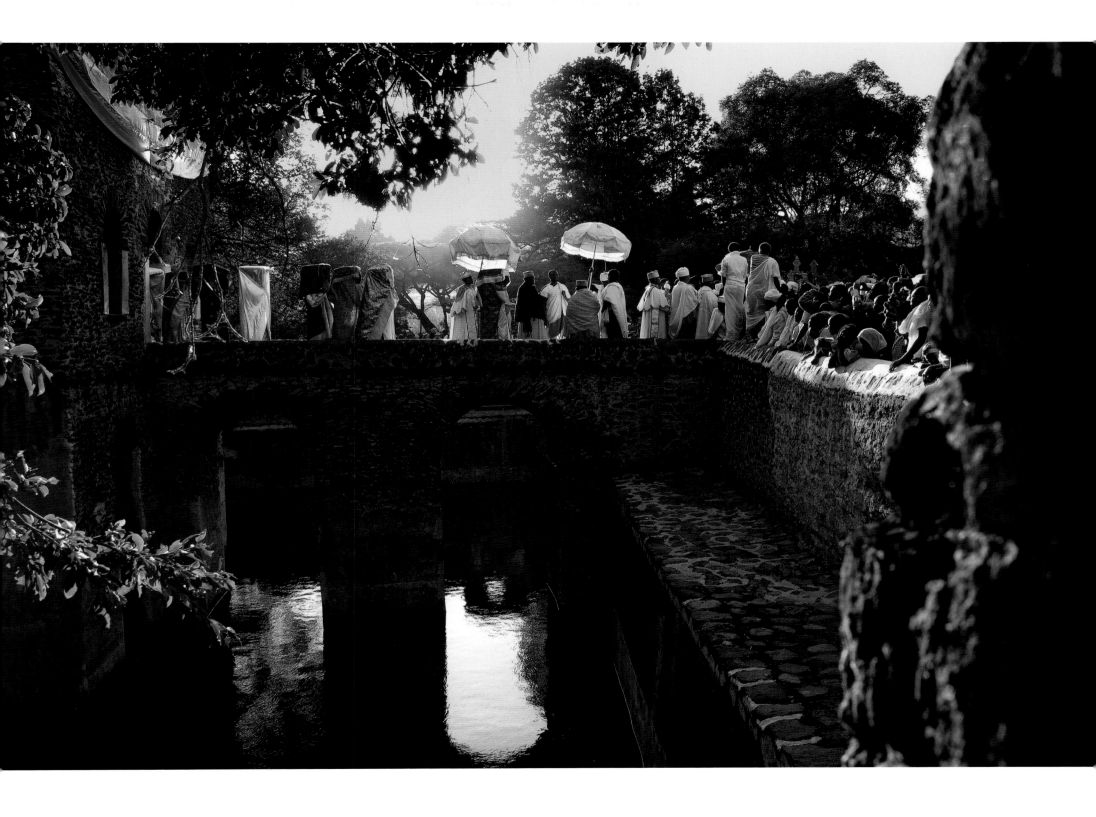

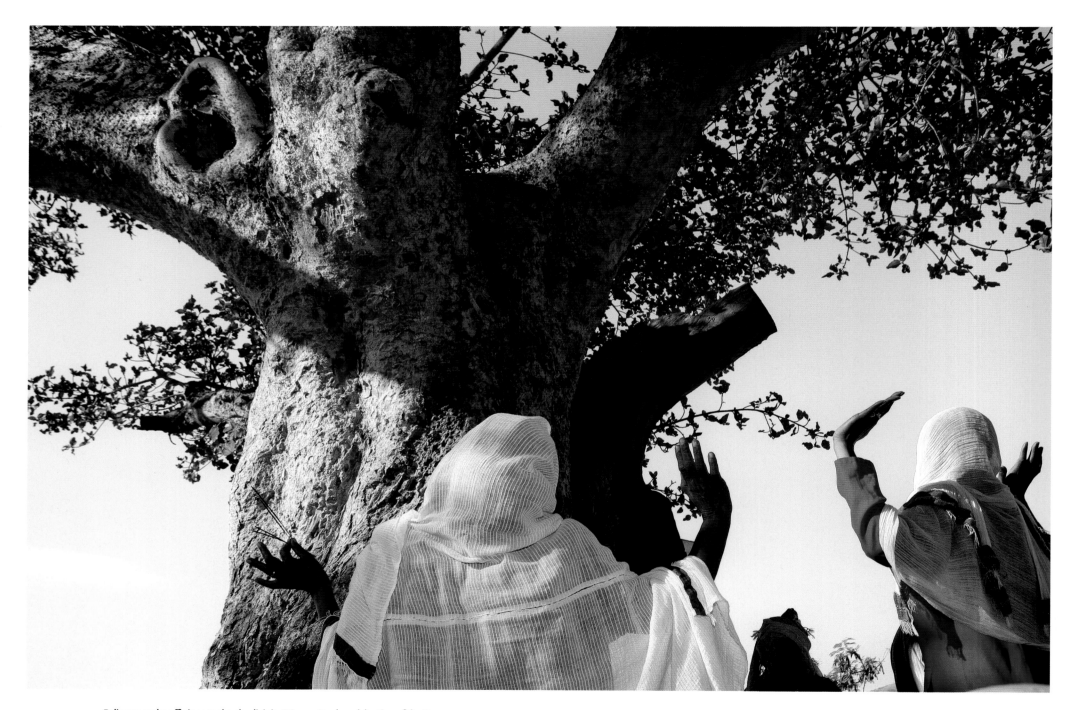

Believers make offerings to the sky divinity *Waaqa*. *Erecha* celebration of the Oromo people. Bishoftu, Ethiopia, 2010

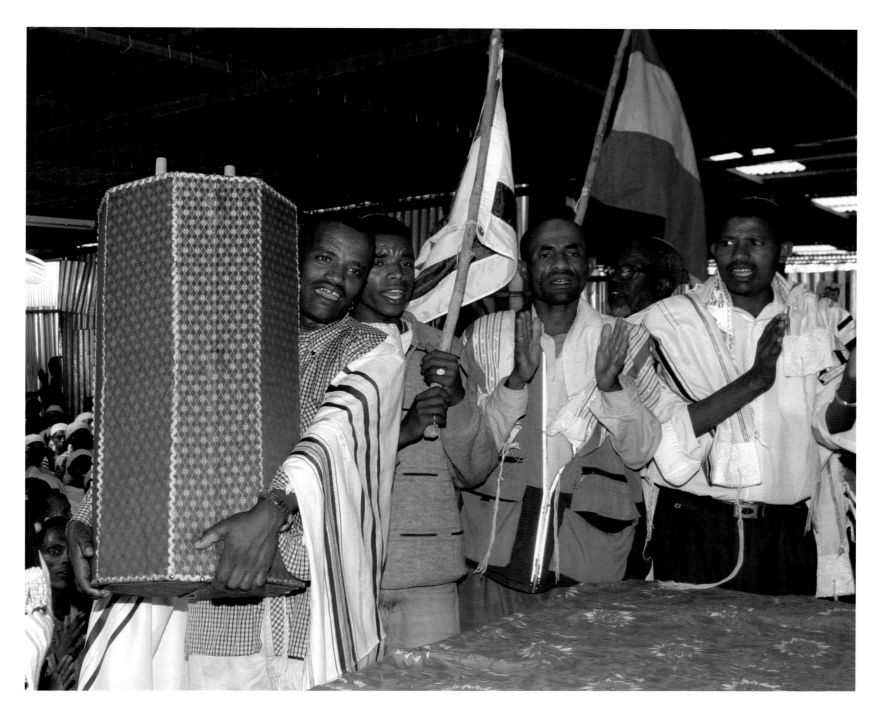

The Torah contains The Five Books of Moses —- the core of the Hebrew faith. The
Procession of the Torahs (Simka Torah). Ha Tikvah Synagogue, Gondar, Ethiopia, 2002

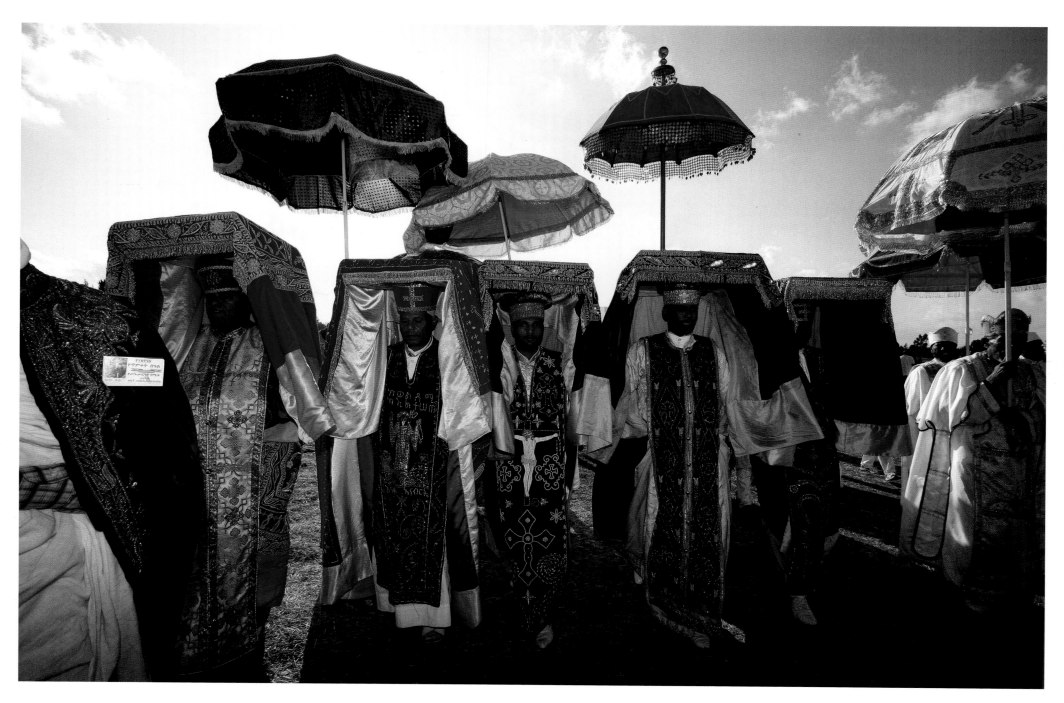

Priests carry their churches' *tabots*, enshrouded by ornate brocade. *Timkat* procession. Addis Ababa, Ethiopia, 2006

Bete Israel pilgrim. Addis Ababa, Ethiopia, 2011 ⟶

Waaqeffanna elder. Yabello, Ethiopia, 2011 ⟶

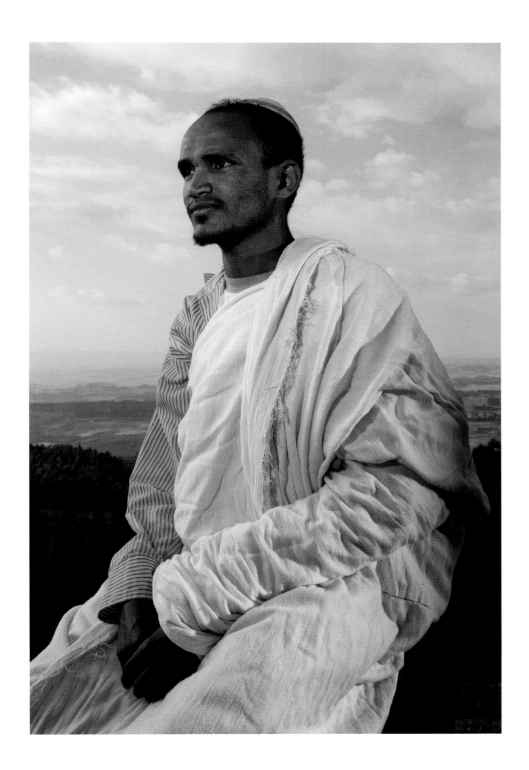
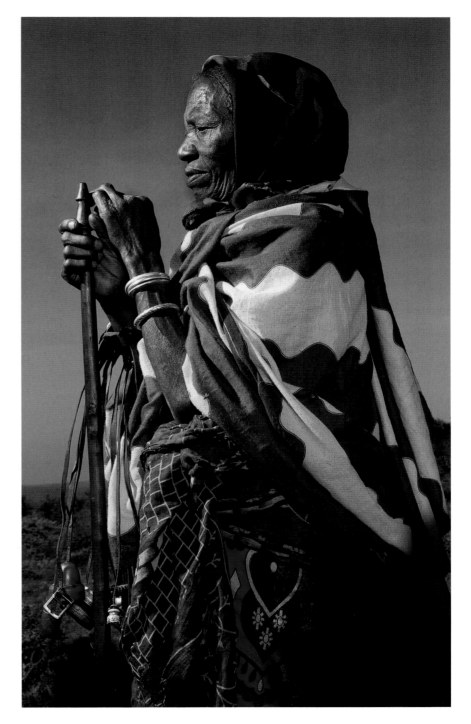

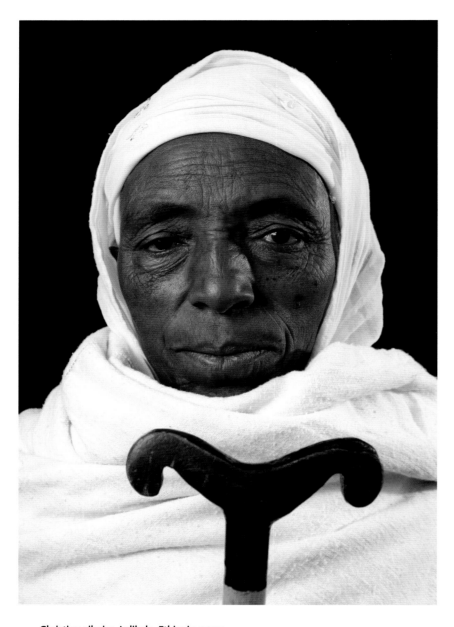

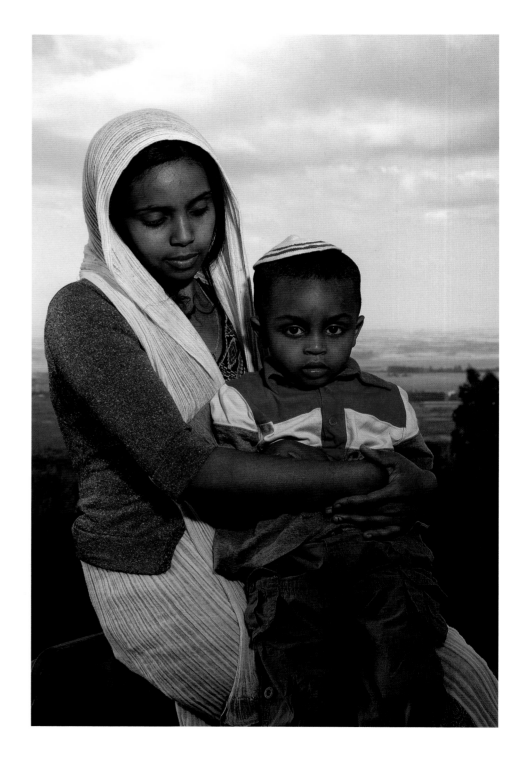

Christian pilgrim. Lalibela, Ethiopia, 2009

Bete Israel pilgrims. Addis Ababa, Ethiopia, 2011 ⟶

Muslim pilgrim. Afar region, Ethiopia, 2011 ⟶

Christian pilgrim. Lalibela, Ethiopia, 2009 ⟶

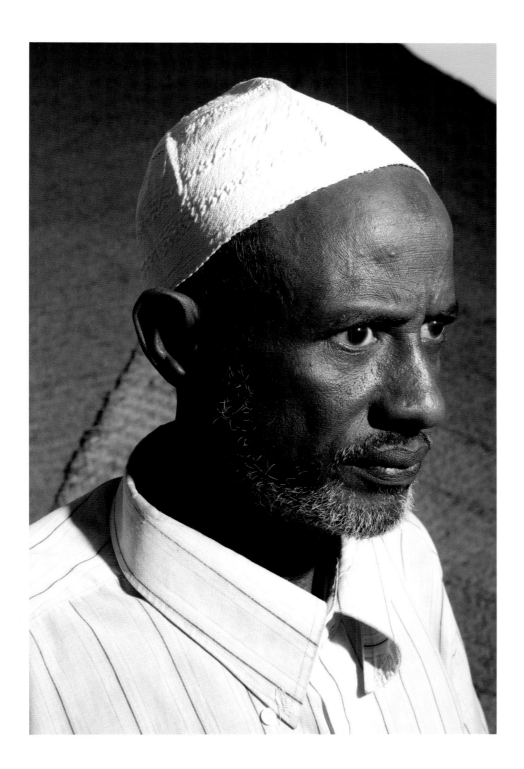
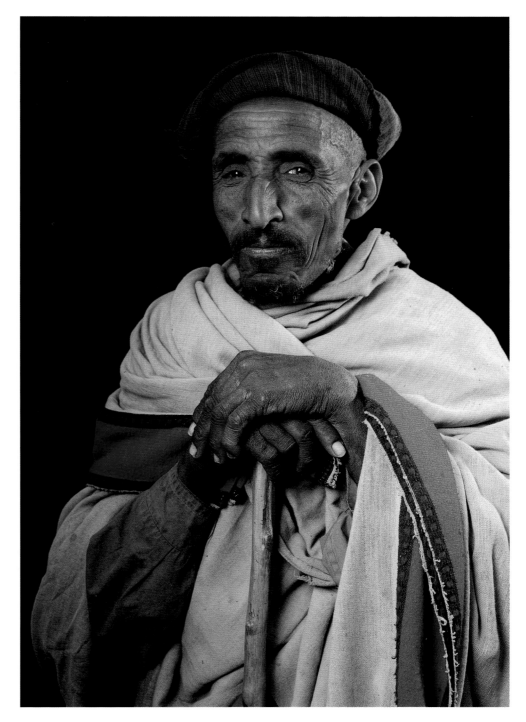

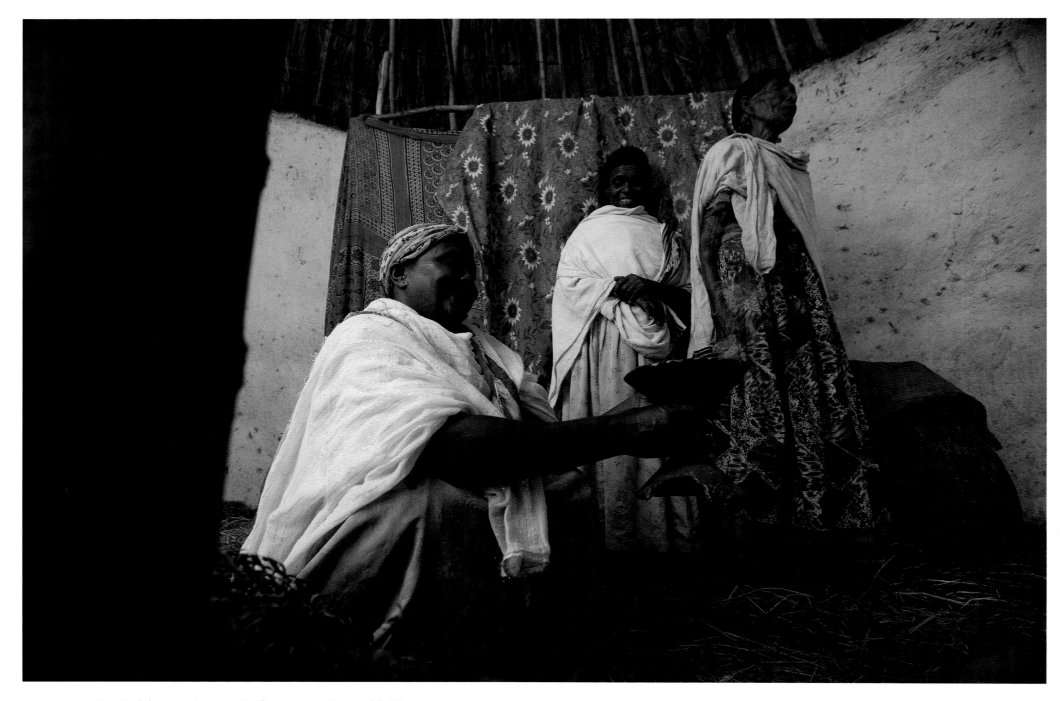

Roasting *kolo* (grains) in preparation for a ceremony. Temple of the Woman.
Bishoftu, Ethiopia, 2007

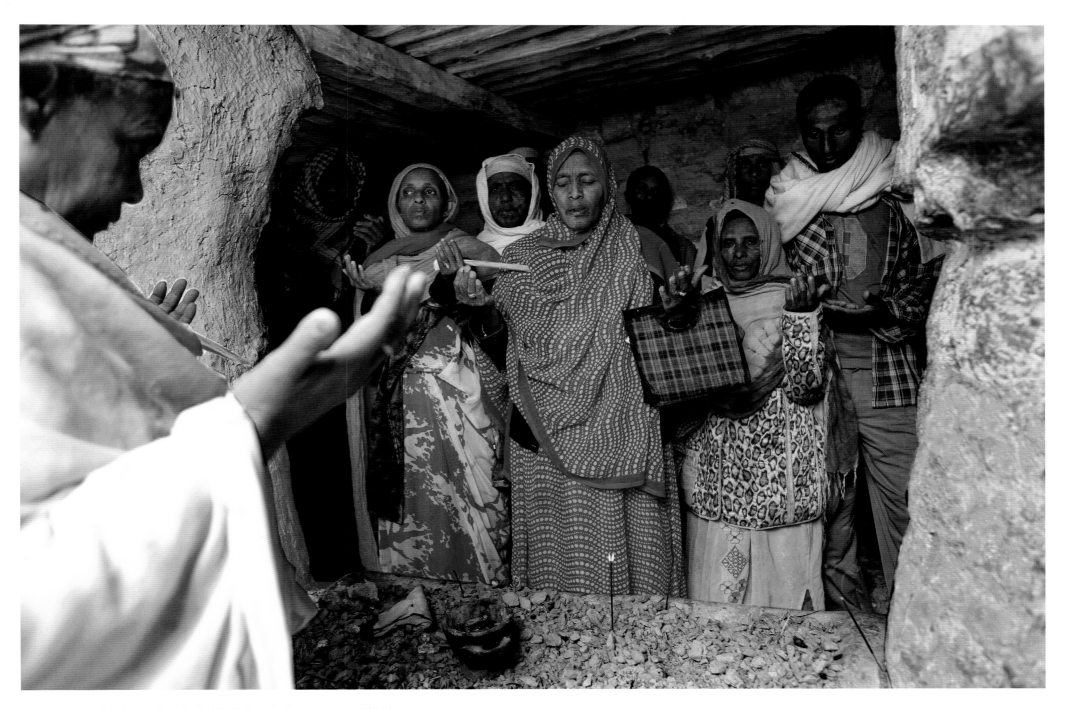

Pilgrims praying. Tomb of Sheik Hussein. Bale Mountains, Ethiopia, 2013

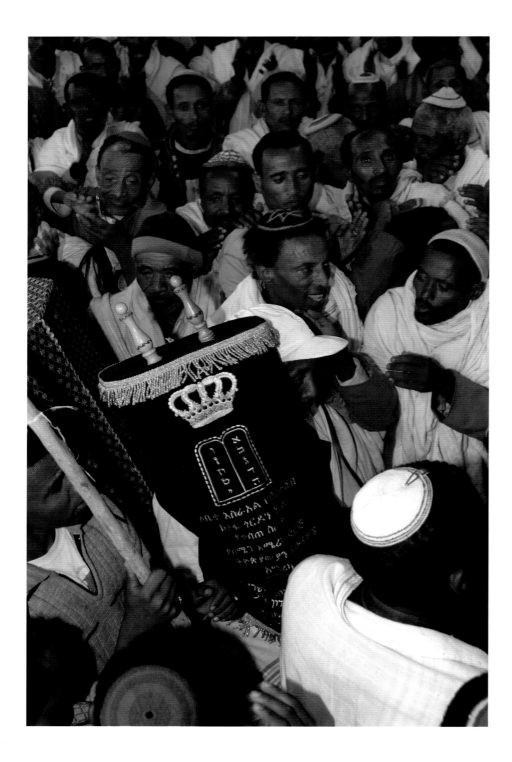
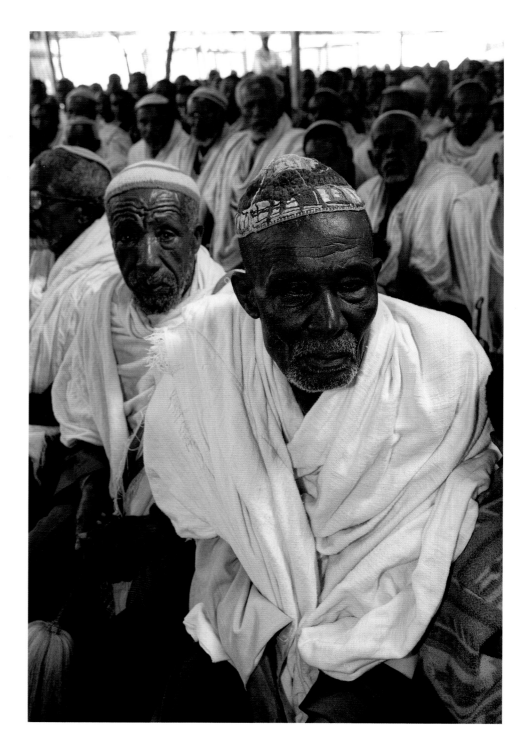

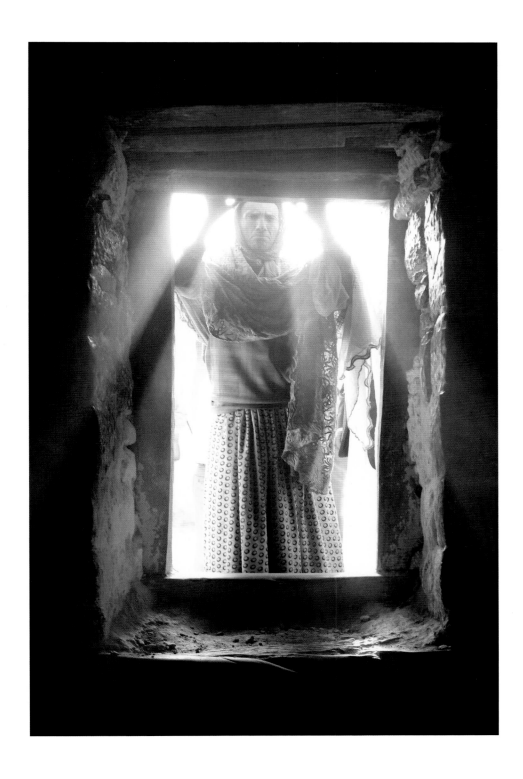

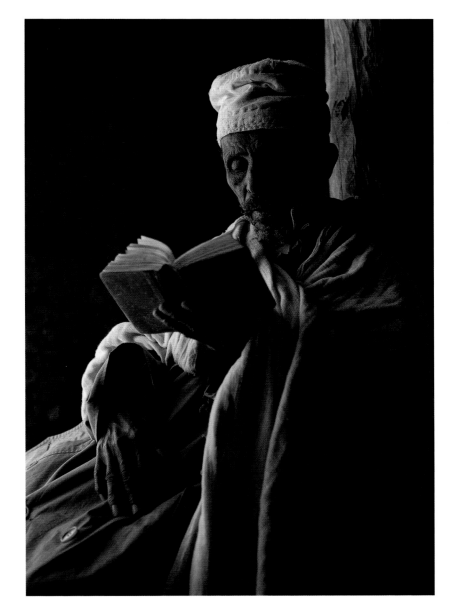

Pilgrim. Debre Damo Monastery. Ethiopia, 2011

←———— Celebrating Simka Torah. Ha Tikvah Synagogue. Gondar, Ethiopia, 2002

←——— Congregants. Ha Tikvah Synagogue. Gondar, Ethiopia, 2002

←— Pilgrim. Tomb of Sheik Hussein. Bale Mountains, Ethiopia, 2013

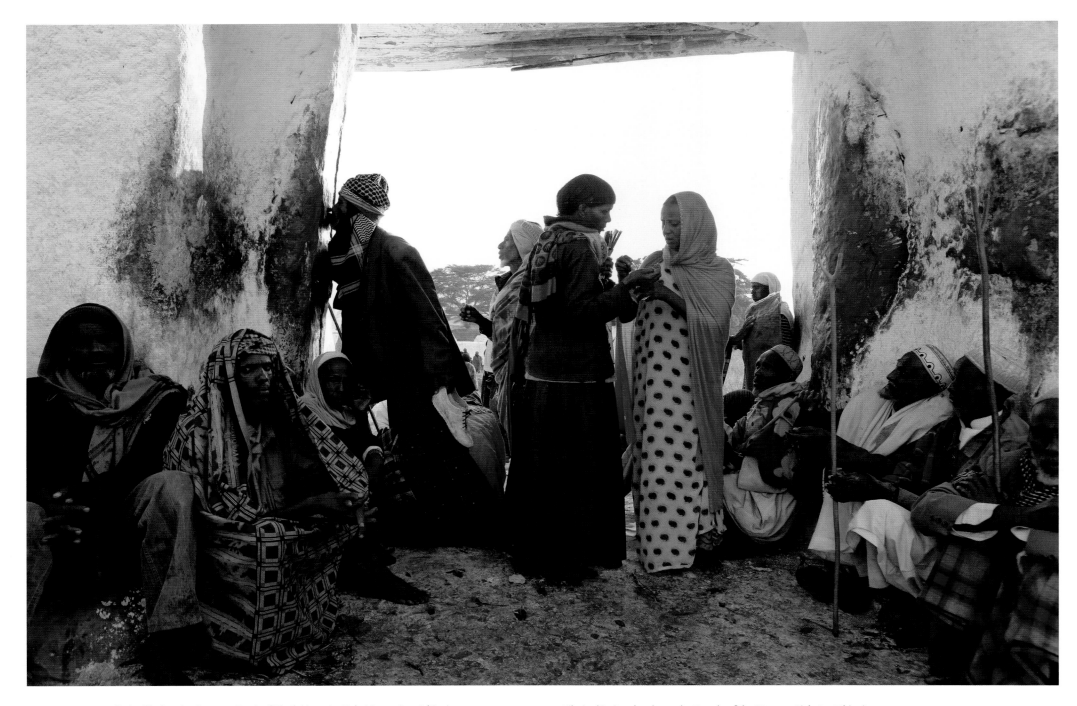

Pilgrim kissing the doorway. Tomb of Sheik Hussein. Bale Mountains, Ethiopia, 2013

Pilgrim kissing the altar pole. Temple of the Woman. Bishotu, Ethiopia, 2007 ⟶

Pilgrims. *Bete Medhane Alem* (Church of the Savior of the World). Lalibela, Ethiopia, 2009 ⟶

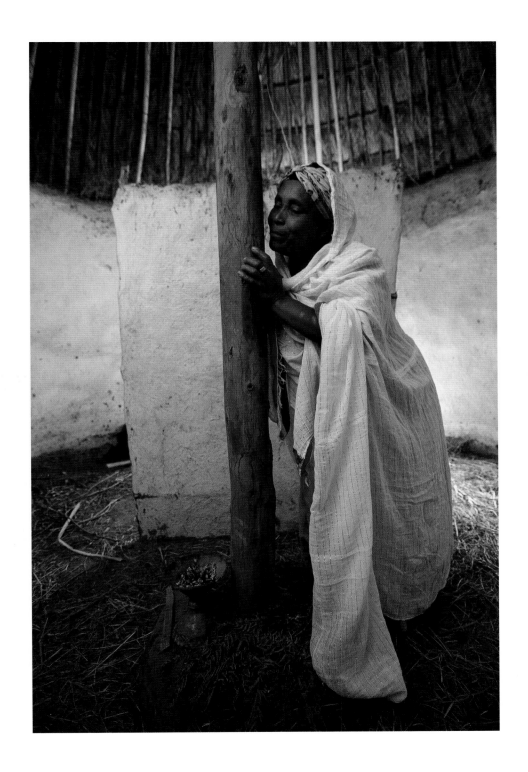
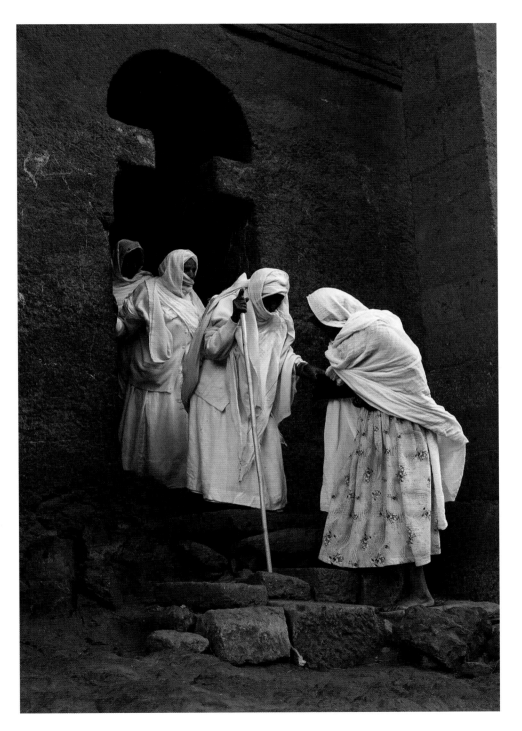

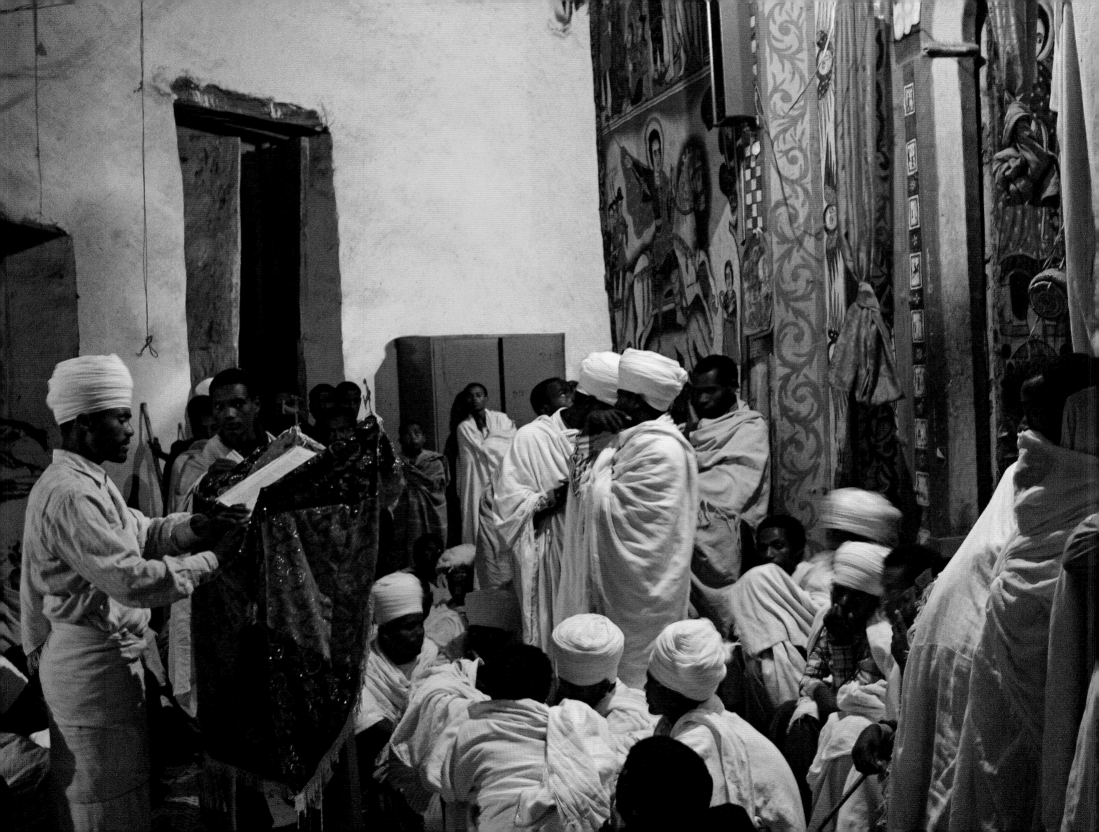

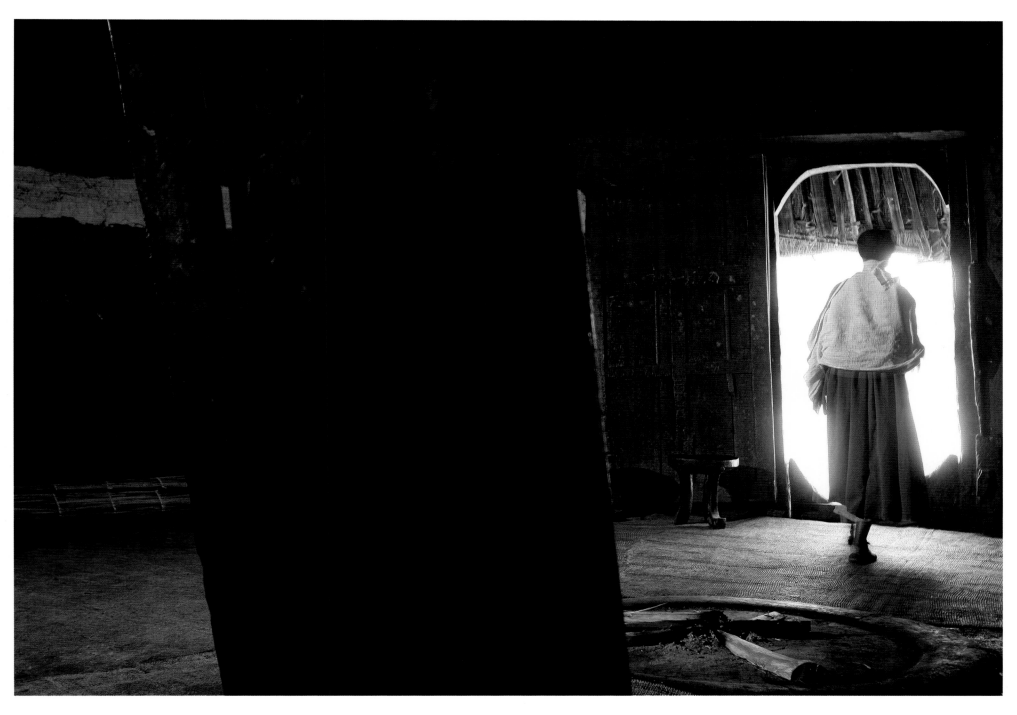

⟵ Priests celebrating mass. *Bete Maryam* (Church of Saint Mary). Wollo Robbit, Ethiopia, 2011

Priest. Temple of the Woman. Borja, Ethiopia, 2007

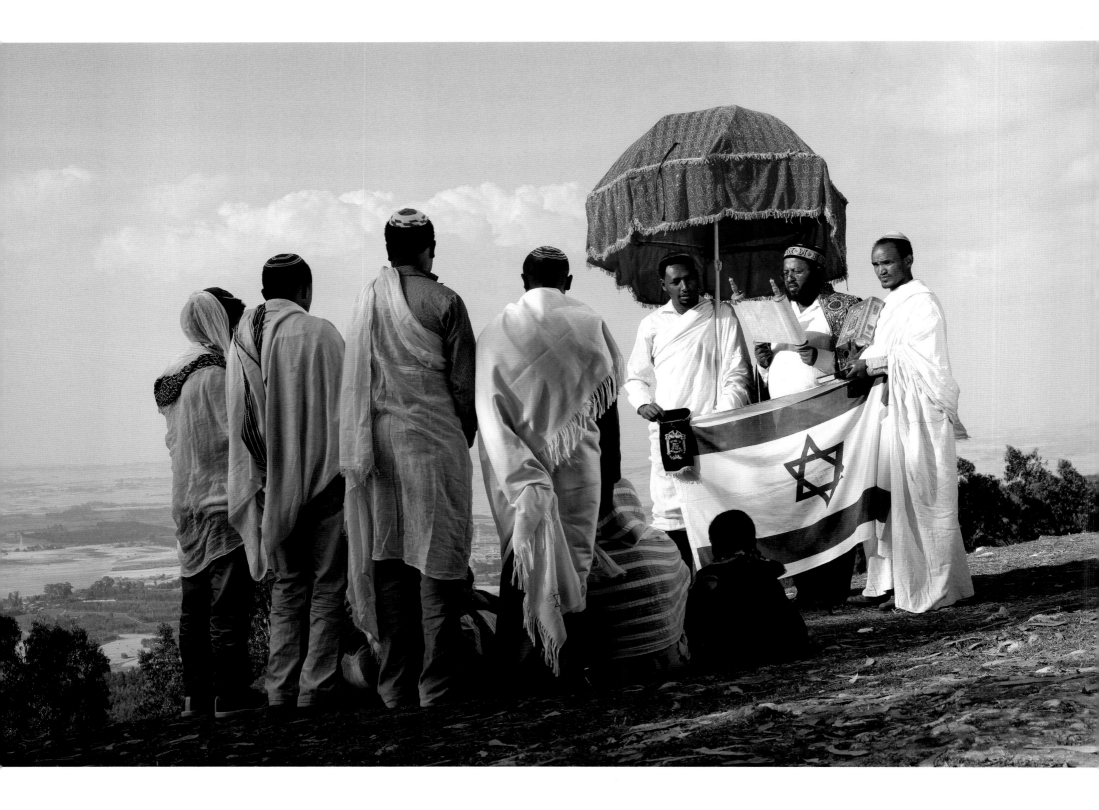

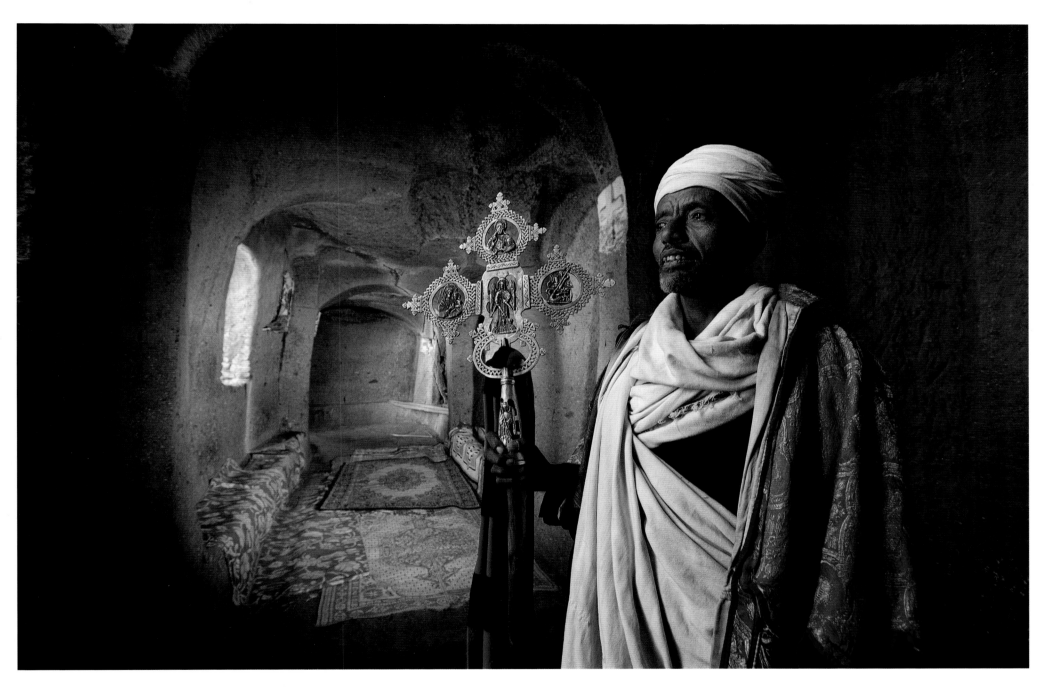

← The *Sigd* ceremony of the *Bete Israel* honors the deliverance of the Ten Commandments to Moses by God at the top of Mount Sinai. Mount Entoto. Addis Ababa, Ethiopia, 2011

Priest with processional cross. Asheton Maryam Monastery. Lalibela, Ethiopia, 2011

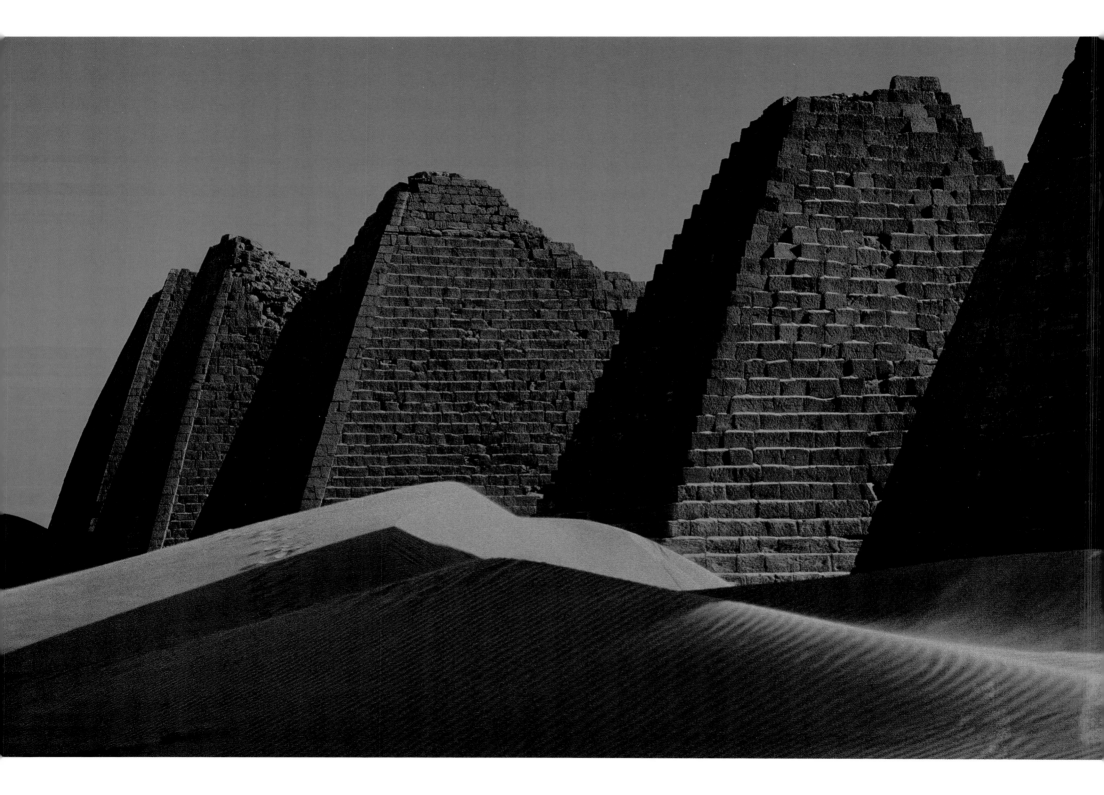

Iconography

Icons help us channel the light of The Spirit into our world experience.

The sun, the moon and the stars have been venerated beside the sacred River Nile over millennia. Ruins of temples that were dedicated to solar and lunar deities confirm this ancient worship. In 2005 I made an excursion with Fisseha Zibelo, then-director of Aksum Antiquities, located in north central Ethiopia. We traveled to the ruins of the Moon Temple in Yeha, Ethiopia. At this 8th century BCE site, I photographed a stone altarpiece with both the Crescent Moon and Sun carved in relief honoring *Almaqah* — a lunar deity shared by this pre-Aksumite and earlier cultures. With Fisseha Zibelo's aid, I obtained permission to remain on site one evening to photograph a rising quarter moon from within the Temple's still-standing walls where the view of the sky is unobstructed. On this clear crisp night, light from a quarter moon — floating in a sea of stars — suffused the ruins with a surreal calm.

In 2001 at the Sudan National Museum in Khartoum I photographed *Nubian* ceramic vessels ringed with bands of crescent moons. Farther upriver in the *Nubian* Royal Necropolis at al-Kurru, I came upon echoes of this lunar presence in the spectacular 25th Dynasty burial chamber of Queen Qalhata; painted on a wall is a bark (a boat) in the shape of the crescent moon, transporting the solar disk, configured just like the sun and moon on the Yeha altarpiece. This motif of crescent moon and sun is represented again farther north on a pectoral (chest) decoration exhumed from the tomb of King Tutankhamen, today displayed in the Grand Egyptian Museum, Cairo.

In *Kemet,* stars were often painted on tomb ceilings. On some, *Nut,* the supple star-studded deity who personifies the night sky, arches above the earth; the sun travels nightly through her lean stretched body to emerge reborn each morning. I delight in the exquisite tranquility of paintings of *Nut* in royal tombs; her serene image also decorates the underside of coffin lids poignantly facing the deceased.

Perhaps the most sublime interpretation of the sun arose during the reign of 18th Dynasty King Akhenaten, who streamlined the overcrowded pantheon of *Kemet* when he made *Aten,* the sun deity, the most prominent. Akhenaten is credited with writing, "O sole god, like whom there is no other!" in a hymn praising *Aten* (1976 translation by Egyptologist Miriam Lichtheim). After only twenty years, the faith of the ancestors — belief in *Amen,* that had been practiced for thousands of years — was restored and Akhenaten's pre-adolescent son Tutankhamen succeeded him. Akhenaten's short-lived transformation of the state religion is seen by some as the first effort to democratize access to the religion in *Kemet*. For a short but remarkably influential period in the history of humanity, he broke the stranglehold of the priests and made the worship of *Aten* more accessible to all.

Contemporary religions still recognize the significance of celestial bodies. Major holidays celebrated in Judaism, Christianity and Islam are often determined by lunar cyclical appearances. In Christian religious art the heads of sacred persons are often shown encircled with a radiant glow: sun-like halos. Christians honor the "Star of Bethlehem" as the celestial marker for the birth of their Savior, recorded in the New Testament Gospel of Matthew. Both the icon of Islam, the Crescent Moon and the Star, and the modern Judaic Star of David have ancient histories and symbolism not necessarily limited to either religion. Indeed, whenever we consider the residence of the Almighty, we all assume it is far above us in the "Heavens" where the infinite drama of celestial bodies plays out.

Nubia — Pyramids at sunrise. Northern Royal Necropolis, Meroitic Period (300 BCE to 350 CE). Meroe, Sudan, 2007

Spiritual narrative from those who first wrote it

An avenue lined with ram-headed sphinxes guards the pathway to the entrance to Karnak Temple in *Kemet.* King Ramses III dedicated this temple to *Amen,* supreme deity who evolved in power and prominence over millennia. Called the "Hidden One," *Amen* was believed to have created himself and then all aspects of reality (seen and unseen). Around the beginning of the New Kingdom (c. 1570 BCE), this regional deity fused with the sun deity *Re* to become the supreme divinity *Amen Re* in the pantheon of *Kemet. Amen* was often depicted as a ram, symbolizing fertility. Today in Abrahamic religions, rams (sheep) are still sacred. Sheep are sacrificed for Hebrew and Muslim festivals commemorating the biblical story of Abraham; Hebrews use a ram horn for the ritual blowing of the shofar; and Christians embrace the lamb as the natural sacrificial animal when referring to Jesus Christ as the Lamb of God. The sacred cow and lamb are always present in a Christian Nativity scene; I find it telling that for the ancient Egyptians, the ram represented the divine father *Amen* and the cow represented the divine mother *Het Heru* (Hathor).

One of my favorite icons at Karnak Temple is *sema tawy* which translates roughly as "unifier of the two lands." In this Karnak bas-relief, hawk-headed *Heru* (Horus) is paired with ibis-headed *Tehuti* (Thoth). The two deities tie the stems of local plants — papyrus from Upper *Kemet* with grass-like sedge from Lower *Kemet* — around a stylized windpipe and lungs to represent the unity of the two lands. When I first saw this scene, I had no idea of its significance or that variations of *sema tawy,* spanning thousands of years, are found on temple walls and the bases of statues and thrones throughout *Kemet* and *Nubia.* They were often branded with a king's cartouche. The cartouche is the official seal of a king, bearing the ruler's name framed within an elongated vertical oval shape edged by what looks like a rope. The top or bottom of the cartouche is finished with a horizontal line at a right angle to the oval.

In other bas-reliefs of *sema tawy,* knotting the plants are two images of the king, or sometimes two representations of the River Nile deity *Hapi.* I have come to appreciate this icon as an apt metaphor for the theocracy of *Kemet,* where spirituality and religion bound people together consciously and unconsciously around the core of nationhood.

Story of the holy family, told and retold

Across the Nile from the Karnak Temple, on a wall of the Temple of Medinet Habu, I came upon an iconic image of a Holy Family, which mirrored the Holy Family of Mary, Joseph and Jesus from the Bible that I knew from childhood. But this Holy Family consisted of *Amen* with his consort *Mut* and their son *Khonsu.* Cities in *Kemet* celebrated local Holy Families, or Triads; this was *Waset's* Triad. Upriver in Abydos, the Holy Family was composed of *Asar* (named Osiris by the Greeks), Lord of the Afterlife; *Ast* (Isis), Mother of Resurrection; and their son *Heru,* Protector of the Throne of *Kemet.* The myth about this particular Holy Family was told and retold for millennia. Simply put, *Asar* married *Ast,* but *Asar* was killed by his jealous brother *Seth,* deity of chaos. *Ast* searched for her dead husband's body, which *Seth* had chopped in pieces. Finding most of the parts, she reassembled and mummified the body. Spiritually embracing his seed, *Ast* was able to conceive their son *Heru,* who grew up to avenge his father's murder. It has been suggested that this is the earliest account on record of a miraculous conception, a paradigm that persists today in the biblical narrative of the Immaculate Conception of the Virgin Mary. In the Koran the birth of Jesus, whom Muslims recognize as a prophet, is considered a miracle, but Jesus is not a god in human flesh.

On a related trip upriver, ten miles from Cairo, at Abusir where I was photographing the distant pyramids of Giza, I noticed some workers clearing out the last artifacts from an Old Kingdom tomb. As I watched, they brought out several metal tools that to my untrained eye looked like scalpels and tweezers. And then I saw a bronze statue of a mother nursing her baby. It brought to mind the Virgin Mary with her baby Jesus. But this c. 4,500-year-old statue showed *Ast* nursing *Heru* — the first-known Holy Child, two thousand years older than the Christian version in the New Testament.

Two syllables heard across time

Whenever I hear the word *"Amen"* vocalized, I am transported back to the Karnak Temple of *Amen* and reminded of the ancient faith that arose beside the River Nile. In all the Abrahamic religions, the one constant is the homage that is given to the one and only *Amen*, the singular word that seems to represent the crest of the world and a pillar to heaven. No matter how *Amen* is pronounced or spelled, these two syllables flow from religion to religion, region to region and epoch to epoch. And no matter in what language prayers are recited, the concluding word, *Amen*, is the same in every tongue, never requiring translation. So universally understood is it today that people say it even in casual conversation, to convey enthusiastic agreement. This similarity could represent merely a serendipitous alignment of sound in different languages, or perhaps the deity — whose name and ram horns manifested in various forms in Greek culture until the beginning of the Common Era (2,100 years ago) — is actually the genesis of our use of this word. Further research is required to quiet the controversy surrounding the origins of this word that is, astonishingly, the same in every language.

In 2006, I returned to *Nubia* to the southern home of *Amen* in Gebel Barkal (in Sudan) where a sacred flat-topped mountain is fronted by a rock outcropping that to the ancients embodied a *uraeus* or rearing hooded cobra. In the Bible, the snake represents sin, but where I grew up in rural Alabama, it is also synonymous with danger and death. I found the ancient adoration for serpents unsettling. In a quest to understand and perhaps then to appreciate the cobra's spiritual appeal, I set out to make a picture of the sacred rock outcropping at sunset. In order to capture the whole mountain, I had to go miles away from it across the River Nile. My facilitators drove us a few miles from Gebel Barkal to the nearest boat landing where we crossed the river by ferry. On the other side, our driver drove us to a spot directly across from the temple. We then bounced down dirt roads as far as possible, before the terrain forced us to set out on foot instead. We jumped over irrigation canals and dikes and slogged through muddy fields dotted like the stubble on a shaved chin, with short stalks poking through, left behind from a recent harvest of sorghum. Just as the sun was reaching the horizon, I was finally able to set up my tripod. My photograph, I hope, captures this silhouetted backlit "snake" with a reverence similar to that which the ancients must have given it.

Sacred serpent, Nile symbol of royal authority

The serpent, iconic symbol of royal authority reflected in the Gebel Barkal sacred rock outcropping, adorned the crowns of Nile monarchs in *Kemet, Nubia* and it seems even the Aksumite Kingdom. Legend, so ancient and contested that its renditions often conflict, relates that Ethiopia was once ruled by a serpent dynasty until its last sovereign was slain by an ancestor of *Makeda*, the biblical *Kandake* (Queen) of Sheba. In the 4th century CE, located within today's Ethiopia, Aksumite King Ezana converted, leaving the Nature-based faith of his ancestors and changing the state religion to Christianity. The coming of Christianity to the Aksumite Empire severed the link to the ancient faith, the population now swept into a new era of Christianity.

Iconography on the crowns of pre-Christian rulers, including the crowns of King Ezana before his conversion — visible today on ancient Aksumite gold coins in the Ashmolean Museum of Art and Archaeology at Oxford University, England — suggests a rich and as-yet little understood belief system. Ringing the tops of many pre-Christian crowns is a row of rising ovals topped by round shapes that resemble rearing serpents. I can't help but equate the patterns of the Aksumite crowns, visible in crudely formed images on ancient coins, with those on the crowns of monarchs from *Kemet* and *Nubia* that clearly show a rearing cobra (the *uraeus*) — the universal symbol of power along the River Nile. More symbolism on the Aksumite crowns before the arrival of Christianity duplicates the crescent moon and sun in the identical configuration found on the altarpiece at the Moon Temple in Yeha, Ethiopia. Further, the crowns feature a stylized band of silhouettes in the shape of the tops of Aksumite obelisks.

Such evocative royal iconography speaks to a deep and unifying reverence for the Divinity of all of Nature and every one of its diverse creations, celebrated up and down the mighty Nile.

Nubia — Winged lioness-headed deity *Sekhmet* found at Soleb, Meroitic Period (300 BCE to 350 CE). Small faience amulet, Sudan National Museum. Khartoum, Sudan, 2004

Angels on the ceiling. *Debre Berhan Selassie* Church built in 1693. Gondar, Ethiopia, 2010 ⟶

Angel. Holy Trinity Cathedral, Addis Ababa, Ethiopia, 2016 ⟶

Saint Mary and Saint Michael holding the scales of judgment. *Ura Kidane Mehret* Monastery (16th century), Lake Tana. Bahir Dar, Ethiopia, 2003 ⟶

Kemet — Deity *Anpu* (Anubis), kneeling with the scales of judgment weighing the heart (life actions) against truth (the feather); the *Ba* bird, at left, looks on. Papyrus of Ani, Dynasty 19. British Museum publication, 1895 ⟶

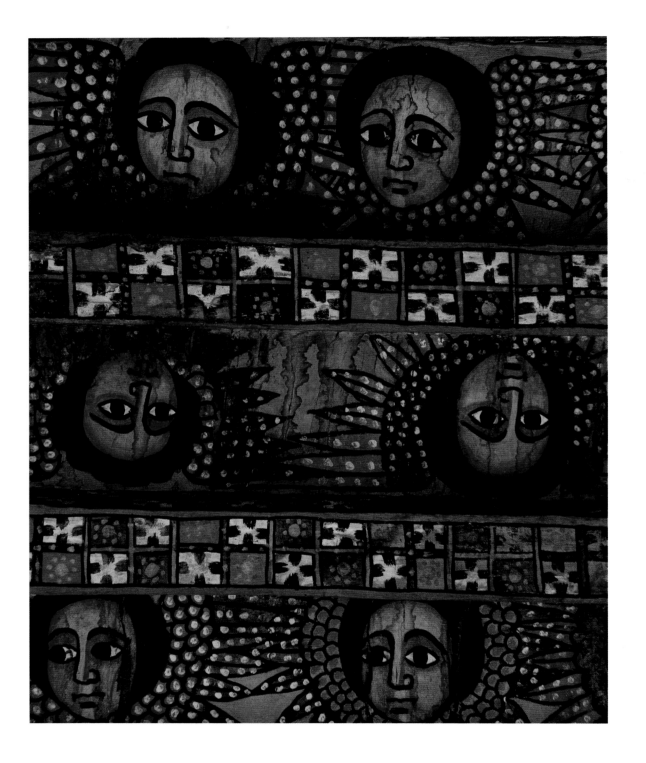

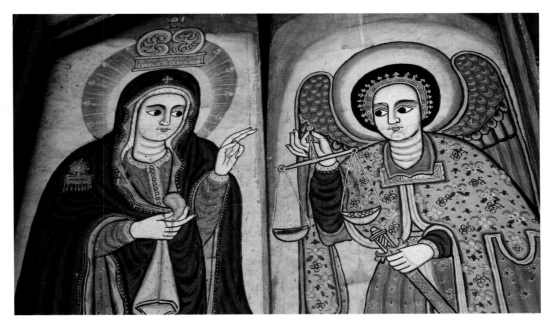

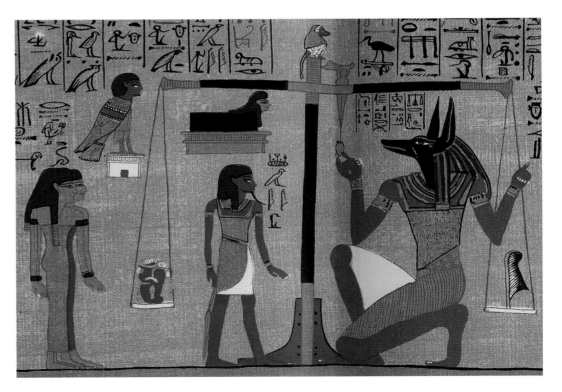

Divinity of the Sun

Solar imagery. 13th century *Bete Genette Maryam* (Garden of Mary Church).
Lalibela, Ethiopia, 2016

Opening page of Abba Gerima Gospels (c. 6th century). Monastery of Abba
Gerima. Tigray Region, Ethiopia, 2010 ⟶

Kemet — The deity *Re Herakhty* with a sun disk crown being adored by two
images of the King. The 3,245-year-old Grand Temple of King Ramses II,
Dynasty 19. Abu Simbel, Egypt, 2007 ⟶

Kemet — Statue of 18th Dynasty King Akhenaten who reigned from 1353 to 1336 BCE and broke tradition to establish a short-lived religion with the Holy Solar Disk (the *Aten*), the king and his family as its sole focus. Dynasty 18. Grand Egyptian Museum. Cairo, Egypt, 2000

Kemet — The Holy Family King Akhenaten and Queen Nefertiti adore the *Aten*, or Holy Solar Disk, with two of their daughters, Dynasty 18. Amarna Boundary Stelae, c. 1340, Tell el-Amarna. Minya, Egypt, 2019 ⟶

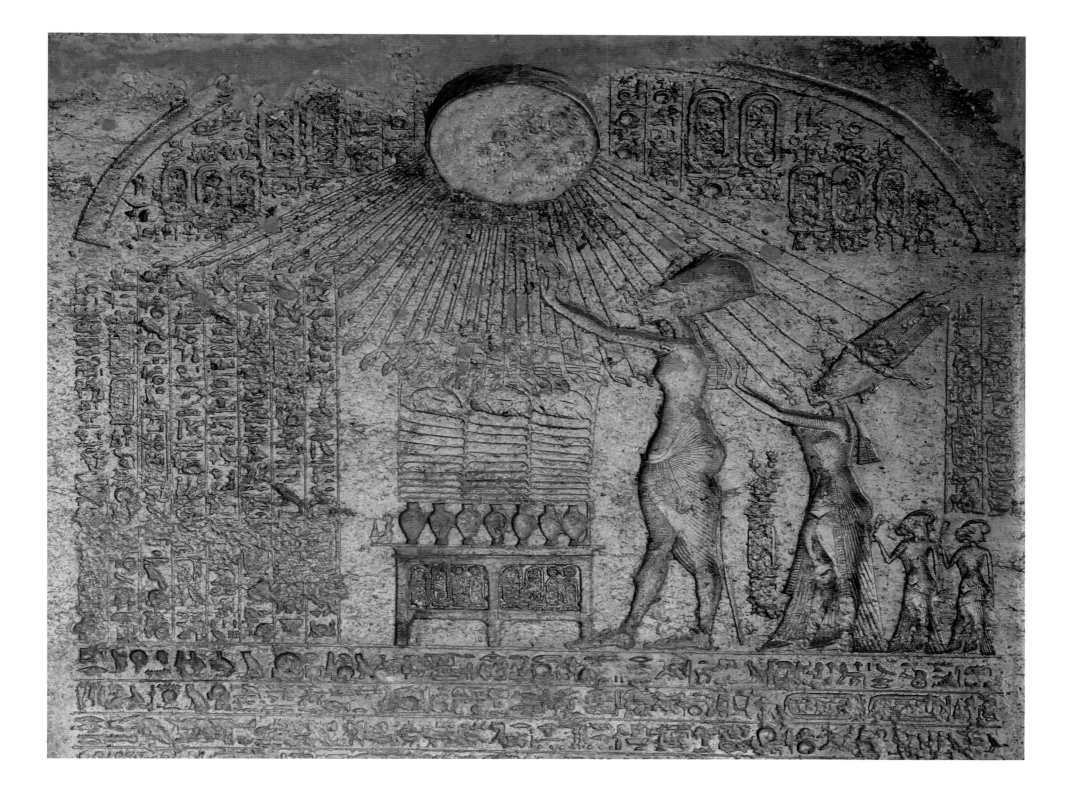

Sacred Music

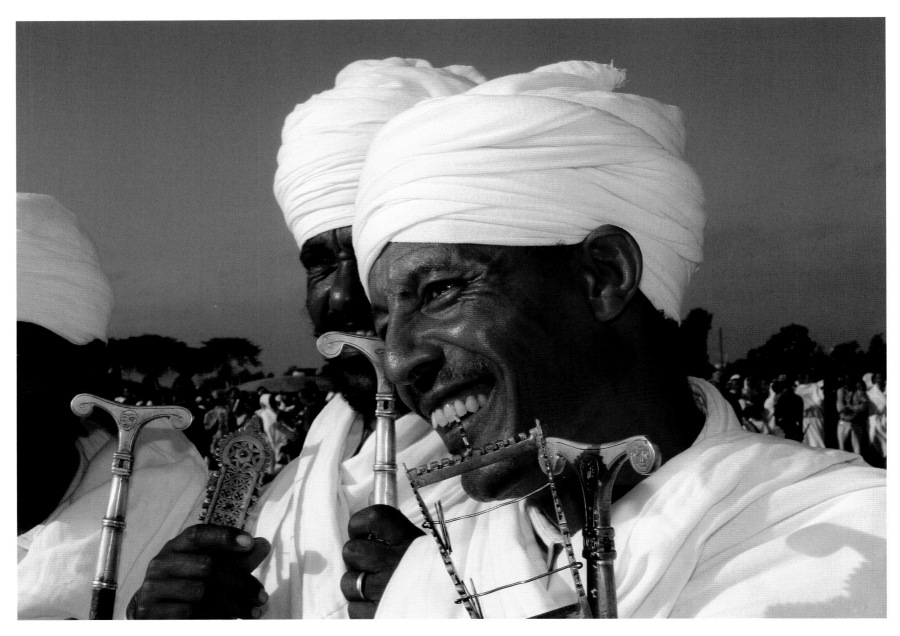

Debteras (unordained members of the Ethiopian Tewahedo Church clergy) with sistrums (musical instruments). Addis Ababa, Ethiopia, 2012

Kemet — The wife of Pennout, Takha, holding the sistrum, stands behind her deceased husband who is saluting the Lord of the Afterlife *Asar* (Osiris). Tomb of Pennout, 20th Dynasty. Lake Nasser, Egypt, 2007 ⟶

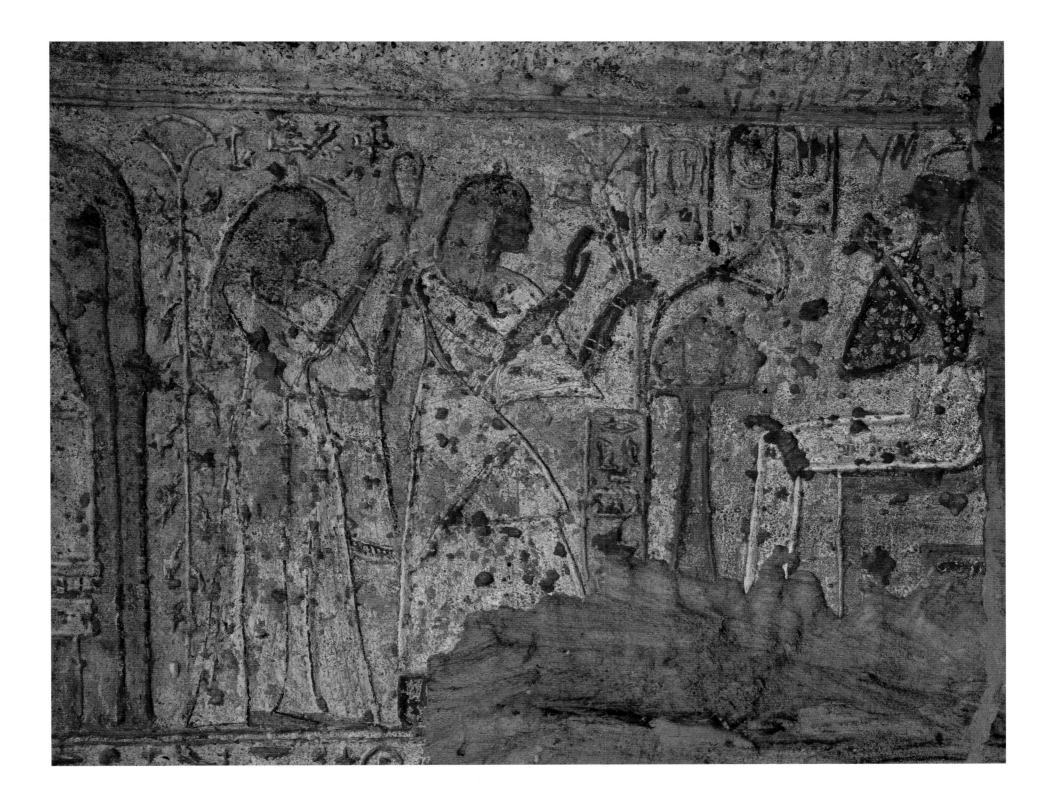

An African American pilgrim holding a sistrum. Courtyard of the Egyptian Temple of *Ast* (Isis) — built c. 350 BCE and active until 537 CE when it was closed by conquerors. Philae, Egypt, 2007

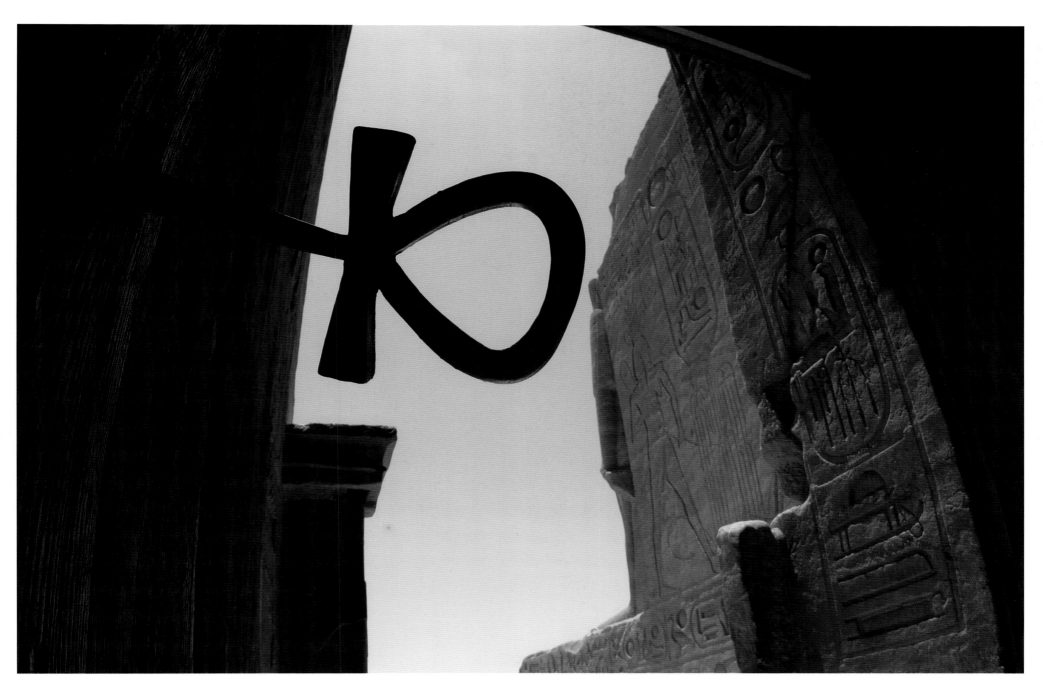

The modern Ankh key in the door to the 13th century BCE Grand Temple of Ramses II.
Abu Simbel, Egypt, 2003

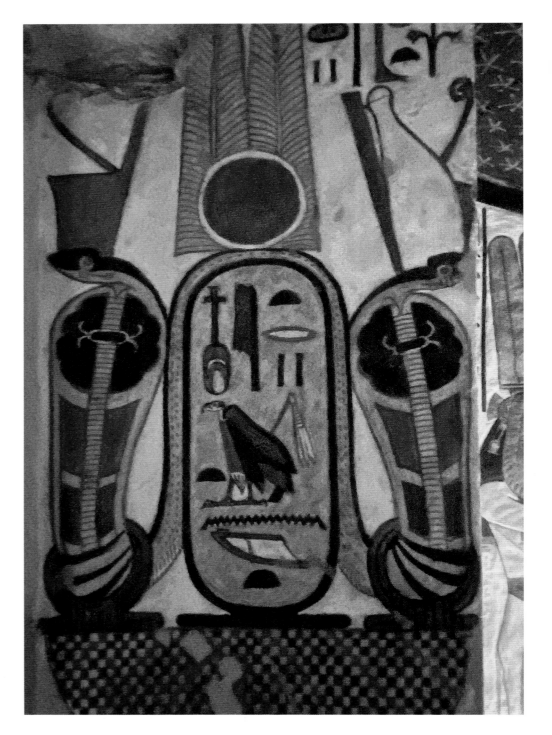

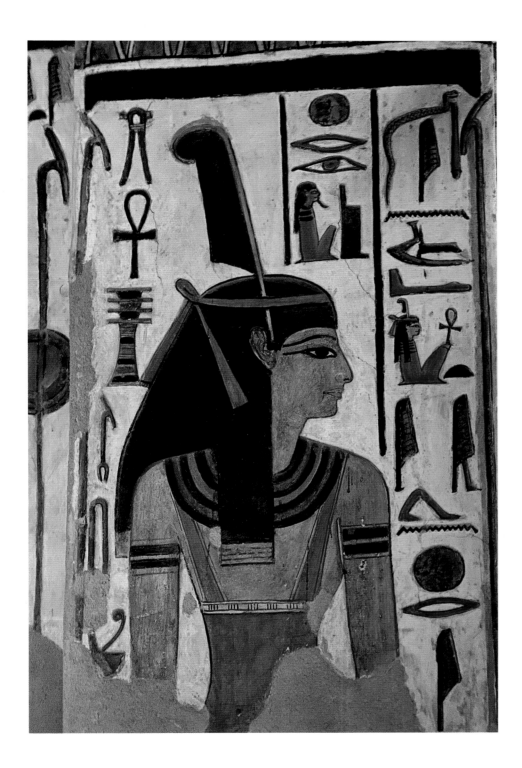

Kemet — Eternal night: stars on the ceiling. Tomb of Nefertari, Valley of the Queens, West Bank, Luxor, Egypt, 2019

←——————— Sunset on the River Nile, Aswan, Egypt, 1998

←—— *Kemet* — Cartouche of Queen Nefertari, protected by two serpent deities; to the left, *Wadjet*, wears the red crown of southern Egypt; at right, *Nekhbet* wears the white crown of northern Egypt. Tomb of Queen Nefertari (1300 to 1255 BCE). West Bank, Valley of the Queens, Luxor, Egypt, 2019

←—— *Kemet* — *Ma'at*, deity of truth, in the Tomb of Queen Nefertari. Valley of the Queens, West Bank, Luxor, Egypt, 2019

161

The Crescent Moon

Nubia — Ceramic Nubian bowl with bands of crescent moons. Meroitic Period
(300 BCE to 350 CE). Sudan National Museum. Khartoum, Sudan, 2001

Pre-Aksumite — Around c. 330 CE, Emperor Ezana converted to Christianity from the
Nature-centric belief of his ancestors and made Aksum one of the earliest Christian
states in Africa. This transformation saw the replacement of celestial symbols (seen on
this pre-Aksumite altarpiece) with the Christian cross. Moon Temple Museum. Yeha,
Ethiopia, 2001 ⟶

Muslim icon of the star and crescent moon surmounts the dome of the c. 11th century
Abu Haggag Mosque. East Bank, Luxor, Egypt, 2007 ⟶

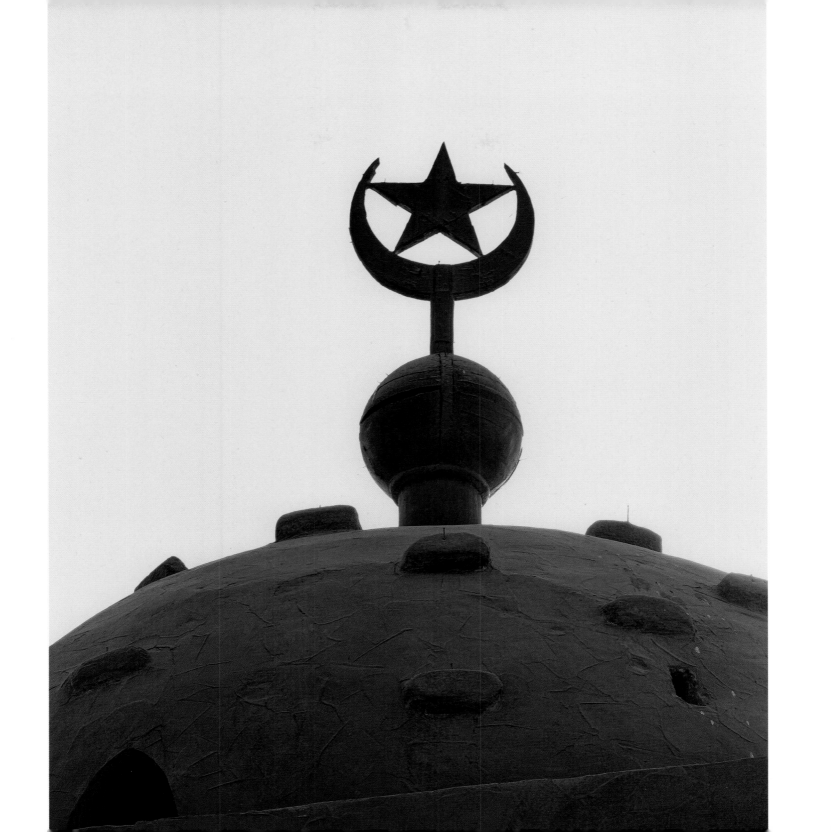

Leopard Skin, the Vestment of the Priest

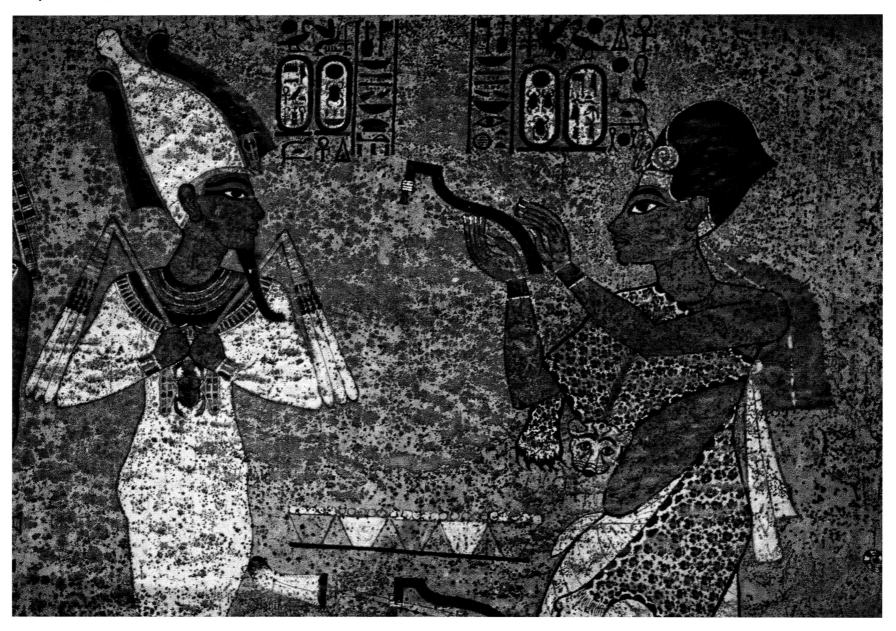

Kemet — Dressed as a High Priest or *Sem* with leopard skin mantle (right), the successor to King Tutankhamen prepares to perform the Opening of the Mouth ceremony on the mummified King (left). Tomb of King Tutankhamen, Dynasty 18. Valley of the Kings. West Bank, Luxor, Egypt, 1999

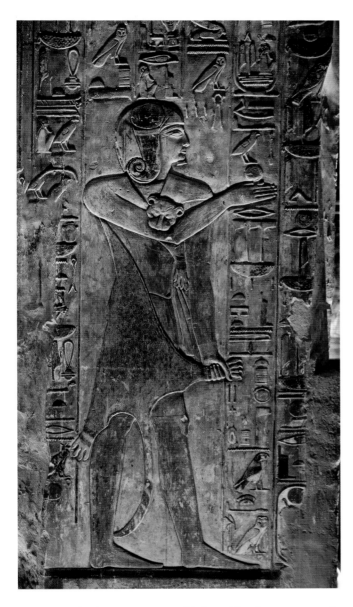

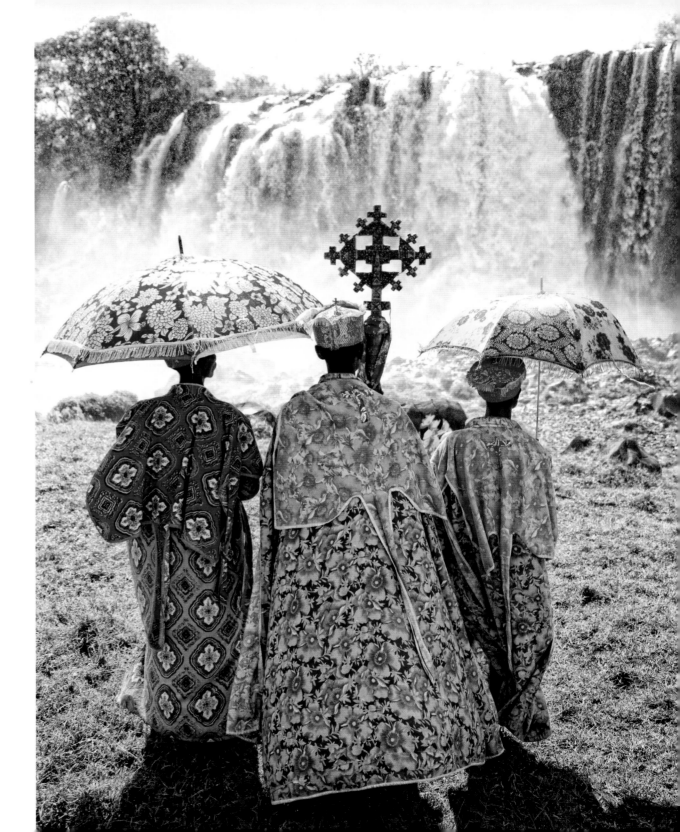

Kemet — High Priest or *Sem* responsible for reciting chants necessary for eternal life. 3,379-year-old Tomb of King Sety I, Dynasty 19. Valley of the Kings. West Bank, Luxor, Egypt, 2019

Ethiopian Tewahedo Church priest and two deacons; they are wearing vestments similar in design to the leopard skin mantle worn by the Ancient Egyptian High Priest (*Sem*). Blue Nile Falls. Bahir Dar, Ethiopia, 2011 ⟶

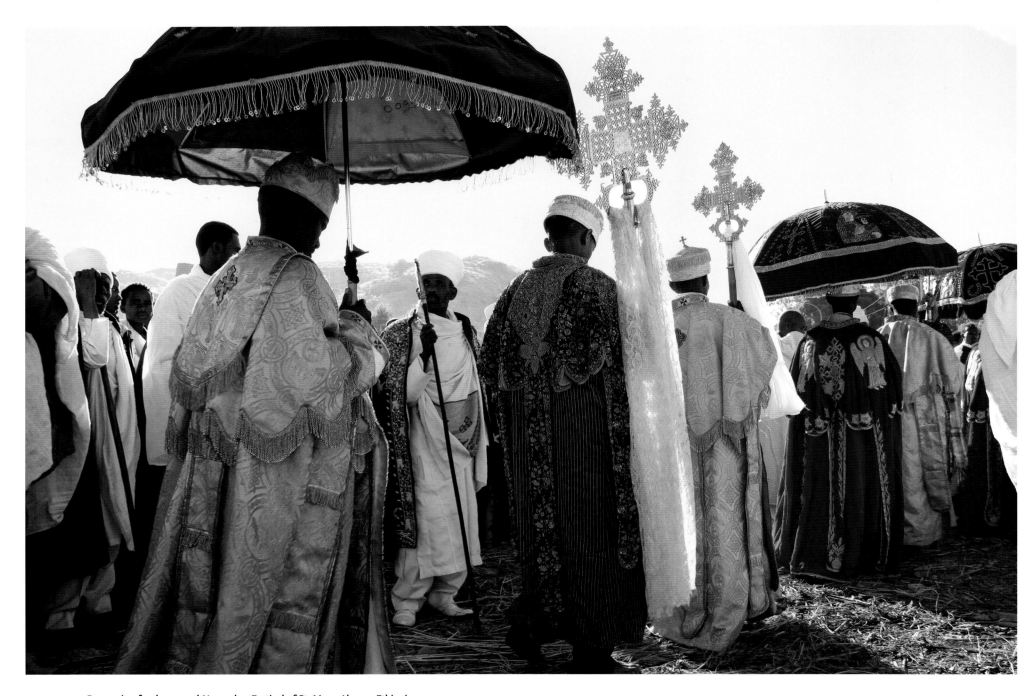

Procession for the annual November Festival of St. Mary. Aksum, Ethiopia, 2011

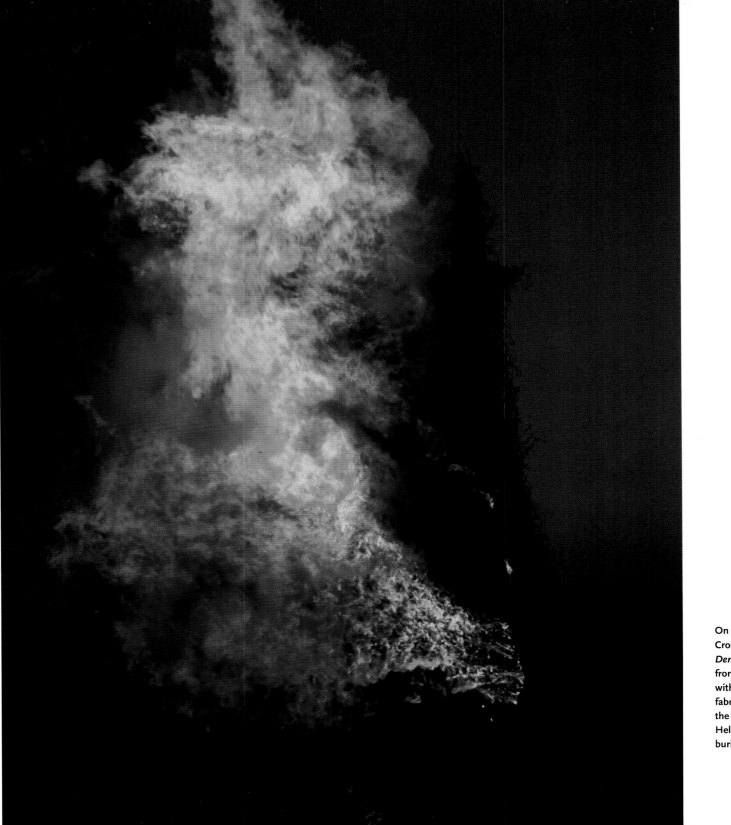

On the eve of *Maskal* (The Finding of the True Cross), bonfires are lit in town squares. Called *Demeras,* these flaming towers are assembled from upright bundled poles and twigs, decorated with *maskal* flowers and overlaid with colorful fabric. The smoke from the *Demera* symbolizes the smoke in a dream that led Byzantine Empress Helena to the spot where the True Cross was buried. Addis Ababa, Ethiopia, 2009

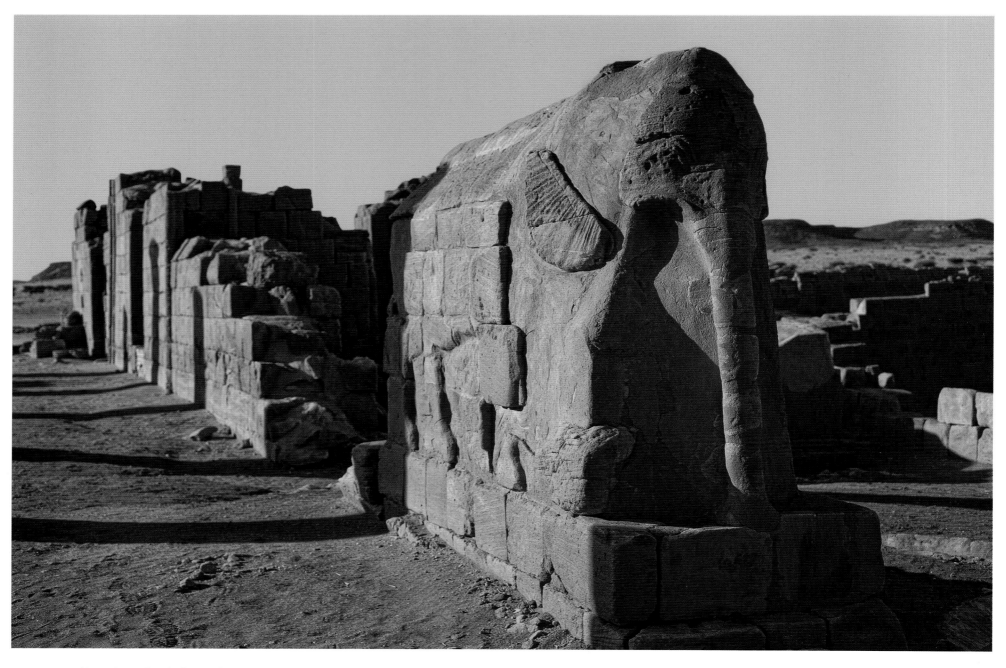

Nubia — Figure of an elephant in the Great Enclosure at Musawwarat es-Sufra Temple (c. 3rd century BCE). Sudan, 2012

Nubia — Bas-relief showing *sema tawy* (unification of the two lands). In this *Nubian* version, ibis-headed *Tehuti* (Thoth) and hawk-headed *Heru* (Horus) tie the stems of local plants around a standard with the cartouches of King Natakamani and *Kandake* and *Qore* Amanitore. Altar, *Amen* Temple, Meroitic Period (300 BCE to 350 CE). Naga, Sudan, 2007 ——>

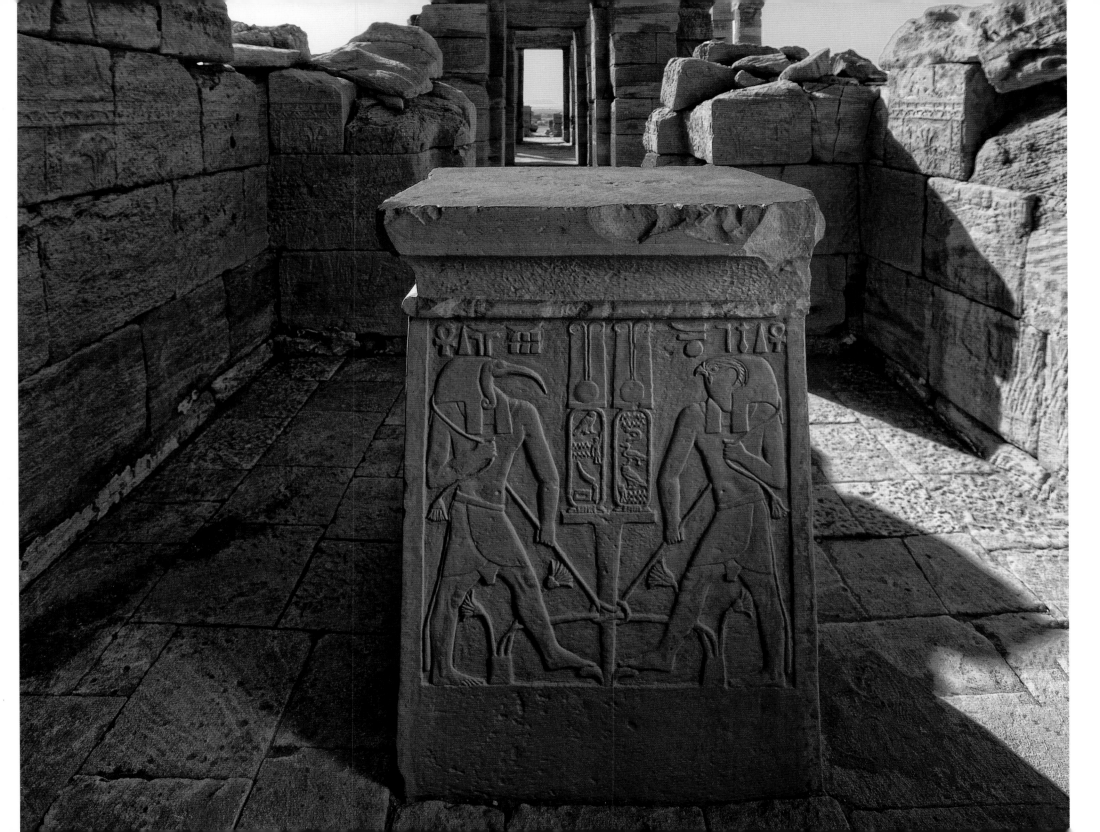

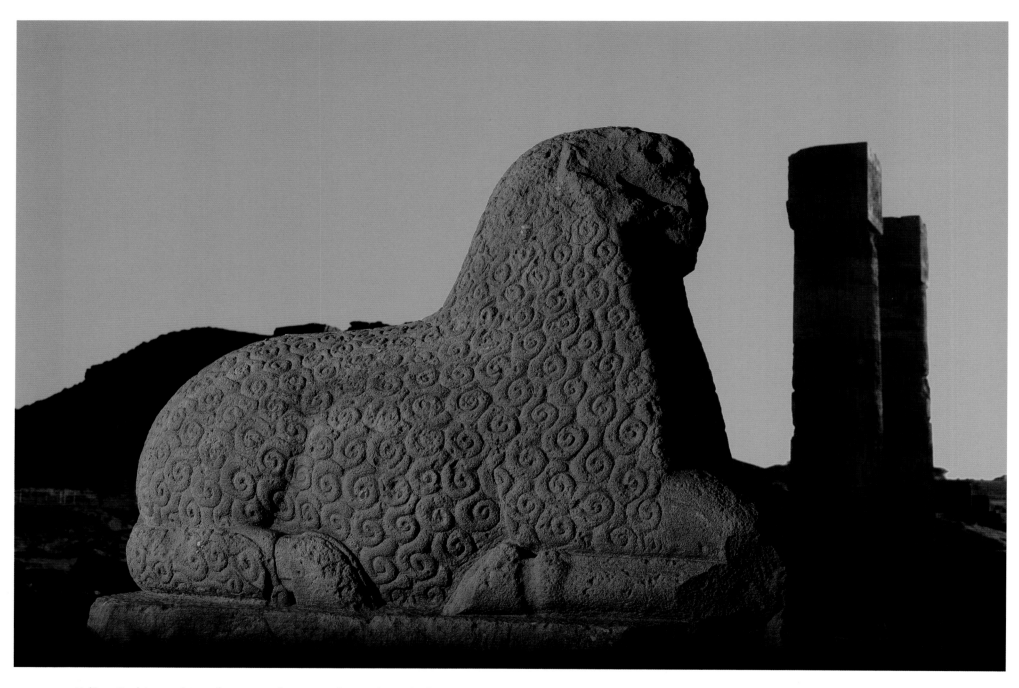

Nubia — Sandstone sculpture of a ram, part of an avenue of ram sculptures leading to the Temple of *Amen*. Meroitic Period (300 BCE to 350 CE). Naga, Sudan, 2007

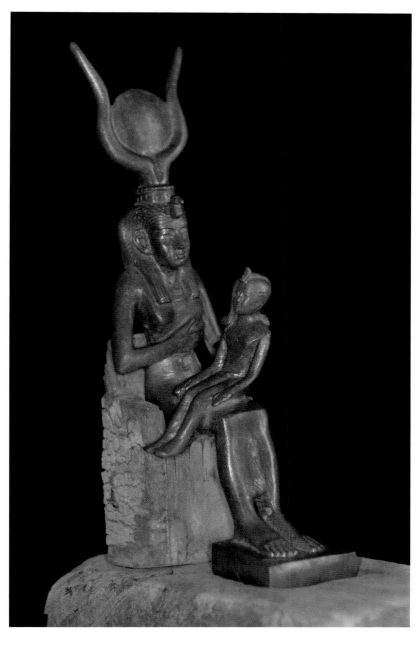

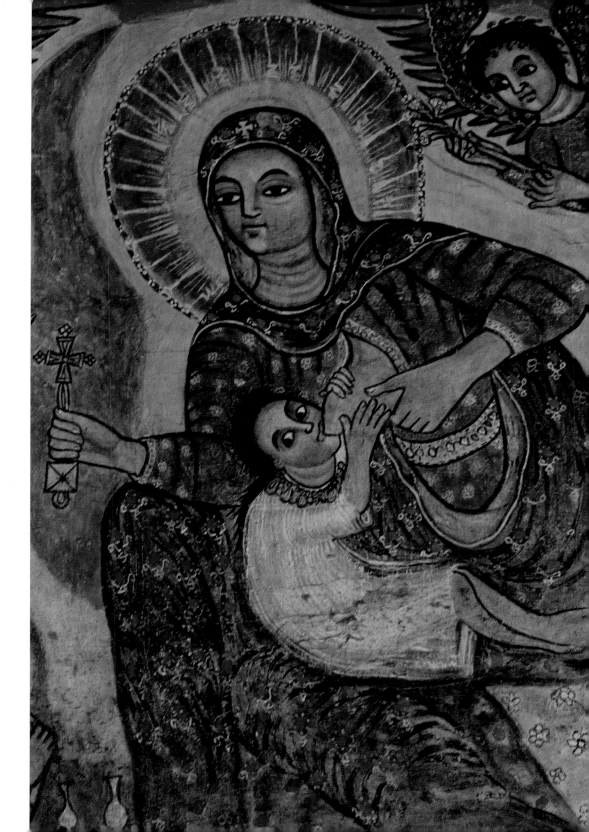

Statue of the Holy Mother *Ast* (Isis) nursing the Holy Child *Heru* (Horus), from an Old Kingdom tomb. Abusir, Egypt, 2001

Holy Mother Mary suckles the Holy Child Jesus. Late 18th century Narga Selassie Monastery, Dek Island, Lake Tana. Bahir Dar, Ethiopia, 2016 ⟶

← Ceiling painting showing eight of the nine saints recognized by the Ethiopian Tewahedo Church. Abune Yemata, the patron of this rock-hewn church (c. 6th century), is riding the bay horse. *Abune Yemata Guh*, Hawzen, Ethiopia, 2011

Kemet — Spirit doors are found outside and inside tombs and in mortuary temples providing a focus for offerings left to sustain the divine essence of the deceased. Chapel, Mastaba of Khenu, Dynasty 6, c. 2200 BCE. Saqqara, Egypt, 2000

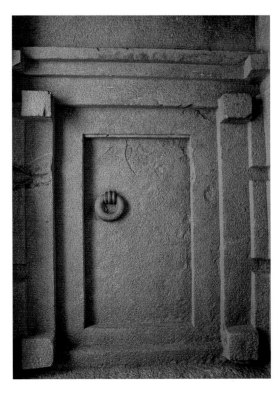

Aksumite Kingdom — Ethiopian spirit doors (as early as 400 BCE) were placed at the base of grand obelisks above royal tombs. Royal Aksumite Necropolis. Aksum, Ethiopia, 2001

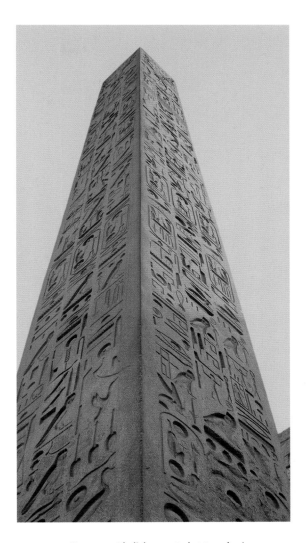

Kemet — Obelisks, erected at temples in pairs and topped with pyramidions, appear to advertise a king's accomplishments. Obelisk of King Ramses II, Dynasty 19, c. 1400 BCE, Luxor Temple. East Bank, Luxor, Egypt, 2007

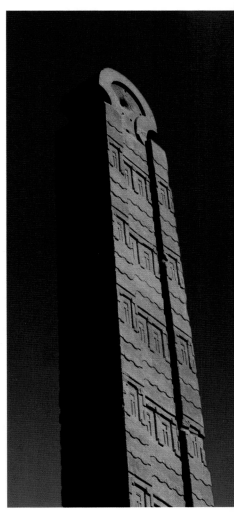

Aksumite Kingdom — In Ethiopia, obelisks (as early as 400 BCE) served as royal tomb markers. Without inscriptions, these monoliths are difficult to date. Obelisk, Royal Aksumite Necropolis. Aksum, Ethiopia, 2009

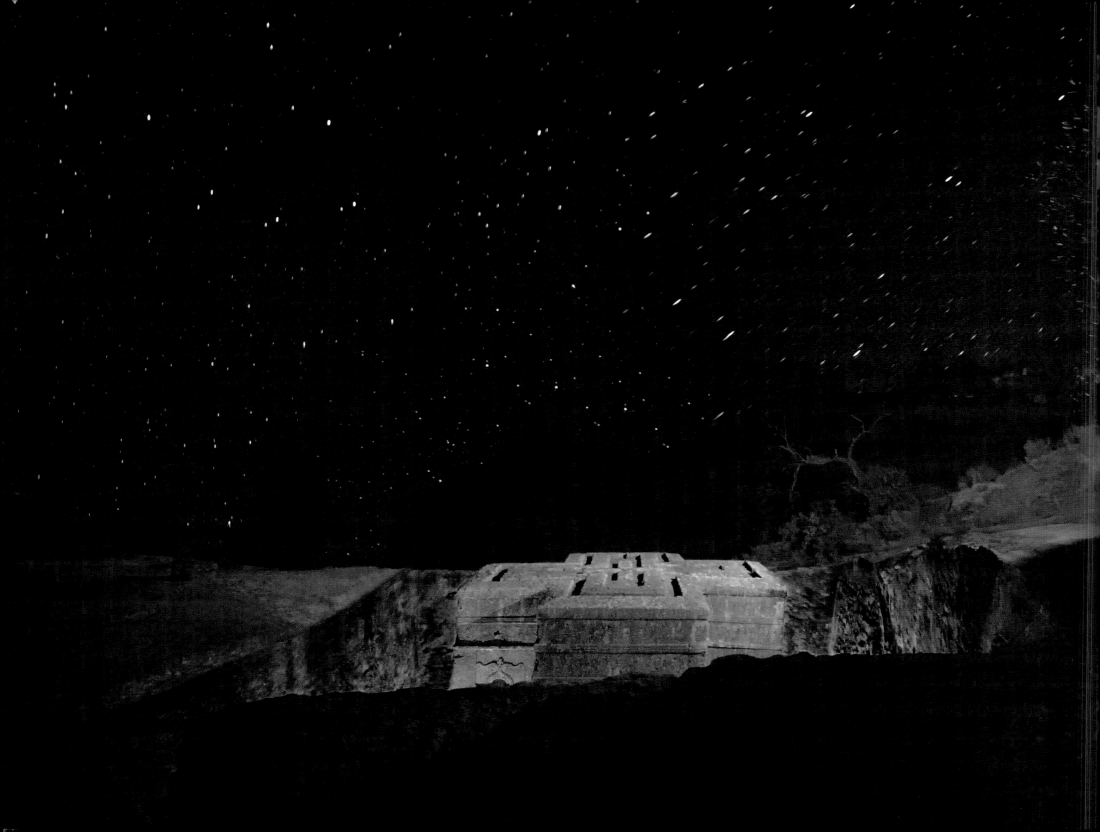

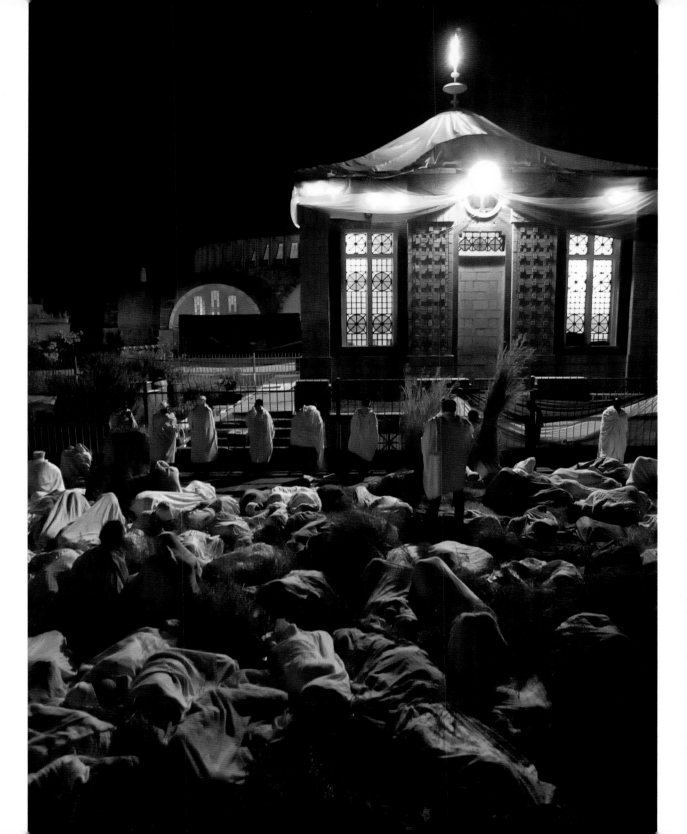

Worshipers holding vigil outside The Treasury. Every Ethiopian Tewahedo Church possesses and houses in its innermost sanctuary a *tabot* or replica of the original Ark of the Covenant (believed to have been brought to Ethiopia from Jerusalem by the son of King Solomon in Biblical times). Ethiopian Christians believe that the Ark of the Covenant, given to Moses, resides here today under guard in The Treasury. Aksum, Ethiopia, 2011

←——— Before dawn. 13th century *Bete Giyorgis* (Church of Saint George). Lalibela, Ethiopia, 2008

175

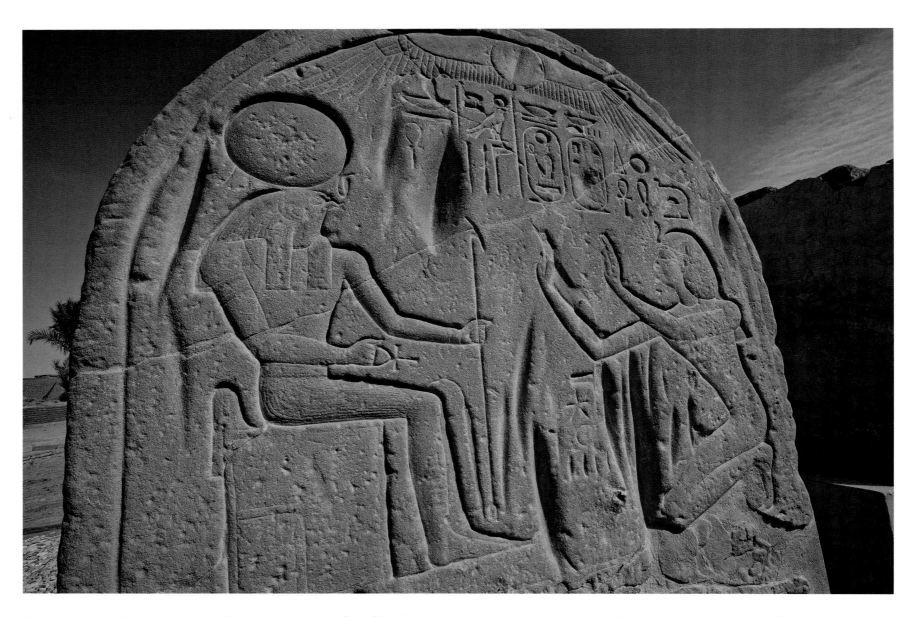

Kemet — King Sety I, Dynasty 19, worshiping *Heru* (Horus) on a stele in front of his Mortuary Temple (erected c. 3,300 years ago). West Bank, Luxor, Egypt, 2007

Kemet — Deity *Heru*, protector of monarchs, in hawk form. Temple of *Heru* (completed in 57 BCE), Ptolemaic Period. Edfu, Egypt, 1980 ⟶

Nubia — *Ast* (at right), wearing her crown of the sun disk and cow horns, stands behind her son *Heru,* depicted with hawk head and human body. *Apedemak* Temple (c. 300 BCE), Meroitic Period. Musawwarat es-Sufra, Sudan, 2007 ⟶⟶

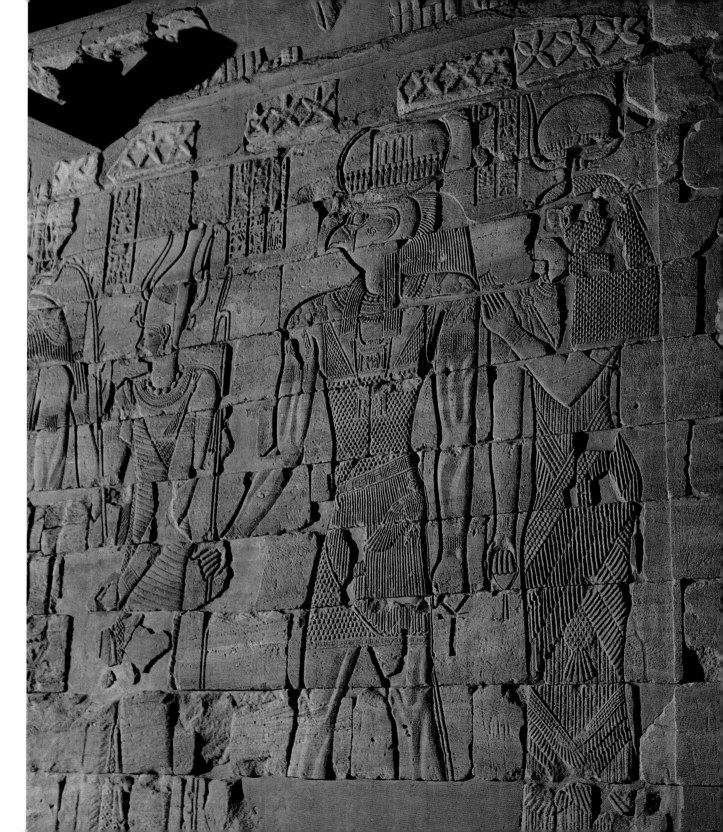

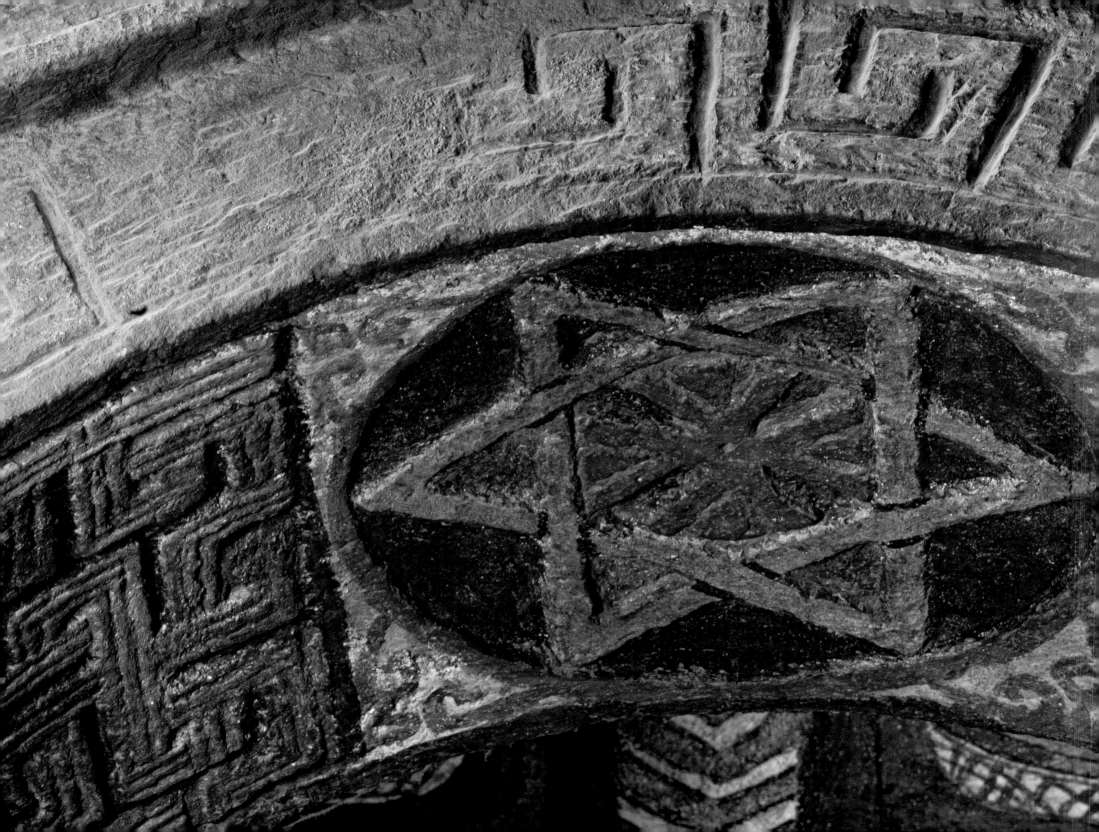

Priest of *Bete Medhane Alem* (Church of the Savior of the World). Lalibela, Ethiopia, 2009

←— Arch in 13th-century rock-hewn *Bete Maryam* (Church of Saint Mary) shows a cross inside the Star of David. Lalibela, Ethiopia, 2007

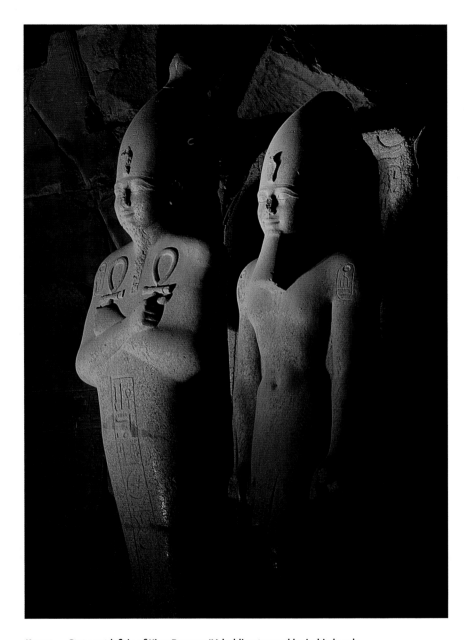

Kemet — Statue at left is of King Ramses IV, holding two ankhs in his hands, crossing his chest, Dynasty 20; at right is a statue of King Thutmosis III, Dynasty 18. Temple of *Amen*, Karnak. East Bank, Luxor, Egypt, 2007

Into the Night

Only faith can see beyond death.

The landscape of death is a major focus of all faiths. Throughout millennia, our ancestors have honored the memories of loved ones. Our grandest monuments reflect this need to kiss the memory of those who leave us behind.

Beside the River Nile, deceased rulers were memorialized and celebrated with extravagant pyramids, tombs, temples and obelisks. King Unas was entombed in 2500 BCE in the vast burial ground in *Kemet* known as the Necropolis of Saqqara. In his tomb was discovered the first-known compilation of written Holy Scripture. French Egyptologist Gaston Maspero (1846–1916) first entered the tomb in 1881, about a half century after the French linguist Jean-François Champollion (1790–1832) had deciphered Egyptian hieroglyphs. Although the pyramid of King Unas is crumbling, underneath it his empty tomb chamber is intact, complete with three hundred lines of hieroglyphic script chiseled in the walls. The religious text is in fact a meticulous spiritual guide to aid the spirit of the deceased in transit to the Afterlife. A pitched ceiling embellished with stars and with a hint of its once brilliant blue background remains as indelible canopy above these chambers.

The treacherous journey to life after death

I first entered this subterranean tomb chamber in 1999. Visitors descend via a narrow rock passageway, bent at the waist to avoid bumping their heads. A wooden ramp constructed over the steep stone surface helps visitors maintain their footing. It is possible to straighten at the bottom briefly before bending again to enter the chambers, filled with the earliest known sacred funerary scripture, referred to as *Pyramid Texts*.

Windswept sand dunes. Meroe, Sudan, 2006

On all four walls of the antechamber (twelve by ten feet), vertical lines of hieroglyphs carved 4,600 years ago, fill almost every inch of the stone wall space — characters in an ancient language that evoke their own significance. Ducking again to pass into the burial chamber (twenty-four by ten feet), I came upon more glyphs taking over even a tight crawl space connecting the chambers. A huge black stone sarcophagus occupies one side of the burial chamber, where above it are more glyphs carved into the walls. The inscriptions give clear instructions for ascending to heaven and toward insuring the successful re-absorption of the dead king's soul into the eternal energy of the universe. This labor of passion is the oldest known spiritual text. The concepts of resurrection and eternal life introduced here relied on the ability of the Lord of the Afterlife *Asar* — believed to have raised himself from the dead — to, in turn, aid the deceased King Unas in attaining his own everlasting life. By honoring the ceremonies presented on the chamber walls, the spirit of the deceased could become one with *Asar* and ascend to the heavens to reside in the Afterlife with all the royal ancestors. Images of *Asar,* carved and painted, show the deity mummified in white (the color of mourning) linen with feet together to differentiate him from the living; his face and hands are rendered green to signify rebirth. It is this concept of *Asar* that Ethiopians express at the end of the annual rains and in celebration of the new year and rebirth of the land when they carpet the floors of their homes with green grass.

Pyramid Texts were intended in the Old Kingdom for the monarch, the earthly representative of the Divinity. Around 2100 BCE during the Middle Kingdom, abridged versions called *Coffin Texts* appeared painted directly on the outside of coffins of the noble class, which extended the reach of spiritual comfort and guidance to these societal elites.

By 1500 BCE, the time of the New Kingdom in *Kemet,* sacred funerary writings featured portions of both *Pyramid Texts* and *Coffin Texts.* This new collection of information was disseminated in two additional ways. One was on linen shrouds, wrapped around the mummified body; the other was on papyrus scrolls, buried with the deceased. As the appeal for these religious formulas grew, the use of light-weight materials simplified the process for disseminating the sacred texts — ritual instructions, narrative, chants and prayers. This coveted funerary scripture held all the sacred guidance essential for navigating the treacherous journey to new life after death.

Due to the fact that Egyptologists found these compilations of sacred funerary texts in burial chambers — before hieroglyphs could be translated — they named them *The Book of the Dead.* Since we are now able to read the translated hieroglyphs properly, the actual title is known to be *The Book of Coming Forth by Day.*

The path to immortality

Chapter 125, "Declarations of Innocence" is a key chapter of *The Book of Coming Forth by Day.* A requisite step along the spiritual path to immortality is for the deceased to affirm innocence of committing all evil. These affirmations, rich in moral wisdom, are generally believed to be the basis for The Ten Commandments. There are forty-two declarations in all, a few listed below. The source is *The Book of Coming Forth by Day: The Ethics of the Declarations of Innocence,* translated by Maulana Karenga, 1990.

> ". . . I have not robbed.
> . . . I have not killed people.
> . . . I have not told lies.
> . . . I have not been false or dissembled.
> . . . I have not committed adultery.
> . . . I have done no evil.
> . . . I have not cursed or opposed God."

In addition to *The Book of Coming Forth by Day,* compilations of sophisticated theological concepts and values codifying belief in the supremacy of the creator of the world have been found in the tombs of some Middle and New Kingdom monarchs. These "books" or, in fact, rolls of papyrus — *The Book of Gates, The Book of the Celestial Cow, The Book of the Wanderings of the Soul* and *The Book of What Is in the Netherworld* — merely hint at the prodigious amount of spiritual guidance, measures of adherence, and declaratory, and affirmation syllabus produced by this spiritual culture so long ago.

Pillars to heaven

Upriver in Aksum, Ethiopia, near the source of the Blue Nile, soaring obelisks are thought to identify the tombs of rulers over what was once the Aksumite Kingdom. Only a handful of the hundreds of tombs found here have been excavated. In 2005 I strolled through the field of stone monoliths. I was accompanied by Fisseha Zibelo, the local Director of Antiquities for the Ethiopian Government. He oversaw research and maintenance of these precious antiquities. On this day, he agreed to take us on a tour of the various sites around Aksum, dating to the 1000-year Aksumite Kingdom straddling the period from 200 BCE to about 800 CE. He was a valuable resource with a compelling grasp of his country's history. He took us first to the Aksumite Park with the grand obelisks. Here I saw "false doors" (or spirit portals, as I prefer to call them) chiseled into the faces of a few of the obelisks. I was struck by the similarity of design — but the lack of inscriptions — to spirit portals in burial chambers and mortuary temples downriver in *Kemet.* These Aksumite "doors," which are simply carved into façades — not actual doors or even openings at all — are thought to be locations for mourners to place offerings in memory of the deceased royalty.

Without any inscriptions, Aksumite obelisks cannot be precisely dated or given attribution. On that 2005 visit, the tallest obelisk, standing in situ, rose seventy-five feet. Taller was the eighty-two-foot obelisk, weighing one hundred and sixty tons, that was missing on that visit. Three years later, it was repatriated to its original location in Aksum

by the Italians, who had looted it in 1937. The tallest obelisk here once stood an estimated one hundred feet; it toppled and broke into a few big chunks after what most archaeologists agree must have been an ancient earthquake.

Such stone monoliths to the Sun existed only in two places in Africa, in *Kemet* and the Aksumite Kingdom in Ethiopia — and both places were close to the River Nile. The forms of these grand obelisks are quite similar except the Egyptian ones (called *techen* by the people of *Kemet*) top off in a pyramid shape. The Aksumite ones (called *hawelt* in the Amharic, Ge'ez and Tigrinya languages) have rounded, crescent-shaped tops, the symbolism of which are not yet understood. The uses each culture made of their obelisks differ. Erected in pairs in front of temples and topped with pyramidions, obelisks in *Kemet* appear to celebrate the reigning king's accomplishments. Obelisks were erected as a pride of honor: the rulers with the most obelisks to their names are some of the ones we most readily recognize today: King Tutmoses II and IV, King Ramses II, King Sety I, and Queen Hatshepsut. In contrast to the *Kemet* obelisks, the ones in Aksum are believed to have served as grave markers for Kings; the façades of the largest ones exhibit carved multi-storied windows and at the bottom what seems to be a spirit portal or "false" door.

Celebrating the transit of the sun

After decades documenting Aksumite obelisks, I had begun to wonder about the decorative form that tops nearly all of the taller ones — a half circle with deep c-shaped cutouts at the base of both sides of the curve. Perhaps the path of the sun was the inspiration for this detailing. In 1893 British archaeologist James Theodore Bent (1852–1897) chronicled seeing a "representation of the solar disc" at the top of an obelisk at Aksum. Today inside Aksum's Museum of Archaeology and Ethnology a fragmented bronze roundel (circle) with a human face is on display. It was discovered in a tomb in the field of obelisks at Aksumite Park. Archaeologists believe the roundel with an indecipherable script had once been atop an obelisk.

Over years of visits to Ethiopia, I noticed that when the path of the rising and setting sun crosses the elevated horizon of the Ethiopian highlands, it often hits a ribbon of clouds causing the path to seemingly fragment. The cutouts at the tops of the obelisks symbolize for me that moment when the sun appears to break up.

Early one morning I climbed a hill overlooking the field of obelisks at Aksumite Park to capture with my camera the rising sun at the horizon. I believe that with their ancient design, the ancients might have been celebrating the transit of the morning and evening sun as I seek to do with my camera today. One day archaeologists and linguists will find a key to unlock this cultural expression of the Aksumite Kingdom. Perhaps then these mysterious mute monuments will reveal their origin and purpose. Until that time, we can contemplate and imagine.

Sealed for eternity

The most enduring symbols of death for me are the pyramids of *Kemet* and *Nubia* where they still dominate the landscape so many thousands of years after they were built. After the royal corpses, ceremoniously mummified and wrapped in linens, were placed inside their pyramid tombs and secured, the tombs were sealed for eternity.

Rising four hundred and fifty feet above the Giza Plateau in Cairo and built in 2560 BCE, the Great Pyramid of King Khufu was until 1887 the world's tallest structure; its original facing of white limestone reflected sunlight across the desert — that is, until this outer layer was removed in the 7th century CE to be reused for building projects in Cairo. Today visitors enter via a tunnel hacked by robbers. Deep in the belly of the Great Pyramid, I came to what I think of as its spiritual heart: the Grand Gallery. For sixty-nine feet, this Gallery gradually ascends underneath a three-story corbeled vault ceiling (supported by stone slabs that progressively overlap and finish with one slab in the center). Inside, all exterior sound is blocked by the dense walls. The result is an atmosphere of charged silence, akin to the hush of a cathedral. At the end of this one hundred and forty-three-foot-long Grand Gallery is the King's Burial Chamber, wherein a huge empty stone sarcophagus remains. King Khufu's remains have never been found.

On an earlier visit in 1986 before the City of Cairo encircled the Giza Plateau pyramids, I hired a horse cart with driver to take my wife and me a couple of miles into the desert behind Khufu's towering pyramid and the two adjacent, slightly smaller pyramids constructed for the remains of Khufu's son and grandson. In the gathering darkness with the stillness of the heavens above, we watched these three timeless structures shrink to tiny swellings on an otherwise flat horizon. Spotlighted in the glow of a full moon, the pyramids seemed to dance for us in a celestial ritual of eternity.

Priceless treasures

Early in the twentieth century, upriver at Luxor in the Valley of the Kings, Tutankhamen's tomb was found by an amateur English archaeologist Howard Carter (financed by the English Lord Carnarvon). To date it remains the single most spectacular cache of ancient burial goods ever unearthed. So elaborate and spellbinding were the contents of this 3,345-year-old royal tomb — including three solid gold coffins, gold jewelry, exquisite furniture, weaponry, and shrines — that this discovery in 1922 mesmerized and propelled the world on a feverish path toward prolonged Egyptomania. Even so, this tiny twelve by fifteen-foot tomb of 18th Dynasty boy King Tutankhamen remains the only one discovered in modern times that had not already been looted in antiquity. My imagination takes flight when I compare Tutankhamen's small tomb to the grand forty-five-by-one-hundred-foot tomb of 19th Dynasty King Sety I (who died in 1279 BCE). What inconceivable treasures must have packed this mammoth tomb before it was emptied in ancient times! Such a complicated culture, spiritually and technologically advanced with cumulative wealth, made *Kemet* a force with which to be reckoned, admired, and ultimately emulated.

Undisturbed by human footsteps

I was introduced to *Nubian* pyramids in northern Sudan while working there in 2000, 2002 and again in 2006. Curiously Sudan has more than two hundred and fifty pyramids, far exceeding the one hundred or so

in Egypt. Of course nothing is as impressive as the Great Pyramid at Giza. For one thing, *Nubian* pyramids are shorter, rising on average about one hundred feet at roughly a sixty-degree angle, as compared to a more gradual forty-five-degree slope of the pyramids in Egypt. In addition, many are badly damaged, some through erosion and some vandalized since ancient times by treasure hunters. But there are more pyramids standing in Sudan, and the effect of so many clustered together in vast royal burial grounds with attached chapels is stunning.

In 2000, we visited the pyramids at ancient Meroe, about one hundred and sixty miles north of Khartoum between the Nile's fifth and sixth cataracts. I pitched my tent within sight of the Meroe Necropolis, the royal burial grounds. At sunrise on the first morning, I rose for a walk to the northern pyramid field. The rose-tinted sand was undisturbed by footsteps; dunes still held the mesmerizing wave patterns left by night winds. In the shimmering radiance of the rising sun, I set up my tripod to make photographs of the east-facing chapels fronting the pyramids. The gentle morning wind was my only companion. Meroe's monarchs are buried in tombs below the pyramids, not inside the structure itself as they were in *Kemet*. I passed between pylons through a doorway-sized opening into chapels to document scenes of rituals carved into the walls. In one, a young woman priest leans forward in the presence of her deity to pour a liquid libation on what looks like an altar to the spirit of the deceased *Kandake,* buried in the tomb below the chapel. I have, I realized, witnessed this exact scene many times in my lifetime. In Ethiopia, *Waaqeffanna* priests pour fermented libation beside the sacred lake during *Erecha* ceremonies to honor the ancestors. In West Africa, I have witnessed similar scenes in which the officiant calls out the name of the deceased before pouring liquid directly onto the ground.

By mid-day at the pyramid field, the sun was directly overhead and the temperature reached 120° — too hot to work. Later that afternoon I returned with a single strobe and selected one of the chapels to light from within. I wanted to illustrate the possibility of a spiritual presence within — backlit with the drama of the sunset.

Farther north between the Nile's third and fourth cataracts is the El-Kurru Necropolis, site of tombs of 25th Dynasty monarchs of *Kemet* and *Nubia*. Over time, pyramids here have eroded, dissolving to mounds. I was so impressed by one tomb that I returned to it on three successive photography trips. It is the burial site of Queen Qalhata, consort of 25th Dynasty King Shabaka. Except for water damage obscuring the bottom of some walls, the paintings are remarkably well preserved. After examining the photographs yielded by my first two sessions, I determined that there were some important enhancements I needed to make to illuminate and capture the exquisite details in the three small compartments of this tomb. I would need more lighting equipment than I had used on those first two trips, if I were to truly reveal the majesty of this space. I was committed to going back for a third foray. So in 2006 I had come fully prepared with a diffused lighting system to capture the rich colors and fine detail of the tomb images still preserved here. The scenes demonstrate a profound reverence for the rituals of death. They reveal intimate ceremonies, some of Queen Qalhata with her family and deities. In paintings in the first chamber, the deity *Heru* tenderly holds the Queen's hand as he leads her into the Afterlife. The second chamber holds paintings of the mummy of the Queen, portrayed Sphinx-like, lying on her stomach on a daybed crafted with the legs and tail of a lion; here, she gazes into the eyes of her successor who performs a re-animation ritual to enable her to exist in the next world.

Witness to the imperishable night

In many ways faith offers both a "passport" to eternity and a map to the afterlife. Outside Queen Qalhata's 1st century BCE tomb in the windswept desert, I am yet another witness to the imperishable night sky of *Nut* shimmering with billions of bright stars — the constant companions of all souls under the gaze of tomorrow.

In the dance of eternity, we are all spirits passing through human form.

Amen

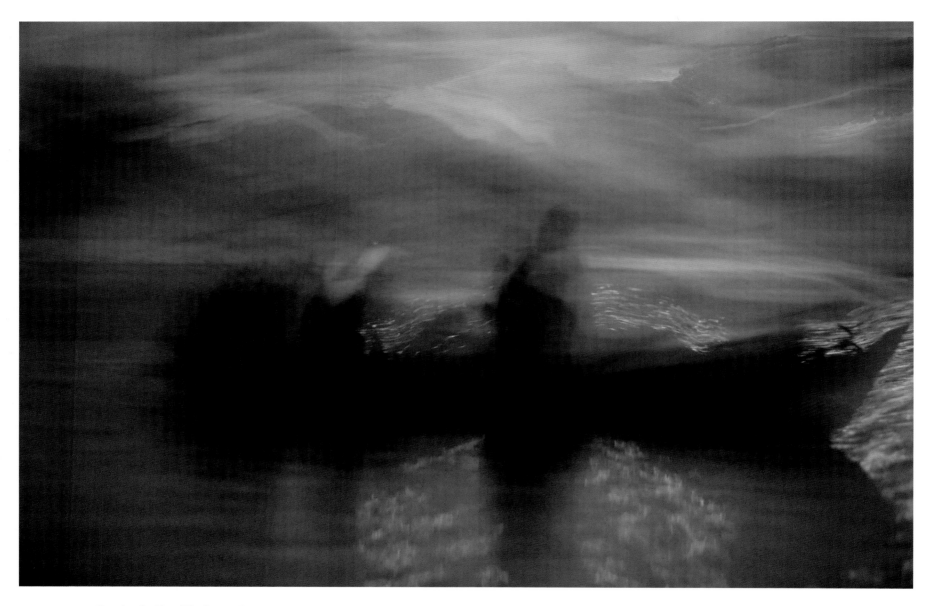

Crossing the River Nile. Aswan, Egypt, 2007

Kemet — Full moon over the pyramids, Dynasty 4. Giza Plateau, Cairo, Egypt, 1986 ⟶

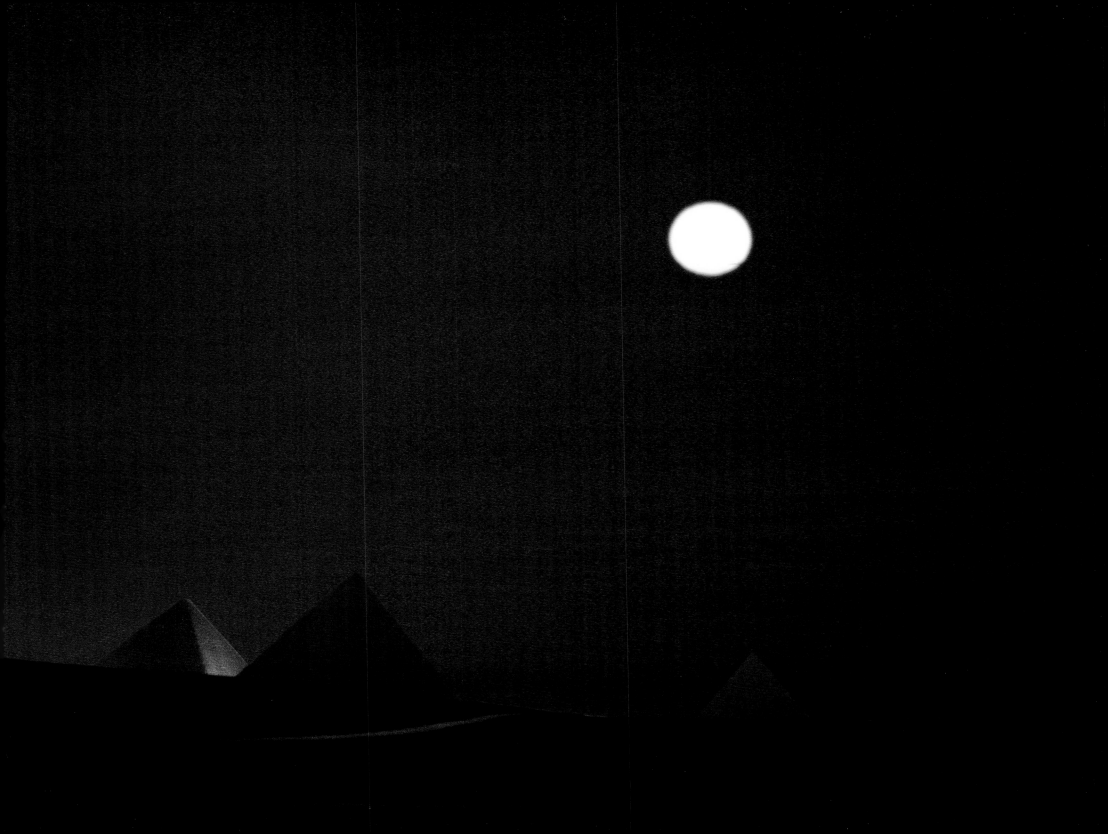

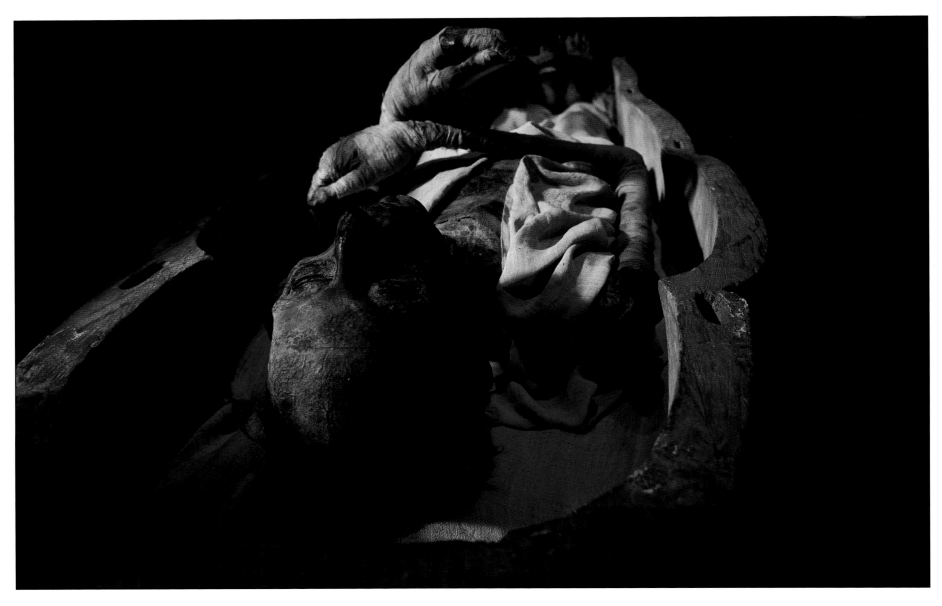

Kemet — Mummy of King Ramses II (1303 to 1213 BCE), Dynasty 19. The National Museum of Egyptian Civilization. Cairo, Egypt, 2003

Kemet — Mortuary Temple (c. 13th century BCE) of King Ramses II. West Bank, Luxor, Egypt, 2007 ⟶

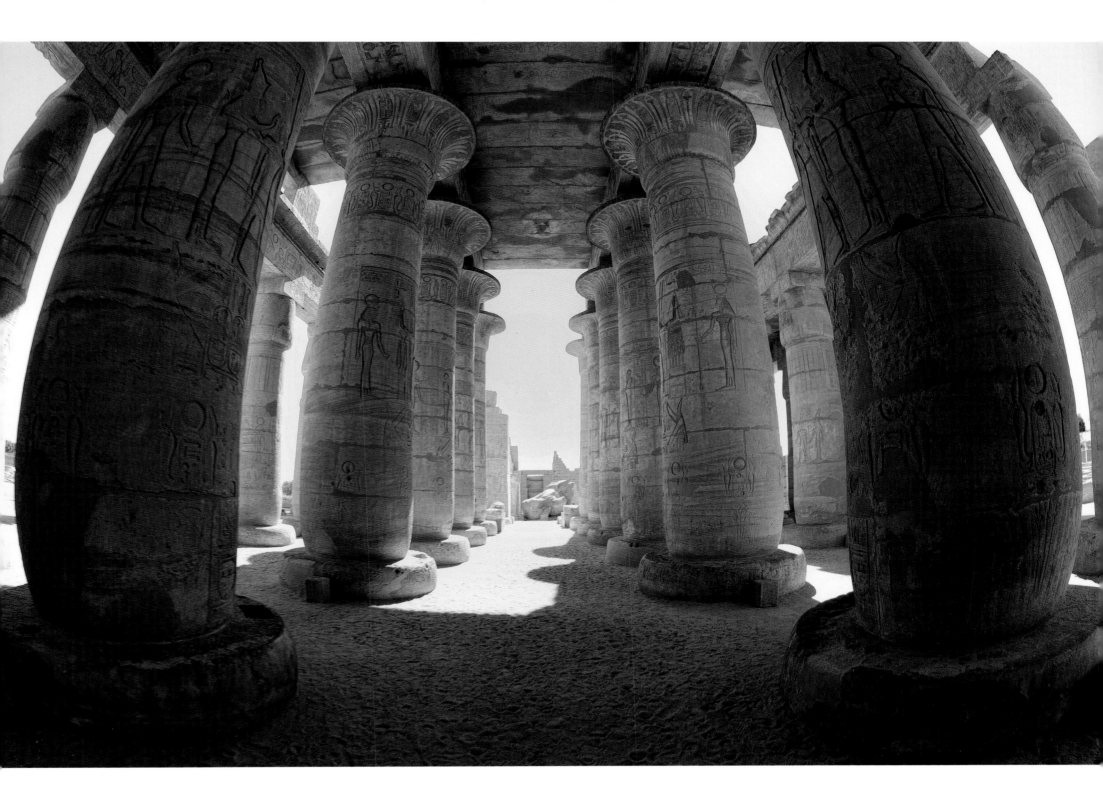

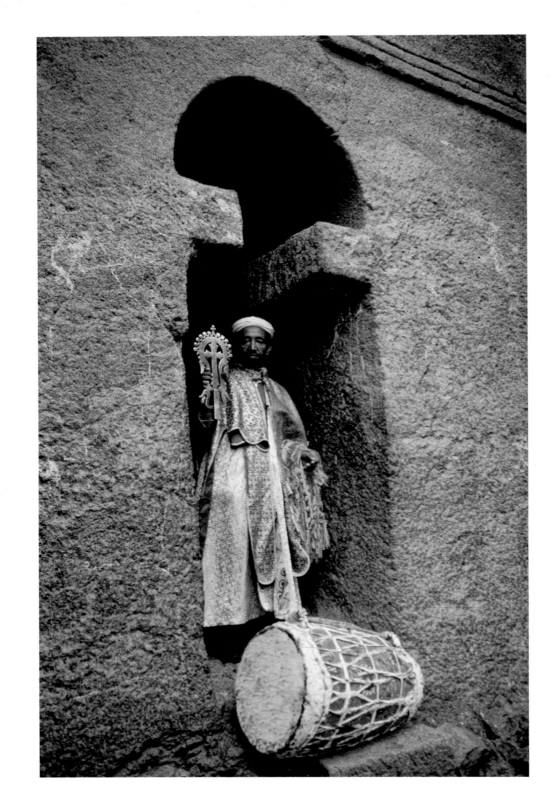

Priest in obelisk-shaped doorway of 13th century *Bete Medhane Alem* (Church of the Savior of the World). Lalibela, Ethiopia, 1974 ⟶

Aksumite Kingdom — Grand obelisk, a royal tomb marker (erected as early as 400 BCE) in the Aksumite Necropolis. Aksum, Ethiopia, 2016 ⟶

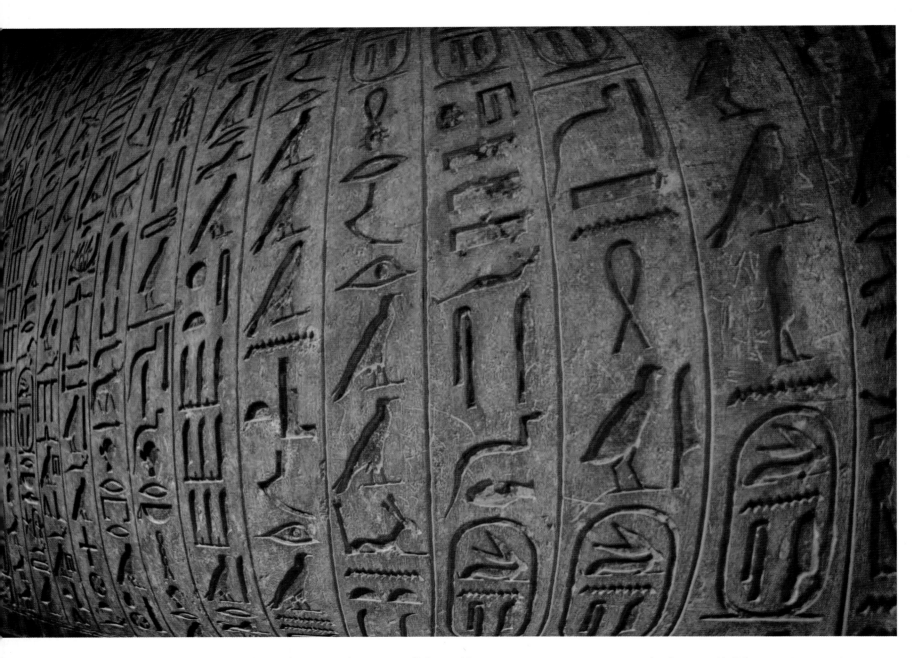

Kemet — First-known compilation of a written Holy Scripture, called *Pyramid Texts*, was chiseled here in 2500 BCE. Pyramid of King Unas, Dynasty 5. Saqqara, Egypt, 1999

Kemet — Antechamber. Pyramid of King Unas, Dynasty 5. Saqqara, Egypt, 1999 \longrightarrow

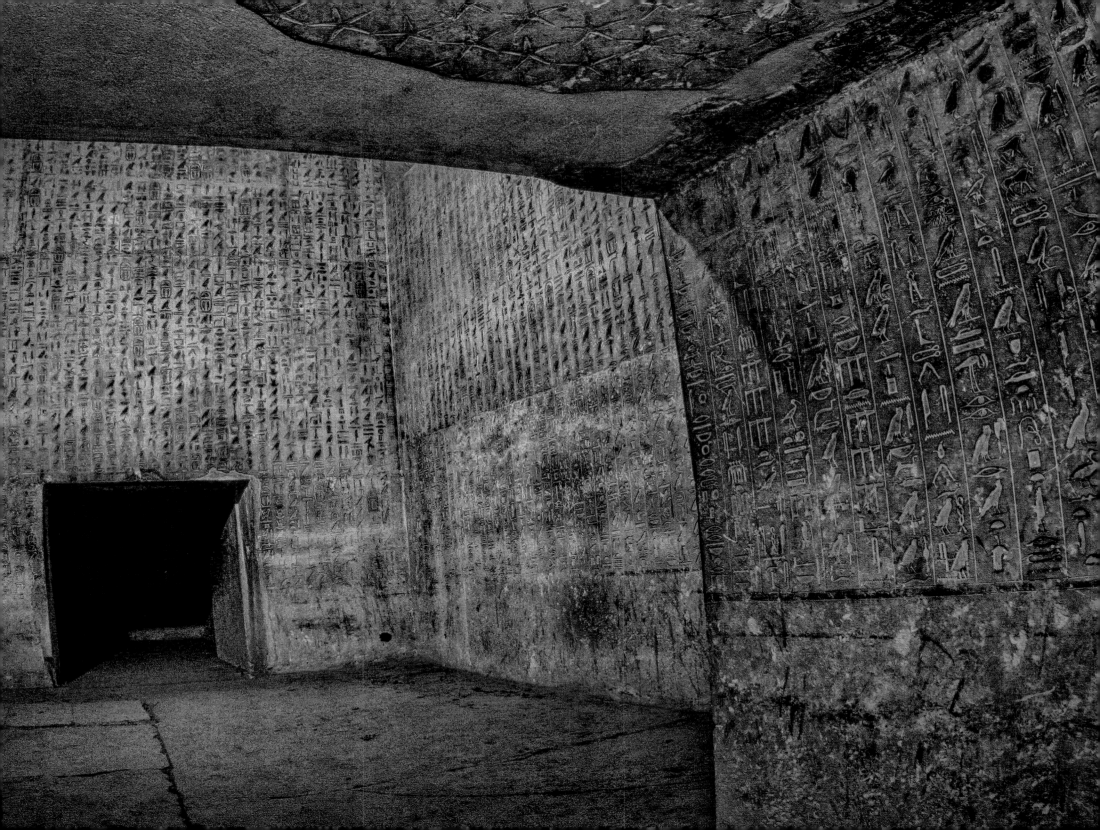

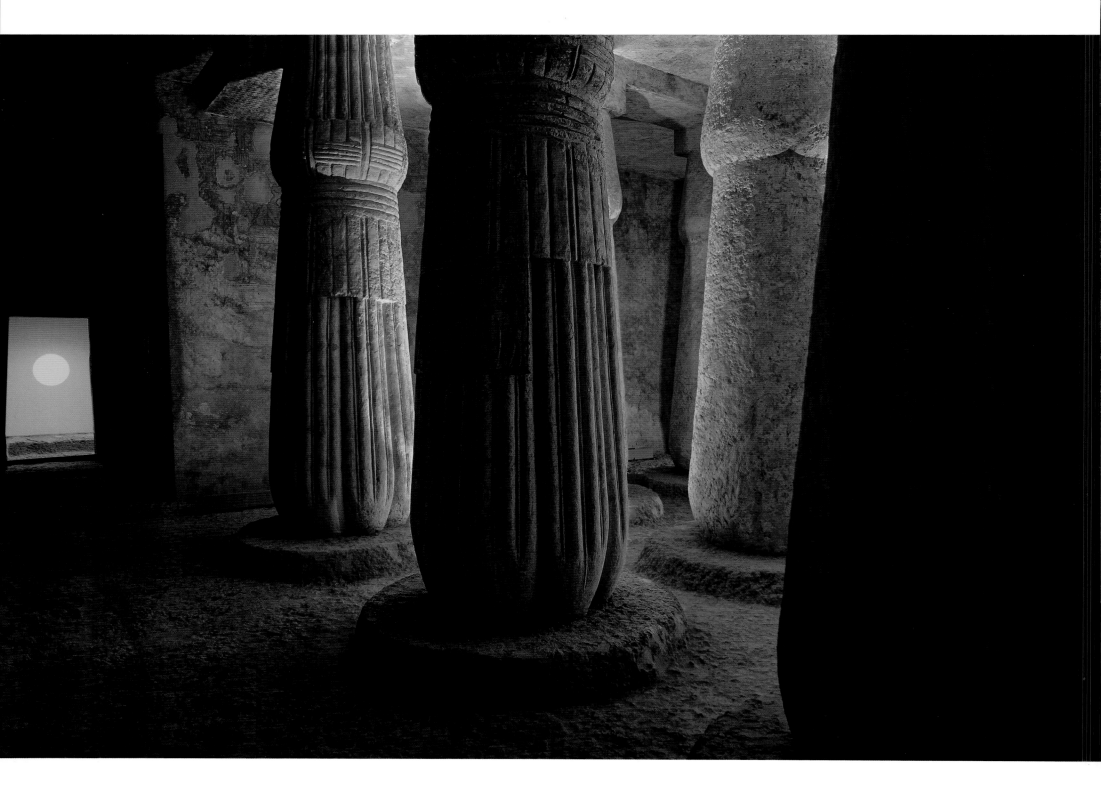

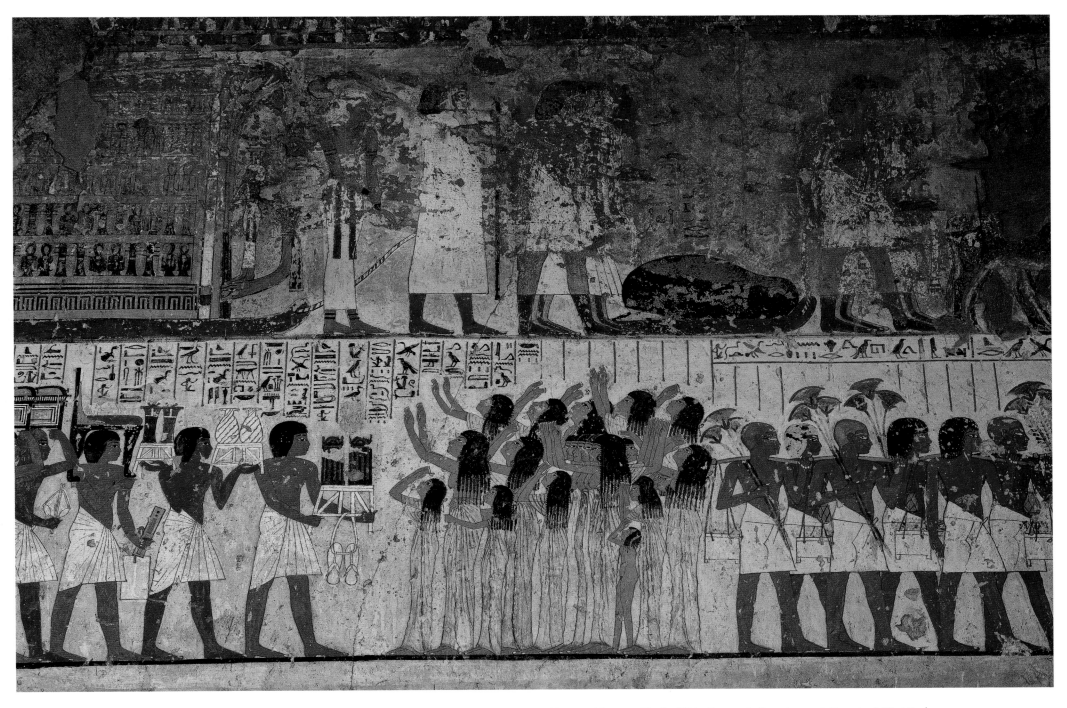

Kemet — Unfinished Tomb of Vizier Ay (who became king after Tutankhamen), Dynasty 18. Amarna Period (1353 to 1336 BCE). Minya, Egypt, 2019

Kemet — Mourners. Tomb of Vizier Ramose (14th century BCE), Dynasty 18. West Bank, Luxor, Egypt, 2019

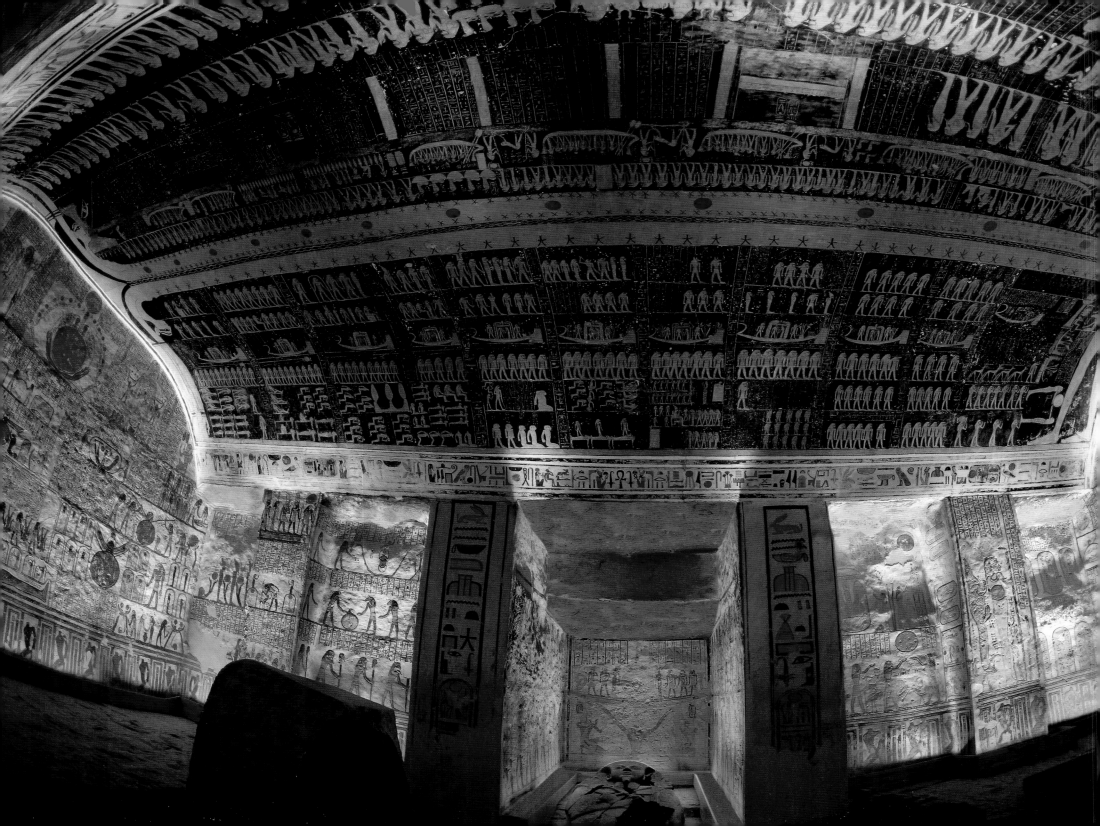

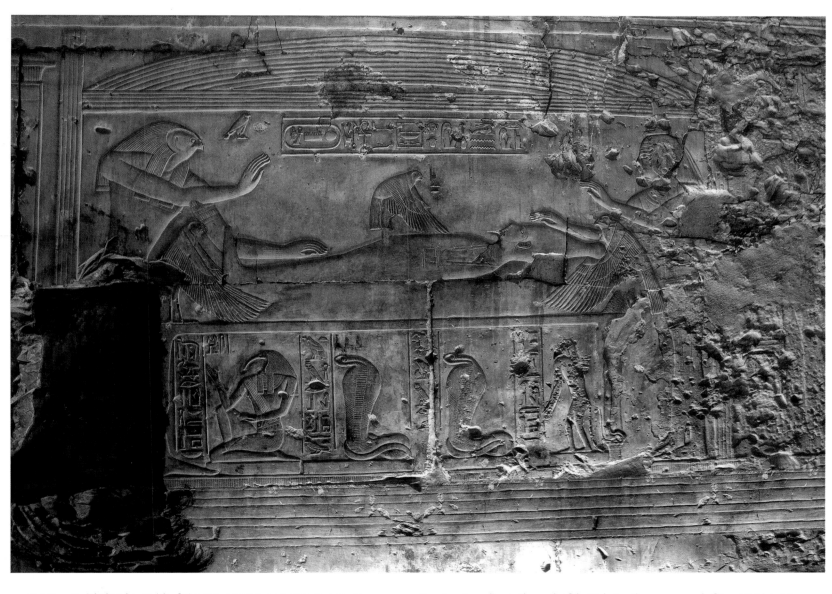

← *Kemet* — Burial Chamber. Tomb of King Sety I (1323 to 1279 BCE), Dynasty 19. Valley of the Kings. West Bank, Luxor, Egypt, 2019

Kemet — According to the myth of the Holy Family — composed of *Asar* (Osiris), *Ast* (Isis) and their son *Heru* (Horus) — *Ast's* husband *Asar* was murdered and dismembered by his jealous brother *Seth*. After *Ast* collected the body parts of her husband, she reassembled and mummified his body. In this scene, she is depicted as a bird spiritually receiving the mummified *Asar's* seed. 3,300-year-old Temple of *Asar*, built by King Sety I, Dynasty 19. Abydos, Egypt, 2019

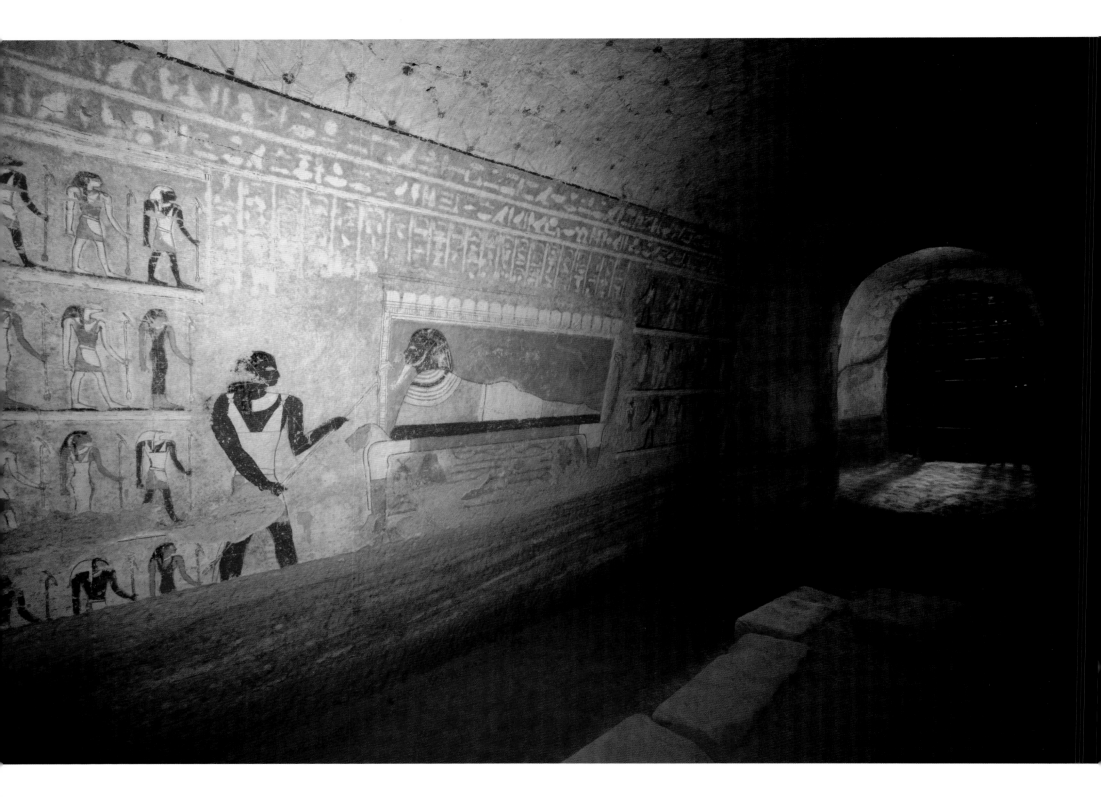

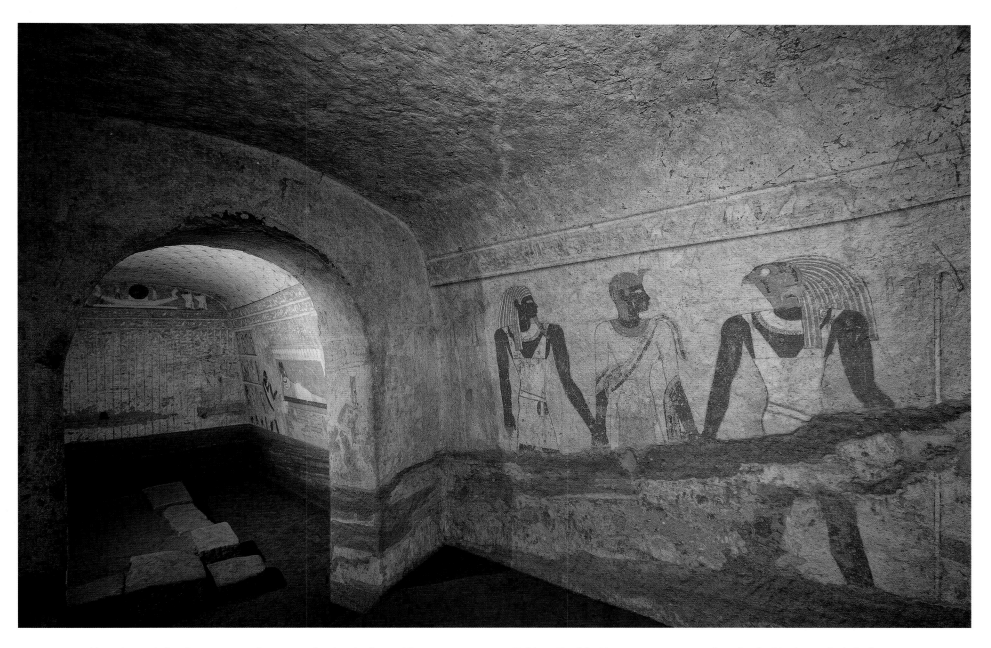

←— *Nubia* — Queen Qalhata's successor performs a re-animation ritual to enable her spirit to exist in the next life. Tomb of Queen Qalhata, al-Kurru Necropolis, Sudan, 2007

Nubia — The deity *Heru* (Horus), represented as a hawk with a human body, leads Queen Qalhata into the Afterlife. Tomb of Queen Qalhata, al-Kurru Necropolis, Sudan, 2007

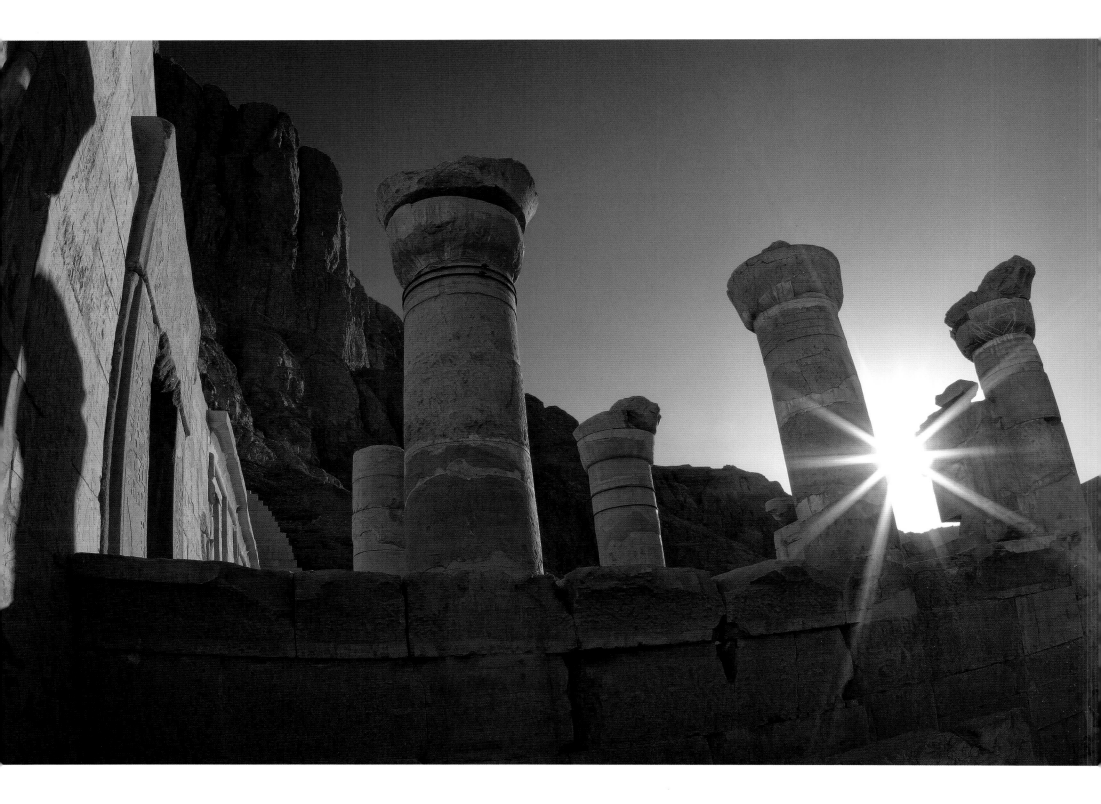

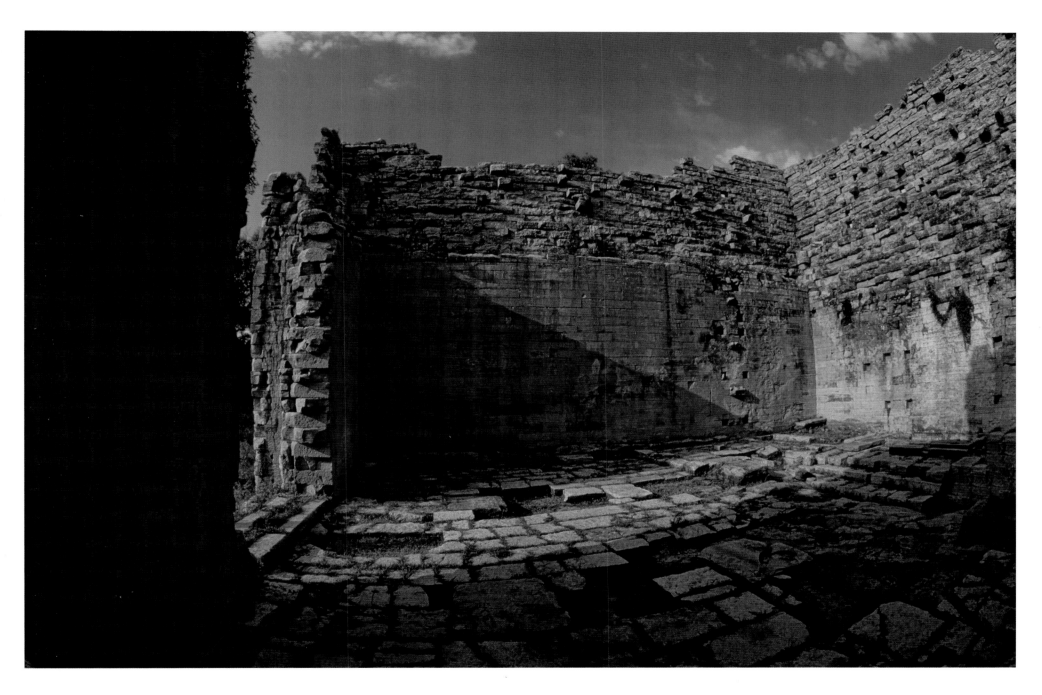

←— *Kemet* — Upper terrace Chapel of the Mortuary Temple of Queen Hatshepsut; the entrance, at left, is a sanctuary for *Amen*. Dynasty 18. West Bank, Luxor, Egypt, 2019

Pre-Aksumite — Temple of the Moon (c. 500 BCE). Yeha, Ethiopia, 2003

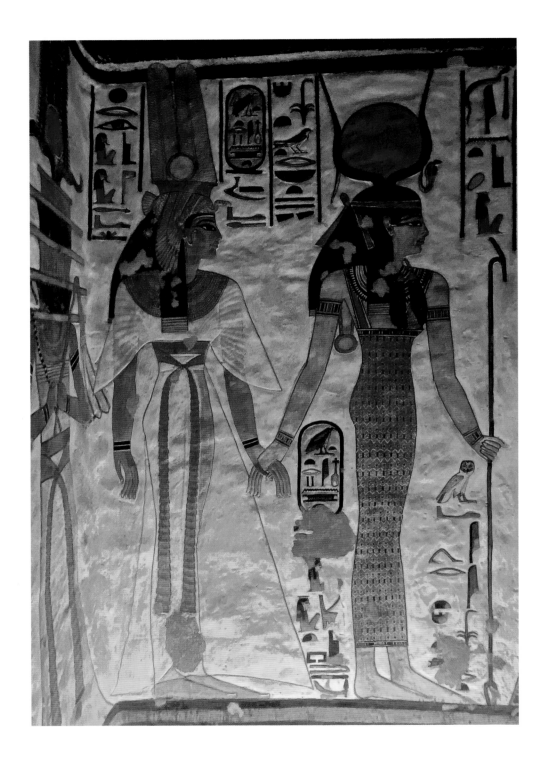
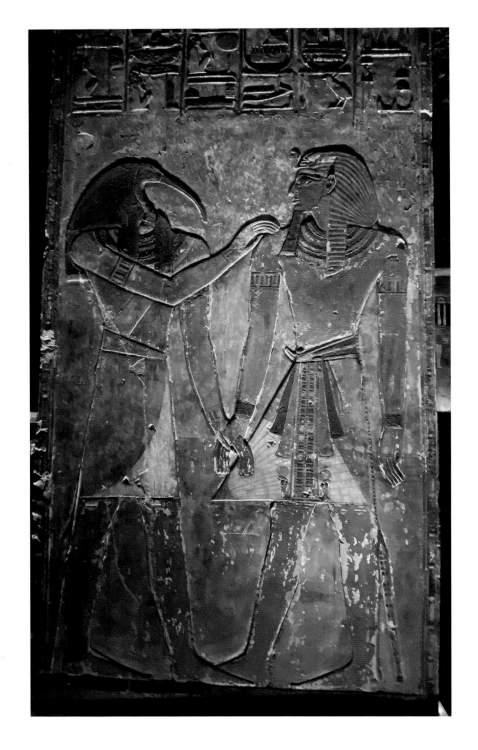

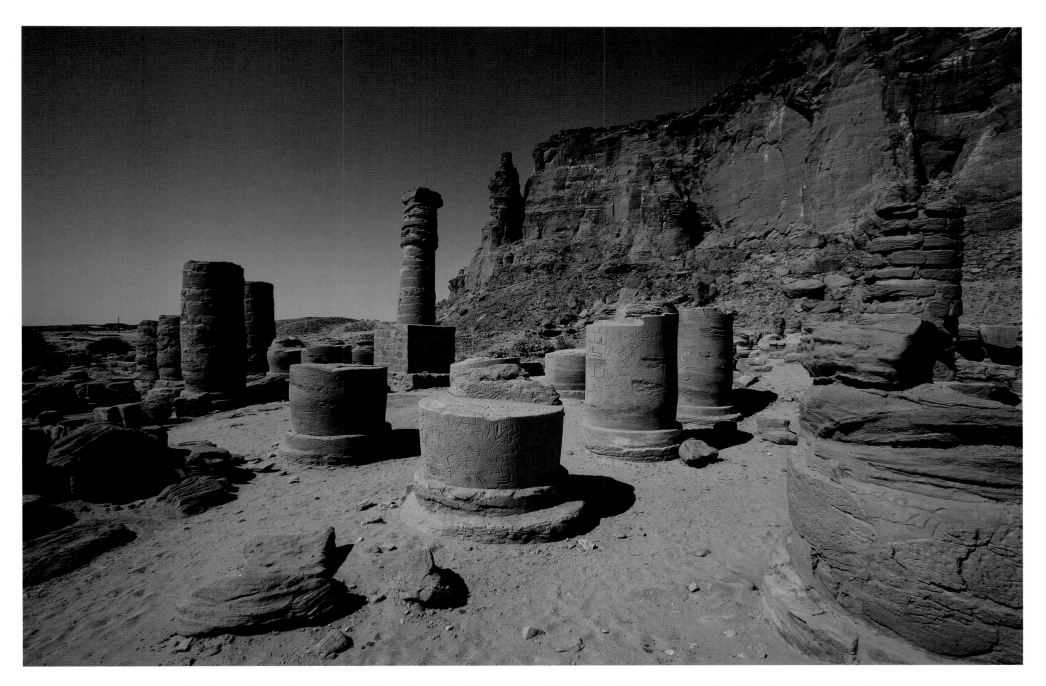

←—— *Kemet* — *Ast* (Isis), Mother of Resurrection, leads Queen Nefertari into the Afterlife. Tomb of Queen Nefertari (1300 to 1255 BCE). Valley of the Queens, West Bank, Luxor, Egypt, 2019

←—— *Kemet* — *Tehuti* (Thoth), deity of wisdom, leads King Sety I into the Afterlife. Tomb of King Sety I, Dynasty 19. Valley of the Kings, West Bank, Luxor, Egypt, 2001

Nubia — Ruins of the 1500 BCE *Amen* Temple Complex at the base of the Pure Mountain. Gebal Barkal, Sudan, 2007

←— *Kemet* —— The 4600-year-old Red Pyramid of King Sneferu, seen from the interior passageway of the Bent Pyramid. Dashur, Egypt, 2000

Muslim funeral ceremony. Negash Amedin Mosque, built on the site of the first settlement of Muslim refugees including relatives of Mohammed escaping persecution in the 7th century. Negash, Ethiopia, 2011

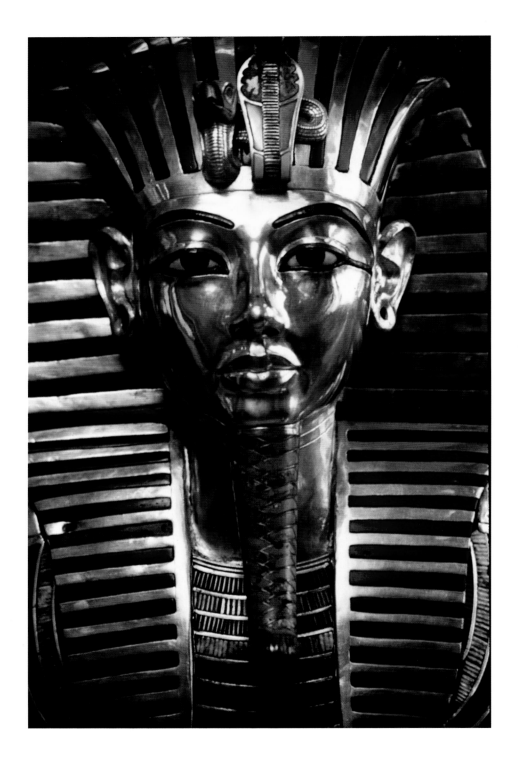

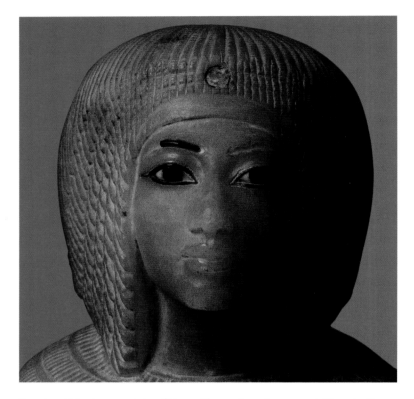

Kemet — Alabaster canopic jar of Queen Ahmose (1504 to 1492 BCE), Dynasty 18. Grand Egyptian Museum. Cairo, Egypt, 2001

←— *Kemet* — Gold funerary mask (C. 3424 BCE) of King Tutankhamen, Dynasty 18. Grand Egyptian Museum. Cairo, Egypt, 2001

Nubia — Ceramic canopic jar from an 18th Dynasty Egyptian tomb at Serra East in northern Sudan. National Museum of Sudan. Khartoum, 2001 —→

Nubia — Royal *Shawabti*, holding a plow, from the tomb of King Taharka at the Nuri Royal Necropolis. Napatan Period (900 to 300 BCE). National Museum of Sudan. Khartoum, 2001 —→

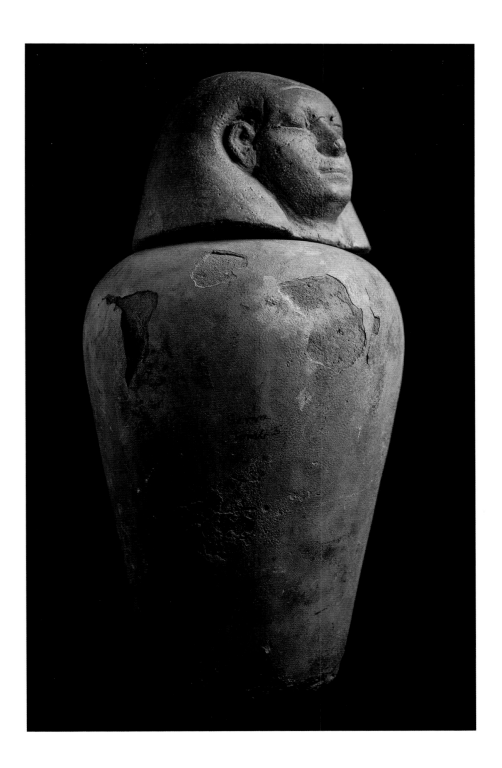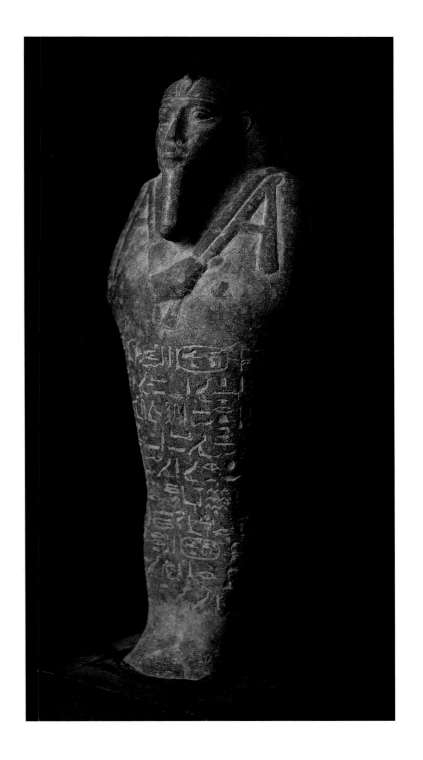

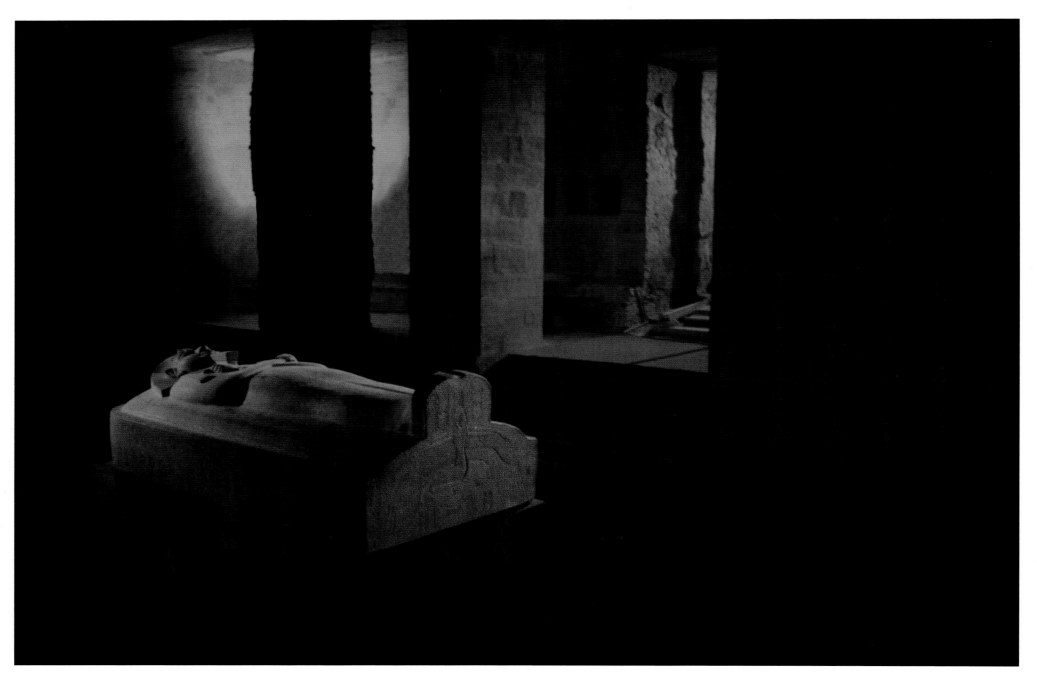

Kemet — Tomb of King Merenptah (13th century BCE), Dynasty 19. Valley of the Kings. West Bank, Luxor, Egypt, 2001

Waaqeffanna Necropolis for women priests serving the supreme deity *Waaqa* of the Oromo people. Borja, Ethiopia, 2007 ⟶

208

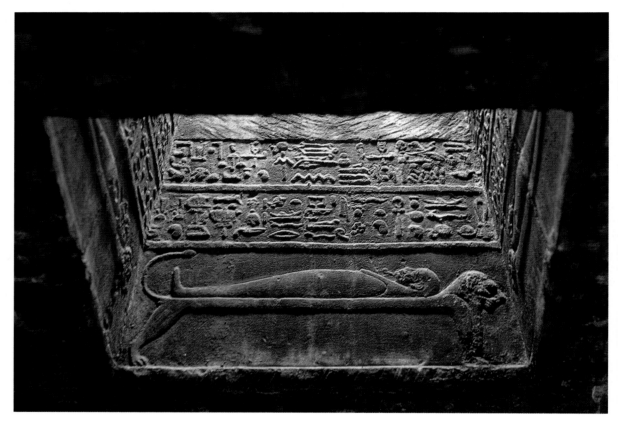

Kemet — Rendering of a mummy on a bier. 1st century BCE Temple of *Het Heru* (Hathor), Ptolemaic Period. Dendera, Egypt, 2004

⟵ *Aksumite Kingdom* — Necropolis, called Gudit Stelae Field (mid-2nd to mid-4th century). Aksum, Ethiopia, 2016

Nubia — Interior of the Temple of *Mut,* commissioned by King Taharka (king and *qore* from 690 to 664 BCE). Napatan Period (900 to 300 BCE). Gebel Barkal, Sudan, 2007 ⟶

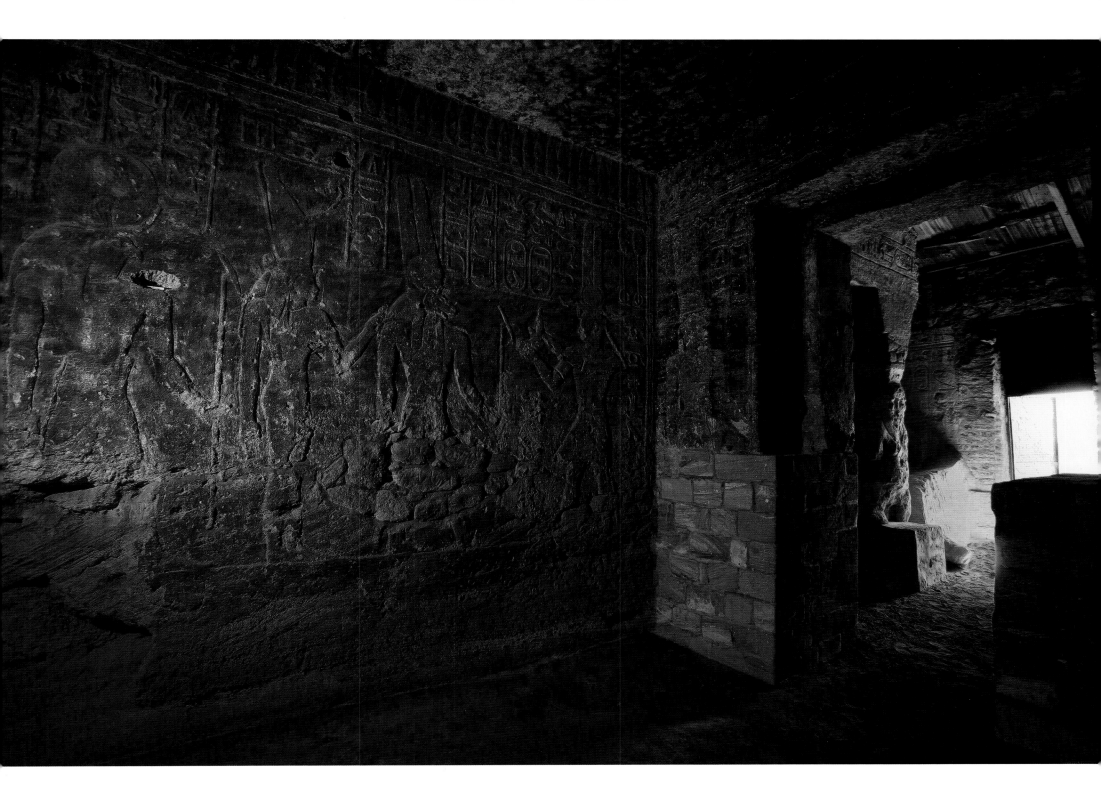

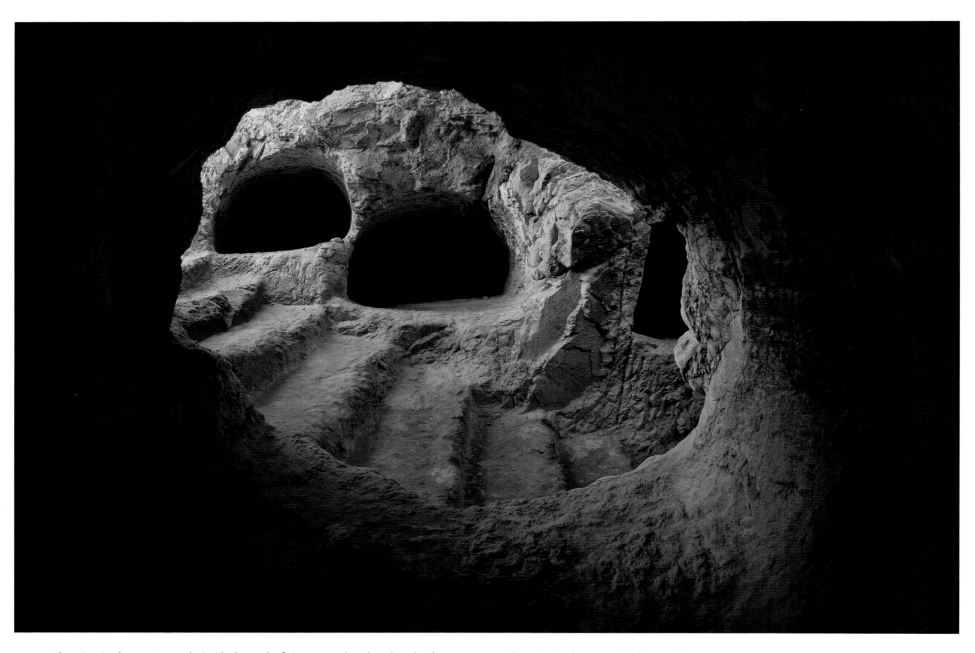

Aksumite Kingdom — Catacombs inside the Tomb of King Bazen (thought to have lived around the time of Jesus Christ). Royal Necropolis. Aksum, Ethiopia, 2016

Aksumite Kingdom — Tomb of King Kaleb (c. 500 CE). Royal Necropolis. Aksum, Ethiopia, 2016 ⟶

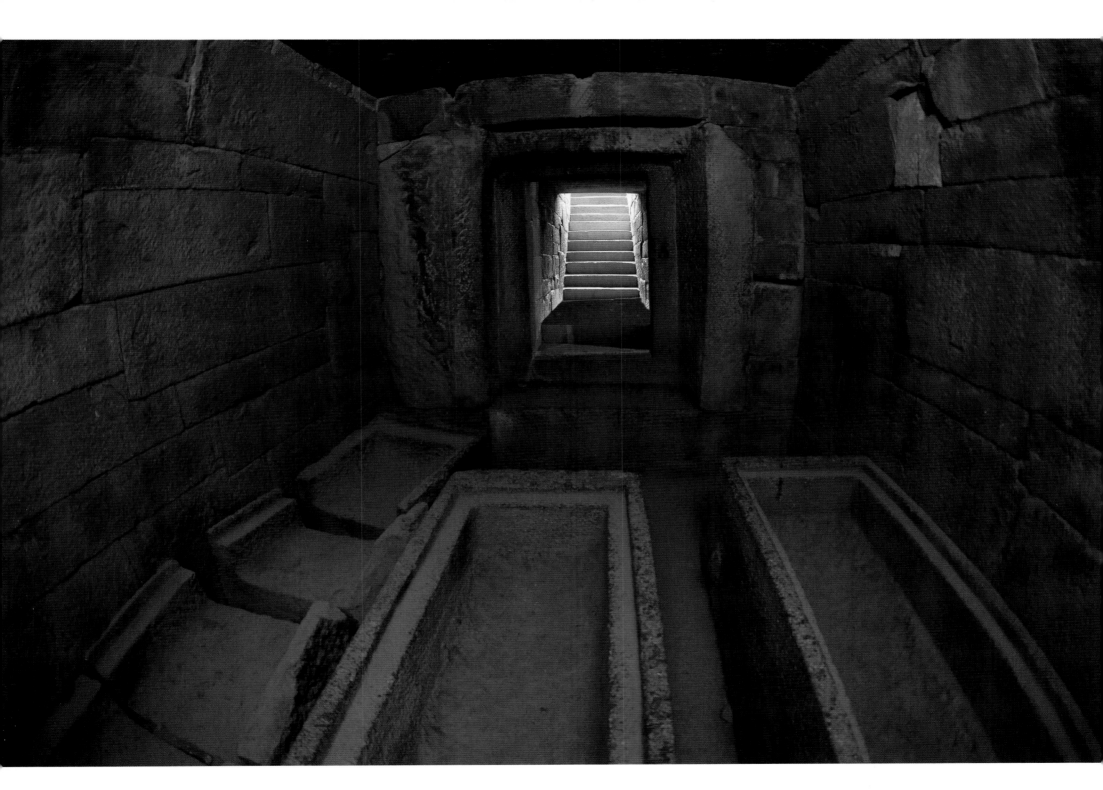

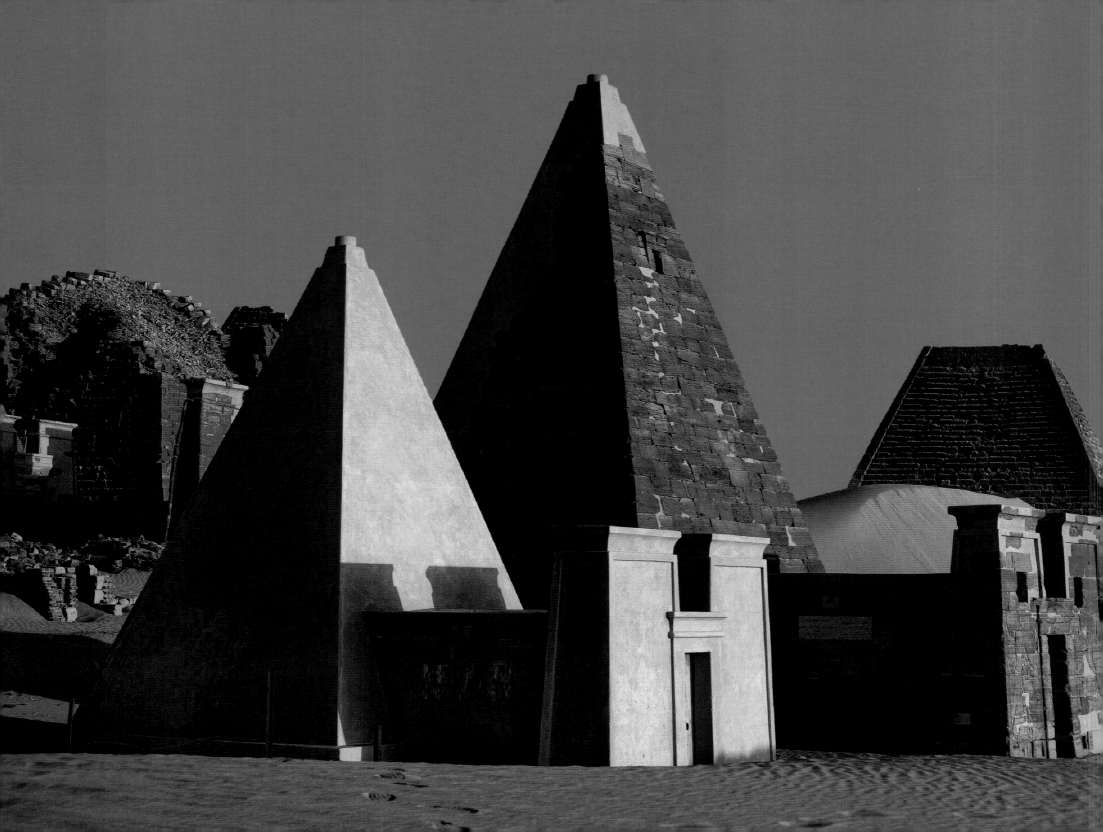

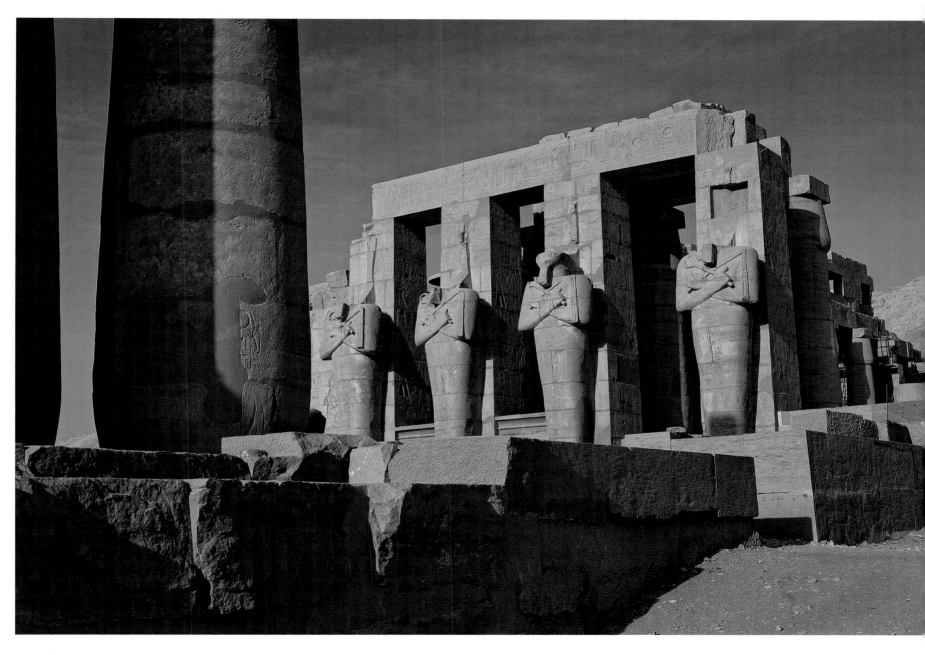

← *Nubia* — Northern Royal Necropolis, Meroitic Period (300 BCE to 350 CE).
Meroe, Sudan, 2007

Kemet — 13th century BCE Mortuary Temple of King Ramses II, Dynasty 19.
West Bank, Luxor, Egypt, 2007

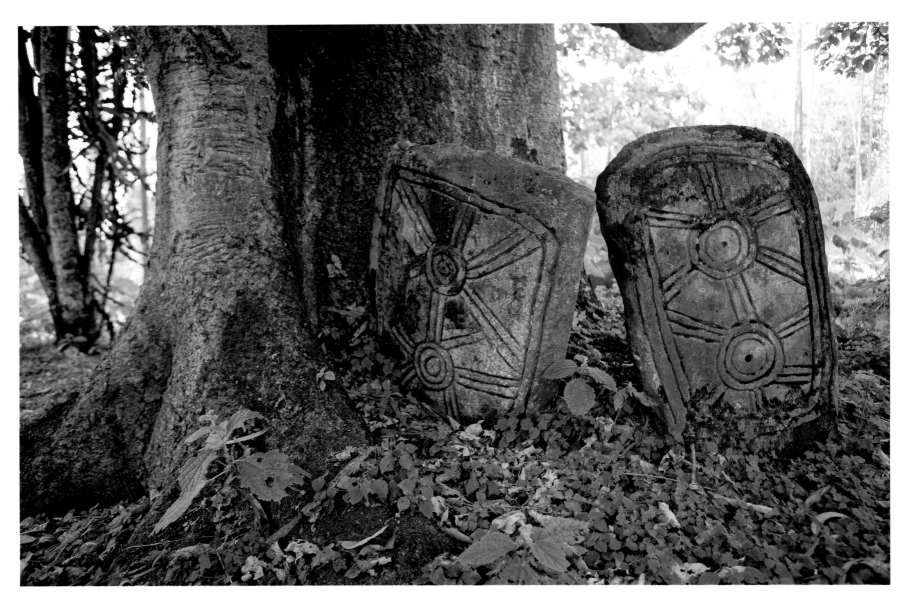

The engravings on these Oromo tombstones suggest celestial markings, perhaps symbolizing the two eyes of the sky (the sun and the moon). Kofele, Ethiopia, 2013.

Nubia — Sunset at the Third Cataract. River Nile, Sudan, 2001 ⟶

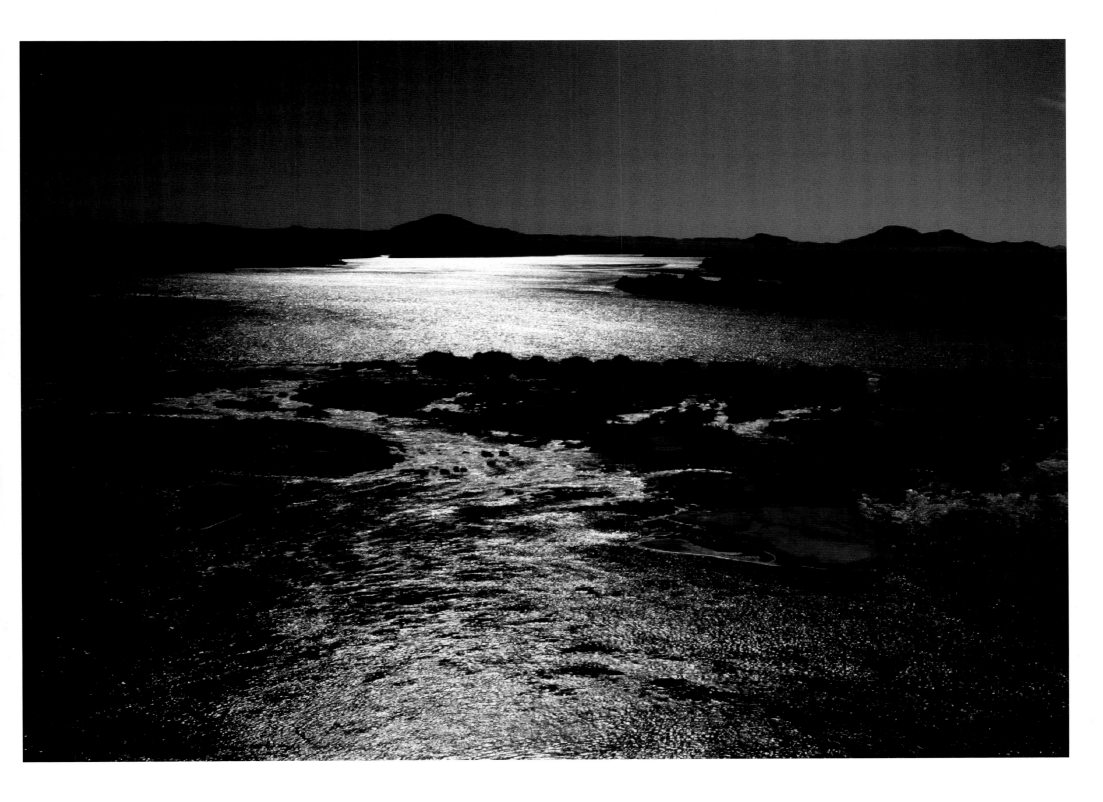

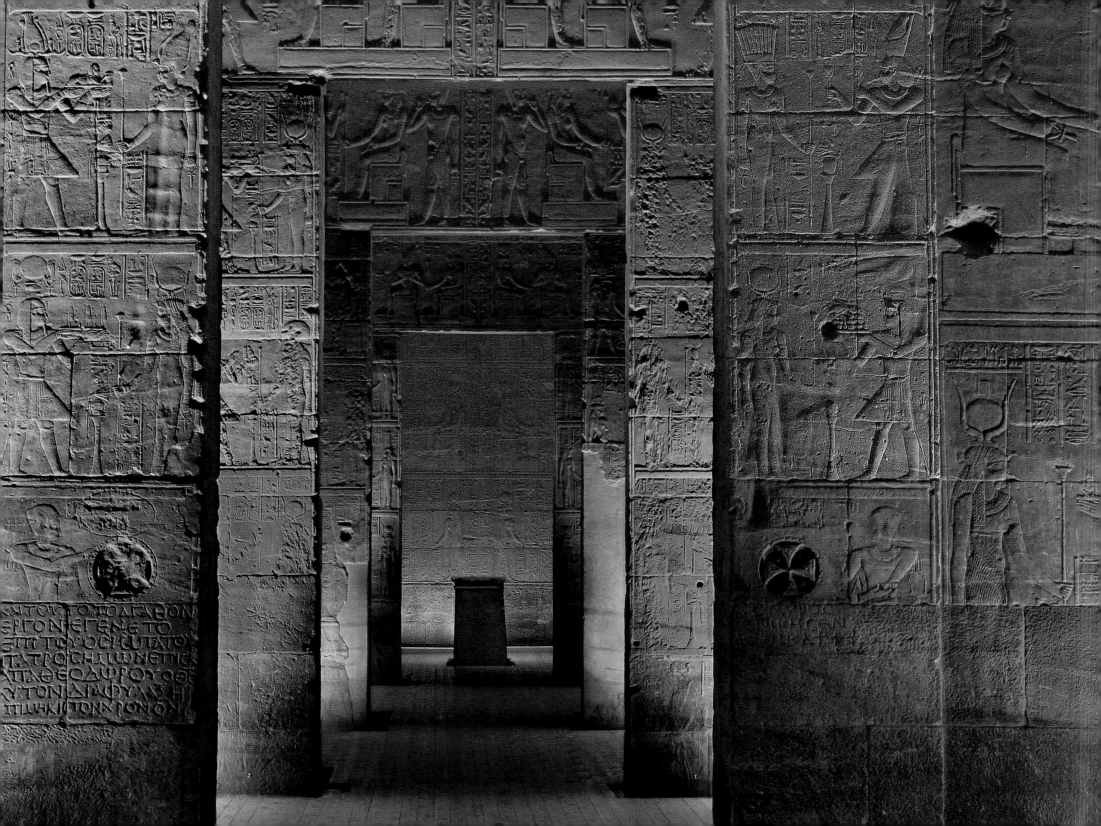

←—— *Nubia* — Ptolemaic Period Temple of *Ast* (Isis) at Philae, built c. 280 BCE by the last Egyptian king. Dynasty 30. Aswan, Egypt, 2007

←— Inside this sarcophagus with Aksumite iconography are the remains of the last Emperor of Ethiopia, Haile Selassie. Cathedral of the Holy Trinity. Addis Ababa, Ethiopia, 2010

Aksumite Kingdom — Tombstone in the burial area sometimes called Gudit Stelae Field (mid-2nd to mid-4th century). Aksum, Ethiopia, 2016

The Milky Way from the 8,600-foot-high sacred cave of the rock-hewn church *Abune Yemata Guh*. Hawzen, Ethiopia, 2011 —→

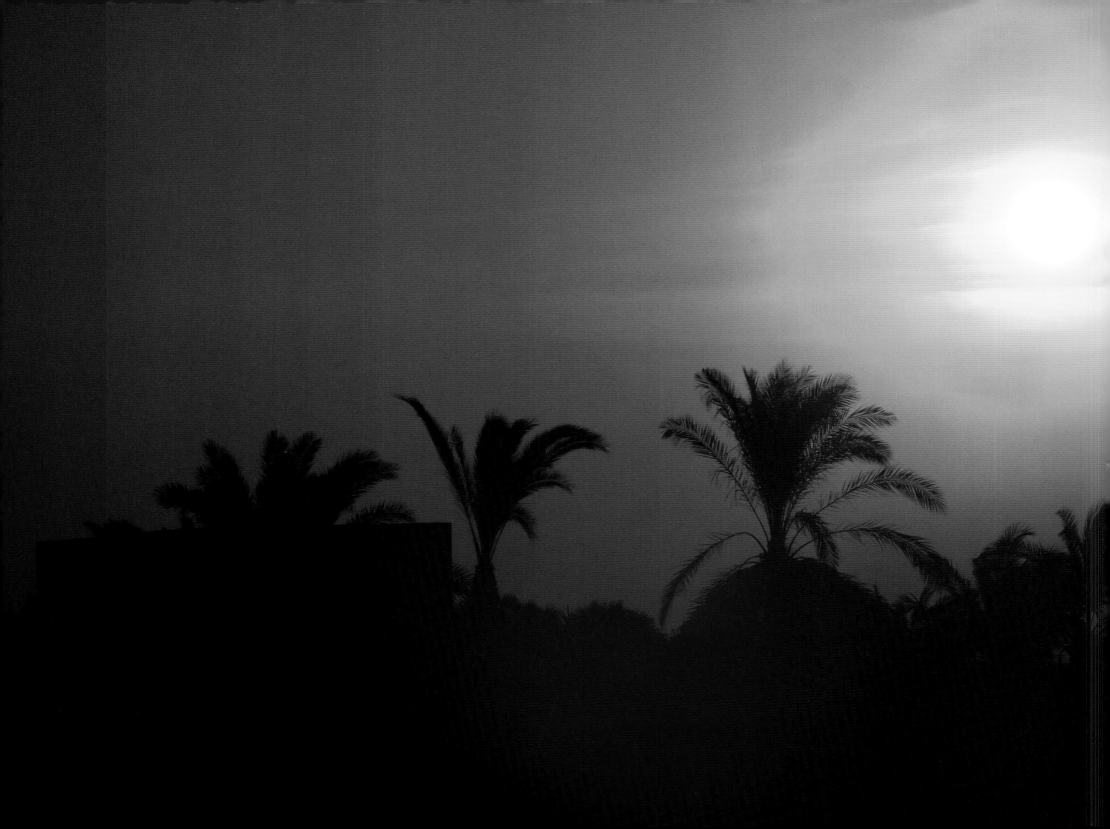

Epilogue

Religion is the result of metaphysical thinking. It is sacred pageantry, with overtones of elaborate heart-skipping and soul-inspiring splendor.

It's been with us, it seems, since the beginning of time. Some places more than others feel connected to the ancestors — where deep roots go back generation after generation, millennium after millennium. We felt this thread of connection along the Sacred River Nile. Here, religion isn't just a part of life; it is more often lived as life. The joy of those assembled was palatable and all-embracing.

In the mystic traditions of different religions, we found a remarkable unity of spirit.

Spirit is eternal.

Amen

Along the banks of the River Nile. Egypt, 1979

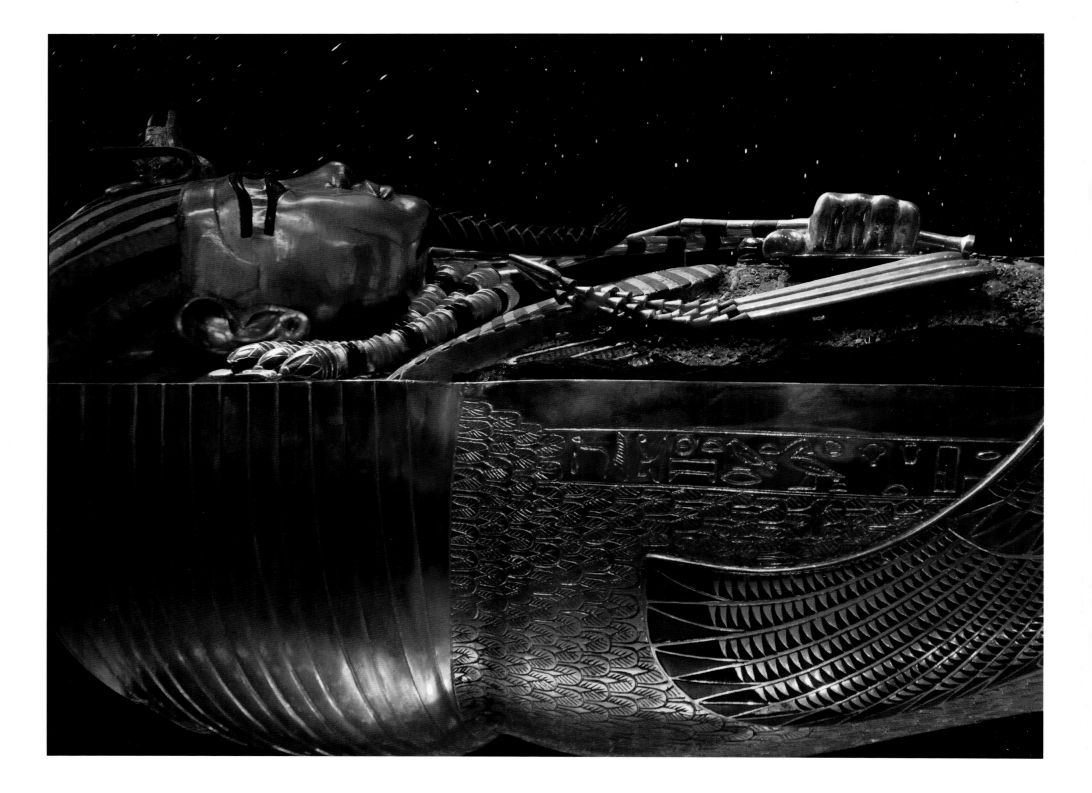

Related Readings

Below is a list of books that I have found to be most helpful over the years in my research of seminal beliefs and expressions of spirituality, faith and religion among earth's earliest civilizations. They are great companions on any journey along the Nile.

This list of related readings is organized according to the chapters of *Sacred Nile* to which they are most relevant. The list is further ordered alphabetically by the author's surname. Many volumes are no longer in print or might be difficult to obtain outside a rare book dealer's catalogue. Still, there are many that can be found online, in libraries, and some which are mainstream and more readily available.

I include those books whose content I have quoted in *Sacred Nile* in the appropriate chapter. There are a few volumes I mention that are deep dives into archaeology, should the reader seek deeper immersion and serious study.

Perhaps I should caution you that such study is deeply habit-forming, providing a lifetime of discovery, illumination, and satisfaction.

The Journey

Assman, Jan, *The Search for God in Ancient Egypt*, translated by D. Lorton, Cornell University Press, Ithaca & London, 2001

Budge, E. A. Wallis, *The Egyptian Sudan: Its History and Monuments*, Vols. 1 and 2, J. B. Lippincott Co., Philadelphia/London, 1907

Diodorus, Siculus, *Diodorus on Egypt*, translated by Edwin Murphy, McFarland & Co., NC, 1985

Diodorus, *The Library of History*, Vol. II, Bk. III (beginning); https://penelope.uchicago.edu/Thayer/E/Roman/Texts/Diodorus_Siculus/3A*.html

Diop, Cheikh Anta, *The African Origin of Civilization: Myth or Reality*, translated by Mercer Cook, Lawrence Hill & Co., NY, 1974

Kemet — King Tutankhamen (Dynasty 18) in his coffin of eternity (c. 1324). The Grand Egyptian Museum. Cairo, Egypt, 2010

Hansberry, William Leo, *Pillars in Ethiopian History*, "African History Notebook Vol. I and *Africa & Africans As Seen by Classical Writers* Vol. II, edited by Joseph E. Harris, Black Classic Press, Baltimore, MD, 2019

Quirke, Stephen, *Exploring Religion in Ancient Egypt*, Wiley Blackwell, UK, 2015

Thurman, Howard, *The Search for Common Ground*, Harper & Row, NY, 1971

Ullendorff, Edward, *Ethiopia and the Bible*, The Schweich Lectures, 1967, Oxford University Press, UK, 1968

Wilkinson, Toby, *The Rise and Fall of Ancient Egypt*, Random House, NY, 2010

Children of the River

Bekerie, Ayele, *Ethiopic: An Africa Writing System*, Red Sea Press, Lawrence, NJ, 1997

Fisher, Marjorie M., Peter Lacovara, Salima Ikran and Sue D'Auria with photographs by Chester Higgins, *Ancient Nubia: African Kingdoms on the Nile*, The American University in Cairo Press, Cairo, New York, 2012

Karenga, Maulana, *Maat: The Moral Ideal in Ancient Egypt: A Study in Classical African Ethics*, Routledge, NY, 2004

Meeks, Dimitri and Christine Favard-Meeks, translated by G. M. Goshgarian, *Daily Life of the Egyptian Gods*, Cornell University Press, Ithaca, NY, 1996

Rilly, Claude and Alex de Voogt, *The Meroitic Language and Writing System*, Cambridge University Press, NY, 2012

Torok, Laszlo, *The Kingdom of Kush: Handbook of the Napatan-Meroitic Civilization*, Brill Publishing, Leiden, The Netherlands, 1997

Welsby, Derek A., *The Kingdom of Kush: The Napatan and Meroitic Empires*, British Museum Press, London, 1996

Divine Nature

Assegued, Meskerem, "Women of *Erecha*", in *African Identities: A Journal of Economics, Culture & Society*, April issue, (2004), Vol. 2, No. 1, pp. 53–76, Routledge Taylor & Francis Group, London

Bokku, Dirribi Demissie, *Oromo Wisdom in Black Civilization*, Finfinnee Publishing, Addis Ababa, Ethiopia, 2011

Feyissa, Girma, "Masses Give Thanks: Celebrate *Erecha* for Week under Oaks by Lake," *Addis Fortune* (Ethiopian newspaper), October 3, 2010, Vol. 11, No. 544, p. 31, Addis Ababa, Ethiopia

Freed, Rita E., *A Divine Tour of Ancient Egypt*, The University Gallery, Memphis State University Press, TN, 1983

Leykun, Samuel, *Documentation of 'Irreecha' ceremony among Showa Oromo*, LAP Lambert Academic Publishing, Saarbrucken, Germany, 2012

Megerssa, Gemetchu and Aneesa Kassam, *Sacred Knowledge Traditions of the Oromo of the Horn of Africa*, Fifth World Publications, Durham, England & Finfinnee, Ethiopia, 2019

Sacred Space

Burstein, Stanley, ed., *Ancient African Civilizations: Kush and Axum*, Markus Wiener Publishers, Princeton, 1998

Gerster, Georg, Churches in Rock: Early Christian Art in Ethiopia, Phaidon Publishers, New York, 1970

MacQuitty, William, *Abu Simbel*, G. P. Putnam's Sons, New York, 1965

Mercier, Jacques and Claude Lepage, *Lalibela: Wonder of Ethiopia/The Monolithic Churches and Their Treasures*, Paul Holberton Publishing, London, 2012

Remler, Pat, *Egyptian Mythology A to Z: A Young Reader's Companion*, Facts On File, Inc., NY, 2000

Wilkinson, Richard H., *The Complete Temples of Ancient Egypt*, Thames & Hudson, NY, 2000

Drama of Ritual

Bruce, James, *Travels to Discover the Source of the Nile*, edited by C.F. Beckingham, Horizon Press, NY, 1964

Budge, E. A. Wallis, translator, *The Queen of Sheba and Her Only Son Menyelek (Kebra Nagast)* — http://www.yorku.ca/inpar/kebra_budge.pdf

David, Rosalie, *A Guide to Religious Ritual at Abydos*, Aris & Phillips Ltd., Warminster, Wilts., England, 1981

David, Rosalie, *Temple Ritual at Abydos*, The Egypt Exploration Society, London, 2018

A Guide to Lalibela, Arada Books, Addis Ababa, Ethiopia, 2008

"The Mausoleum of Sheik Hussein," http://whc.unesco.org/en/tentativelists/5649/

Nasr, Seyyed Hossein, *The Study Quran: A New Translation and Commentary*, HarperOne, NY 2015

Pritchard, James B., Ed., *Solomon & Sheba*, Phaidon, London, 1974

Iconography

Allen, James P., *Genesis in Egypt: The Philosophy of Ancient Egyptian Creation Accounts*, Yale Egyptological Studies 2, Yale University Press, New Haven, CT, 1988

Desroches-Noblecourt, Christiane, *Tutankhamen: Life and Death of a Pharaoh*, New York Graphic Society, 1963

Edwards, I.E.S., *Tutankhamum: His Tomb and Its Treasures*, Metropolitan Museum of Art/Alfred A. Knopf, NY, 1976

Hahn, Wolfgang and Vincent West, *Sylloge of Aksumite Coins in the Ashmolean Museum*, Oxford, UK, 2016

Hornung, Erik, translated by David Lorton, *Akhenaten and the Religion of Light*, Cornell University Press, Ithaca, NY, 1999

Lacovara, Peter and Yvonne J Markowitz: *Nubian Gold: Ancient Jewelry from Sudan and Egypt*, The American University in Cairo Press, Cairo, New York, 2019

Lichtheim, Miriam, *Ancient Egyptian Literature: Vol. 2: The New Kingdom*, University of California Press, Oakland, CA, 1976

Munro-Hay, Stuart, *Aksum: An African Civilization of Late Antiquity*, Edinburgh University Press, UK. 1991

Strudwick, Nigel and Helen, *Thebes in Egypt: A Guide to the Tombs and Temples of Ancient Luxor*, Cornell University Press, Ithaca, NY, 1999

Into the Night

Allen, James P., translator, *The Ancient Egyptian Pyramid Texts*, 2nd ed., SBL (Society of Biblical Literature) Press, Atlanta, GA, 2015

Baud, Michel, *Meroe: Un empire sur le Nil*, Musee du Louvre Editions, Paris, 2010

Bent, James, *The Sacred City of the Ethiopians: Being a Record of Travel and Research in Abyssinia in 1893*, Elibron Classics, London, 2005

Bonnet, Charles & Henry Louis Gates Jr., *The Black Kingdom of the Nile*, Harvard University Press, Cambridge, MA, & London, 2019

Brier, Bob, *Cleopatra's Needles: The Lost Obelisks of Egypt*, Bloomsbury Publishing, London, 2016

Chiari, Gian Paolo, *A Guide to Aksum and Yeha*, Arada Books, Addis Ababa, Ethiopia, 2009

Faulkner, R. O., translator, *The Ancient Egyptian Book of the Dead*, University of Texas Press, Austin, with British Museum Publications, London, 1990

Faulkner, R. O., translator, *The Ancient Egyptian Coffin Texts, Vols. I, II, and III*, Aris & Phillips, Liverpool, UK, 1973, 1977, 1978

Herodotus, *The Histories*, translated by Aubrey de Selincourt, Penguin, London, 1972

Karenga, Maulana, translator, *The Book of Coming Forth by Day: The Ethics of the Declaration of Innocence*, translated by, University of Sankore Press, Los Angeles, CA, 1990

Lehner, Mark and Zahi Hawass, *Giza and the Pyramids: The Definitive History*, University of Chicago Press, Chicago, 2017

Piankoff, Alexandre, translator, *The Pyramid of Unas*, Bollingen Series, Princeton University Press, NJ 1968

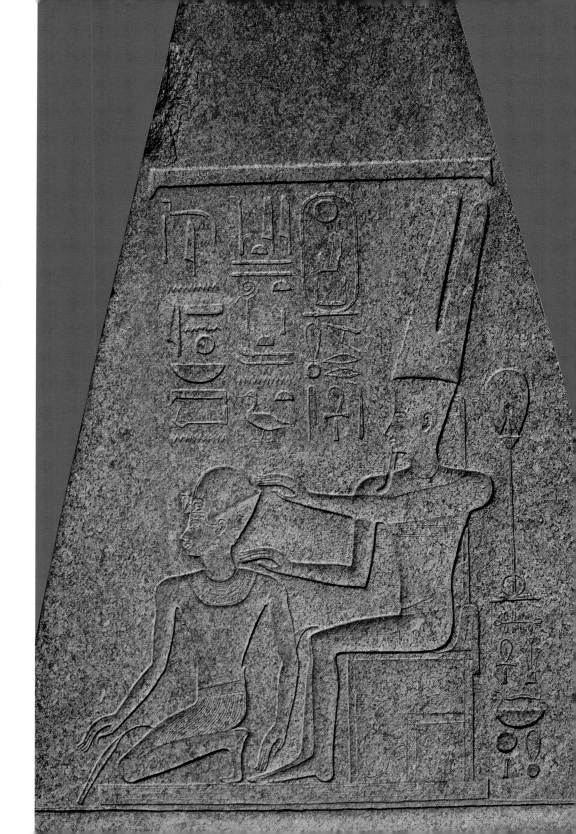

Kemet — Amen anointing Dynasty 18 Queen Hatshepsut as the Chosen One.
Broken obelisk, 15th century BCE Temple of *Amen*. Karnak, East Bank, Luxor, Egypt, 2000

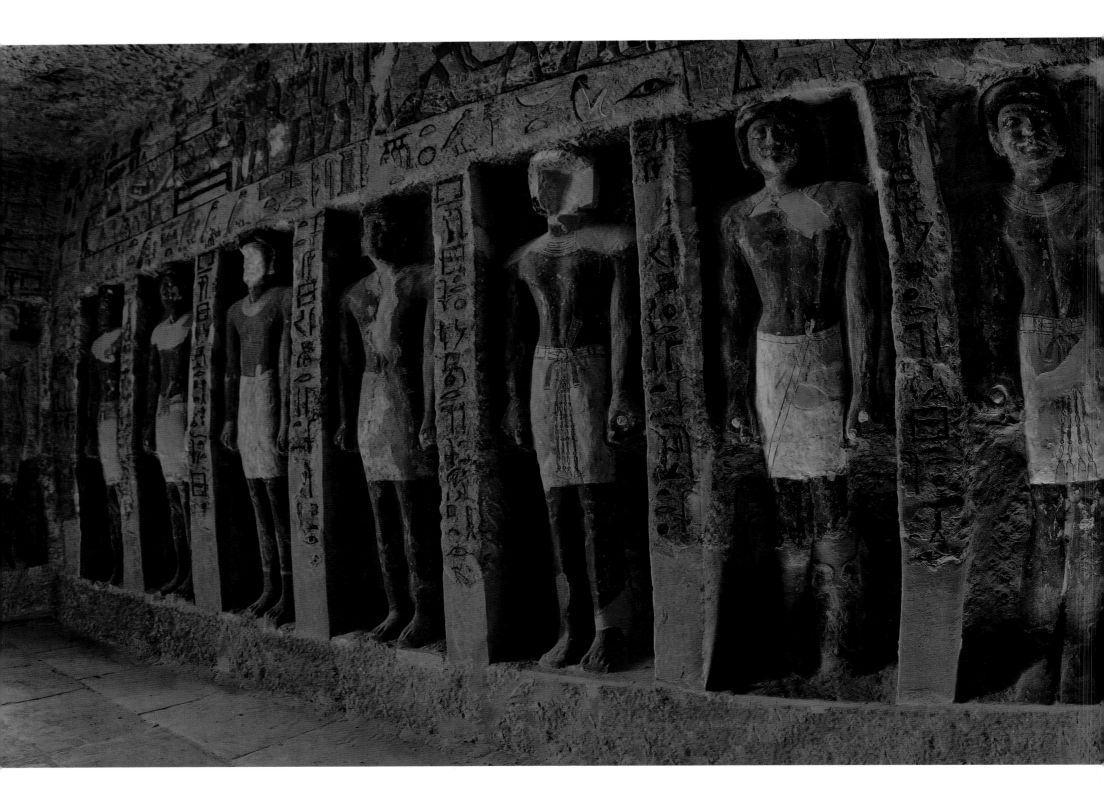

Acknowledgments

This book took almost fifty years to coalesce. In the beginning, it was a thought without form or words; it existed only in Chester's mind. But as the photographs and ideas took root, they began to reveal the lineage of Africa's contributions.

Chasing this thought, we have made deep, lasting friendships — people we've learned to rely on for information, opinions and support. We are grateful to our friend, historian and linguist Hailu Habtu; the late playwright Tsegaye Gebre Medhin; and the most reliable guide in all of Ethiopia Teddy Berhanu of Acacia Tours and his assistant Masai Amberber (who caught me before I slipped into the Omo River). And thanks to the most unique, kind and empathetic government official in any country — the late Fisseha Zibelo of Aksum, Ethiopia.

Special recognition goes to the late William Y. Adams — first to publish a major work on archaeological sites in Sudan *Nubia: Corridor to Africa* (1977) — who allowed Chester to photocopy his only copy of this rare book. Thanks to the late historian John Henrik Clarke who nurtured Chester's passion for Ancient Egyptian history. We owe much to good friends Egyptologists Bob Brier and Pat Remler who never hesitate to tell us when they believe our theories need more scrutiny or direct us to new sources. We acknowledge Peter Bailey, assistant to Malcom X and editor at *Ebony* magazine, who arranged Chester's first trip in 1973 to Egypt (on assignment for an airline) — a journey that ignited his curiosity and dedication to understanding and promoting Africa's glory. Thanks to Director Mamitu Yilma of the National Museum of Ethiopia for permission to photograph the traveling bones of Dinkinesh (Lucy) in NYC.

We are indebted to photographer Gediyon Kifle for introducing us to travel director and now friend Teddy Berhanu and to Meskerem Assegued, who wrote her Ph.D. on the Oromo celebration of *Erecha*. Thank you to cultural historians Aneesa Kassam and Gemetchu Megerssa for furthering our, and the world's, understanding of the Oromo people with their 2020 seminal book *Sacred Knowledge Traditions of the Oromo of the Horn of Africa*.

We acknowledge owner/facilitator George Pagoulatos of the Acropole Hotel in Khartoum for helping us find our way in Sudan. In Egypt, there's retired fundraiser Menar Abdoud in Dashur and our guide in Luxor, Abdelrazk Mohamed Ali, who both opened their homes to us. Thanks to the scholars who helped us sort through all the millennia of facts: Egyptologists Marjorie Fisher, Salima Ikram, Sameh Iskander, Tim Kendall, Peter Lacovara, Stuart Tyson Smith, and Independent Researcher Tony Browder. Closer to home we recognize Egyptologist Yakaterina Barbash for her advice and help with hieroglyphs, and Janice Yellin, Egyptologist specializing in Nubian Studies, whose expertise on ancient nomenclature has been invaluable to us.

A good photography book requires a skilled team: we value Deborah Hofmann for her word prowess and printer Antoon Taghon for his expertise. Profound gratitude to longtime friend and printer Nick Vergoth, now our trusted mentor guiding us as we manage the printing process. Thanks to book packager Nicholas Callaway who introduced us to our talented designer Katy Homans.

To dear friends Gabriel Abraham, Joel Motley, Thelma Austin, Betty Crutcher, Jessica Harris, and Senur Semahj who listened and always commented; and to journalist Tefera Gedamu, who early on embraced this work and presented it to his Ethiopian audience, and Jeff Burzacott, who published our 2019 photo essay on River Nile cultures in his *Nile Magazine*: Thank you. We are grateful to Peter Lapschultz, astrophotography advisor, who taught Chester how to make stars twinkle; and to Dr. Kevin Cahill, tropical disease specialist, for always being available.

We owe special recognition to those who helped make it possible to publish this book: Marjorie Fisher, Sheldon and Judy Gordon, Edna Handy, Raymond McGuire, and Joel and Isolde Motley.

We thank you, the reader! Our enduring hope for *Sacred Nile* is that it sparks further, deeper research into the connections and shared values of the people who lived in the ancient cultures along the Nile — the "Children of the River." —BK

Tomb of Irukaptah, a libationer. Saqqara Necropolis, Egypt, 1979

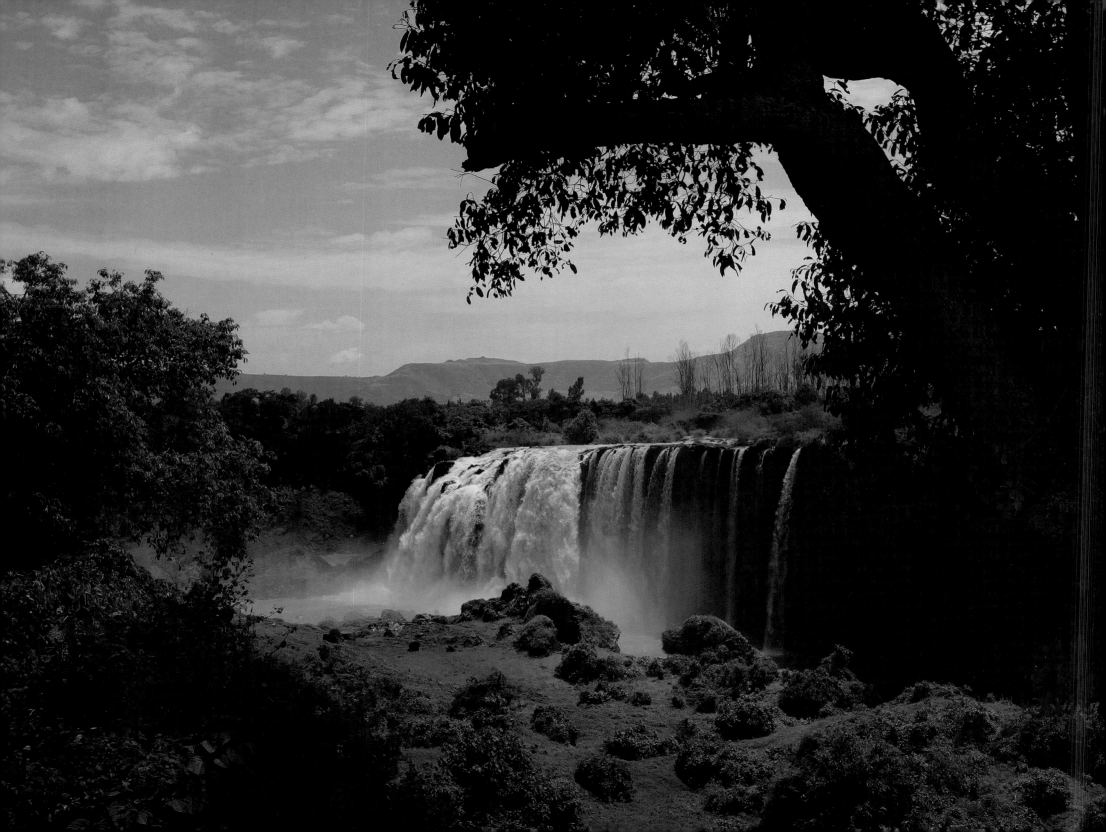

Praise for *Sacred Nile*

The photos in Chester Higgins's **Sacred Nile** are the most remarkable images of Egypt I have ever seen; the text is equally important and innovative. The authors present a thoughtful and quite original meditation on the ancient religion of the Nile Valley and how it infuses life today.
—**Bob Brier**, Egyptologist, C. W. Post University

Sacred Nile takes us on an unforgettable journey down the world's most important cultural highway. With soul stirring text and awe inspiring photography, our introduction to the African roots of faith and spirituality is truly transformative.
—**Anthony T. Browder**, independent researcher

This important, original book gently forces one to think, question and make connections. It is beautiful and visually stunning, while at the same time eye-opening, and for me it provides a feeling of peace, serenity, beauty and harmony.
—**Sylviane Diouf**, historian of the African Diaspora, Brown University

A fascinating tableau of timeless visuals shot with dignity, a sense of history and the power of truth. Higgins spots the divine, weaves it with the earthly, while deconstructing his own long-held views; in the process, he helps us shed some of our own.
—**Tefera Gedamu**, host, Ethiopian television

Sacred Nile is the book Chester Higgins was born to make. He has spent over five decades compiling images of religious practices past and present along the banks of the Nile. The result is a vibrant visual history annotated by an informative text with Betsy Kissam that brilliantly celebrates the matrix of African religious impulse.
—**Jessica B. Harris**, culinary anthropologist

Tis Esat (Water That Smokes), Blue Nile Falls, 6,035 feet above sea level. Bahir Dar, Ethiopia, 2002

In **Sacred Nile**, spectacular photographic images — a colorful celebration of the deep roots of the great Nile River civilizations — show three historical and cultural concepts. The first is that dwellers along the waterway from Ethiopia to the Mediterranean Sea in Egypt share abundant cultural practices; second that there is cultural continuity from ancient to modern times. And third, Judean, Christian, and Muslim religious beliefs are deeply rooted in the mythology and culture of these Nile River dwellers going back several millennia.
—**Sameh Iskander**, Egyptologist, NYU

Chester Higgins uses his camera as a window into the souls of his subjects. He accomplishes with photographs what W.E.B. DuBois did with words in his epic treatise "Souls of Black Folk."
—**Rabbi Sholomo B. Levy**, President, International Israelite Board of Rabbis, New York

Sacred Nile is a bible of African imagery that stuns you with the truth of the Abrahamic spiritual beginnings in a continent that, despite rape and ravage, has preserved its holiness and faith. It all started in Africa. Before Abraham, before Moses, before Jesus, before Mohammed, there was the sacred passage of faith along the Nile River. Amen.
—**Felipe Luciano**, poet

Through this mesmerizing book, Chester Higgins defines the very existence of a human civilization which includes all of us whoever we are. These stories and pictures touch in every detail, our very origins and multiple heritages. It's a comfortable feeling to set aside all critical and skeptical consideration and just let yourself be penetrated by Chester's gaze and journey.
—**Raoul Peck**, filmmaker

In a stunning visual journey through lush and rugged terrain, Higgins illuminates the art, culture and spiritual devotion the River Nile has inspired for centuries. These photographs, by turns intimate and expansive, are an impressive tribute to the space that lies between the physical and the spiritual in this extraordinary land.
—**Carrie Springer**, curator

Published by March Forth Imprint, Brooklyn, New York
© 2022 ® Chester Higgins, Photographs
© 2022 Betsy Kissam, Text

ISBN 978-0-578-85118-1
10 9 8 7 6 5 4 3 2

Printed in China by Chang Jiang Printing Media Co., Ltd.

All enquiries to March Forth Imprint:
info@sacrednile.com
kishig@mindspring.com
Online orders:
sacrednile.com or bookch.com

Book designer: Katy Homans
Copy editor: Deborah Hofmann
Cartographer: Adrian Kitzinger
Digital specialist: Antoon Taghon
Printing and production: Chang Jiang Printing, Joanne Chen and Joseph Braff

Sacred Nile is the story of our collective spiritual imagination and practice. Chester Higgins celebrates the sacred agency of people of African descent and their influence on the foundation of Western religion. His images illustrate how faith migrated up and down the River Nile from Ethiopia to Egypt leaving vestiges of ancient practice in today's worship. This visual portrayal of faith reexamines our spiritual beginnings.

About the Photographer

Chester Higgins's photographs have been exhibited by museums around the world and published widely in *The New York Times*. He has produced seven books; most recently his photographs illustrate *Ancient Nubia: African Kingdoms on the Nile*, edited by Marjorie M. Fisher, Peter Lacovara, Salima Ikram and Sue D'Auria (American University in Cairo Press, 2012). He first visited Egypt and Ethiopia in 1973 and has been documenting antiquity sites in Egypt, Sudan and Ethiopia and contemporary religious ceremonies in Ethiopia for the past five decades.

See chesterhiggins.com, #chesterhiggins12, #sacrednile
Exclusive representation by Bruce Silverstein Gallery,
www.brucesilverstein.com/

About the Author

Betsy Kissam is a freelance writer. She is Editor at Chester Higgins Projects and has been accompanying the photographer for the past three decades on his many field trips to the Blue Nile countries. *Sacred Nile* is their fourth collaboration.

Title page: Sunrise. Meroe Royal Necropolis, Sudan, 1999